A History of Sāmoan Tattooing

Sean Mallon and Sébastien Galliot

with contributions from
Tusiata Avia
Ron Brownson
Adrienne Kaeppler
Takahiro Kitamura
Tupe Lualua
Tavita Maliko
Selina Tusitala Marsh
Le'ausālilō Lupematasila Fata 'Au'afa Sadat Muaiava
Leali'ifano Albert L Refiti
Benoît Robitaille
Nicholas Thomas
Nina Tonga
Maria Carolina Vesce
Maualaivao Albert Wendt
Sonya Withers
Rachel Yates

HAWAI'I

In memory of
Suʻa Suluʻape Paulo II
(1950–1999)

Suʻa Loli Misitikeri
(1963–2017)

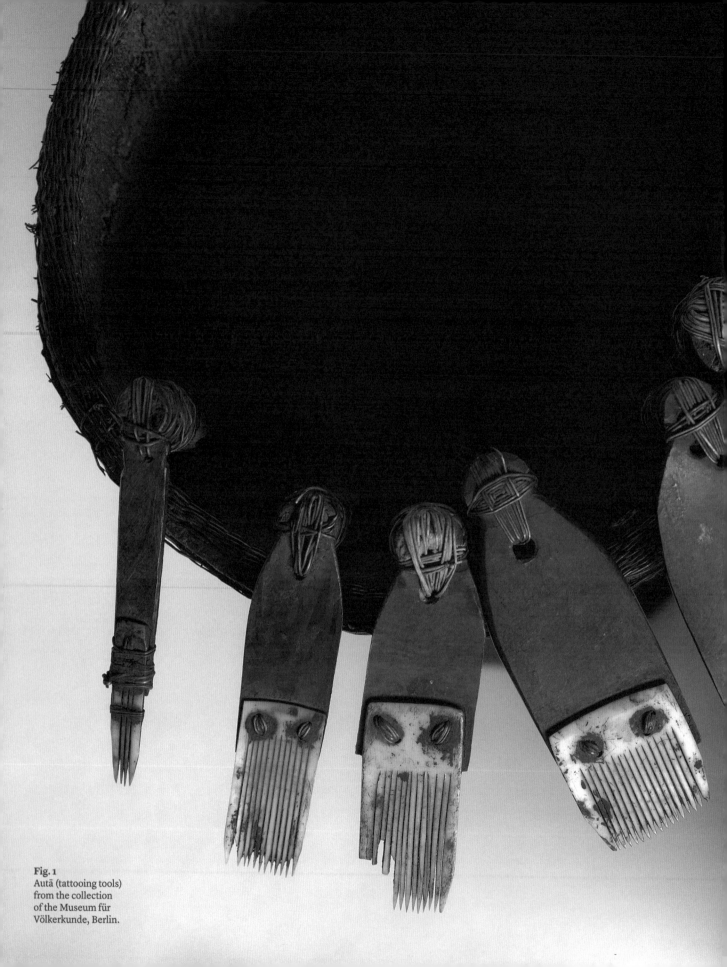

Fig. 1
Autā (tattooing tools)
from the collection
of the Museum für
Völkerkunde, Berlin.

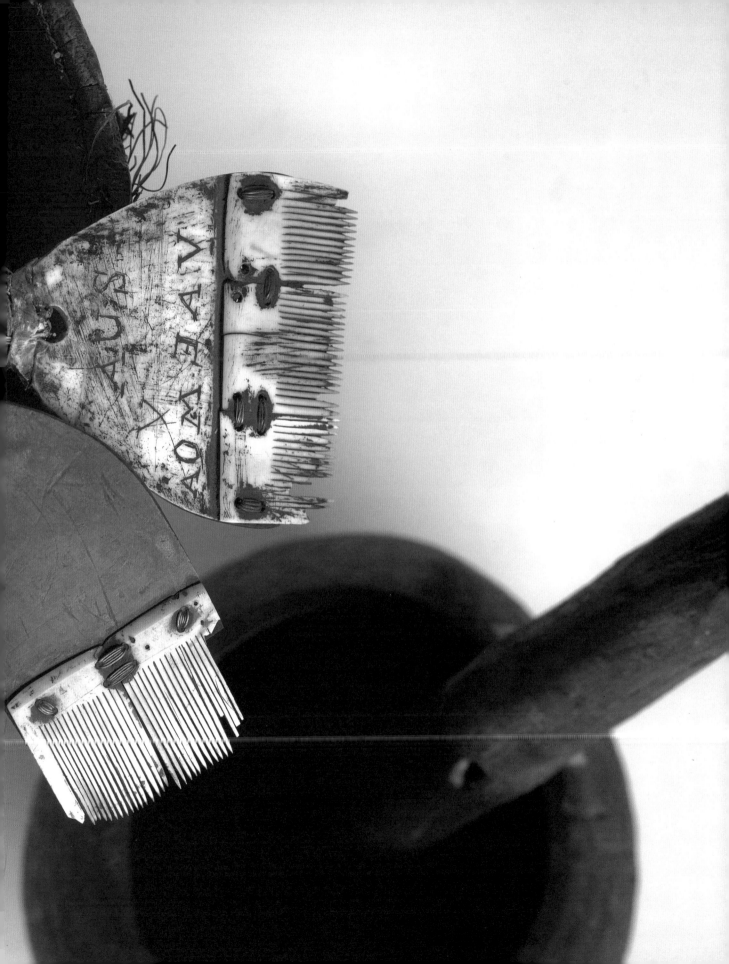

E sui faiga ae tumau fa'avae
The form changes, but the underlying principles remain
— Sāmoan proverb

CONTENTS

Foreword: Sean Mallon...10
Foreword: Sébastien Galliot ..12
Introduction...14

Chapter 1:
TATAU: ANCIENT TRACES ...19

Chapter 2:
TATAU: EUROPEAN ENCOUNTERS AND OBSERVATIONS, 1722–190033
MARK ADAMS PORTFOLIO ...81

Chapter 3:
TATAU: PERSISTENCE AND CHANGE, 1900–2000.......................97
GREG SEMU PORTFOLIO ... 177

Chapter 4:
TATAU AS A RITUAL INSTITUTION, 2000–2010........................ 178
JOHN AGCAOILI PORTFOLIO..225

Chapter 5:
TATAU AND ITS GLOBALISATION, 2000–2017.............................241

Postscript ..298
Acknowledgements...302
Glossary .. 304
Bibliography..308
Image credits .. 319
About the contributors...320
Index ...322

FOREWORD:
SEAN MALLON

The first time I saw Sāmoan tattooing was on my grandfather's crookedly tattooed wrist and inner forearm when he came to stay with my family in Wellington, New Zealand, during the early 1970s. His name was Afoa Ioane Mauga and he was born and raised in Sāmoa and was then aged in his sixties. It is an early and vague memory, and I learned later that he had been a skin stretcher for a tattooist named Popo.

Throughout my childhood I attended Sāmoan ceremonial events, where I occasionally glimpsed the Sāmoan male tattoo. Often it would be during weddings, when men performed 'aiuli or clowned around a dancing woman to enhance the dignity and gracefulness of her performance – hitching up their lavalava (cloth worn around the waist) and exposing their heavily tattooed legs, taking off their shirts to expose dark concentric circles curving down the sides of their abdomens. Only once or twice did I ever see a female tattoo. When I did, it was only the quickest reveal, at the very edge of the lavalava where a small part of the knee might show itself.

I also encountered Sāmoan tattoo on other less formal occasions. In my early twenties, in a crowded Wellington bar popular with Polynesians, I visited the men's room to find half a dozen people gathered around a man who had dropped his trousers and was showing off his tattooed legs. The onlookers stared as he stood there basking in glory as other patrons of the men's room went about their business. A year or two later, I saw tattooed armbands up close for the first time. I was at

university, and a group of my friends had been to see a Sāmoan tattooing expert in South Auckland. They had each come back with tattooed upper arms. When I caught up with them a few days after the event, their arms were a dark bruised colour from the shoulder to the forearm. Everyone was impressed with their courage and the beautifully rendered designs, despite them being barely discernible on their temporarily discoloured skin. It was the first time I had seen how painful and potentially dangerous receiving a Sāmoan tattoo could be.

Through the 1990s, I travelled several times to Sāmoa in the course of my work as a museum curator. On one visit I took a trip around the coastline of the island of 'Upolu with a Sāmoan Catholic priest and some family members. In the afternoon we stopped at a secluded beach for a swim, and the priest, obviously feeling the heat, decided he wanted to go for a swim as well. Stripping down to a lavalava, he revealed that he had a full male tattoo. While he was proud that those in the family should see it, he was reluctant for strangers to see him. A priest having, let alone displaying, a full tattoo is controversial in several denominations.

In the last twenty years, I have had the opportunity to be tattooed myself and to observe Sāmoan tattooing on people and in practice in New Zealand, Sāmoa and in Europe. I have seen it inscribed on bodies – Sāmoan and non-Sāmoan – and in art, photographic images, film and various media. I've seen it on the sports field, in art galleries and museums, in tattoo studios and in cultural performances. The diversity of these locations no longer surprises me. But what did surprise me, and continues to intrigue me, is the idea that a set of symbols from a seemingly remote group of islands in the South Pacific could circulate in many forms across a range of contexts and on the bodies of people from all walks of life and from across the world.

In examining how that has happened, I was fortunate enough to come across Sébastien Galliot, who had been working in Sāmoa and had developed his own detailed view of the practice of tatau and its historical background.

FOREWORD: SÉBASTIEN GALLIOT

When I was growing up in the northern part of Marseille, the most tattooed individuals I encountered were dock workers and gypsies from the local Spanish gypsy community. I only came to know about Sāmoan tattooing in the early nineties, after the publication of V Vale and Andrea Juno's *Modern Primitives* which, at that time, exposed the limits of body art beyond anything I had heard of before. Back then, publications on Sāmoan tattooing were quite limiting; none addressed the contemporary cultural context of its making and displaying. None provided an indepth account of its ritual dimension.

In the early 2000s, after completing my undergraduate studies in philosophy, I planned to research Sāmoan tattooing as an ethnology student. Before I went to Sāmoa for the first time in June 2001, I did a voluntary course at the South Pacific Community (SPC) in Nouméa. There, my supervisor, whose husband sported a very rough, hand-tapped Sāmoan tattoo, asked me to look after the English translation of the SPC's website pages devoted to Pacific artists and custodians. Thanks to that job, I learned the whereabouts of several tufuga tā tatau, information that I eventually used for my fieldwork in Sāmoa.

Once I was in Sāmoa, locating the tufuga proved to be a difficult task. I was staying in Moataʻa with members of the ʻāiga Fuimaono as well as with the Lokeni, in a village where daily activities were more dominated by rugby practice than by tattooing rituals. There were several difficult weeks before I met an active tufuga tā tatau. Before that I travelled around Sāmoa and ʻUpolu in search of a tattooing operation. I first took an exhausting bus ride to Siʻumu to discover that the late Suʻa Liʻo Tusiʻofo had passed away a couple of weeks before my visit but I had the chance to meet his son Suʻa Lesa Moli Tusiʻofo, who showed me his tools and with whom I shared a couple of Vailima. I then went to Falelatai, where I met the tufuga Misa Suʻa, who had stopped tattooing because of a loss of eyesight. I then went to Savaiʻi, where I met Vaipou Vito in the village of Vaitoʻomuli (Palauli). He also had stopped tattooing several years earlier. I also briefly met Touloʻena Peni Faʻamausili near a bus stop in Gautavai. But none of them was currently busy. Back in ʻUpolu, I ended up in Faleasiʻu, where Suʻa Suluʻape Alaivaʻa Petelo invited me to join him the next day in Savalalo, where he was starting to work on one man and several girls.

When I came back to Sāmoa as a PhD student in 2004 and 2005, I spent some time in Gāgaifo o le Vao with Suʻa Laʻai and his sons, and learnt more about the history of the ʻāiga sā Suʻa as well as the politics and the controversy around the transmission of the craft.

In 2005 an encounter with Suʻa Loli Misitikeri from Vaipuʻa village in Salega district brought me a deeper understanding of what a tufuga tā peʻaʼs life looked like. Experiencing the overwhelming love, generosity and sense of humour of Loliʼs ʻāiga, my fieldwork transformed into a wonderful human experience. Eager to give back a little of what was given to me during my stay in Sāmoa, I did my best (perhaps not enough) to organise the very first trip of a Sāmoan tufuga to France in 2008, which was followed by another European tour involving Loli Misitikeri and his son Alaivaʻa (named after his master Alaivaʻa Suluʻape) and financed by the Marquesan tattoo artist Teiki Huukena.

That is how my long journey into Sāmoan tattooing started: from perfect ignorance to passionate student and researcher.

INTRODUCTION

Tatau are the tattooed lines and motifs worn by Sāmoan men and women. The process of tattooing is known as paʻū le mālōfie, or tuʻituʻi mālōfie in its polite form; the tatau specialist is known as tufuga tā tatau. Sāmoan tatau is distinctive for the location of the markings on the body, their extent and density, and the tools used in the tattooing process. It is usually described as having two main forms. Men wear the tatau or peʻa, a densely rendered set of markings that begins on the lower back, extends around the waist, completely covers the lower body down to the knee and is finished off with a small group of motifs at the navel. Women wear malu, a set of markings less dense than the peʻa, starting at the upper thigh and extending down the legs and finishing behind the knee; and until at least the mid twentieth century the malu could also include the punialo – a series of patterns on the pubic area. There are other smaller, popular forms of tatau such as armbands and wristbands, but peʻa and malu are the most valued and important in contemporary Sāmoan cultural life.

Another distinctive feature of tatau is how the markings are rendered. Despite the availability of electric tattooing machines, many Sāmoan tufuga prefer to do their work with a set of handmade tools called au or autā. An au is usually made of three parts: a small bone or pig's tusk comb attached to a turtleshell plate, both of which are lashed with coconut fibre to a wooden handle; today, the turtleshell plate is sometimes replaced with a piece of plastic or metal and the coconut fibre with nylon fishing line. The comb has very fine teeth, carefully sharpened to perforate the skin and deliver the pigment into it. A set of au comprises several tools, each designed to render different types of designs. Tools with a wide comb are used for filling in large dark areas of the tatau, while narrow combs are used to make very fine motifs and dots.

The tatau is popularly described as a necessary rite of passage for young men. In Sāmoa, after being tattooed the young man is not only accepted as a full member of the ʻaumāga (the village association of young men), but is also allowed to serve some ceremonial foods called taufolo and vaisalo to the matai (chiefs). In a similar way, women who receive the malu are also admitted to participate in Sāmoan ceremonial and cultural life in a more active way. The tatau has been associated with ideas connected with the wrapping, sealing and defence of the body, as well as with ornamenting it and making it beautiful. However, these are very simplistic and conventional descriptions of Sāmoan tattooing and its meaning in contemporary Sāmoan society.

Finding a way of acknowledging complexity is an intervention in the writing and historiography of tattooing practices in the Pacific.[1] The Sāmoan Islands are unique in Polynesia in that tattooing has been continuously practised there without major interruption, using indigenous tools and techniques. But it has also changed in subtle ways in its design and meaning while maintaining a significant (but not uncontested) role in Sāmoan society and culture. Indeed tatau has a history: it has been shaped by the stories and movements of ancient Pacific peoples, the histories of Sāmoan families, villages and districts, as much as by foreign influences and incursions. To talk about tatau as having a history is to understand how it has changed as an artform in appearance and in practice, but also how it has mediated or marked changes in Sāmoan society and culture. To even talk about tatau as an artform is a recent practice. Indeed, Sāmoan tatau is contested, fragmented, cut through by different cultural values, pedigrees of training, networks of association, collaboration and patterns of inclusion and exclusion.

This cultural history is the first to examine 3000 years of Sāmoan tatau. Through a chronology rich with people, encounters and events it describes how Sāmoan tattooing has been shaped by local and external forces of change over many centuries. It is a narrative that argues that Sāmoan tatau has a long history of relevance both within and beyond Sāmoa. The first part of the book traces the origins of tattooing: it connects the prehistory of the practice to around 1500 BC and to the early seafaring ancestors of the Polynesian people. At this time, peoples of the Pacific were making the distinctive decorated pottery that archaeologists call Lapita ware. The designs and motifs on this ancient pottery relate directly to those present in contemporary tattoo and barkcloth decoration of the islands of Fiji and Tonga. The origin stories of tatau found in early recorded oral histories reinforce these connections to an Oceanic world beyond the Sāmoan archipelago.

The second part of the book examines Sāmoan tattooing from the 1700s to 1900. The markings of tatau are conspicuous in the first recorded observances of early European visitors to Sāmoa; indeed they would wear these markings on their own skin as they settled and travelled through Sāmoa. This history draws on indigenous accounts and the writings and observations of European explorers, missionaries and colonial officials. It includes stories of the impact of the missionaries on tattooing; Sāmoan resistance to attempts to prohibit the practice; and the tattooing of Europeans, Tongans and other foreigners. It also examines Westerners' fascination with tatau and their efforts to document and display it in institutions in Europe. Tatau would tour the world on Sāmoan bodies as several groups visited the homeland of Sāmoa's German colonisers, and at fairs and exhibitions across other parts of Europe and in the United States.

The third part of the book examines the history of Sāmoan tatau in the twentieth century. It includes stories of German colonial administrators getting a full body tattoo, the impact of the First and Second World Wars on tattooing, and the expansion of Sāmoan tattooing in the postwar years through processes of decolonisation and the

1.
This approach is inspired by two key research projects: Tanya Harrod, *The Crafts in Britain in the 20th Century* (New York: Bard Graduate Center for Studies in the Decorative Arts, 1999); Peter Brunt and Nicholas Thomas, *Art in Oceania: A New History* (London: Thames & Hudson, 2012).

TATAU

development of air travel and tourism. It describes the migration and development of Sāmoan communities overseas and how tatau has changed as a result of these processes. It highlights the interests and engagement of European and American tattooing communities with Sāmoan tattooists in the 1980s and 1990s.

The last two parts of the book describe and analyse the dynamics of contemporary Sāmoan tatau. The fourth part is a portrait of contemporary tattooing in Sāmoa: the practice, the cultural politics and the range of practices called 'tattooing' within the archipelago. The fifth part examines the practices and beliefs associated with Sāmoan tattooing transnationally and globally, with a focus on Sāmoan people in New Zealand but including the United States and Europe; it examines the politics of tattooing in the global milieu, its various forms and contexts of production and circulation.

The book brings together a rich collection of historical images of nineteenth- and twentieth-century Sāmoan tattooing, contemporary tattooing, diagrams of tattoo designs and motifs, and supplementary photographs such as posters, ephemera, film stills and artefacts. It also includes new writing and excerpts from the published writings of Sāmoan scholars and authors, interviews with tufuga tā tatau and tattooed Sāmoans and non-Sāmoans.

This book sits within a very large literature on Sāmoan tattooing that includes popular and academic articles, films and documentaries, poetry and novels, websites and blogs. Nonetheless, there has been no single publication on Sāmoan tattooing since Carl Marquardt's *Die Tätowirung Beider Geschlechter in Sāmoa/The Tattooing of Both Sexes in Sāmoa* (1899). *Tatau: Sāmoan Tattoo, New Zealand Art, Global Culture* (2010) is another publication that was focused primarily on the work of a small group of tattooists and the work of New Zealand photographer Mark Adams. These two studies offer limited discussion of the broader historical processes of cultural exchange or the multiple indigenous and other perspectives included here. This book complements the groundbreaking *Tatau: Marks of Polynesia* exhibition and catalogue (2016) that documents the present generation of tufuga tā tatau and tattooers working with masini (tattooing machines).

The idea for this book originated in conversations between Sean Mallon and Sébastien Galliot during the early 2000s. It draws on their longterm research and engagement with Sāmoan tattooists in New Zealand, Sāmoa, Europe and the United States. Mallon's work includes interviews and research on Sāmoan tattooing in the Western milieu and among Sāmoan tattooists in New Zealand and Sāmoa. Galliot's work includes an unprecedented survey of the missionary archival sources and longterm fieldwork in Sāmoa where he lived with the 'āiga sā Su'a, photographing, studying and writing about their work. Mallon and Galliot have combined their research and writings to make them accessible to a wider readership. This book is the result of this collaboration.

TATAU: ANCIENT TRACES

Fig. 3
Did the knowledge
and tools for Samoan
tattooing originate in Fiji?
A tattooed female figure
from Fiji (1800s).

The practice of tā tatau came to Sāmoa 3000 years ago. Archaeologists tell us that the first arrivals were descendants of seafarers entering Oceania from or through Taiwan. They originally explored eastwards into the Pacific, populating the Marianas and islands of the Bismarck Archipelago and the Solomon Islands, then they ventured to the southeast to the islands of Tikopia, Vanuatu and New Caledonia before populating the archipelagos that we now know as Sāmoa, Fiji and Tonga. They travelled in sailing canoes, taking with them their languages, cultures, animals and plants.

Archaeologists connect these groups of explorers and settlers to each other through a distinctive type of pottery that they made – they called the pottery Lapita ware, after a site in New Caledonia where they first discovered it, and they named the people who made the pottery the Lapita people, who are the ancestors of many distinct societies and cultural groups found in the Pacific today.[1]

The analysis of Lapita pottery offers insight into how the practice of tattooing may have travelled with the people who settled Sāmoa and other Pacific islands. Archaeologists have argued that some of the designs and motifs found on this ancient pottery relate directly to those present in contemporary tattoo and tapa (barkcloth) decoration.[2] However, a connection between tattooing and the dentate stamp decoration techniques used to decorate Lapita pottery has been challenged by archaeologist Wal Ambrose, who argues for woven technologies of high-value plaited and ornamented textiles as an alternative model for Lapita ornamentation.[3] Andy Mills makes a similar argument for Tongan tātatau, where tattooing motifs replicated abstract weaving motifs.[4]

Further connections between Lapita people and tattooing are based on archaeological excavations of Lapita pottery-bearing sites where tattooing-related artefacts have been found. One of these sites is in Tongatapu in Tonga, where archaeologists have unearthed examples of tattooing blades. Another is in the Reef Island Lapita site in the Santa Cruz group of the Solomon Islands, where a small baked clay figurine's buttocks bear images that may represent tattoo.[5] Similarly, a small clay-modelled head with a facial tattoo has been reported from a Lapita site in Papua New Guinea.[6] Although there are Lapita pottery-bearing sites in Sāmoa, no tattooing-related implements have

1.
Patrick Vinton Kirch, *The Lapita Peoples: Ancestors of the Oceanic World* (Oxford: Blackwell, 1997).

2.
RC Green, 'Early Lapita Art from Polynesia and Island Melanesia: Continuities in Ceramic, Barkcloth and Tattoo Decorations', in *Exploring the Visual Art of Oceania*, edited by S Mead (Honolulu: University of Hawai'i Press, 1979); Patrick Vinton Kirch, *On the Road of the Winds: An Archaeological History of the Pacific Islands Before European Contact* (Berkeley: University of California Press, 2000).

3.
W Ambrose, 'Oceanic Tattooing and the Implied Lapita Ceramic Connection', *Journal of Pacific Archaeology* vol. 3, no. 1 (2012): 1–21.

4.
A Mills, 'Bodies Permeable and Divine: Tapu, Mana and the Embodiment of Hegemony in Pre-Christian Tonga', in *New Mana: Transformations of a Classic Concept in Pacific Languages and Cultures*, edited by M Tomlinson and TPK Tengan (Canberra: ANU Press, 2016), 91.

5.
Green, 'Early Lapita Art', 16–17.

6.
GR Summerhayes, 'The Face of Lapita Archaeology', *Oceania* 33 (1988): 100.

been found there. The turtleshell components and the wooden handles of Sāmoan tools do not stay preserved at archaeological sites, so only the bone points would survive – but none has been discovered to date. This material evidence is supported by the linguistic reconstruction of the word 'tatau' and the word 'uhi' – the Eastern Polynesian term for a tattooing implement – which point to an origin for tattooing early in the human settlement of the Pacific.

Oral traditions recorded in the nineteenth century say that the knowledge and tools for tattooing came to Sāmoa from Fiji. In one of many versions of the story, Tilafaigā and Taemā, who were joined like Siamese twins, acquired the tools and the instructions on how to use them from the tattooists Filelei and Tufou in Fiji. They were told to 'tattoo the women and not the men', and they sang this instruction over and over as they paddled their canoe to Sāmoa. On the way they saw a large and beautiful shell glistening in the waters below and they stopped singing their song to swim down and fetch it. On returning to the surface they tried to remember what they were singing and got the song mixed up. 'Tattoo the men and not the women', they sang, and this was the message they took on to Sāmoa.[7]

Oral traditions inevitably reflect the politics and historical circumstances of those telling the story, those recording the story and, later, those who use, reproduce and reference the story. The origin stories relating to tatau are contested; there are various versions that emphasise different people and events within the story. Among contemporary Sāmoans there has been some resistance to the idea of Fiji as the point of origin for Sāmoan tattooing. The part of the story where Taemā and Tilafaigā are instructed to tattoo women and not men is particularly questioned: some people (including Fijians and Sāmoan tufuga tā tatau) say that women were not tattooed there.[8] However, tattooing was practised in Fiji on and by women up until the late nineteenth and early twentieth centuries. In the twenty-first century it is undergoing a revival initiated by Fijian women living in New Zealand and Australia.[9] Despite these historical details, Sāmoan tufuga and some historians are looking closer to home for an origin of Sāmoan tattooing.

In the context of the origin story of tatau, where or what was Fiji? One contemporary explanation suggests Fitiuta in Sāmoa's eastern islands of Manu'a as an origin site;[10] Fiti was possibly confused in the past with Fiji (Fiti in Sāmoan). Manu'a was once the political centre of Sāmoa so it is possible Fiti, Viti or Fiji may have been a reference to Fitiuta. This apparent rethinking of the origin story reminds us that indigenous ideas relating to space and geography are often subject to change. The names of places can be abandoned, replaced, forgotten and confused or evolve over time. They can be influenced by the movement of people, by politics and conflict, and by processes of colonisation from within and outside the Pacific. Even natural disasters can influence how people think about, interact with and remember the environment and its histories. A detailed examination of the various versions of the origin stories allows us to solve this problem but, at the same time, it complicates another aspect of this mythology by introducing conflicting stories of the twins' journey.

7.
G Milner, 'Siamese Twins and Sāmoan Tattoos', Man 8, no. 1 (1973): 10; Ministry of Youth Sports and Cultural Affairs, Sāmoa Ne'i Galo Talatu'u ma Tala o le Vavau a Sāmoa (A Compilation of Oral Traditions and Legends of Sāmoa) (1998), 158–64.

8.
Su'a Sulu'ape Alaiva'a Petelo, interview with Sean Mallon at Faleasiu, Sāmoa, December 2002.

9.
See The Veiqia Project – an artist-led research project inspired by the practice of Fijian female tattooing: https://theveiqiaproject.com/about/ (Retrieved 3 October 2017).

10.
See for example the explanation given by Su'a Vaofusi Pogisa Su'a in Sāmoa News (6 November 2012): 4.

The myths collected in the second half of the 1800s by the missionaries George Pratt[11] in Savai'i and Thomas Powell[12] in Manu'a somehow introduced the idea of the existence of two main versions of the doings of the conjoined twins. The twins, whose genealogy and birth names diverge according to these versions, ended up being called Taemā and Tilafaigā after some inadvertent encounters with objects during their swimming journey. The episodes relating to the introduction of tattooing tools are in fact only a short sequence within a longer saga whose central premise deals not with tattooing but with the dreadful and uncertain consequences of giving birth. Ultimately this can be read as a myth about the status of women.[13] During their journey Taemā and Tilafaigā travel to many places and meet many people all over the archipelago and beyond (in Fiji and in Pulotu, the underworld). These primordial encounters gave birth to clan names and sacred places where the link with those deities is remembered – and were still worshipped at the time of missionaries' settlement in the early 1800s.

This being said, in each of these early collected versions of the story, Taemā and Tilafaigā imported the tools from Fiji. Only the version told by members of the clan Su'a in Lefaga (namely Su'a i Vaiaga) says that the twins made the first tattoo on Sina, daughter of Tagaloalagi the god creator of all things, in Fitiuta. According to this version they swam away from Fitiuta with the tools and reached Faleālupo on the land of chief Auva'a; he wasn't there to receive his visitors, but he eventually marked this unusual event by taking a new name, Muaifaiva (the first of the craft), associated with the name of a ceremonial ground (Mapuifagalele). It is precisely details about chiefs' names and places of encounters, scattered in many versions of the story, that are crucial for the contemporary tufuga tā tatau. What seems to be at stake for the tufuga in the current context is to relink one's own kin and place of origin with the territorial and clan foundation resulting from Taemā and Tilafaigā encounters.

The details of the voyage are too numerous and confusing to be discussed at length here.[14] However, if one puts aside these details – especially the sequences that occur before the twins' discovery of the tattooing tools, which are irrelevant to the topic of tattooing – a running theme can be reconstituted. The sequence involving the tools starts in Fiji, then follows a series of calls in several locations where the twins attempt to present the tools in recognition of the welcome accorded to them by the local ruler. The first place they reach is Falealupo in Savai'i, on the land of Auva'a. Their next place of call is Safotu with chief Lavea or Seve (depending on the version). The story goes on with an episode in Salelāvalu with chief Mafua, who is said to have accepted the tools but infringed on the rules attached to the craft – namely the acceptance of the first kava cup. In Salelāvalu, chief Su'a is also mentioned in connection with a talie tree under which the twins had a rest while waiting for him, and which became the dwelling place of Taemā's spirit.[15] This place was called Lalotalie and was known as the malaetā (a ceremonial site dedicated to the guardian deity of tattooing) of Su'a.

From Salelāvalu the twins pursued their journey to 'Upolu in Lefaga, Safata and Sale'ilua, where they made contact and interacted with other characters of importance for the

11.
J Abercromby, 'Samoan Tales', *Folklore*, no. 2 (1891): 455–67.

12.
J Fraser, 'Some Folk-songs and Myths from Samoa', *Journal of the Polynesian Society*, no. V (1896): 170–78.

13.
We owe this interpretation to Serge Dunis and his great knowledge of Pacific mythology.

14.
Sébastien Galliot has counted at least seven different versions of the origin myth.

15.
While the idea that the Su'a clan of tufuga is historically rooted in 'Upolu is widespread, the Tulou'ena clan has its ancestors in Savai'i, the episode involving the land of Su'a in Salelāvalu contradicts this popular assumption. The fa'alupega of Salelāvalu (traditional terms of address and polite greeting) acknowledges Su'a as a ma'upū of Nāfanua (the son of Nāfanua's sister Taemā).

TATAU

clan Suʻa of tufuga. In Safata, their encounter with a chief called Tapu is said to have been at the origin of the creation of another malaetā called Faʻamafi. Whatever the details of the interactions, this oral tradition constitutes a corpus of reference from which the tattooers can draw clues of legitimacy and clan membership, especially in the contemporary context of the emergence of Sāmoan practitioners whose apprenticeship occurred outside the archipelago, and for whom traditional affiliation is more blurred.

For at least 200 years, members of two ʻaiga (extended families) – the ʻāiga sā Touloʻena and the ʻāiga sā Suʻa – have been the custodians of Sāmoan tattooing. However, the claims of these ʻaiga are contested by other families in Sāmoa who have their own accounts of Sāmoan tattooing and its history. Today, Sāmoans contest and lay claim to origin stories of tatau, and the historical figures who participated in the events they describe, because the genealogical connections are considered true and meaningful to them. The origin stories that relate to specialist trades such as fale building, vaʻa building and tā tatau legitimise people's claims to matai (chiefly) titles and the right to practise these trades. Families manage these rights carefully because they carry social and cultural prestige in wider society; they also depend on them for their economic security.

The origin stories for tatau demonstrate how the development of Sāmoan society and culture was connected to the nearby archipelago of Fiji. However, a wider network of trade, intermarriage and interactions also connected Sāmoa to Tonga, ʻUvea (part of Wallis and Futuna), the Cook Islands and Solomon Islands. Between Fiji, Tonga and Sāmoa there was trade in a number of material products including red feathers, hardwood timbers from Fiji, ʻie tōga (Sāmoan fine mats) and basalt adze blades from Sāmoa, and kie hingoa (fine mats) and sperm-whale teeth from Tonga. There was also movement of expert tradesmen and their knowledge that included tufuga fau vaʻa (canoe builders) from Manono in Sāmoa: in the 1700s they resided with Maʻafutukuiʻaulahi, a prominent chief from Tongatapu,[16] before settling in Lau in Fiji and establishing the mātaisau – a hereditary line of craftsmen influential throughout Lau and as far north as Taveuni.[17]

Tufuga tā tatau also travelled between the archipelagos. From at least the 1700s Tongan nobles were tattooed by Sāmoans who acted as matapule – an intermediate class of ceremonial attendants who played important roles in Tongan society. Tongan commoners were forbidden to touch the Tongan elite, so Sāmoans were brought to Tonga to attend to their needs. As outsiders, they 'could tattoo Tongan chiefs with immunity, cut their hair (the head of a Tongan chief is extremely tapu) and prepare their bodies for burial'.[18] Tongan male tatau was similar in appearance to Sāmoan male tatau: it covered the body from the lower torso to the knees. The presence of Sāmoan tattooists in Tonga doesn't mean all tattooists in Tonga were Sāmoan – just that the social elite could not be tattooed by Tongans.

16.
AC Reid, 'The Fruit of the Rewa: Oral Traditions and the Growth of the Pre-Christian Lakeba State', *Journal of Pacific History* vol. 12, pt 1 (1977): 17.

17.
MA Tuimaleali'ifano, *Samoans in Fiji: Migration, Identity and Communication* (Suva: USP, 1990), 35.

18.
A Kaeppler, 'Exchange Patterns in Goods and Spouses: Fiji, Tonga and Samoa', *Mankind* 11, no. 3 (1978): 246–52; A Gell, *Wrapping in Images: Tattooing in Polynesia* (Oxford: Clarendon Press, 1993), 106–08.

The autā:
Deeply Austronesian,
uniquely Sāmoan

Benoît Robitaille

The Sāmoan tufuga tā tatau (tattooists) toolkit as it was observed, described and collected, starting in the nineteenth century, carries within itself the story of its origins and represents the culminating achievement of generations of craftspeople who strove to create what may be the most sophisticated expression of tattooing technology ever produced in the pre-electric era of tattooing history.

This toolkit generally consists of four perpendicularly hafted composite tattooing pointsv (au) of varying sizes, a sausau (mallet) used to strike the handle of these tools to drive in the tattooing points, a mortar and pestle to grind the candlenut soot pigment used to make the tattooing ink, a palette to hold the ink, a water bowl to rest the tools in when not in use during the operation, and towels of siapo barkcloth used to stretch the skin of the person being tattooed, to wipe off blood and excess ink and to wrap around the handle of the au to provide a steady grip. The tools are kept in a tunuma (container) made from a hollowed-out trunk of pandanus wood.

The particular manner in which the tufuga tā tatau wield their instruments, now commonly referred to as hand tapping, provides important clues as to the origins of Sāmoan tattooing and its family ties with tattoo traditions across Oceania, island Southeast Asia and in a few remote pockets of the Asian mainland. The perpendicular hafting of the tattooing points and the use of a mallet to drive them into the flesh to produce tattooed marks is a practice at once very widely and almost exclusively shared among peoples speaking languages belonging to the Austronesian family. The most likely explanation for such a coherent and well-defined distribution is that the practice of hand tapping tattoos and the ancestral Austronesian language designated by linguists as Proto-Austronesian share a unique point of origin and were then disseminated throughout their known range by the migrating ancestors of people speaking Austronesian languages. Many strands of linguistic and ethnographic evidence point to neolithic southern China or Taiwan as the birthplace of both Austronesian languages and hand-tapped tattooing. There is in fact no other element of material culture that can be

called 'typically Austronesian' apart from the perpendicularly hafted tattooing instrument. If some aspects of Sāmoan tattooing technology yield insights into its ancestry, others define its uniquely Sāmoan character. Indeed, the Sāmoan autā stands apart from even its closest Polynesian relatives within the wider Austronesian family of perpendicularly hafted tattooing instruments, by virtue of the distinctly complex assembly of its tattooing points. These points consist of comb-like quadrangular plates of ground boar's tusk (or possibly human pelvic bone in ancient times) attached with 'afa (sennit cord) to a connecting turtleshell (or, less frequently, bone) shank that is lashed to the tool's handle.

The narrowest tools in the tufuga's kit employ a single-toothed plate; the widest tools can feature up to ten such plates lashed together side by side and attached to the connecting shank. Different types of lateral composite assemblies featuring two or more comb-like plates are known to have been used in various Oceanic tattooing traditions, notably in the Society Islands, Hawai'i and possibly among Māori; but the added complexity of a superposed connecting shank is a unique feature of the Sāmoan tradition. The few reports of such tools having been used on Tonga most likely refer to instruments wielded by Sāmoan tufuga serving as attendants to the Tu'i Tonga (Tongan King).

The Sāmoan lateral superposed composite tattooing points are the crowning achievement of an extraordinarily dedicated drive by a specialised class of craftsmen towards technological sophistication: they represent the endpoint of a trend in tattoo instrument complexification in Polynesia since the time of Early Central Polynesian cultures. We can confidently proclaim that the autā is both deeply Austronesian and uniquely Sāmoan.

On Sāmoan tattooing

Sébastien Galliot
Tua'efu, Upolu, Sāmoa, 3 October 2005

Fig. 5
An ancient tool form in contemporary materials: 'au sogiaso lapo'a (large wide tattooing implement), 2012, Sāmoa, by Su'a Sulu'ape Paulo III.

Born in 1937, His Highness Tui Atua Tupua Tamasese Ta'isi is a Sāmoan political leader and a scholar. The Prime Minister of Sāmoa from 1976 to 1982, he subsequently held several academic positions in New Zealand before his election as Sāmoa's Head of State in 2007, a role he held until 2017. Throughout his life, Tupua Tamasese has studied Sāmoan indigenous knowledge and religion and has published numerous papers on these subjects. In 2005 this writer interviewed Tupua Tamasese him at his residence in Tuaefu. I had arrived in a decrepit car and without an appointment. With great courtesy he allowed me to ask him many questions about tattooing. The interview lasted longer than expected, and when I noticed that several respectable matai were waiting in the next room for an audience with him, I thought it was time to let him deal with more urgent matters.

TA: Tattooing was more than just tattoo. It is ritual that is not only physical but basically spiritual that celebrates the movement from puberty to manhood. So, when a boy is born you go through the ritual of the placenta and the umbilical cord and then you go through the celebration of what is known as nunu fanau, the celebration of the birth. And one of the significant rituals which follows is the preparation for the tattoo. They go through preparing the pigment (lama), and that too is a special ritual, as is crushing the lama. You abstain from food, prayers and meditation until you start making the lama and then when it's ready you put it into a coconut container and hang it up in the house.

The central message is that you cannot find yourself without pain and suffering. This is quite an essential agreement that the body develops from boyhood to manhood, which is why you have the saying 'Ae mana'o le pe'a tali le tiga' – 'If you want to have a pe'a you have to accept the pain.'

Tattooing is about the thesis of creation. It's the link with the god Tagaloa and the tenth heaven sending out the tuli (plover) to identify land. Populating with the people. So, you have as well the vaetuli. And the va'a, the boat that symbolises the journey – that life is a journey that you are travelling to the underworld. Funeral ritual is mainly about celebrating this journey: it's normally aboard a boat heading towards its destination. The tattoo is meant to be displayed. It wasn't meant to be hidden. On a man's tattoo the focus is the penis. So, in a way it's not only a celebration of the physical beauty, it's also sex. A lot of funeral ritual is celebrating life and particularly sexuality. The message in these rituals is: as long as I have my sexuality, I can produce more people. So, the tattoo is not only about our concept of creation, it's also about life and our relationship to the gods. We don't see the gods as something awful, we see the gods as an extension of the family.

SG: Can you talk a little bit about the social implications of tattooing?

TA: People want to find their place in the contemporary society. For a lot of them, you find that place by first finding out about yourself, your references, where you come from. Therefore, the philosophy, the theology, the social system, the rituals, the legends, the conventions, the protocols… all of these establish not only a pattern but an identification. So, even though there sadly is ignorance about why we tattoo in a religious or a spiritual sense, people sense intuitively or instinctively that they will establish themselves as a people with a distinctive unique culture by undertaking these rituals and even the physical exhibition and the physical pain that accompany the ritual.

0102

And I tend to think this is the reason why people are taking on the tattoo even though they might not understand the fundamentals in the spiritual or the fact that by feeling, by consciousness, we realise that this is one way of becoming ourselves. I mean, for a lot of religions, particularly Protestantism, there was a prohibition against tattoo. The thing is, it's not only against that religion, it's also against all the other things that are implied because when you finish [receiving a pe'a] you're supposed to have a sexual experience – not necessarily with your wife or inside the marriage but, you know. This was a connotation that was not acceptable to the Christian practice.

Today a lot of these things that are part of the protocols and conventions are no longer taken on board. But as I said before, the tattoo was meant to be displayed. I can remember as a young man people coming into the bath – they were naked but by our cultural standard they were dressed because they had tattoos. A lot of missions wrote against the pōula [the night dance] because the highlight of the pōula was when you threw off your clothes, exhibited your body. Because the whole purpose of the tattoo is to celebrate the physical beauty of the body.

SG: What is your understanding of the samāga [the anointing ceremony]?

TA: Sama [mix of turmeric and coconut oil] is something that comes straight through the gods. Sigano [pandanus flower] makes the sama yellow. Sama is medicinal for sores but it's supposed to be a special gift from the gods. When you are preparing sama, you're supposed to go through certain religious rituals that people don't go through anymore so that by now you have the medicinal. You do the sama with u'u, fa'au'ua and lulu'uga and the hair so that when you go out you are supposed to be somebody who's gone through a special religious ritual and you declare it with the u'u and the sama. But again the u'u is a special u'u, a holy u'u – for a special purpose like reburial you use holy oil. When someone dies you oil with sacred oil. And equally when you have these rituals you use sacred oil. There is a massage oil but it's always sacred oil which is kept apart. But it's also the responsibility of people like Petelo [Su'a Sulu'ape Alaiva'a] to protect their own distinctive unique culture or the culture of their guild. Because each one had their own practices and their own gods.

The author would like to thank His Highness for his availability and the kindness of his welcome.

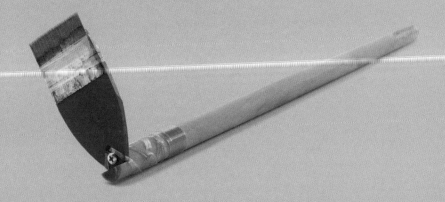

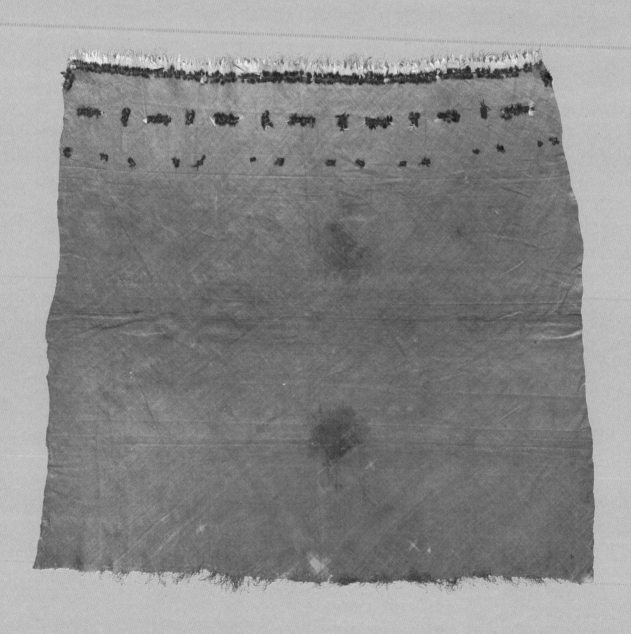

Fig. 6
An 'ie toga/kie (fine mat);
Sāmoa/Tonga. Fine mats
are highly valued textiles
worn as garments and/or
exchanged in ceremonies.

Sāmoan tatau, fine mats and Tongan royalty

Adrienne Kaeppler

TATAU

Two kie hingoa (fine mats) said to have come directly from Samoa with the Tu'i Tonga (Tongan King) are 'Valatau-oe-Tuimanu'a' (war garment of the Tui Manu'a) and 'Vā-'o-Ofu-mo-Olosenga' (the gulf between the islands of Ofu and Olosega in Sāmoa). These kie hingoa are said to have been acquired by the Tu'i Tonga Fatafehi during his tattooing in Sāmoa.

Tongans considered the Tu'i Tonga's person sacred and dangerous to touch; it was necessary to recruit outsiders for certain tasks such as hair cutting (the head of a Tu'i Tonga is particularly taboo and cannot be touched), preparing the body for burial, and tattooing. The falefā ceremonial attendants, who descended from the sky with the first Tu'i Tonga, did many of these tasks for the Tu'i Tonga, but Tu'i Tonga were usually not tattooed. Fatafehi, however, wished to be tattooed, and as no Tongan could do the work, Fatafehi made two trips to Samoa for this purpose. His first trip was to Manono Island, where the first part of his tattoo was done; and his second trip was to Manu'a, where the rest was completed. Fatafehi's nickname was Fakauakimanuka (twice, or second time, to Manu'a) to commemorate his tattooing trips to Samoa. On both occasions the tattooer's body is said to have swelled up and they ultimately died from 'wounding' the Tu'i Tonga's sacred body. The kie hingoa associated with Fatafehi's tattooing trips to Samoa are 'Valatauotuimanu'a' ['Vala-tau-oe-Tuimanu'a'] and 'Vaofumoolosega' ['Vā-'o-Ofu-ma-Olosenga']. As noted above, it is a Samoan custom for a fine mat to be given to the tattooer; here it appears that Samoans gave fine mats to the Tu'i Tonga, perhaps to commemorate the event.

Halaevalu Maile [Mataele] (1899–1989), with whom I resided in 1964, was a granddaughter of Fakauakimanuka II, a son of the last Tu'i Tonga, Laufilitonga. She believed that the first Fakauakimanuka may have brought Sāmoan women with him to Tonga, although he was already properly married to the moheofo. Halaevalu felt that the Tu'i Tonga, one or more Samoan women and the kie hingoa are all associated with each other, and that a metaphor for a high-ranking Samoan woman was a kie hingoa because this was the most important part of her dowry.

The name of the second kie hingoa associated with Fakauakimanuka's tattooing in Samoa, 'Vā-'o-Ofu-mo-Olosenga', refers to two islands in the Manu'a group, Ofu and Olosega. Today this name is used as a metaphor for good relations between the traditionally warring Samoa and Tonga resulting from intermarriages and their offspring. The metaphor was used by Queen Sālote (1900–1965) in her lament for the last 'Ulukālala Ha'amea, who died in 1960. She notes:

Pea tala ki he Tu'i Manu'a
And tell to the Tu'i Manu'a

Kaufaki atu ai ki 'Uta
Brought by sea to the land

He Va-'o-Ofu-mo-Olosenga
The Vā-'o-Ofu-mo-Olosenga

Manono e mo 'Apolima
Manono and 'Apolima (Samoan islands)

To'o e kakapu 'o e Mo'unga
Take away the mist/fog of the mountain

Fili ai hano ta'ovala
Sorted out from his waist garment

Kia Tungī mo Tu'ifaleua
To Tungī (now Tupou IV) and Tu'ifaleua (Tu'i Pelehake)

Ko e fua 'o e kie hingoa
The fruit of the kie hingoa (i.e., Vā-'o-Ofu-mo-Olosenga)

Queen Sālote presented Vā-'o-Ofu-mo-Olosenga to the funeral of the late 'Ulukālala.

Extract from 'Kie hingoa: Mats of power, rank, prestige and history', *Journal of the Polynesian Society*, vol. 108, no. 2, (1999), pages 178–79.

Tongan tātatau and the Sāmoan connection

Nina Tonga

The first contact with Europeans in Tonga took place in 1616, when Dutch navigators Willem Schouten and Jacques Le Maire visited the Niuas – the northernmost island group – and fired on a canoe. This violent altercation also marked the first exchange of European 'trinkets' such as linen, nails, hatchets and beads, given as a form of reparation. News of the newcomers and their goods soon spread through the Tonga–Fiji–Sāmoa region.[1]

French explorer Jules Dumont d'Urville was the first to make an extended stay in Tongatapu. On his 1826–1829 voyage in the corvette *Astrolabe*, d'Urville spent three months in Aotearoa then sailed to Tongatapu where he spent a month from 20 April to 21 May 1827. Here he and his crew recorded their observations in illustrations and journals.[2] Louis Auguste de Sainson, official draughtsman on the voyage, produced a number of drawings in Tonga including views of chiefs' tombs, architectural structures and cultural material. His portrayal of Tongan peoples paid careful attention to distinctive details such as whaletooth necklaces, hairstyles and the pattern of ngatu (decorated barkcloth) worn around the waist. He also included a drawing of the tattooed thigh of an unnamed Tongan man.

As with his illustration of puhoro (Māori thigh tattoo), de Sainson depicts the tātatau as a disembodied thigh that starts at the top of the waist and truncates just below the knee. Gathered around the waist are folds of ngatu that appear to have been purposely lifted to reveal the full length of the tātatau. The Tongan tātatau has a striking resemblance to the Sāmoan peʻa in terms of structure and position, but with a bold point of difference in the intensity of tattooed bands that adorn the thigh. De Sainson's composition gives only a partial view of the tātatau – a profile of the outermost side – leaving the viewer to ponder what may be on the other side.

De Sainson's drawing is often heralded as the only known image of Tongan tātatau. As noted by anthropologist Fanny Wonu Veys, this is not entirely accurate, however: tātatau appeared in accounts from Abel Tasman in 1643, and in one of four drawings from his voyage by the official artist Isaac Gilsemans.[3] In *Clothing of Tongans in Nomuka* (c1643), Gilsemans takes care to delineate objects such as a flywhisk and tattoo markings that adorn the chest and arm of two of his subjects. More than a century later Tongan tātatau appears in the portraits of Juan Ravenet, an Italian painter who accompanied Spanish explorer Alessandro Malaspina's voyage of the Pacific 1789–1794. Like de Sainson, Ravenet benefited from having a good rapport with his subjects.[4] In his portrait *Latu* (1783), the young man holds his waist garment open, exposing his tattoo in full to the viewer. There are elements such as the motif that stretches across the lumbar area that are recognisable from de Sainson's earlier drawing.

Like many expeditions in the Pacific, the linguistic and cultural connections between islands were often observed and recorded, but cultural practices were largely framed as existing in seemingly discrete islands. Unbeknown to de Sainson, his image captures a moment in time where the art of Tongan tātatau existed within a constant flow of peoples between Sāmoa and Tonga. Accounts from various explorers note the fluid movement of objects, cultural material and languages between the two archipelagos.

We know that the Tuʻi Tonga travelled to Sāmoa to be tattooed, as his body was tapu for Tongans to touch. It was well known that this established passageway provided a route for Tongans during the implementation of the 1839 Vavaʻu Code introduced by King George Tupou I that outlawed the practice of tātatau.[5] Despite the restrictions put in place, tātatau persisted and was literally inscribed into the memories and onto the bodies of Tongans well into the twentieth century. Given this, it is possible to query the cultural specificity of de Sainson's drawing.

1.
Serge Tcherkézoff, 'First Contacts' in Polynesia: The Samoan Case (1722–1848) (Canberra: ANU Press, 2008), 17–19.

2.
On Dumont d'Urville's second voyage in 1837 he stopped in Tonga for eight days: Fanny Wonu Veys, *Unwrapping Tongan Barkcloth: Encounters, Creativity and Female Agency* (London: Bloomsbury, 2017), 66.

3.
ibid.

4.
Mercedes Maroto Camino, 'Ceremonial Encounters: Spanish Perceptions of the South Pacific', in *European Perceptions of Terra Australis*, edited by Anne M. Scott, Alfred Hiatt, Claire McIlroy & Christopher Wortham (New York: Routledge, 2011), 156.

5.
Sione Latukefu, *Church and state in Tonga: the Wesleyan Methodist missionaries and political development* (Canberra: ANU Press, 1974), 121–126.

6.
Rodney Powell, 'Tattooing and Traditional Tongan Tattoo', 2012, https://matadornetwork.com/nights/tattooing-traditional-tongan-tattoo/.

In contemporary times, his drawing offers new opportunities for reinterpretation and reuse. In 2002 Su'a Sulu'ape Alaiva'a Petelo revived the Tongan tātatau, supposedly 150 years after the last known recipient.[1] Among his reference materials was de Sainson's drawing as well as images of incised clubs and kupesi (pattern design boards). Using this material and his extensive knowledge of Sāmoan tatau, Su'a tattooed Ata'ata Fineanganofo of San Francisco. As part of the process Petelo also trained Hawaiian-based Tongan tattooist 'Aisea Toetu'u, who later received the Su'a title. This contemporary collaboration saw the revival of tātatau, and the revitalisation of an indigenous network that once sustained the practice in Tonga.

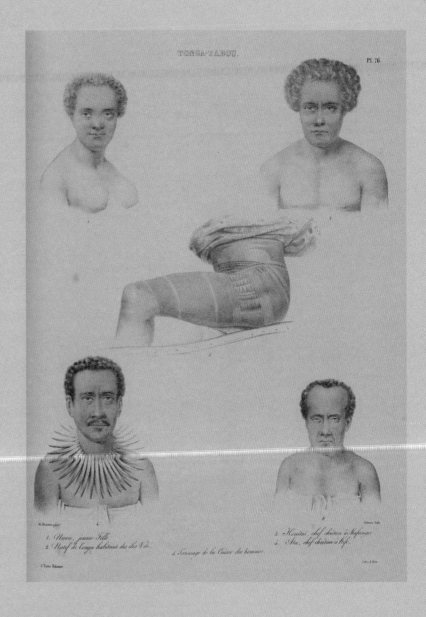

Fig. 7
A rare drawing of Tongan tātatau by Louis Auguste de Sainson, official draughtsman of the voyage of Jules-Sébastien-César Dumont d'Urville 1826–1829 on the corvette *Astrolabe*.
1. Naou jeune fille 2. Natif de Tonga habitant des îles Viti 3. Houitai chef chrétien à Mafanga 4. Ata chef chrétien à Hifo 5. Tatouage de la cuisse des hommes.
Pl. no. 76 of: *Voyage de la Corvette* l'Astrolabe. *Atlas Historique.*

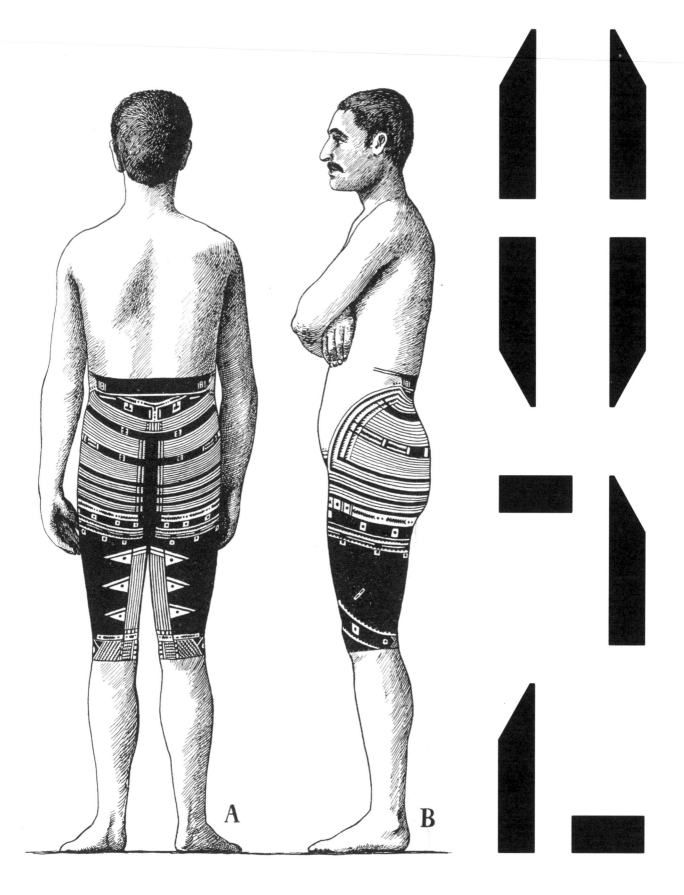

TATAU: EUROPEAN ENCOUNTERS & OBSERVATIONS 1722—1900

Fig. 8
Sāmoan male tatau,
based on Felix von
Luschan's observations
of a Sāmoan dance
group on tour in Europe
between 1889 and 1890
(Luschan 1897: 363–65).

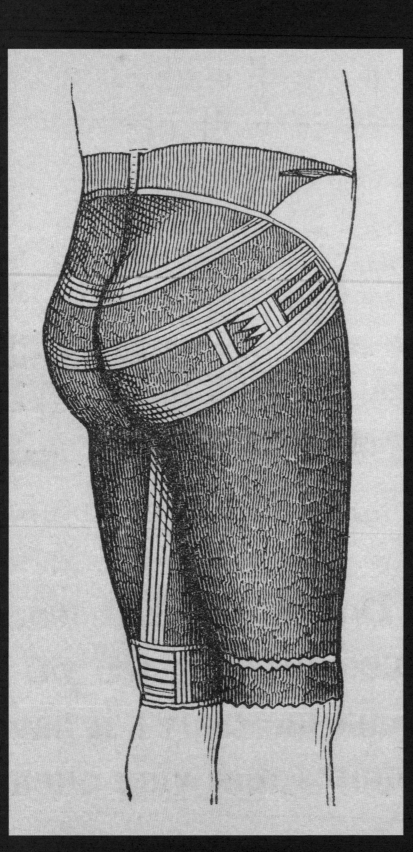

Fig. 9
Sāmoan male tatau as observed during the United States Exploring Expedition between 1839 and 1841, drawn by Alfred Thomas Agate.

Despite the continuous visibility of tattooing in Sāmoa from 1722 onwards and its importance for the population – most European explorers agree that all adult men were tattooed – it was not described in detail until the end of the nineteenth century, more than 150 years after the European discovery of the archipelago. In fact, during this period – and with the exception of the Reverends John Williams and John Stair, who were present in Sāmoa during the 1830s and 1840s – tattooing was observed 'from a distance', at times with repugnance, at others with fascination, and seldom with precision.

The first European residents in Sāmoa, those who could have described tattooing in detail as an institution, preferred to deal with the subjects of oral tradition and chiefdom organisation. There is nothing exceptional in this. Up until the end of the nineteenth century, the accounts of most European explorers of Oceania mention the islanders' physical appearance (skin colour, build, presence of body markings and decorations) in passing, without making the connection with other local customs.

Oral traditions collected in the nineteenth century and, in particular, the different versions of the origin myth of tattooing[1] make it possible to follow the tracks of the two deities, Taemā and Tilafaigā, in various places across the archipelago. They also make it possible to track the distribution of the 'atoau (the basket containing the tattooing tools) to certain chiefs. Despite numerous details on their doings and routes, however, the origin myth contains no information about the designs, the ways they were applied to the body, or the social function of tattooing. By reviewing the testimonies of explorers and occasional visitors before and during the establishment of the missionaries, this chapter aims at a historical reconstitution of the social implications of tattooing as a rite of passage before the European presence began to have a noticeable impact.

1.
The story of Taemā and Tilafaigā, the deities who introduced tattooing, represents a short episode in the Sāmoan tale entitled *Māvaega i le Tai*.

This necessarily fragmentary and ethnocentric data leads us to build a hypothetical 'classic period' during which the relatively limited influence of Europeans is thought not to have disturbed the exact reproduction of a practice that is thought to have been a thousand years old. Though social changes in Sāmoan society and external influences may have had an impact on the institution of tattooing before the missionaries' arrival, the available sources do not allow us to make any conjecture; we must be content with the impressions left by short-term visitors.

TATAU

The first Europeans to approach the Sāmoan Islands, in June 1722, were the crew of the three ships of a Dutch expedition commanded by Jacob Roggeveen, whose aim was to open up a new route to India. The first encounters occurred in the eastern part, in the Manu'a group, where Roggeveen recorded in his journal having seen tattooing on the Sāmoans' bodies. This is the first mention of Sāmoan tattooing in the history of contact between Europeans and Sāmoans.[2] The Polynesian term tatau, from which the word 'tattoo' originated, was as yet unknown to Europeans; Roggeveen spoke of the 'application of images'.

> The Indians of this first island are like the Paaschlanders [Easter Islanders] in sturdiness and robustness of body, also of painting themselves, but not so much and abundantly, as their colouring commences from the thighs downward to the legs.[3]

Later commentators Reverend George Turner[4] and Dr Augustin Krämer[5] attributed the discovery to Behrens, a young officer on the expedition who published a popular account of the voyage, but did not go ashore onto the islands themselves.[6] Behrens wrote: 'Neither were their bodies painted like those on the islands we had discovered before. They were dressed from the waist to the heel in fringes and a sort of artistically made silk cloth.' According to Turner and Krämer this 'silk cloth' clearly designates men's tatau. During the expedition, only Captain Cornelis Bouman and his crew from the *Thienhoven* (the second boat) went ashore, briefly. The only exchanges Roggeveen's crew had with the Sāmoans took place at sea between vessels and canoes – which meant it was difficult to make any accurate observation of details such as the men's tattooing.

Frenchman Louis-Antoine de Bougainville's expedition in May 1768 was the second official contact with the Sāmoan Islands. Bougainville believed he was the first to discover these islands; he named the group 'L'archipel des navigateurs' (Navigator Islands) for the islanders' skill in manoeuvring their canoes around his vessel. Again the crew did not go ashore; they merely observed the islands from their ship. But although they wrote of 'painting' on the bodies, they were aware of the practice of tattooing in this area: Bougainville had noted in Tahiti, where his ship *La Boudeuse* had called before reaching the Sāmoan Islands:

> Whilst the women in Europe paint their cheeks red, those of Taiti dye their loins and buttocks of a deep blue. This is an ornament, and at the same time a mark of distinction. The men are subject to the same fashion. I cannot say how they do to impress these indelible marks, unless it is by puncturing the skin, and pouring the juice of certain herbs upon it, as I have seen practised by the natives of Canada.[7]

At Sāmoa he noted: 'These islanders appear to be of a middle size but active and nimble. They paint their breast and their thighs, almost down to the knees, of a dark blue.'[8] Charles Félix Fesche, a volunteer sailor on *La Boudeuse*, observed that these 'paintings' on the thighs were sometimes blue, sometimes black[9] and reached 'from

2.
J Roggeveen, *Daagverhaal der Ontdekkings-reis van Mr Jacob Roggeveen in de Jaren 1721 en 1722* (Middelburg: Abrahams, 1838), 189.

3.
A Sharp (ed.), *The Journal of Jacob Roggeveen* (Oxford: Clarendon Press, 1970), 151.

4.
George Turner, *Samoa: A Hundred Years Ago and Long Before* (London, 1884).

5.
Ibid., 183; Augustin Krämer, *The Samoa Islands, Vol. II* (Honolulu: University of Hawai'i Press, 1995), 72.

6.
Translated from CF Behrens, *Histoire de l'Expédition de Trois Vaisseaux, Envoyés par la Compagnie des Indes Occidentales…* (The Hague: Aux dépens de la compagnie, 1739), 206 (French translation, under the name of the author's initials only, of the original in German: *Reise durch die Südländer und um die Welt* [Frankfurt & Leipzig, 1737]).

7.
L de Bougainville, *A Voyage Round the World: Performed by Order of His Most Christian Majesty, in the Years 1766, 1767, 1768, and 1769*, trans. Johann Reinhold Forster (London, 1772), 251.

8.
Ibid., 281.

9.
The colour difference is due to fading of the pigment from exposure to the sun. As nothing was known about this at the time, this difference seems to have been interpreted as a pigment difference.

the waist of breeches halfway down their thighs'; Commerson, the expedition's naturalist, added that 'they also have kinds of flames on their navel and ribs'.[10]

In December 1787 Jean François de Galaup de la Pérouse's French expedition was the first to put crew members ashore at Tutuila.[11] In his journal La Pérouse described the Sāmoans as being the biggest and most robust islanders he had encountered, and he adds:

> The men are painted or tattooed in such way that one could almost believe they are clothed, although they are always absolutely naked, having only a belt of seaweed around the waist and down to the knees.[12]

La Pérouse's account of the voyage, published in France, devotes a good deal of space to what he describes as a 'massacre' during which Captain de Langle and eleven members of his crew were killed.[13]

Two notable visitors came after the La Pérouse incident in Sāmoa: Captain Edward Edwards, whose mission was to find the *Bounty* mutineers, made a brief visit to Sāmoa in 1791, followed in 1824 by Otto von Kotzebue, a Baltic German navigator on a Russian expedition. Neither recorded any detail of tattooing. Although the archipelago offered merchant ships a good stopover for fresh supplies, it was avoided by most European navigators until the mid 1820s.[14] Another little known and seldom mentioned visit took place in 1831 when the French captain Gabriel Lafond de Lurcy, who had lost his merchant ship in Tongan waters and been taken on board a whaler, put in at Sāmoa. Lafond de Lurcy spent a few days in Apia and nearby, where he noted:

> The men wear a belt of seaweed around their loins which is not inelegant. They are tattooed from the navel to halfway down their thighs; this very dense tattoo forms quite a nice contrast with their skin which is nearly black and makes them look like the Sepoys of India, dressed in their breeches. On women, the tattoos do not always cover the same parts of the body as on men: they tattoo themselves in spots, so to speak, on their arms, breasts and legs. They also burn their skin, which leaves little round, white marks on it.[15]

In the 1830s the first European settlers arrived in Sāmoa. John Williams and Charles Barff established a London Missionary Society (LMS) outpost in 1830 by leaving a group of native missionaries from the Society Islands and the Cook Islands who would be allocated to different locations. Permanent settlement began in 1836. Williams mentions tattooing only very briefly in his published account but he is one of the rare visitors of this period, along with Lafond de Lurcy, to note its existence among women:

> The modes they adopt to ornament their body are peculiar. Few of the women were *tatooed*, but many of them were spotted. This is what they call *sengisengi*, and is effected by raising small blisters with a wick of native cloth, which burns,

10.
Quoted in S Tcherkézoff, *'First Contacts' in Polynesia: The Samoan Case (1722–1848)* (Canberra: ANU ePress, 2008), 24.

11.
Tutuila is the main island of what is now American Sāmoa.

12.
J Dunmore (ed. & trans.), *The Journal of Jean-François de Galaup de la Pérouse, 1785–1788* (2 vols) (London: Hakluyt Society, 1994), 179–80.

13.
La Pérouse gave Captain de Langle permission to make a brief call at Tutuila with a few sailors who were ill. Sixty-one members of the crew went ashore to get provisions but, cut off by low tide, they became an easy target for several hundred Sāmoans, who threw stones at them, killing 12. The French, on their part, estimated 30 Sāmoans had died. For a detailed account, see Tcherkézoff, *'First Contacts'*, 56–67.

14.
Edwards' sole concern was to gather information about a possible visit of the *Bounty* (he was looking for the mutineers all over the Pacific); Kotzebue talks only of the 'massacre' that took place when La Pérouse's men landed. For more details on this point, see Tcherkézoff, *'First Contacts'*, 72. This is not evidence of the absence of tattooing – rather, it indicates that the subject of tattooing was at that time only anecdotal for European navigators.

15.
G Lafond de Lurcy, 'Quelques semaines dans les archipels de Samoa et Viti', *Bulletin de la Société de Géographie* 3, no. 3, pt 1 (1845), 17–18.

TATAU

16.
J Williams, *A Narrative of Missionary Enterprises in the South Sea Islands* (London: John Snow, 1837), 540.

17.
In Sāmoa Williams speaks of burns, but in Polynesia and Micronesia women could also accompany mourning with self-mutilation practices in the form of cuts, scarification or even moxibustion.

18.
R Moyle, *The Samoan Journals of John Williams, 1830 and 1832* (Canberra: ANU Press, 1984), 88, 230, 230fn, 252.

19.
C Wilkes, *Narrative of the United States Exploring Expedition during the years 1838, 1839, 1840, 1841, 1842, Vol. II* (Philadelphia: Lee & Blanchard, 1845), 149.

20.
H Hale, *United States Exploring Expedition During the Years 1838, 1839, 1840, 1841, 1842 under the command of Charles Wilkes, Vol. VI, Ethnography and Philology* (Philadelphia: Sherman, 1846), 39.

but does not blaze. When these are healed, they leave a spot a shade lighter than the original skin. Thus indelible devices are imprinted. They adopt this method at the Samoas, and tatooing at other islands, to perpetuate the memory of some important event, or beloved and departed relative.[16]

By 'spotted' he is referring not to tattooing but rather to the burns women inflicted on themselves as a mark of mourning.[17] Williams mentions tattooing on three other occasions in his journals, and compares it to that of the Tongans.[18]

Between 1838 and 1842 US naval officer Lieutenant Charles Wilkes led the United States Exploring Expedition (the Wilkes Expedition) to survey new areas of the South Pacific and increase knowledge of places already known. Wilkes called at Tutuila on 7 October 1839. He noted that men's tattoos were similar in the whole archipelago, and he gave a more precise description of tattoo and how it was performed.

> Tattooing, if not in reality, at least in appearance may be said to form a part of dress. It is performed by persons who make it a regular business. The age at which it takes place is from fourteen to eighteen, and is usually considered the initiation to manhood. The usual colouring matter is obtained from the kernel of the candlenut. Tattooing is here called ta-tatau, and is tastefully drawn. The natives are very fond of it. It is expensive to the family, for the operator receives a high price for his labour, consisting of the finest mats, siapo [tapa], and other property, as agreed upon before the operation is begun. The instrument is made of bone, sharp like the teeth of a comb, and requires but a slight blow to enter the skin, the part tattooed is from the loins to the thighs, but the women have a few lines on their hands and bodies.[19]

Wilkes's text was illustrated with the first reproduction of a Sāmoan male tattoo. Although it lacks detail, this engraving shows that the general appearance of tattooing has changed very little up to the present day, and that what Wilkes saw was similar to the tattooing practised at the same period in Tonga. Horatio Hale, an anthropologist and linguist with the expedition, reinforced this when he noted:

> The usual dress of the Navigator Islanders is a mere apron of leaves, tied around the middle of the body which it covers only in front. The tattooing is also applied to the middle of the body, from near the waist behind, down to the knees. In front however, the abdomen is free from it, except only a small patch over the navel. When asked why this spot was tattooed, they replied that, as it was the part which was connected to the womb before birth, they were ashamed to leave it uncovered, – showing clearly the feeling which had given origin to the custom. The general effect, at a little distance, is to give the person the appearance of being dressed in short, dark-blue drawers.
>
> The Tonga tattoo is the same with the Samoan …[20]

The mark Hale noticed on the navel seems to correspond to what Commerson had earlier described as 'kinds of flames' (see page 37); this design, called pute (navel), is still present in male tattoos.

Reverend John Stair, a missionary in Sāmoa between 1838 and 1845, made the most detailed observation of tattooing that we have for this period. He summarises the mythological, technical and ritual elements and provides the first description of the closing ceremony of the tattooing ritual:

> *O le ta tatau* was once in high repute with the Samoans, and may well be noticed as a trade or profession, once very thriving and highly paid. The fraternity of tattooers were an influential and important body, presided over by two female deities, *Taema* and *Tilafaiga*, whose patronage was regarded as most important to the success of the fraternity. The operation of tattooing, although most painful, was submitted to by all men on attaining the age of twelve to fifteen upwards, since it was looked upon as an initiation into the state of manhood, to shun which should be a disgrace. Women especially regarded the omission of the custom with disfavour, and freely expressed their contempt for those who had failed to comply with this time-honoured custom and observance. Hence it was looked upon as an important period of life, and when a young chief was tattooed, great preparations were made for the ceremony, and often costly presents were given to the operators. A curious custom prevailed in connection with the initiation of a young chief to this ceremony. It was customary for a number of young lads, sons of the various *tulafale* of the district in which he lived to be operated upon with him at the same time, in order that they might share the sufferings of their chief. These lads were not only tattooed gratis at the cost of the chief's family but, after the distribution of property to the operators had been completed, each young lad was presented with a mat from the young chief's family, in recognition of the sufferings he had shared with his young master during the operation. This mode of tattooing was, however, rather looked down upon and spoken of contemptuously, being called *O le ta Tulafale*, and the markings were often carelessly done.
>
> From the importance attached to this observance, the gatherings at the tattooing of a young chief were often large, and the occasion of much interest, not only to the family, but to the whole district. A number of operators were summoned, and crowds from all parts flocked to witness the ceremony and take part in the feasts and sports usual on such occasions. Invitations were freely given in all directions and, while the visitors honoured the occasion with their presence, the family and the district at whose expense they were entertained spared no trouble in their welcome.
>
> As the day for the opening ceremony drew near the operators began to assemble, accompanied … by their family and assistants, the principal operators bringing with them cases of instruments *O le tunuma*. These were made from bones, either human or animal, the former, I think, being preferred. The bones were first rubbed and ground into thin, flat pieces, and then with wonderful skill and

care cut so as to resemble a beautifully made small tooth-comb … The combs were afterwards neatly fastened to a small reed handle, somewhat after the manner of the native adze. The combs were of various widths, from an eighth of an inch to an inch, or an inch and a half or more, ten or twelve usually forming a set, which were highly prized by the owner. In addition to these instruments the operators provided themselves with a short stick, used in striking the comb or instrument into the skin during the operation, as also some burnt candlenut powder, to form the pigment used in the markings.

A large shed was usually erected in the *malae* [the village square] in which the ceremony was to be performed, and when all was ready the opening scene commenced, a kind of military parade or sham fight – which was followed by the first distribution of property to the operators, this first instalment consisting of seven or eight good mats and twenty pieces of *siapo*.

The young chief then advanced and, having laid himself down, the tattooers gathered around him, some holding his arms, other straining tightly the skin upon the small of his back, on which part the most skilful operator commenced the first part of the design. The instrument was dipped in the pigment provided and then, struck sharply into the skin by a blow from the stick, the instrument being shifted for each blow. The punctures were made rapidly, and the incisions placed as close as possible together, so that the marking might be dark, depth of colour and every part being well covered forming the chief beauty in tattooing. The comb was dipped into the lampblack as often as required, and during the interval thus occasioned an assistant wiped the blood from the punctured parts, so that the operator might proceed with his work. The operation was continued as long as the patient was able to bear the pain, some continuing the operation for several days in succession, while others were compelled to allow days to intervene before the inflammation had subsided, so as to enable the operation to be resumed. The style of tattooing in the Sāmoan group differed much from that in use in most other islands, the hips and thighs being the principal parts marked in Sāmoa.

The various markings were often skilfully drawn, and the whole had a strange and singular effect, giving the impression that the wearer had donned a suit of small clothes. The time occupied in marking a person of rank, and those tattooed with him, varied as they were able to endure the pain, but it frequently extended to a month or six weeks, during which time the family, the visitors, and dependants were engaged every evening in sham fights, wrestling and boxing matches, or dances, which were always attended by much obscenity. When the operation was complete payment was given to the operators, consisting of a large number of valuable mats, sometimes to the extent of 600 or 700, and even 1,000, besides large quantities of native cloth.

The next day the families of the lads who had been sharers of their chief's sufferings came to receive the payment allotted to them. Property was also distributed to those connected in any way with the family of the chief, and also in recognition of the large quantities of food they had supplied to the visitors

during the ceremony. This, however, went but little way towards indemnifying them, a sense of pride and the hope of being entertained in like manner themselves at other similar gatherings making up the deficiency.

The distribution of property having been completed, nothing remained but the important ceremony of *O le Lulu'unga-o-le-tatau*, the sprinkling of the tattooed. The evening before this all-important ceremony – or rite, as I almost think it may be considered – was performed, the operators and attendants provided themselves with lighted torches and proceeded to the *malae*, where they went through a variety of motions until, at a given signal, the torches were all extinguished simultaneously. A water-bottle was then brought out and dashed into pieces in front of the newly tattooed party, after which the torches were relighted and a strict search made for the cork of the broken bottle. Much anxiety was felt respecting this cork, or rather plug, since, if lost, it was thought to forebode the death of one of the tattooed party.

The next day all underwent the ceremony of *Lulu'u*, or sprinkling, which was performed by one of the operators taking coconuts and sprinkling the water over each individual of their number. After this the workmen took their leave and the company separated to their homes. The bottle of water was only broken before a chief, but the ceremony of the sprinkling was performed on each one of the tattooed, whatever their rank might be. This singular custom appears to have been used, as in other cases, to remove what was considered to be a kind of sacredness attaching to those newly tattooed.[21]

John E Erskine, who was in command of a 'cruise' in the Western Pacific in 1849, wrote later about the inhabitants of Ta'ū in the Manu'a group. He noted the following details: 'none of them were tattooed about the face, but where the lava lava was scanty I observed they sometimes were so on the belly, hips, and thighs, giving them the appearance of being clad in tight knee breeches'.[22] At Tutuila, he notes, 'As at Tau, they seemed to be generally tattooed from the loins to the knees which we were told was considered as answering the purposes of decency in the absence of clothing, and it certainly had that effect in our eyes.'[23]

LMS missionary George Turner, in his written accounts of life in Sāmoa, mentions the practice of tattooing on several occasions.[24] Although it was less precise, his account of the ritual of tattooing was similar to Stair's. He nonetheless remarks that 'Sāmoan men were all marked with the tattooing… Some had, in addition, the mark, or coat-of-arms, of the particular district to which they belong, a dog it might be; and in the event of his being killed in battle, his body was the more easily identifiable.'[25] Such an iconographic detail is quite striking for the time; early visitors were not usually so precise about tattoo motifs.

Another early resident, William Thomas Pritchard, the British consul to Sāmoa between 1848 and 1857, gave a clear description of the economic dimension of tattooing in his memoir *Polynesian Reminiscences*.[26] He, too, noted that the operations were performed in groups, and that the tattooing of chiefs' sons triggered a communal tattooing procedure.

21.
JB Stair, *Old Samoa; or Flotsam and Jetsam from the Pacific Ocean* (London: Religious Tract Society, 1897), 158–64.

22.
JE Erskine, *Journal of a Cruise Among the Islands of the Western Pacific, Including the Feejees and Others Inhabited by the Polynesian Negro Races, in HMS* Havannah (London: John Murray, 1853) [facsimile by Southern Reprints, Papakura, NZ, 1987], 36.

23.
Ibid., 41.

24.
George Turner lived in Sāmoa between 1842 and 1861. He was the administrator of the Malua Theological College, founded in 1844, established to train Protestant pastors and missionaries in the Pacific. See George Turner, *Nineteen Years in Polynesia* (London: John Snow, 1861), George Turner, *Samoa: A Hundred Years Ago and Long Before* (London, 1884), 55–56, 88–91.

25.
Turner, *Nineteen Years*, 349.

26.
WT Pritchard, *Polynesian Reminiscences, or Life in the South Pacific* (London: Chapman & Hall, 1866).

Tattooing is a regular and honourable profession, and the operator ranks as a *matai* – master or professor. When application is made for the services of a *matai*, the application is always accompanied by a present of fine mats, or tōga, the acceptance of which is the sealing of the contract. A house is set apart for the performance of the operation, and the youths pass in turn under the hands of the *matai*, – first the young chief, the others following, usually according to tribal rank, and each having but a small portion of his body tattooed at a time. When all is ready and the operation is about to commence, more fine mats are presented, or perhaps a new canoe, and food is daily supplied by the friends of the youths. The party of operators consists of the *matai*, and five or six assistants, whose duty it is, with pieces of white *masi* (unfinished barkcloth), to wipe away the blood as it oozes out of the skin under the manipulation of the *matai*. A young woman, generally a relative of the youth operated upon, sits cross-legged on a seat, on whose lap the young man places his head, and stretching himself out at full length, three or four more young women hold his legs and sing, to drown his groans as he writhes under the lacerations of the instruments. […]

When the operation is about half finished, the *matai* waits for another instalment of fine mats, and when the navel only remains to be operated upon, the great payment is made. If the *matai* is dissatisfied with the property presented, he delays the completion of the design. An unfinished 'tatau' as it is called, being considered very disreputable, the friends of the youths are quick to take the hint and hunt up more property. […]

Altogether, what with the payments in fine mats, native cloths, and canoes, and the food consumed during three or four months of the process, tattooing is an expensive affair. When it is all over, and the youths thoroughly healed, a grand dance is got up on the first available pretext to display the tattooing, when the admiration of the fair sex is unsparingly bestowed.[27]

Pritchard gave specific technical details similar to those noted by Stair, and he recorded the importance of this decoration both for young men and for their elders; at the age of forty, some chiefs would have the procedure repeated in order to gain youth and virility. Pritchard also commented on the decline of the practice of tattooing:

The custom is slowly falling into disuse. Discountenanced by the missionaries and the native teachers, it receives its main support in the pride with which a tattooed Sāmoan looks upon himself, and in the spirit of emulation and jealousy with which he looks upon the Tongans, who flock from their own islands to have their operation performed in Samoa.[28]

In fact, it was the collective dimension of the tattooing ceremony and its public character – it took place in the central village square, the malae – that was in decline and not its practice as such. Pritchard noted the value the marking had for the Polynesians in general; Tongans had no hesitation in defying a royal ban to go to Sāmoa to be tattooed.[29]

27.
Ibid., 143–45.

28.
Ibid., 146.

29.
Tattooing was forbidden in Tonga by the Vava'u code of laws as decreed in 1839 by King George Tupou I.

Fig. 10
Autā collected before 1871
and now in the British
Museum collection.

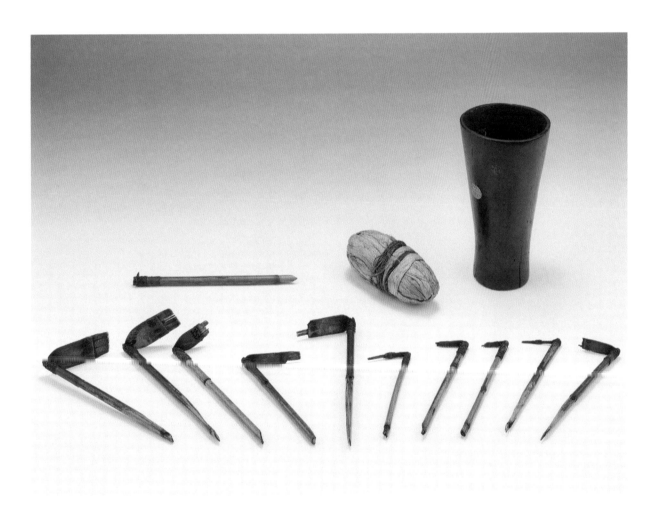

Fig. 11
Sāmoan male tatau in the
mid nineteenth century,
illustrator unknown
(Stair 1897: 161).

Fig. 12
Sāmoan male tatau c. 1888.
Illustrator Joseph Lister.

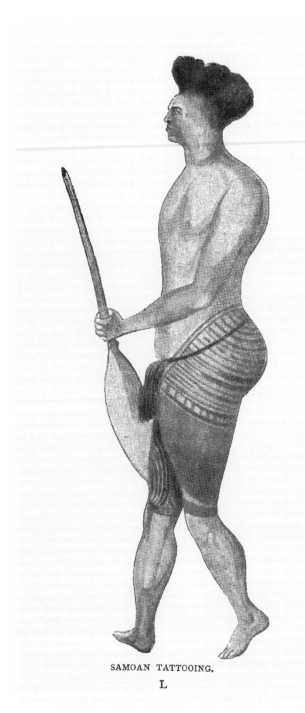

SAMOAN TATTOOING.

L

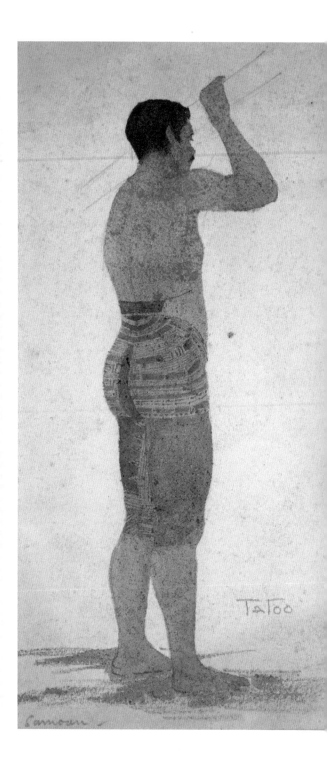

TaToo

Samoan

In his account of a cruise in the Pacific in 1862, Thomas H Hood does not linger over a description of tattooing, but he does consider its social value at the time of his visit.[30] Among other things, he explains that most tattooers were specialised craftsmen; they lived on the island of Savai'i, where some villages were not controlled by the missionaries with their prohibitions over tattooing and other customs they considered pagan. Because of this, says Hood, young men from all over the archipelago – and more particularly those from Ta'ū – went there en masse to obtain the mark of manhood. He records that the missionaries' opposition to tattooing could be explained by the social disturbance it caused: the procedures were always accompanied by large gatherings, dances and wrestling matches. He also specifies that the tattooer did not fix a price; the recipients paid according to their family's rank.

30.
TH Hood, *Notes of a Cruise in HMS Fawn in the Western Pacific in the Year 1862* (Rediscovery Books, 1863), 123–25.

The next noteworthy mention of Sāmoan tattooing is in William Churchward's *My Consulate in Sāmoa*, published in 1887. Churchward, the British consul in Sāmoa from 1881 to 1885, remarks on what may have been a strategy used by Sāmoans in order to continue a forbidden practice; according to him, the operation took place in a remote part of the forest. He also observed that tattooing was a hereditary profession and that it was still popular:

> The men, in spite of missionary denunciation, still adhere to the practice of tattooing their bodies from hips down to the knees, making a naked Samoan always appear as though he had on a pair of blue silk netted knee-breeches. A youth is not respected until he is tattooed, and can get no girl to marry him, but sometimes cannot afford to pay for the operation; an untattooed man is invariably a very poor one. A tattooer's profession is very lucrative, and generally descends from father to son. The instruments are various, of comb-like shape, made of human bone of different sizes, from two inches long downwards, to suit the various traceries required. The operation takes from two to three months, during which time the patients remain in the bush at some retired place. When a young chief is about to be tattooed, as many of his friends as can afford it join in the party; and so the tattooer is kept pretty well employed going from one to the other, doing a small piece at a time on each individual, and so permitting an interval of rest from the tiresome torture. All this time the relations keep bringing mats, money and food, which if not produced with sufficient liberality the professor will strike work, and refuse to resume it until a proper present be made, which is always forthcoming, for no Samoan could face the shame of going about half-tattooed; it would be worse than nothing at all, and an everlasting brand of cowardice and meanness.[31]

From these different accounts we learn that tattooing continued despite the missionaries' growing influence and attempts to suppress it; and that being tattooed was a crucial and essential event in a man's life. And in some situations it still is: the question "Ua tā sau pe'a?' (Do you have a tattoo?) is today a common means of shaming a speaker who has overstepped his position. Moreover, the use of the verb tā, which

31.
W Churchward, *My Consulate in Samoa: A Record of Four Years' Sojourn in the Navigator Islands, with Personal Experiences of King Malietoa Laupepa, His Country, and His Men* (London: Bentley & Son, 1887), 392–93.

clearly denotes the action of tattooing, can also be used metaphorically to address someone who plans to get a tattoo but is not yet considered mature enough or with sufficient command of formal speech: in that case one of his elders would tell them, 'Tā muamua lou gutu!' (Tattoo your mouth first!)

There can be no doubt that the Sāmoans resisted the missionaries' prohibitions against tattooing. In the 1930s anthropologist Felix Keesing spoke of the Sāmoans as 'the most conservative of Polynesians',[32] In the islands of Micronesia, which were Christianised much later than Sāmoa, the practice of tattooing disappeared within a few decades with successive colonisers. In the late nineteenth and early twentieth centuries the German ethnographers who visited Sāmoa, and later Micronesia, all agreed on the disappearance of Polynesian and Micronesian cultures; they could not have imagined that Sāmoans had already overcome the missionaries' ban on tattooing, as we shall see in this chapter.

The sources all state that tattooing was a collective rite of passage that involved a whole district. The tattooer – sometimes there were several – was a professional who came with his assistants to live in the village of the group to be tattooed for the duration of the procedure; the stay could range from several weeks to two or three months. He was highly respected and received regular gifts; he and his assistants were fed and entertained with songs, dances and aigofie (wrestling contests). The event would be organised by an important person, described in various sources as a chief of high rank (in this context, an ali'i) acting for his son. The sons of subordinate chiefs (according to some sources the sons of tulāfale, speaking chiefs or orators) were tattooed at the same time, so they might share the pain of their leader.[33] In their role as organisers of the ceremony the chiefs created an opportunity to display their district's wealth through the abundance of siapo or native barkcloth and 'ie tōga or fine mats, and to make ceremonial exchanges which, at the same time, reaffirmed their political power and their role in social reproduction.

These large-scale events also embodied a duty of hospitality and generosity based on the fa'aaloalo (mutual respect) that chiefs owed each other. Here – as is still the case today – this respect was expressed in a demonstration of the receiving group's productivity and strength. In addition to the supply of siapo and fine mats, this involved the preparation and provision of abundant food and gifts of 'oloa (food, instruments, arms, canoes, materials for ceremonial houses). Pritchard, for example, noted the gift of a canoe to the tattooer and described different forms of entertainment such as dances and wrestling contests.

Foreign observers viewed these courtesy visits between different villages or districts as an extremely expensive exchange of civilities that could lead to the ruin of the district responsible for the reception.[34] The ceremonial visits, formal journeys or travelling parties, called malaga, involved long nights of singing and dancing whose aim was to create alliances.[35] For example, the pōula or night dances involved male and female groups from both parties. The 'aumāga from the village – a group of

32.
FM Keesing 'The Taupou System of Samoa: A Study of Institutional Change', Oceania 8, no. 1 (1937): 14.

33.
Village high chiefs' male offspring can be entitled to the position of mānaia (ceremonial leader of the 'aumāga).

34.
The missionaries often complained about these celebrations, which lasted several days and diverted the villagers from religious duties.

35.
These dances are described in Richard Moyle's edition of John Williams' journals, as well as in Krämer's ethnography (Moyle, The Samoan Journals, 246–47; Krämer, The Samoa Islands, Vol. I, 320). Tcherkézoff underlines the fact that these night entertainments were of a ceremonial nature and were supervised by the elders (S Tcherkézoff, 'FaaSamoa, Une identité Polynésienne (Économie, Politique, Sexualité). 'L'Anthropologie comme Dialogue Culturel' [Paris, L'Harmattan, 2003, 390]). This reminds us of the case of tattooing since, during the operation, this type of entertainment seems to have had an important place in relations between the tattooer and the host village.

young men who are not (or not yet) chiefs and so do not have ancestors' title names – was led by the mānaia, the son of one of the village high chiefs; and the aualuma or group of unmarried girls of the village was led by the tāupou – one of the village high chiefs' daughters appointed to the position of ceremonial virgin, or 'village maiden'.[36] The wrestling contests and dances were a formal display of the village's strength[37] and dignity.

The tattooing ritual is understood as a collective male initiation ceremony that allowed membership in the 'aumāga. Over and above the initiation of a group of young men into adulthood and the celebration of their reproductive capacities, the reputation of the district and its chiefs was at stake in the organisation of such a ceremony. As today, the 'ie tōga (fine mats) received by the tattooer and redistributed among his assistants constituted the most prized goods and were the subject of comments concerning their quantity, beauty and origin. Accounts of a badly performed – or poorly paid – tattooing ceremony could spread far beyond the district where it took place; and a recipient who was unable to see the ritual through to the end would create a feeling of shame that encompassed the whole district.

It is likely that these communal tattooing operations had an impact on the warrior ethos of the village's young men. The ritual had the effect of enhancing the group's courage, willingness and aptitude to serve and defend the chiefdom. At the same time, this rite of passage was the final stage in the creation of a community spirit among the young men. But the evangelisation of Sāmoa, while changing religious ideology, also changed the way ritual life articulated with politics.

◄— • —►

The Christian missions that arrived in Sāmoa in the nineteenth century had already established mission stations in other Pacific islands. They were always accompanied by supervisors with previous experience in the Pacific, or by converts from other Pacific islands who had been trained as missionaries. Their encounters with Sāmoans and their understanding of Sāmoan customs occurred in the context of their previous engagement with groups elsewhere in the Pacific. Protestant missionaries with the London Missionary Society had already settled in Tahiti and the Cook Islands and had converted the islanders there to Christianity, and Catholic Marist Brothers had already evangelised New Caledonia and Wallis and Futuna. All of these islands except New Caledonia had a history of tattooing. As a consequence of the missionaries' spread of Christianity, customs that were considered 'heathen' such as cannibalism, infanticide, 'idolatry', war, polygamy, 'obscene' dances, games and, of course, the 'bloody custom'[38] that tattooing represented were often rapidly abandoned in those regions. As regards tattooing, however, the Sāmoan Islands are an exception; the practice was not completely abandoned, even though the population was very quick to adopt the new religion.

36.
There could be several mānaia and tāupou; the latter could be designated as saotama'ita'i, 'the female leader of the village's unmarried women', or by other ceremonial terms; see Tcherkézoff 2003, 297–98.

37.
The Sāmoan word mālosi refers to physical strength in the context of war or strength in the sport of wrestling. It also describes a village's capacity for work, and the evocation of male sexuality.

38.
The expression was coined by a Catholic priest (RPA Monfat, *Les Premiers Missionnaires des Samoa* [Lyon: E. Vitte, 1922], 71) and is a reflection of the Protestants' opinion on the subject of tattooing.

TATAU

39.
A d'Alleva, 'Christian Skins:
Tatau and the Evangelisation of
the Society Islands and Sāmoa',
in *Tattoo: Bodies, Art and
Exchanges in the Pacific and the
West*, edited by Nichola Thomas,
Anna Cole & Bronwen Douglas
(Durham, North Carolina: Duke
University Press, 2005), 105.

40.
NL McOrevy, 'O Le Ta Tātāu: An
Examination of Certain Aspects
of Samoan Tattooing to the
Present', unpublished MA thesis,
Pacific Island Studies, University
of Hawai'i, 1973, 78.

41.
The exact date of these first con-
tacts with Christianity is difficult
to establish, but they may have
occurred sometime between
1826 and 1829.

42.
Malama Meleisea, *Lagaga: A
Short History of Western Samoa*
(Apia: USP, 1987), 61–62.

43.
See Raeburn Lange, *Island
Ministers: Indigenous Leadership
in Nineteenth Century Pacific
Islands Christianity* (Christchurch:
Macmillan Brown Centre for
Pacific Studies, University of
Canterbury, 2006), 85–86.
Sébastien Galliot's own research
in the Methodist archives and
literature at the SOAS in London
did not reveal any mention or
information on the Wesleyans'
attitude to tattooing in Sāmoa.

44.
D'Alleva, 'Christian Skins', 104–05.

45.
George Taufa'aahau's (George
Tupou I's) adoption of
Wesleyanism constituted a
political act in the context of
rivalry with the Tu'i Tonga, who
occupied the highest position
in the archipelago's sacred
hierarchy. See C Duriez-Toutain,
*Présence et Perception: Maristes
à Tonga, 1840–1900* (Bordeaux:
CRET, Collection Îles et Archipels
no. 22, 1995), 23.

It is generally acknowledged that the Catholic missionaries were more tolerant of tattooing than the other Christian denominations, even if they were opposed to other practices that, in general, they condemned elsewhere in Oceania – polygamy, cannibalism, war, dancing and so on. This tolerance was both a deliberate decision by the priests and an evangelisation strategy.[39] Some commentators have even suggested that the French priests' tolerance might have contributed to the preservation of tattooing in the western part of Sāmoa, thanks to the transmission of the craft of tattooing among Catholic families.[40] It is not that simple, however: records from 1830 to 1868 show that the Marists were no more in favour of tattooing than were their Protestant counterparts; their 'lax' attitude towards the practice arose for reasons that were beyond their control.

The introduction of Christianity to Sāmoa began in the late 1820s, when a group of Sāmoans converted in Tonga, where Wesleyanism (later known as Methodism) was spreading.[41] When Peter Turner, the first Methodist missionary, arrived in Sātupa'itea in 1835, some 200 Sāmoans were already followers of the lotu Tōga (the Tongan form of worship), and another 2000 from Savai'i, Manono and 'Upolu were awaiting Wesleyan missionaries. Turner's mission was shortlived. John Williams convinced the Wesleyan mission headquarters in London that an agreement had been made between the two missions that would give a free hand to the LMS in Sāmoa.

As a consequence, Turner left Sāmoa in 1839.[42] The lotu Tōga endured but did not make any notable progress until 1857, when the Wesleyan Methodist Missionary Society sent missionaries to Sāmoa.[43] The Methodists appear to have been largely indifferent to tattooing. Historian Anne d'Alleva notes that Turner does not seem to have made rejection of tattooing a condition for admittance to his church.[44] This is only conjecture, however, as present-day Sāmoan Methodists in New Zealand are still forbidden to have a tattoo.

In Tonga, on the other hand, the conversion of the population that occurred in the wake of the sovereign George Taufa'aahau's own adoption of the Methodist faith in 1831[45] was followed by a ban on tattooing, enshrined in 1839 in the Vava'u Code (Tonga's first code of laws). Therefore there was no obvious reason for Wesleyan missionaries to be more tolerant of the practice when they settled in Sāmoa. Their seeming indifference to Sāmoan tattooing seems to be better explained by their sparse and brief presence during the first years of evangelisation: Peter Turner, his wife and the four Tongan teachers who accompanied the couple stayed less than four years.

The London Missionary Society was established in London in 1795 on the principle that, by guiding the explorers (Cook, Wallis and Bougainville in particular) towards the islands of the Pacific, Providence had opened a new path for spreading the evangelical message to populations whom they described in favourable and sometimes idyllic terms. The LMS began proselytising in Eastern Polynesia (Tahiti and Rarotonga) before advancing westward.

Fig. 13
Tattooing day in Sāmoa
1868–70. An illustration for
a publication titled 'The
Natural History of Man:
Being an Account of the
Manners and Customs of the
Uncivilized Races of Men'.

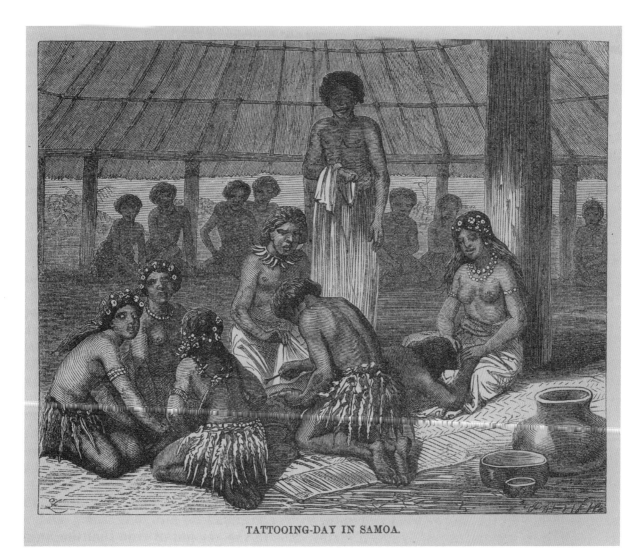

TATTOOING-DAY IN SAMOA.

46.
The discussion concerning the creation of Malua Theological College began in 1840 – just a few years after John Williams' arrival in Sāmoa, and the training centre for local pastors was opened in 1844.

47.
This intention is clearly expressed, particularly in Narrative of a Voyage Performed in the Missionary Schooner 'Olive Branch' by J. Williams, CWM, South Seas Journals, Box 7, SOAS.

48.
John Williams, Letter of 17 October 1835, CWM/ LMS/Home, Incoming correspondence, Box 6, folder no. 5, Jacket A, SOAS.

49.
Moyle, The Samoan Journals, 258.

50.
Ibid., 257.

In Sāmoa the LMS, led by John Williams, practised an 'indirect' method of evangelisation based on two main projects: quickly training 'native' pastors,[46] and working at converting the chiefs who would subsequently impose the new religion themselves.[47] However, the decentralised organisation of Sāmoan political power frustrated the latter aspiration. Shortly after Williams arrived in 1830, the conversion of the Sāmoan chiefs Mālietoa Vaiinupō and Tui Ā'ana Tamalelagi made it possible for the missionaries to establish themselves on a long-term basis in several districts, but a large part of the archipelago remained either without the evangelical message or impermeable to Mālietoa's influence. The districts that were traditionally opposed to the 'āiga sā Mālietoa (Mālietoa's clan), and that were powerful enough not to be afraid of a war against their camp, were more inclined to remain attached to the indigenous forms of religion, or to convert to Catholicism when the Marist missionaries arrived. Williams understood the limitations on evangelism that this presented. In 1835 he warned the young missionaries against imposing laws and making hasty rules about marriage in the country:

> There are two things I regret slipped my memory in speaking to our young brethrens who are in/come to the Navigator Islands. The first is the introduction of laws, this they will find a difficult subject there being no one chief at the head of the whole; what I wish to say to them is not to be hasty about the introduction of laws. Let the chiefs & people be brought into perplexity they will then apply to the missionaries for advice, let the missionaries keep in the background & let the onus of law making & law expecting rest on the chiefs.
>
> The other subject is that of polygamy. I regret much that the young men are going out without any information or ideas on this subject. Will you tell them, that my present opinion is that where a Chief has but two, has a family by both and is living happily with both that they ought to remain so, but as in many cases they have from five to ten that they ought on making a profession of Christianity or seeking admittance into any meetings be required to put them away.[48]

Williams took an interest in the status of wives, and differentiated between the chiefs' grand marriages with one or two young women of high rank and the secondary, multiple marriages with women of lower rank. He was opposed to this second type of marriage because it could be terminated by the arrival of a woman of higher rank who, in general, would demand that the other wives leave. Having lost their virginity and been 'impregnated', these women would return to their villages where, as Williams wrote, they 'become as it were for general use'.[49] Above all, Williams – whose interpretation of the entire context of these marriages was simplistic – believed that fa'amāsei'au (a custom where virgins were ceremonially deflowered) constituted a means for young women to indulge in sexual freedom without suffering the shame of 'ordinary prostitutes'.[50] As with tatau, the missionaries considered fa'amāsei'au and polygamy to be directly connected with a form of sexuality that we would today call extramarital or, in the case of tattooing, premarital. Indeed, young men who were tattooed were generally encouraged to have sexual intercourse soon after the end of the operation

in accordance with a practice that may have been called fufulu peʻa, or washing the tattooing – a metaphorical idiom for sexual intercourse.[51]

The Sāmoan context seems to have led to the LMS pastors making adjustments and concessions. Elsewhere in Polynesia, forming an alliance with the sovereign in order to obtain the relative submission of the populace was an effective strategy, and one the Wesleyans employed in Tonga; but in Sāmoa those who were regarded as sovereigns were in fact only great chiefs – 'sacred', admittedly, but with limited authority.

During the first years of the LMS's presence, the reception of their biblical message was also confused by the influence of the Sailor's Lotu – Christian-like cults led by sailors and 'beachcombers' (escaped convicts and sailors living in Sāmoan villages) – or Sāmoan sailors such as Siovili,[52] who had introduced a form of Christianity despite having had no religious education. They had proclaimed themselves prophets, cult leaders or pastors and had celebrated sacraments such as baptism. Williams rebuked one of these self-proclaimed pastors in the following terms:

> Suppose you were to go to England and just as naked as you are now with your navel tattooed and the lower part of your tattooed belly showing as it is now, with nothing in the world but a hat and an old pair of trousers on & go into a large church or chapel & stand there to baptize people, what would people think of it?[53]

Despite these difficulties, in less than ten years the LMS had managed to establish a large network of mission stations from Savaiʻi to Manuʻa. Tattooing coexisted with conversion in Sāmoa, but in the small eastern islands of Tutuila and the Manuʻa group, where no other Christian denominations were present, an official ban was enforced. The missionaries punished offences such as polygamy by refusing access to Christian education and imposing fines. In a letter in 1851 the LMS missionary John Sunderland, who was stationed in Tutuila, described how he could not stop the young men going to ʻUpolu to be tattooed:

> There is a great desire amongst many of the young men of the district to get tattooed. The custom seemed to be passing away on Tutuila, but the war on Upolu has revived it again and has induced many persons expert in the art of tattooing to renounce their profession and a considerable number of young persons have secretly gone off to Upolu to get marked as no person, at present, is allowed to tattoo on Tutuila.[54]

Reverend Thomas Powell writes that a code of law had been established on Taʻū, in the context of which to practise tattooing was to challenge the authority of certain local chiefs who enforced the prohibition at the missionaries' request:

> During the time of spiritual prosperity salutary laws were adopted. The population increased and general prosperity prevailed. But about 1860 or earlier serious

51.
This is indirectly supported by the connection between tattooing and the celebration of male sexuality – a local interpretation of Sāmoan tattooing recorded during an interview with former head of state Tupua Tamasese.

52.
JD Freeman, 'The Joe Gimlet or Siovili Cult: An Episode in the Religious History of Early Sāmoa,' in *Anthropology in the South Seas*, edited by JD Freeman and WR Geddes (New Plymouth: Thomas Avery, 1959), 185–200.

53.
Narrative of a Voyage Performed in the Missionary Schooner 'Olive Branch' by J. Williams, Saturday 20 October 1832, CWM, South Seas Journals, Box 7, SOAS.

54.
Sunderland, Tutuila, 25 December 1851, CWM/LMS, South Seas, Incoming correspondence, Box 24, Folder 5/Jacket D, SOAS.

TATAU

evil began to appear. Among them a chief named Lalolagi belonging to Olosega went to Upolu and there became a professed papist. He returned with rosary and catechisms and set up as a catholic teacher. The chiefs were much annoyed at this proceeding but I warned them to beware of offering any opposition than that of calm remonstrance. This advice was followed and since he obtained no adherents beyond his own family, he gave up in despair and returned the rosary and books to the priest on Upolu. He seemed however bent on evil, and he trampled under foot the law which had been agreed to by all the chiefs in reference to the discontinuance of the heathen practice of tattooing. He fetched a tattooer from one of the Leeward islands and had young men tattooed at his village and thus set the chiefs at defiance.[55]

55.
Extract from T. Powell's visit to Ta'u, Manu'a c. 1860, CWM/LMS, South Seas Journals, Box 10, SOAS.

56.
Krämer, *The Sāmoa Islands, Vol. II*, 68.

German ethnographer Augustin Krämer mentions that a code of law was enacted in Manu'a, and that it included a ban on tattooing; more precisely, he reported that in 1898 the island of Manu'a officially forbade tattooing and punished offenders by a fine of $5 payable to the church.[56]

On Savai'i and 'Upolu it was impossible to enforce prohibitions as strictly because many districts on these vast islands were untouched by the LMS. Some influential chiefs, such as chief Su'a of Salelāvalu, were seemingly impervious to the evangelical message and had remained faithful to ancient traditions and practices. When the Marist fathers arrived on Savai'i, chief Su'a was described as 'an inveterate heathen' even though some members of his family had converted to Catholicism.

In a letter on 18 December 1865 the missionary Joseph King recounted how he achieved the destruction of a place of worship to which Su'a was devoted until his death. This exceptional document is of great importance for the history of religious change in Sāmoa. It confirms oral tradition about tattooing and enables us to understand the complexity of the relations between the missionaries and the local chiefs. In particular, it demonstrates how just one influential chief could thwart the plans of an institution as powerful as the LMS in the second half of the nineteenth century.

> The last heathen temple in Samoa has recently been destroyed in my district. It was a large tree situated in the village of Salelavalu only a mile or two from the spot where John Williams first landed in Samoa. Under the shade of this tree the principal deity of the village was supposed to reside. There the people were formerly accustomed to assemble to keep their feast sacred to their village god. One of the highest chiefs of the village called Sua who has died since we have been here remained a heathen to within about 9 months of his death and by him the sacred character of this tree was preserved.
>
> Although his fellow countrymen had years before forsaken their imaginary gods so that for more than a quarter of a century Samoa has been called a Christian land, this man with one or two companions indignantly refused to embrace Christianity declaring their unshaken faith to the gods in whom their forefathers had trusted. But the infirmities of age at length compelled this old heathen to

acknowledge what pride had hitherto prevented his doing…, his [belief] in the God of the bible, and he died earnestly seeking the favour of Him, whom he had so long despised.

The influence of this man upon the inhabitants was very harmful. Through him a great deal of heathen superstition remained among the people, although with one or two exceptions they were all professedly Christian. While they worshipped Jehovah in this temple, it was evident that many of them had not ceased to reverence the temple of their old god.

Soon after the death of Sua, I appointed a new teacher to the village, a young man from the Malua institution to go to this appointment, one of his fellow students, a young man of Salelavalu urged him to commence his labours in the village by an attempt to destroy the heathen temple. Several attempts had been made to do this in Sua's lifetime in vain as it was impossible to do it without the consent of the principal chief of the village. Now however all that was necessary was the consent of the remaining rulers who were all professedly Christians. The teacher went to his appointment resolved to carry out the suggestion of his fellow student. After being in the village about a fortnight he went to the chiefs and proposed to them that he should be allowed to destroy the temple of Taimā, and so remove from their midst what had so long been a reproach to them.

They consented, although some of them did not so without manifesting considerable superstitious fear. Having obtained their consent, he set to work, assisted by the boys of his (choir?) and after gaining new members of the church he collected fire wood of which they made a huge pile around the trunk of the tree. This done, they waited till the evening, and then as the villagers were lighting their evening fires, at the hour at which in their heathen state they would have been seen carefully closing up all their houses, lest the flare of their fire should reach the temple of their god – fire being particularly offensive to him – the teacher lit his torch and with grateful joy went forth to kindle the fire which was to destroy the last temple shrine in Sāmoa. As the flames arose the whole village were attracted out of their houses to witness the work of desecration. Among them was a decrepit old man, a heathen who was heard vehemently imprecating curses from his gods upon the teacher for this act of profanation. In the wrath of this old heathen, one sees how reluctantly Satan retreats from his stronghold.[57]

57.
Letter from Joseph King to Reverend A. Lidman, CWM, South Seas, Incoming correspondence, Box 30, Folder 4/Jacket C, SOAS.

Joseph King's correspondence establishes other points essential to the history of tattooing in Sāmoa, besides the link between Su'a and the twins Taema and Tilafaiga. The first point is the connection between Su'a and the sacred place of worship called Lalotalie (under the talie tree) which, far from being only mythological, appears in the correspondence as an actual place of worship. His letter also sheds new light on the role of the malaetā. Just like the village malae, these places were indicated by particular items which located a clan's foundation in the territory; they were dwelling places of the guardian spirits to which the villagers brought gifts and where the head of the clan led them in acts of worship. This goes against the assumption that malaetā were dedicated to the actual tattooing operation.

TATAU

58.
G Koch, *The Material Culture of Tuvalu* (Suva: USP, 1984).

The end of the nineteenth century was a time of establishing stations for the LMS. It both opened a theological college at Malua and set up a printing press to produce documents in the Sāmoan language, enabling it to create a missionary body comprised mainly of Sāmoans. Through its Sāmoan pastors, the LMS would then spread its message to smaller archipelagos such as Tuvalu, where the pastors appear to have contributed to the disappearance of tattooing.[58]

◄ • ►

59.
Duriez-Toutain, *Présence et Perception*, 23–24.

60.
R Aldrich, *The French Presence in the South Pacific, 1842–1940* (Honolulu: UHP, 1990), 36.

61.
C Girard, *Lettres des Missionnaires Maristes en Océanie, 1836–1854* (Paris: Karthala, 2008), 423.

Encouraged by their success in Wallis and Futuna and New Caledonia, and anxious to halt the progress of Protestant missionaries in the Pacific, the Marist fathers Roudaire and Violette – accompanied by two Wallisians and two Sāmoans baptised on Wallis – were sent to Sāmoa in 1845 by Monsignor Bataillon, who had been in charge of the Vicariate of Central Oceania since the Marists had settled in Wallis Island. The Sāmoa Islands represented the last big central Oceania archipelago missing from the Marist Brothers' trophies. But unlike their experience in Wallis and Futuna, the first years of Marist presence in Sāmoa were not marked by massive conversion and the rapid disappearance of tattooing. The missionaries encountered the same obstacles as the Protestants had fifteen years earlier, and they faced two additional drawbacks: the LMS had preceded them; and their ministry emphasised a form of voluntary renunciation that, as in Tonga, was incompatible with the islanders' traditional way of life.[59] In other words, France's annexation of Tahiti three years earlier had not made the Marist arrival in Sāmoa any easier.

The Catholic missionaries brought with them a reputation for plotting in favour of the French colonial empire. The LMS Protestants, forewarned of the arrival of 'papists', had prepared for their arrival by circulating rumours. According to Captain Marceau, who accompanied the first Marists to the Sāmoa Islands, the Protestants were accustomed to representing the Marists as 'bloodthirsty monsters'.[60] Not surprisingly, the locals were reluctant to accept the Marist missionaries. The chiefs who had already converted to Protestantism and who had to some extent been 'indoctrinated' by the Protestant missionaries refused them access to their districts and prevented them from building places of worship, for example at Safotulafai.

The party of Marists from Wallis reached the Sāmoan village of Falealupo on 26 August 1845[61] and began to look for a more welcoming region to settle in. They found they could take advantage of the competition and rivalry between different districts. In general, the Sāmoan chiefs interpreted a missionary's arrival in their district as a potential means of gaining foreign goods ('oloa). They had also realised that these new residents could help them extend their reciprocal trade relations. Indeed, after a few years the missionaries – Protestants and Catholics – had a good command of the Sāmoan language and could make commercial exchanges more easily by serving as intermediaries between the native population and foreign traders.

Very soon a real demand for missionaries developed, and when it was not satisfied the chiefs resorted to their contacts in Tonga in order to obtain Methodist pastors. The competition between villages was exploited both by the chiefs, who allied themselves with a religion according to political rivalries, and by the Marists as newcomers. Chief Mālietoa Talavou was a case in point – he became a Wesleyan as opposed to his LMS rival Mālietoa Laupepa in the 1860s.[62]

The Marists' strategy was to 'prospect' in the regions and villages not yet converted to Protestantism; their experience in Wallis and Futuna and in Tonga had shown that this method was effective.[63] The first noticeable alliances took place on the island of Savai'i at Lealatele with chief Tuala, then at Salevalu with chief Moe (the brother of the heathen chief Su'a). Tuala[64] and Moe were the first to embrace the Catholic religion. Moe is reported to have told those who wanted to make him renounce Catholicism: 'You see the tattoo on my body; well! I have another one done on my soul by Silipele [Gilbert Roudaire], neither of them can be erased. The only way to erase a tattoo is to flay the person.'[65] Five years later at Lealatele it appears that the chiefs themselves forbade tattooing. Father Padel reported:

> I heard, a while ago, that the chiefs of Lealatele had forbidden tattooing. The tattooer (tufuga) had defied this ban, persuaded by his own son and by a foreigner who wanted to be tattooed. For his pains, the tattooer was condemned to a fine of 20 hogs and 5 fields of taro which he did actually pay.[66]

This example seems to indicate that rather than being generally more permissive the Marists treated each case individually, according to each missionary's feelings and the fervour of the local population.

During the first ten years of Marist settlement the central theme of the fathers' journals and correspondence was the missionaries' extreme destitution and poverty.[67] There were two underlying reasons for this: the Marists were far from their headquarters in Lyon and Rome; and the very nature of their ministry, based as it was on the life of the Virgin Mary, was steeped in humility and modesty. This undermined the authority of the priests, who complied with Sāmoan customs rather than attempting to control them. The Marists 'voluntary simplicity' was in sharp contrast with the Protestant missionaries, who had become accustomed to living in comfortable residences and being carried by the natives when they travelled.

The Marists' existence in Sāmoa was harsher than anywhere else in Oceania. For ideological reasons – such as the practice of penitence – they generally refused to trade with the islanders and occasional visitors; instead they depended on their own capacity to grow enough food to be self-sufficient, and limited their trading to a few exchanges. They seldom bought land, and then only to erect a place of worship. Their distance from the decision-making centre of their church in Rome meant it took several months, sometimes years, for their requests for help to be heard. In contrast, the Protestant missionaries had institutionalised the practice of trading, and ran

62.
RP Gilson, Samoa 1830–1900: The Politics of a Multi-cultural Community (Melbourne: Oxford University Press, 1970), 72–73.

63.
In Tonga the Catholics established themselves in villages (notably that of Pea) that had broken away from the power of the Methodist sovereign King George Tupou I, and thus ensured themselves a number of followers. In Wallis and Futuna the Marists preached in an area largely untouched by the message of Christianity – hence their relative success.

64.
Father Roudaire reports that Tuala was so attached to the lotu pope (the Catholic religion) that he promised to hide in the forest to sing (his prayers) if war was declared on him (because of his conversion to Catholicism).

65.
Letter from Gilbert Roudaire to Jean Claude Colin, December 1845, APM ON (Samoa); Letter from Father Roudaire to Abbot Meydat, January 1847, APM ON (Samoa).

66.
Father Padel's journal, vol. II, 7 November 1850, APM ON (Samoa).

67.
See, in particular, the following letters: Letter from Reverend Father Violette to JC Colin, 26 April 1848, page 208, APM ON (Samoa); Letters from Fathers Mugnery and Verne, September October 1846, page 208, APM ON (Samoa); Letter from Father Mugnery to Colin, 24 February 1850, APM ON (Samoa); Letter from Father Padel to Colin, 26 February 1850, APM ON (Samoa).

TATAU

plantations. This economic resilience gave them greater scope for developing the tools of evangelisation, such as printing bibles in the vernacular.[68]

LMS missionaries George Pratt (who was stationed mostly on Savai'i between 1839 and 1879) and William Harbutt (who resided on 'Upolu during the same period) described the competition between the Marists and the Congregationalists (the LMS pastors) in their correspondence. Pratt observed that:

> In their practice they endeavour to take just the opposite to what is our practice. They neither buy nor sell. They give medicines at all times and to all applicants and in return they do not take a payment. They have made trifling presents to the chiefs of their party. They themselves work at the chapel which is [being built] and choose the heat of the sun instead of the shade of a tree. Their 'voluntary humility' they carry to a great length. The priest at Lealatele refuses to live in the large house and has taken a little back house. When a chief enters they sit on the ground and if a mat is spread for them they lift up the end of it and sit on the ground. If chiefs are gathered together in a house they stoop down while passing them like the most abject menials and sit on the very threshold of the house.[69]

In 1854 Harbutt wrote:

> Night dances they are not wrong or very venial offences tatauing or marking the body, altho' attended by many evils they don't condemn playing at various games or amusing themselves in any way on the sabbath they pronounce quite right. Fishing or any worldly employment on the sabbath they also allow [...] The priests have made the worst of our having wives and requiring comfortable houses and truly if, as I see the reports in the records of the propaganda *de fide*, our houses are the best in the place where we reside, with equal truth it may be said of the priests at Amaile that theirs is the worst and dirtiest. The natives call it a cooking house (the most expressive term they can employ as scrapings of vegetables are accumulated there) as of their persons and linen they remark 'they may well afford to give away soap, as they do, to their friends for they use none themselves'.[70]

As historian Malama Meleisea has observed, Sāmoans did not embrace Christianity lightly. They did so with deliberation, for the most materialistic of reasons and based on Sāmoan assumptions about religion.[71] The missions' presence and conditions of existence depended totally, for the first years at least, on the local chiefs' willingness and on the social status they were given according to local categories. Tcherkézoff's interpretation is that the Protestant pastors had the status of sisters, voluntarily placed in a position in which they would not compete with the chiefs[72] as their superiors in decisions inspired by God; their inferiors in profane decisions concerning the life of the village and district. The Marist fathers' obvious poverty, their celibacy and their manner of adopting Sāmoan rules of politeness and humility were regarded with

68.
The Catholics did not start publishing texts in the Sāmoan language until 1862. There was no local printing press in operation until 1874, and then only in very difficult conditions.

69.
Pratt, 24 January c.1850, Matautu, Savai'i, CWM, South Seas, Incoming correspondence, Box 19d, Folder 5.

70.
Harbutt, 'Upolu, 9 December 1854, CWM, South Seas, Incoming correspondence, Box 25, Folder 8/Jacket D.

71.
Meleisea, *Lagaga*, 17. Aldrich also interprets the islanders' attitude towards the missionaries more as a political strategy than as an accident. R Aldrich, *The French Presence in the South Pacific 1842–1940* (London: Macmillan, 1990), 49.

72.
Serge Tcherkézoff has shown the impossibility of the pastors taking over from the matai (those who conducted prayer) and the fact they were put, by these very same matai, into the same role as sisters (which is to relate to the divine and the family's ancestors). Serge Tcherkézoff, *Fa'aSamoa, Une Identité Polynésienne* (Paris: L'Harmattan, 2005), 220–21.

contempt by the Protestants. Most of the matai would have viewed these priests as individuals who were even further from the chiefs' own way of thinking than were the Protestants. Some of the Marist fathers complained of being totally stripped of their belongings by the villagers and abandoned whenever a conflict was expected – and there was always conflict when missions were being established.

◀— • —▶

According to Meleisea, preparations for war entailed numerous negotiations with potential allies in order to be part of the itūmālō (victorious clan), which included the right to use the land and work capacity of the itūvāivai (defeated clan).[73] Nineteenth-century sources record that the assets of a defeated district would be reduced to nothing; its inhabitants could be expelled and the women taken as wives by the victors.[74]

At this time, Sāmoa was divided into several large coalitions or kingdoms. One of these kingdoms was formed by an alliance between Ā'ana and Atua, and the other was made up of the region controlled by Manono (Apolima and the coastal villages in the west of 'Upolu), also called 'āiga i le Tai; Tuamasaga; and a few districts of Savai'i including Satupa'itea. The objective of the great wars in the mid 1800s was to conquer the four supreme titles of the Sāmoan hierarchy. These are called the four pāpā – the Gato'aitele, Tamasoali'i, Tuia'ana and Tuiatua titles: when embodied by one and the same person, this was the supreme office of Tafa'ifa, the sovereign of Sāmoa. The arrival of the missionaries coincided with a context of struggle over these four titles.

John Williams' first visit to Sāmoa took place on 15 July 1830, a few weeks after the elimination of a tyrannical ruler from Manono (Leiataua Lelologa Tamafaigā) by the villagers of Fasito'outa in Ā'ana district. This event occurred after twenty years of his cruel hegemony, and precipitated the country into a series of wars.[75] Williams witnessed the aftermath of these when he reached Sāpapāli'i on board the *Messenger of Peace*. At the time, chief Mālietoa Vaiinupō was in the process of regaining the power previously held by Tamafaigā, who had proclaimed himself Tupu o Salafai (sovereign of Savai'i). Having the missionaries on his side represented a huge advantage for Mālietoa, given their apparent technical superiority: they had sailing boats visiting every few years, and tools that were unavailable in the Islands at that time.[76] He was victorious. But according to Williams, after this first episode – of which little is known, given the sparse documentation – it was necessary for the LMS to establish a lasting peace,[77] an objective they did not achieve until the twentieth century. A short time before his death in 1841 Mālietoa Vaiinupō expressed his wish to divide his Tafa'ifa and confer the titles on three separate people, including his brother Taimalelagi. However, this did not defuse the tension between the great title holders of the different districts who had contributed to the victory.

73.
Meleisea, *Lagaga*, 21–46.

74.
Pritchard, *Polynesian Reminiscences*, 49–82; Turner, *Samoa*, 80–83.

75.
For a detailed historical account of that period see Tuimaleali'ifano, 2006.

76.
In *Samoa 1830-1906* Gilson twice quotes the speeches of Sāmoan chiefs in which they stress the Europeans' technical superiority and the fact they possess powerful arms.

77.
See also Gilson, *Sāmoa 1830-1906*, 65–114.

TATAU

TATAU

Between 1848 and 1851, and again in 1853, there was a constant state of war: forts were built at several places on 'Upolu (Mulinu'u, Si'umu and Lufilufi) and sporadic battles were fought. It was not a fully-fledged war – it did not cause unrest across the whole territory, and there was no apparent victor – but it created many difficulties for the recently arrived Marists. According to Father Padel, some villagers whose plantations had been destroyed and villages looted in the battles adopted the Catholic religion because they saw the missionaries as a neutral, independent and reassuring presence. Missionaries in warring districts noticed their tools and crops were going missing, and sometimes their hens and pigs, too.[78] Some districts – notably Ā'ana (the eastern part of 'Upolu) – were totally deserted and the missionaries stationed there had to be evacuated.[79]

The violent clashes ended in 1856, thanks to a truce in which the missionaries played a part, and the people of Ā'ana began to return to their own territory. During this period, when the country was more or less ruled by Taimalelagi, then by Mālietoa Mōlī, the different missions expanded and European influence increased across the archipelago. But the death of Mālietoa Moli created a new period of political instability.

<div style="text-align:center">◀ • ▶</div>

On Mālietoa Mōlī's death in 1860 two factions emerged within the sā Mālietoa branch and the country found itself divided into two rival groups: one, united round Mālietoa Mōlī's half-brother Mālietoa Talavou, constituted a large coalition made up of Savai'i, Manono, part of the Tuamasaga district and the Methodists (including the Tongans). The other, united around Mālietoa Mōlī's son Mālietoa Laupepa, formed a smaller coalition that included Malie, the rest of the Tuamasaga district and the Protestants of the LMS. As the claimants had not yet met on the battlefield they could not be identified as itūmālō (winners) or itūvāivai (losers). Conflict was inevitable and the country was impoverished by preparations for war that involved the exchange of land and possessions for food and arms obtained from the various foreigners present in Sāmoa.

In 1869 Laupepa was declared King of Sāmoa by his chiefs and orators, taking the Western notion of parliamentary monarchy as a model. This was seen as a plot by the opposing side, and prompted the parallel coronation of Talavou. These vexations led to a series of battles and population movements that continued until Talavou's death in 1880. During peace talks, the Fono o Ta'imua and the Fono a Faipule (the Pule), a council composed of orators representing the whole archipelago, drew up twenty-five new laws and a document that was in essence Sāmoa's first constitution. These laws and this constitution recognised the traditional authority of Ta'imua and the Pule as the official representatives of government, but nonetheless made abundant use of the missionaries' moral and religious precepts, as well as of the Western concepts of ownership rights and contractual obligations. The ninth law, on tattooing, appeared between the law on the sale of land and the law on government officials.

Fig. 14
Siapo (barkcloth) featuring geometric patterns and parallel line work.

78.
Letter from Father Padel to JC Colin, 24 February 1850, page 208, AMP ON (Sāmoa).

79.
Padel to Colin, Letter 6 December 1850, page 208, AMP ON (Sāmoa).

TATAU

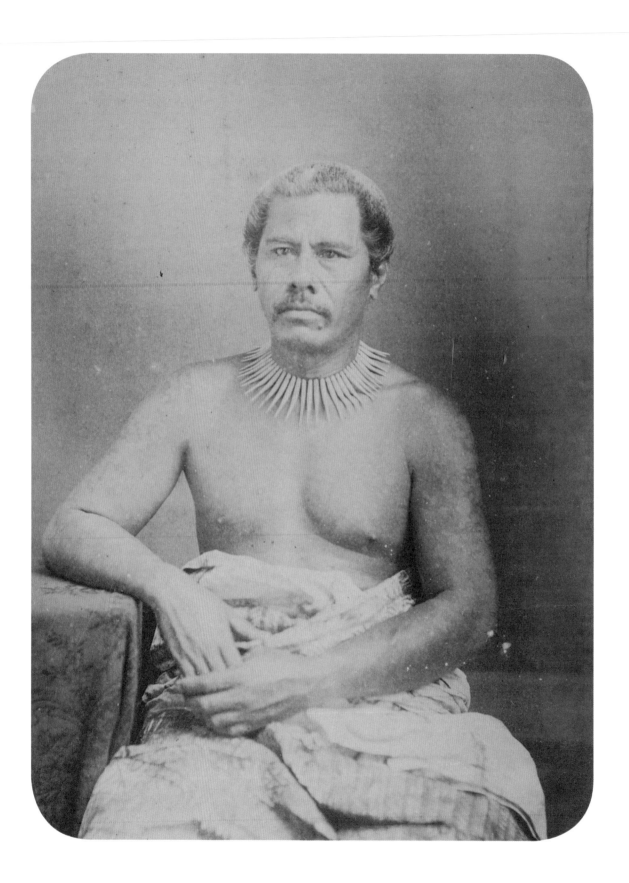

The methods for prohibiting the practice were specified as follows:

> 1. Tattooing is forbidden. Anyone who is tattooed will pay a fine of a hundred dollars. If he does not pay, he will have to work for one year. The same fine for the tattooer. Foreigners who break this law will pay two hundred dollars or work on the roads for two years. This law will come into effect from the day taxes are paid in Sāmoa.
>
> 2. The tattooer will lose his tools and his possessions, except for those necessary to keep his family.[80]

This constitution and the laws associated with it came into force on 1 November 1873. However, the law on tattooing would only come into effect when taxes began to be paid, while all the other laws that made provision for fines did not specify this. These laws seem never to have been enforced, and the country remained politically unstable until Western Sāmoa was annexed by Germany in 1899.

Colonel AB Steinberger played an important role in drawing up this text, whose aim was to organise relations between a central government based at Mulinuʻu, the indigenous population and the foreign residents. He was sent by the US government to observe and report on the state of the territory and its inhabitants with the aim of creating an American port of call for the trade route from the west coast of the United States to Australia. On his return to Sāmoa at the end of 1874 he had himself appointed prime minister of the new government and established a tax system that was deemed despotic. He was greatly criticised and was soon dismissed from his post following accusations from a number of Americans and Europeans living in Sāmoa. He was eventually deported in 1876.

The ongoing state of war was one of the main obstacles in the missions' establishment. The Marists, in particular, had settled in only a few districts on Savaiʻi and ʻUpolu, but the precariousness of their situation in the midst of constant warring meant they had no time to devote to the task of converting the population, let alone exerting control over indigenous mores[81] and customs such as tattooing.

Another possible reason why tattooing was allowed to continue was that it was not identified as a religious practice. We know, for example, that Father Padel was careful not to confuse it with a religious act. He wrote in his journal:

> Today I have discovered that the inhabitants of the Navigators are in the habit of being circumcised and that this operation is carried out when the child is about ten. No superstitious idea is attached to their tattoos; only the men are tattooed and they have this done when they are about 18.[82]

In 1848 Padel, who in general showed little enthusiasm for Sāmoan customs, gave a much more detailed account of tattooing and his views of it.

80.
According to the French version published in 'Les Nouvelles Lois Samoanes', *Les Missions Catholiques* 6 (1874): 350–52.

Fig. 15
Malietoa Laupepa, the son of Malietoa Moli. 'It was only late in life that, in a great political crisis, he consented to be tattooed, to unite his people, some of whom refused to serve in a cause the head of which did not possess a warrior's first qualification.' William Churchward. 1887.

81.
'Ideas of war have started to trouble people's minds again; this has given rise to big meetings to deliberate on political affairs, night dances and all the rest, the putting aside of religion, and finally the country being deserted and abandoned.' Letter from Padel to Poupinel, 6 September and 18 October 1853, APM ON (Samoa).

82.
'Journal du Père Padel', vol. 1, page 108, APM ON (Samoa).

The second or third time that I preached, I forgot to begin my discourse with this requisite expression [He is referring to the polite phrases used in public speeches]. As soon as mass was over, two of the principal chiefs came to find me to rebuke me for having omitted something so essential and they even went so far as to report this to Father Vachon. Pride really must be solidly rooted in man's heart to be expressed to such an extent by our *sans culotte*. But what am I saying, *sans culotte*. They all have breeches and, moreover, they are very proud of them; breeches that once made do not wear out, that they never take off and that they even take to the grave with them; they like these breeches which are always adorned with the same designs so much that they cannot understand how Europeans can do without them. So they are delighted to display them in their entirety, but it is not a great delight for sensitive eyes to contemplate such breeches. I would almost be prepared to wager that you would be quite pleased to enjoy a sight like this. Particularly when the warriors are leaving for the place of battle. Then you would see the breeches in all their splendour, because they are well rubbed with oil; you would see the warrior's face smeared with coal dust; his head covered with red cloth and red feathers; but, despite the breeches, the rest of the togs are exactly like those Adam hurriedly donned as soon as he had sinned. […] But to come back to Samoan breeches which are also those of Tonga? and those of the elders on Uvea, what are these breeches then? They are quite simply a tattoo which is the same for everyone; it begins at the waist and goes down to the knees. In the archipelago, there are a number of people whose profession it is to make this kind of clothing which is as good as any other. These individuals travel around the country: they arrive in a village. First of all, they start by preparing the dye; this is the fruit of a tree which looks like a walnut and is called *Tama* [the correct term is *lama*] in the native language; it is carbonised and, after being crushed to a powder, mixed with water. The next day, the chief has the fifteen year old children, and even younger ones, brought to him whether they like it or not to have the operation performed on them. This operation is very painful. The instrument used is like a carding comb for tow; it is made from the bones of men killed at war, sharks' teeth and pigs' bones. The patient is fetched, lain down on the ground naked and held in this position; the operator dips his instrument in the dye and applies it or, more correctly speaking, beats it into the flesh with a hammer. Yet, all those present, and they are always numerous, men, women and children, clap their hands and shout to prevent the patient's cries being heard; his blood flows freely and he is often ill for several days. I have even been assured that some have died from it; and this is not surprising, for they are tattooed even in the most sensitive parts. This custom is rather barbaric and, I believe, superstitious. Here I had written something I am not sure about, which is why I have erased it as several natives told me that it was not true.[83]

Padel's account of a tattooing operation is quite mild compared to that of Father Monfat, the Marist mission's historian, who published a version of the same letter that incorporated several more lurid images.[84] Beyond this, there is also the matter of the missionaries' personal sensitivity towards local customs. While Father Padel seemed

83.
Letter from Father Padel to Poupinel, 31 August 1848, APM ON (Rome).

84.
'All those who attend this horrible ceremony, and there is always a large crowd present, men, women and children, clap and shout to cover the screams of pain uttered by the victims of this cruellest of customs. It is particularly unbearable when the torturer's hand lingers over the most sensitive parts. (Monfat, *Les Premiers Missionnaires des Samoa*, 71–72).

to be indifferent to the pōula and tattooing, as some of his letters make evident,[85] Father Léon Gavet was as horrified by the Sāmoans' heathen customs as he was by their 'heresy'[86] – that is, their Protestantism. He reported that some 'heretical' families he visited to obtain promises of baptism sometimes waited until one of the family had been tattooed before they converted. He linked this cautious attitude to the prohibition against tattooing issued by the Protestants:

> I have whole families waiting for one of their members who has not been tattooed to undergo the operation, which with them is seen as a grievous crime (the theology of the ministers who have over and over again perverted these poor peoples' consciences).[87]

The Protestants punished church members who had been tattooed by excommunicating them, and it seems the Sāmoans presumed that the Catholics would be equally rigid. But although the Catholics were against tattooing in principle, they would rather have additional tattooed followers than no followers at all. The Marists' lack of authority to stop tattooing was such that, in December 1868, Rome issued a decree in response to a request made in June that year by the Sāmoa-based Marists that the order be permitted to tolerate the practice of tattooing.[88] The request made the following points: there was nothing superstitious about tattooing; a tattoo made it possible to distinguish between adults and adolescents; when a ban was proposed, Sāmoan society expressed such strong disagreement that some fled elsewhere to be tattooed; and it was impossible for the priests to ban the practice.

This document establishes that although the priests would have liked to prohibit tattooing, they had to deal with the Sāmoans' strong attachment to it. It is clear that the Marists' tolerance of the practice was a belated official position stemming from their obvious powerlessness, rather than part of an unofficial evangelisation strategy, as some have suggested.[89] It is difficult to establish the extent to which this decree was respected by the different missionaries from 1868 onwards; it is possible that its observance was left to the discretion of the individual priest. In 1874, six years after the decree, Father Vidal was still preaching against this practice. In his description of a visit to a village to celebrate Easter mass, he notes:

> There were also several young men who had undergone the heathen ceremony of tattooing this very year and who since then had abandoned their religious duties. I had them all brought to me separately. The first one to come is an unusually pious young man. He had long resisted his heretical parents' entreaties, but finally, pressed by their importunities, he had consented to be tattooed. The poor child had not dared come of his own accord; but when I called him he appeared outside my hut. He was there waiting for me to return after evening prayer. As soon as I saw him, I said to him kindly: It's you, my friend. At these words, he could say nothing but burst into tears. I tried to console him and, when he had recovered a bit, he said how much he repented having sinned and asked me what he should do to make up for it. I told him that he must first find grace

85.
'In general, they have abandoned, though reluctantly, the night dances and some others which do not seem to me as bad as they were imagined'. Letter to Mériais 15, 16 September 1846. And concerning tattooing: 'The Protestant ministers have said so much against it that we are not worried about it', Padel to Poupinel, 31 August 1848, APM ON (Sāmoa).

86.
He particularly despairs at seeing one of his subjects performing a marriage ceremony which he judges intolerable and abominates the night dances. Father Gavet's journal, 25 December 1859, APM ON (Samoa).

87.
Letter to M Roux, 10 December 1860, APM ON 208 (Samoa).

88.
Marist Archive No. APM 1351/1915.

89.
See D'Alleva, 'Christian Skins'.

TATAU

again with God and for that make a confession. He prepared his confession and the next day, he was overjoyed to make his Easter communion … A few other young men came to see me for the same reason and they left having found grace with God again.[90]

90.
Letter from Julien Vidal to Father Fraysse, 10 August 1874, APM ON (Samoa).

This letter, with its tone of paternalistic benevolence, demonstrates that being tattooed did not necessarily lead to excommunication, nor to an exclusion from practising Catholic rites. Father Vidal describes how the islanders were afraid of appearing before the priest because they believed that by being tattooed they had committed a sin.

The accounts and interpretations of tattooing presented here are coloured by the attitudes of their writers. Interest in tattooing among the early missionaries was very limited and the information gathered – by Stair for the ceremonial aspect or Powell for oral tradition, for example[91] – lacks context and reference to local social organisation. The missionaries' correspondence nonetheless offers insights into the social importance of Sāmoan tattooing in the eighteenth and nineteenth centuries, and gives an idea of its appearance, its geographical distribution and some aspects of the ritual. These observations, made in different parts of the archipelago from Savai'i in the west to Ta'ū in the east, indicate a homogeneity in tattooing throughout the archipelago – as is still the case today. They also reveal a consistency in Sāmoans' attitudes to tattooing: before it was prohibited in some villages it was prevalent everywhere, on all men and on some women as well.

91.
Stair, Old Samoa, 158–64; Fraser, 'Some Folk-songs', 171–83.

While the similarity of tattooed marks observed throughout the archipelago depended largely on the islanders' and the tufuga's mobility and alliance networks, the continuity of tattooing cannot be attributed entirely to pre-contact culture. The missionaries' efforts led to the disappearance of tattooing in the east, but it remained in the west, in Savai'i, where a handful of missionaries did not have total control and where local warfare disrupted their evangelising. As we will see in chapter 4, the strict rules surrounding the tattooing procedure and the way it is transmitted may have contributed to its longevity over the decades.

It is no surprise that the European accounts reveal an ethnocentric tendency to try to understand indigenous practices using Western criteria. Most of their descriptions view the tattoo as a substitute for clothing. Some associated it with the stockings worn by Europeans in the eighteenth and nineteenth centuries; others regarded it as an alternative to nudity. German observers in the late nineteenth and early twentieth centuries compared the tattoo to a bathing costume. But far from seeing the tattoo as simply a substitute for clothing – already in the nineteenth century the Sāmoans were wearing clothes over their tattoo – it seems more relevant to look for the link between these body markings and the social dynamics that sustain this particular ritual. If its main goal was to clothe a person, tattooing would have disappeared with the introduction of Western garments. Instead, by gathering a large number of young men on the village malae and having them tattooed, the chiefs of a village or of a district were leading an initiation ritual – at the expense of the community – with the aim of creating

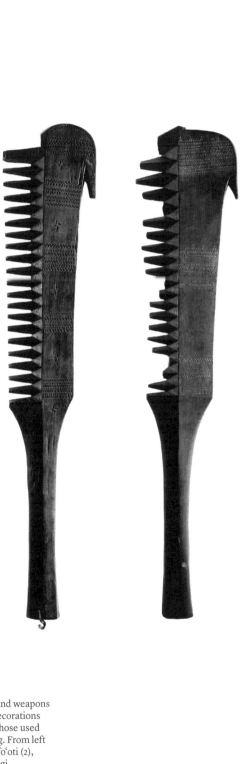

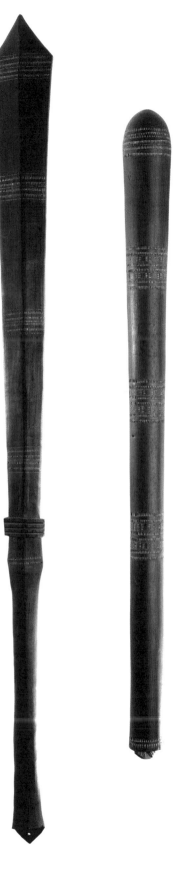

Fig. 16
Sāmoan hand weapons
featured decorations
similar to those used
in tattooing. From left
to right: nifoʻoti (2),
povai, uatogi.

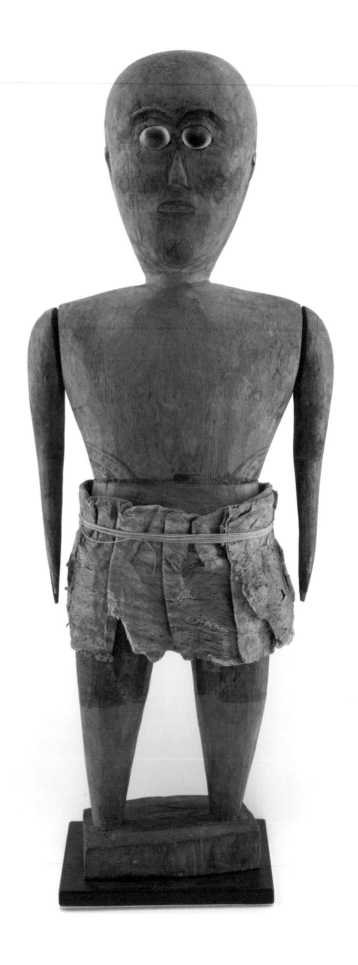

Fig. 17
A rare carved male
figure decorated with a
tatau and attributed to
nineteenth century Sāmoa.

a body of young warriors, strongly bound by this ordeal and ready to serve their group in any event, even death.

◄ • ►

In order to identify the point at which the social implications of tattooing changed, two historical accounts merit closer attention. In the 1850s William T Pritchard, son of a pastor, British consul in Sāmoa and an astute observer of Sāmoan customs, described tattooing as an initiation rite accompanied by the presentation of fine mats to the tattooer; the rite was conducted in public and was followed by celebrations and dances where the tattooing was exhibited. He considered tattooing to have been a dying practice at the time. William Churchward, on the other hand, described tattooing in the late 1880s as a prerequisite to marriage and a means of gaining respect, performed out of sight in a remote part of the forest, but still popular at the time of his writing.

This divergence of opinion coincides with what may have been a turning point in the practice of tattooing. It would seem that as a result of the wars, the missionaries' control and the ban on tattooing issued by the chiefs themselves, the practice of tattooing altered between the mid 1850s and the late 1880s. As Krämer observed, it may have changed from being a large communal and public ritual to a more private one.[92]

In pre-Christian religious practices in Sāmoa spiritual and religious matters – the cult of local and family deities – were in the realm of the matai.[93] Religious changes could have been expected to bring about a profound change in this political system. In Tahiti, for example, the collapse of the highly centralised indigenous cults brought an end to the practice of tattooing. But in Sāmoa the cults – like the power structures – were more decentralised and so the transformation of the Sāmoan religious system did not cause such deep upheavals as in Tahiti.[94] The political system was not dismantled partly because the missionaries accepted a degree of integration with it, thereby creating a very different style of Christianity – at least in the nineteenth century before the arrival of the Mormons, the Seventh-day Adventists and, more recently, the Pentecostal churches.[95]

In the first decades of Christianisation, the missionaries taught the population to read and write and established theological colleges to train them as missionaries. However, although they successfully integrated in many ways, the missionaries could not accept all the principles of the faʻasamoa (the Sāmoan way). The (rare) effigies and various localised incarnations and dwelling places of deities were banned and destroyed, or sometimes collected for the missionaries' museums;[96] they represented heathen symbols and it was important to get rid of them. The missionaries viewed ceremonial events associated with matrimonial alliances, as well as the cult of deities and aitu or spirits, as manifestations of heathenism.

92.
Krämer, *The Samoa Islands, Vol. 1,* 76: 'The public display seems nowadays to have been eliminated by the missions while the tattooing itself continues to be practised as extensively as before.'

93.
If the missionary pastors had managed to take their place, the Sāmoan system would have been far more disrupted by Christianity. Instead of this, the pastors were given a place in the social organisation which did not allow them to replace the matai: this was that of the chief's 'sister' (who has mystic but no political authority). For a more detailed analysis of this integration of the pastors into Sāmoan categories, see Serge Tcherkézoff, 'Culture, Nation, Society: Secondary Change and Fundamental Transformations in Western Samoa. Towards a Model for the Study of Cultural Dynamics', in *The Changing South Pacific, Identities and Transformations,* edited by S Tcherkézoff and F Marsaudon (Canberra: ANU ePress, 2008), 245–302.

94.
A Hanson, 'Political Change in Tahiti and Samoa: An Exercise in Experimental Anthropology', *Ethnology* 12, no. 1 (1973): 1–13.

95.
Tcherkézoff, *The Changing South Pacific,* 2008, 245–302.

96.
John Williams collected a large number of religious and profane artefacts from his voyages in the Pacific.

TATAU

Fig. 18
Plates illustrating Sāmoan tattooing, designed in the late nineteenth century and based on Felix von Luschan's research among Sāmoan performance groups visiting Germany (Luschan 1897: 363–65).

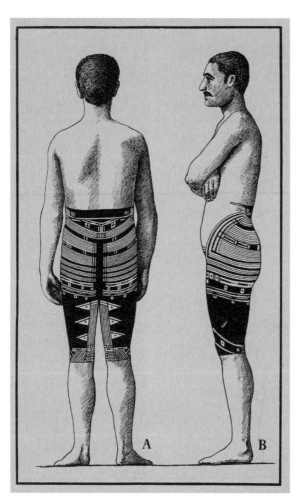

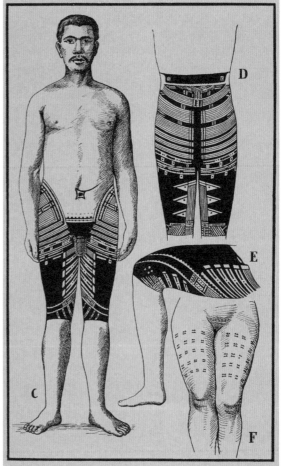

The missionaries did not have the capability to modify the political system; instead they attacked expressions of the chiefs' authority and the external signs of their power – from acquiring several wives and organising great communal gatherings such as the malaga to financing communal tattooing initiation ceremonies. The faʻamāseiʻau, polygamy, the pōula and the tatau were all crucial to the functioning of the chiefdom and the preservation of the group's reproductive capacity.

In the late nineteenth century the Western scientific view was divided between creationism – more or less in line with the principles of Christianity – and Darwin's evolutionism which, in the field of the social sciences, paved the way for evolutionist and diffusionist interpretations, eugenics and what came to be called 'social Darwinism'. In this context the sciences of life and of man developed a specific interest in physical anthropology and biometrics. In the same period articles appeared in which Sāmoans, taken as a racial sample, were measured and their physical appearance described in detail.

Before the annexation of the Sāmoas by the German Reich and during the colonial period (1899–1914), the increased presence of Europeans and Germans generated reports of tattooing. In 1884 an article in the first issue of the review *L'Homme*,[97] founded that year by the prehistorian Gabriel de Mortillet, described a brief stay in Sāmoa and gave an interesting description of tattooing, in particular on women.

> The men are admirably well-built: tall, vigorous and muscular. They are not as tattooed as the Marquesans: their tattoos extend from the hips to halfway down the thighs; a little rectangular design is found on the umbilicus. Their forearms bear the name and christian name of each individual. Seen from a certain distance, the natives seem to be wearing drawers; their clothing consists of a belt of leaves around the waist; the dandies have old trousers or frock coats given to them by travellers; they appear proud of this dress which makes them grotesque. They look much better in their rudimentary costume which enables foreigners to admire their athletic figure.
>
> The women are half-clad. Any old garment protects their modesty. Their breasts are usually bare. The most elegant have a sort of peplum made of two kerchiefs, one covering the breasts and the other the upper part of the back; these two kerchiefs are attached to each other by a cord on the shoulders […]
>
> Tattooing is less common among the female sex; it consists of lines of little dots on the crural region and the back of the hands and in a kind of garland below the umbilicus; their forearms are covered in names as is the case for men.
>
> There is a decoration, as remarkable as it is strange, of which the women are very proud; it is the result of applying many burning wicks (to the skin) above the breasts and along the arms; I have only encountered this mutilation in these islands.[98]

In this period of early colonial expansion, the German authorities considered it important to produce texts that demonstrated the progress of German science

97.
The full title is *L'Homme, Journal Illustré des Sciences Anthropologiques*. This social sciences review, characterised by its 'scientific materialism', was published between 1884 and 1887.

98.
Vallec, 'I luit Jours aux îles Samoa', *L'Homme, Journal Illustré des Sciences Anthropologiques*, vol. 1 (1884), 491. We have been unable to find any information about Vallec or his reasons for visiting Sāmoa.

99.
Felix von Luschan noted in 1896 the disappearance of a large part of the traditional art of tattooing in the Sāmoa islands and that it was necessary to take steps to protect it before it disappeared for ever. Felix von Luschan, *Beitrag zur Kenntnis des Tätowierung in Samoa* (Verhandlungen der Berliner Gesellschaft für Anthropologie, Ethnologie und Urgeschichte, 1896), 552.

100.
Jan Kubary (1885) was one of the Godeffroy Museum's ethnographers who collected ethnographic data and artefacts in Sāmoa. See, for example, FS von Kubary, 'Aus den Samoanischen Familienleben', *Globus* 47 (1885): 70–88. He later visited Fiji, Tonga, the Marshall Islands, Yap, Pohnpei and Palau. Godeffroy's museum collections were subsequently put up for sale. For a detailed account of the Godeffroy ethnographic venture, see RF Buschmann, *Anthropology's Global History: The Ethnographic Frontier in German New Guinea* (Honolulu: UHP, 2009), 33–35.

101.
R Virchow, 'Samoanern', *Verhandlungen der Berliner Gesellschaft für Anthropologie, Ethnologie und Urgeschichte* (1890), 387–92; Felix von Luschan, *Beitrag zur Kenntnis des Tätowierung in Sāmoa*, 551–64; C Marquardt, *The Tattooing of Both Sexes in Samoa* (Auckland: R McMillan, 1984). Translation of *Tätowirung Beider Geschlechter in Samoa* (Berlin: D Reimer, 1899).

102.
B Friedlander, 'Notizen über Samoa', *Zeitschrift für Ethnologie*, no. 31 (1899): 1–55; W von Bulow, 'Beiträge zur Ethnographie des Samoa-Inseln', *International Archiv für Ethnographie*, no. 12 (1899): 129–31.

103.
For a detailed account of this troupe's tour, see pages 78–79.

and its ascendancy over colonised peoples. Although not all German scientists agreed with social Darwinism – the ethnologist Adolf Bastian and Rudolf Virchow (a physician, anthropologist, pathologist, prehistorian, biologist, writer, editor and politician) were radically opposed to it – the ethnographers of the time were convinced that the peoples of Oceania were dying out as a result of their contact with Europeans.[99] Bastian's ethnographic project of documenting 'primitive people' before their extinction was well acknowledged within scientific circles in Germany. As a consequence, ethnographic collecting in Oceania increased between the second half of the nineteenth century and the First World War. Commercial and political interests associated with collecting and commercialising ethnographic objects combined with this scientific 'urgency'. Johan Cesar Godeffroy, the director of the Hamburg trading company Godeffroy in Sāmoa, for example, developed an interest in ethnography in the Pacific and employed several specialists to supply specimens for his future museum collection in Hamburg.[100]

From 1880 onwards the German scientists, politicians and folklorists who visited Sāmoa produced some ethnographic knowledge about tattooing. German ethnology's main contribution to recording Sāmoan tattooing, in particular, lies in the precision with which the designs were recorded and catalogued and in the terminology given to the tattooing tools, many sets of which were collected and brought to Germany. Several ethnographers took just as much interest in the material and decorative aspects of tattooing[101] as in oral traditions[102] and tattooing's social function. European scientists extended their anthropometric studies to Sāmoans in the islands; however, despite several mentions of tattooing in these works, it was in Europe that the first detailed studies of Sāmoan tattooing and decorative designs would be made.

Until the beginning of the twentieth century, exhibitions of 'natives' from various parts of the colonised world were popular in the bigger European cities. In 1889 nine Sāmoans recruited in the village of Leone on Tutuila by Robert Cunningham, a former agent for Barnum & Bailey Circus, were exhibited in Brussels at Maurice Castan Theatre. Doctor Émile Houzé, author of numerous studies in physical anthropology and president of the Brussels Society of Anthropology, seized the opportunity to undertake an anthropological survey – which at the time involved studying human diversity through physical measurements.[103] He made the following observations:

> The Samoans never have tattooed faces; they are tattooed from the waist to the knees, including the genitals. This tattooing, in black and blue and edged with white, resembles tight-fitting breeches. The design is more or less uniform on new subjects. The tattoo is done by pricking the skin with thorns or needles; the colouring substance is lampblack. In Samoa, this design does not represent a caste distinction as is the case with the Maoris. The Samoans are all completely circumcised, like the Jews; circumcision is general among all Polynesians, except in a few islands.[104]

In 1890 the same group of Sāmoans was displayed in Berlin in the Flora von Charlottenburg exhibition hall. There again Virchow, founder of the Berlin Ethnology and Anthropology Society, carried out a physical examination: he took measurements and made detailed notes on the Sāmoans' condition, the colour of their skin and so on. He also described their tattoos:

> Indeed, our people have no tattoos on their bodies, other than on the arms, the buttocks and the top of the legs; only Lealofi has a few names and stars on his arm but, according to him, these were done during the voyage. Otherwise, the region covered by tattoos corresponds exactly to that we cover with bathing drawers. Nevertheless, the design is such that it represents a web over the loins. There are no designs of animals or people. Large almost uniform surfaces broken by lines and bands can be seen. The blue-black colour is obtained by mixing coal.[105]

Between 1890 and 1914 six different groups of Sāmoans were exhibited in Germany, and scientists studied the physical characteristics of these 'natives'.[106] In 1895, on the occasion of an exhibition of Sāmoans at Castan's Panopticum in Berlin, Felix von Luschan noted details of men's tattoos and suggested that some designs were linked to the hierarchical rank of the wearer.[107] After spending several months in Sāmoa, Carl Marquardt wrote a short book in which he admitted he was adding nothing to von Luschan's study except detailed reproductions of male and female tattooing.[108] Augustin Krämer's lengthy stays in Sāmoa in 1902 and 1903 resulted in two volumes that included further details about tattooing.[109]

104.
E Houzé, 'Les Samoans de Leone', *Bulletin de la Société d'Anthropologie de Bruxelles* 7 (1889): 243.

105.
Virchow, 'Samoanern', 389. After an unpublished translation by I Glebov of the original text in German, given to the author by Serge Tcherkézoff.

106.
C Balme, 'New Compatriots: Samoans on Display in Wilhelminian Germany', *Journal of Pacific History* vol 42, no 3 (2007): 331–44.

107.
Felix von Luschan, *Beitrag zur Kenntniss der Tattowirung in Samoa* (Berlin: Verlag von A. Asher and Co., 1897), 551–61.

108.
Marquardt, *The Tattooing of Both Sexes in Samoa*.

109.
Augustin Krämer, *Die Samoa Inseln*, 2 vols (Stuttgart, 1902–1903).

TATAU

Tattooing:
A hidden history

Sean Mallon

1.
Charlotte Macdonald, pers. comm., 2016.

2.
See LP Churchill, *Sāmoa Uma* (New York: Sampson Low, 1902), 87; 'Three Weeks in Samoa', *Samoa Weekly Herald* 1, issue 20 (8 April 1893), http://paperspast. natlib.govt.nz/newspapers/ SWH18930408.2.12.

3.
See Churchill, *Samoa Uma*, 87; 'Walking Birth Certificates', *Western Star*, Issue 2190 (26 March 1898), http://paperspast. natlib.govt.nz/newspapers/ WSTAR18980326.2.34.

4.
The connection of tattooed names with identifying slain warriors is recorded by ESC & WC Handy in *Samoan Housebuilding, Cooking, and Tattooing* (Honolulu: Bernice P. Bishop Museum, Bulletin 15, 1924), 21. The beheadings of men and women that took place during the civil wars in Sāmoa are described by RL Stevenson; see Sidney Colvin (ed.), *Vailima Letters; Being Correspondence Addressed by Robert Louis Stevenson to Sidney Colvin, November, 1890–October 1894, Vol. II* (New York: Scribner, 1896), 165, 166, 171.

5.
Colvin, *Vailima Letters*, 245.

6.
'Samoan Affairs', *Samoa Weekly Herald* 2, issue 75 (5 May 1894), http://paperspast.natlib.govt.nz/ newspapers/SWH18940505.2.22.

7.
Charlotte Macdonald, pers. comm., 2016.

Historically, social historians and other observers have focused on the role of pe'a and malu in Sāmoan society and culture; as a consequence, the historiography of Sāmoan tattooing has obscured the actual history of tattooing in Sāmoa. But beyond these distinctive forms there are other tattooing practices that are as important for understanding the histories of literacy, gender, politics and globalisation in Sāmoa.

Tatau can be considered an indigenous form of writing, so its appropriation of non-indigenous forms of writing on the body should come as no surprise. Bodily marks were a key element in establishing – or maintaining – individuality in an era of partial literacy and slippery identity.[1] One newspaper report claimed, 'Tattooing is carried on in these islands to an absurd extent,' and mentioned Sāmoan mothers tattooing the name and date of birth of their child on their hand or arm;[2] or a father tattooing his child's date of birth directly on the child.[3] The taking of heads during the civil wars of nineteenth-century Sāmoa may have necessitated the tattooing of personal names on warriors' arms to allow for the identification of headless bodies on the battlefield.[4] Scottish writer Robert Louis Stevenson, a longtime resident of Sāmoa, mentions that people had names tattooed on their arms and that it was common to find 'subverted' letters in their inscriptions.[5] This practice can also be seen in text written on siapo (decorated barkcloth) and in lettering cut into the plates of Sāmoan tattooing tools.

In the 1890s the Sāmoan government used various means 'to prevent men deserting from the army'. According to Sir Thomas Berry Cusack-Smith, the British consul in Sāmoa, 'an army regulation was adopted providing that anyone who deserts shall upon capture have the word "Coward" tattooed upon his chest, a stigma the fellow must carry to his grave. Tattooing a man thus when he changes his politics, after the manner of Sāmoans, is not likely to make the cause of the government popular.'[6] Historian Charlotte Macdonald notes that soldiers serving with the British Army in the nineteenth century were tattooed in this way if they deserted their units and were recaptured: those convicted of desertion were branded on the left chest with a 'D'.[7]

A series of advertisements in the *Sāmoa Times and South Sea Advertiser* in 1896 offered 'Tattooing in the latest designs Japanese etc., executed on the Premises.'[8] This appearance of what was possibly the first commercial tattooing business in Sāmoa was probably in response to a growing European and American interest in Japanese tattooing at the time. According to David Cox, in 1881 the future King George V was tattooed at the age of sixteen by an artist in Yokohama, Japan. This served as a royal seal of approval of an increasingly popular trend in Europe and America: if you were wealthy, a businessman or an aristocrat and you visited Japan, 'the done thing was to come back with a tattoo'.[9]

8.
Advertisements, *Sāmoa Times and South Sea Advertiser* 9, Issue 4 (24 October 1896), http:// paperspast.natlib. govt.nz/newspapers/ STSSA18961024.2.15.3.

9.
Matt Lodder, quoted in David Cox, 'The Name for Britain Comes from Our Ancient Love of Tattoos', BBC, 2016, http:// www.bbc.com/future/ story/20161110-the-name- for-britain-comes-from-our- ancient-love-of-tattoos. See also N Koyama, 'Japanese Tattooists and the British Royal Family During the Meiji Period', *in Britain and Japan: Biographical Portraits, Vol. VI* (Leiden, The Netherlands: Brill, 2007), 95–104.

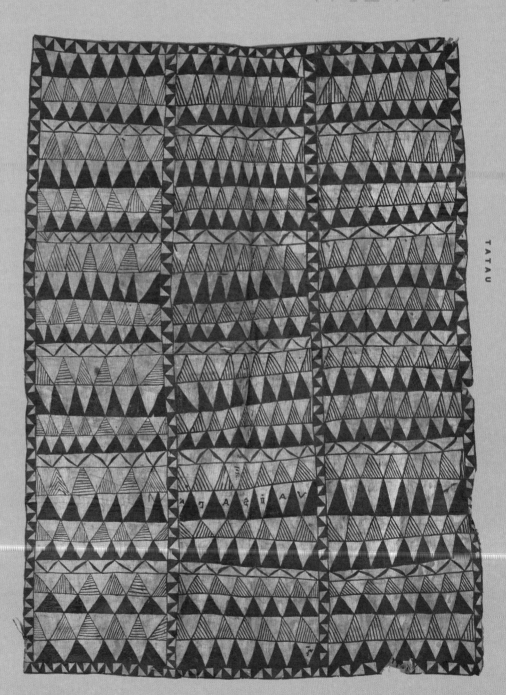

TATAU

Fig. 19
Siapo mamanu (hand-decorated barkcloth), 1896. People with names tattooed on their arms commonly 'subverted' letters in their inscriptions. This practice can be also seen in text written on this siapo.

Songs and tatau

Sébastien Galliot

Tupu le tāne tā le tatau; tupu fafine fanafānau.
A man grows up and is tattooed; women grow up and bear children.

1.
John Fraser, 'Some folk-songs and myths from Samoa', *The Journal of the Polynesian Society* no. V (1896): 171-183; Felix von Luschan, *Beitrag zur Kenntnis des Tätowierung in Samoa* (Verhandlungen der Berliner Gesellschaft für Anthropologie, Ethnologie und Urgeschichte, 1896), 552. B Friedlander, 'Notizen über Samoa'. *Zeitschrift für Ethnologie*, no. 31 (1899): 1–55.

2.
Richard M Moyle, *Traditional Samoan Music.* (Auckland: Auckland University Press, 1988), 147.

Before the twentieth century, tattooing in Sāmoa was described as a public collective male initiation ritual. To counteract the trauma inflicted by the tufuga tā tatau, young women and the family of the patient provided a soothing presence as part of the 'autāpua'i, the group of people who were not participating but who encouraged the work through silent prayers and song.

Although there are not many accounts of the medicinal or magical incantations performed by the tattooist, a number of ethnographic sources give a deeper understanding of the role played by non-material components such as the intervention of supernatural beings and psychological aspects of the ritual – and tattooing songs. In a ritual whose effectiveness was highly dependent on the tattooist's technical skills and during which no secrets were revealed to those being initiated, oratory was of little relevance. The occasional songs formerly sung within and outside the ritual context are nowadays often replaced by Sāmoan pop or reggae music played through loudspeakers, or by singing a very popular and quite recent tattooing song that retraces the main events of the story of Taemā and Tilafaigā and recalls the names of some pe'a designs. Fraser (1896), Luschan (1896) and Friedlander (1899) have published some ancient tattooing songs that, on examination, appear to be versions of the same song.[1]

The Fraser version, collected and translated by G Pratt in the mid nineteenth century, is in effect a song to summon Tufou and Filelei (the two Fijian mythical beings who passed on the craft to the twin deities), whereas the Luschan and the Friedlander versions are more clearly addressed to the patient and aimed at calming him and helping him endure the pain.

In addition to these early sources, ethnomusicologist Richard Moyle collected five other verses in Sāmoa between the 1960s and the 1980s. One has already been published[2] and four others are reproduced here. They bring a deeper understanding of the social uses of tattooing – especially its link to men's tasks, and to marriage, and its metaphorical value as a sign of an accomplished education, and an ordeal that publicly validates a person's courage, endurance and dignity.

1. The following verses (translated by Moyle) were recorded in 1966 at Faifai in Olosega, American Sāmoa.

 Na ou sau mai Manu'a 'o lo'u fia tā
 I came from Manu'a because of my desire to be tattooed

 Fa'ato'ato 'ā nei e maua sa'u āvā
 And now I've just got myself a wife

2. This pese tatau (also translated by Moyle) was recorded during a tattooing session in Fitiuta, Manu'a in 1966. The helpers repeated the refrain after each line sung by the tufuga tā tatau.

 Pepē tau 'ea ma ni ā?
 What will the outcome be?

 'O lo 'outou mālō 'ua fa'apūloulou solo
 Your authority is all-embracing

 Se 'ulu e tuigatā e tu'u atu lea 'iā tua
 If a breadfruit is hard to mash (for making into taufolo), give it to the young men's association

 'O le 'ulu maugatua, malua 'o puapuagā
 If the breadfruit is hard to grip, suffering will soften it

 E to'ulu le sausau na su'e le vai'au
 The mallet falls, and medicine is sought

3. The following song (translated by Sébastien Galliot) is a tagi o le fāgogo (the sung part of a fable). It can be understood as a form of abasement of a non-tattooed man.

 Tila, Tila e
 Tila Tila

 Matafela e
 Crossed eye

 Lē tāina sau pe'a e
 You're not tattooed

4. According to Moyle, these last verses could have been sung during pōula – the night dances that horrified the missionaries because of their sexual connotations and the overturning of socially acceptable behaviour.

Tama'ita'i e
Tila Tila

Ioe
Yes

Fa'asavili le pe'a 'o laofie
Expose your tattoo to the breeze, it's not raining

Fig. 20
A Sāmoan night dance (probably a pōula) involving tattooed men and observed during the United States Exploring Expedition between 1839 and 1841. Drawn by Alfred Thomas Agate.

TATAU

SAMOAN DANCE.

Fig. 21
Design of a female
punialo (pubic tattoo)
as documented by Carl
Marquardt (1899).

TATAU

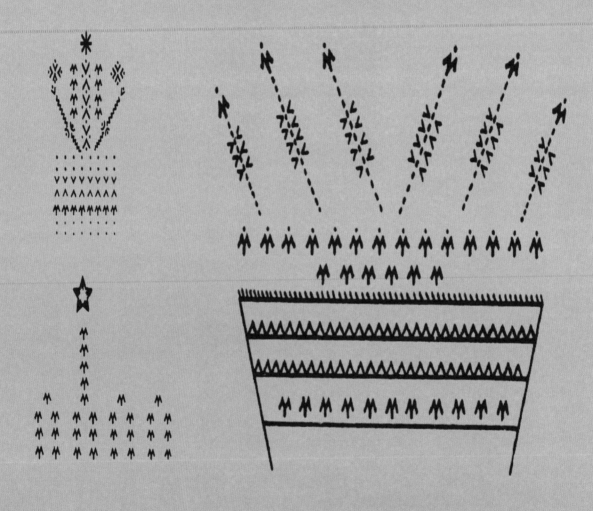

Malu: Rendered iconography

Sébastien Galliot

Malu was recorded by French naval officer Gabriel Lafond de Lurcy and missionary John Williams in the early 1830s, but the first detailed descriptions came from German ethnographers such as von Luschan, Marquardt and Krämer, along with sketches that clearly showed the positioning of the tattooed designs on a woman's body and its gendered iconography.

We know from Carl Marquardt's study that women not only had specific marks (fetu, alu alu, aveau, malu) but were also tattooed on the pubic area, a practice that has now been abandoned and ignored to such an extent that anthropologist Alfred Gell made it a central point in his analysis of the social significance of tattooing in pre-Christian Sāmoa.[1]

Gell argues: 'The malu in the popliteal space is a [displaced] vulva, but one lacking any orifice, permanently impenetrable. As a symbolic device, the malu is a perfect emblem of Sāmoan sexual mores, at once signalling the potential eroticism of the tāupou, yet placing it permanently beyond reach.'[2] In other words, the non-tattooing of the genital area was offset by the malu mark at the back of the knees, which was partly designed to indicate the state of the hidden genitals.

Gell might have missed the ethnographic fact that the malu is made to be displayed at public gatherings such as kava ceremonies, funerals and dance performances. Malu tattooing was often less ritualised than male tattooing, but it was nonetheless a rite of puberty. Girls were tattooed at a younger age than boys, long before marriage and procreation, and afterwards were expected to perform various ceremonial tasks. Obtaining a malu is usually immediately followed by the recipient taking part in the ceremonial life of their group – familial, communal but also religious. The malu can also be understood as an act of beautification, and as a public validation of the temporary but sacred value accorded to the virginity of unmarried daughters and sisters.

Women in the twenty-first century may choose to obtain the malu later in life and for more personal reasons such as achievement in a professional career or a validation of their commitment to Sāmoan culture.

1.
A Gell, *Wrapping in Images: Tattooing in Polynesia* (Oxford: Clarendon Press, 1993).

2.
Ibid., 85.

TATAU

The disastrous fate of the Sāmoans from Leone 1889–91

Sébastien Galliot

1.
Roslyn Poignant, *Professional Savages: Captive Lives and Western Spectacle* (Yale University Press, 2004.), 198–201.

2.
Ibid., 199.

Between 1885 and the outbreak of the First World War in 1914, several Sāmoan dance groups were recruited to tour Europe and the United States. While those recruited after 1895 have been documented in detail, the very first one, formed in 1889, is less well known and far more tragic.

In 1889, despite opposition from Mata'afa and the ruling chiefs of 'Upolu, Robert Cunningham, an independent impresario, hired a group of nine men (Letungaifo, Atafu or Atofau, Lealofi, Leasusu, Manogi, Tasita, Foi, Mua and Tu) from the village of Leone on Tutuila. According to Roslyn Poignant,[1] their contract extended over a period of three years for a salary of $12.50 per month; Cunningham paid for their transport, accommodation and costumes.

The show was promoted as a display of warrior male dances and a demonstration of spear throwing. The group's itinerary and performance schedules were made public through local press releases. However, the chronology of shows and events in Brussels and Germany – where the troupe's hard times really began – has proven difficult to reconstruct, partly because of an absence of records in the Brussels city archives and limited access to sources in Germany.

The troupe left Tutuila on board the SS *Alameda*, accompanied by Cunningham, Cottrel and Hahn (a Swiss beachcomber who apparently lived in Sāmoa for seventeen years and who acted as an interpreter). On a stopover in Honolulu they were presented to the King of Hawai'i before their display at the MacInerny Hall on 1–3 July. On 9 July they boarded the USS *Umatilla* bound for San Francisco, where a Sāmoan woman named Silauli'i and her supposed son joined them. They held a number of performances at the Orpheum during the last week in July. There is no further mention of Hahn after this point.

Up until the last week of October 1889 they performed in several American cities: in Chicago on 20 August; Minneapolis at the Dime Museum for a week from 16 September; and in St Paul at the Kohl, Middleton & Co. theatre for the following week.

Silauli'i and Cottrel left the troupe in Minneapolis. During their brief stay in New York, Cunningham refused to let the impresario PT Barnum hire the troupe, even though he was offering $250 for a week. However, before their departure for Hamburg on the SS *Hammonia* they improvised a performance at the Broadway office of Edwin H Low, and the agency paid their passage to Europe.

The troupe arrived in Hamburg around 5 November 1889. They expected to be in Berlin by the end of December, but there is no record of them until February 1890 in Brussels, in a season that lasted until 22 March. Every day from 11 am to 10 pm they could be viewed at the Musée Maurice Castan, for an entrance fee of one Belgian franc; the programme mentions 'fantastic songs and dances'. Newspaper reports add that the performers spent their days playing pool between shows.

The troupe is mentioned again in the third week of March, when members were accused of attempted theft from a local jeweller; they were taken to the police station on 18 March and released the next day. Soon after this incident members of the troupe were admitted to St Jean Hospital with measles, and on 25 March Atofau died, leaving behind a wife and two young children. Soon after Dr Houzé, who had been in charge of the men in hospital, arranged for Atofau's tattooed skin to be preserved. In 1894 the preserved skin was presented to the Brussels Anthropological Society and entered the collection of the Museum of Medicine. (It was exhibited in 2004–05 as part of the *Tatu-Tattoo!* exhibition in Brussels at the Musées Royaux d'Art et d'Histoire.) In Köln Tu also died. In Berlin the troupe held several performances at Castan's Panopticum and, as on their Brussels sojourn, they were presented to the Berlin Anthropological Society, where they were studied by Rudolf Virchow.

Fig. 22
Newspaper advertisement for the performance of the Sāmoan troupe in Pittsburgh, 1891 (*Pittsburgh Dispatch*, 15 February 1891, 14).

In July 1890 Leasusu and Lealofi deserted the troupe and were taken in by Frau Hauke, the wife of a rich Berliner,[2] who later paid their return passage to Sāmoa on the SS *Lubeck*; they arrived back on 18 October 1890.

Cunningham, who was in financial difficulty, took legal action against Frau Hauke and demanded 100,000 marks in reparation for the loss of the performers. Obliged to stay in Germany, he entrusted the supervision of the last part of the tour in America to Mr Marshall, a circus manager. The rest of the troupe gave performances in Mexico in July 1890 and in Alexandria, Louisiana, in November. From December until February 1891 they performed in New York City at Koster and Bial's, the Globe Museum and the Worth Museum. They spent a week in Pittsburgh at the Harry Davis Museum and Theatre, and were also scheduled to appear in Salt Lake City in May 1891 at the Wonderland and the Bijou Theatorium.

The difficult travelling conditions and hard winters caused two other deaths among the members of the troupe. Letungaifo died from tuberculosis at Denver Hospital. His fate was similar to Atofau's: his body was embalmed and exhibited in a wooden box to promote the skills of the local undertaker, provoking the contempt of newspapers, which published a series of articles critical of the poor living conditions of the troupe. A Mr Jones, a journalist with the *New York World*, was appointed by the newspaper and the state to escort the remaining Sāmoans home. On 14 July 1891, Manogi, Tasita, Foi and Mua left New York on the Pennsylvania Railroad for Chicago. Three days later Manogi died on the train near Cheyenne, Wyoming, and he was eventually buried in Rawlins. On 23 July the others finally left San Francisco for Sāmoa.

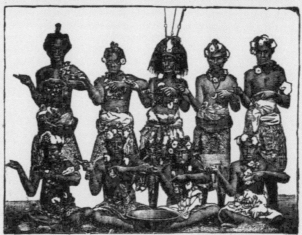

FIFTH AVENUE MUSEUM AND THEATER.

Commencing Monday, February 16,
POSITIVELY BUT ONE WEEK OF THE FIRST AND ONLY TROUPE OF

SAMOAN WARRIORS

That Ever Visited the United States !

A portion of the same band of noble savages that formed a living chain and rescued German and American seamen during the frightful hurricane in Apian harbor March 16, 17 and 18, 1889. The war ships were lost, but these brave Samoans saved many lives.

They are accompanied by Chief Atafau, who commanded the band of rescuers during that terrible storm.

See Their Great Si-Va or War Dance !
See Their Strange Stick Dance !
Watch the Throwing of the Spears !

TATAU

Tataued non-Sāmoans 1800–1900

Sean Mallon

TATAU

1.
William Thomas Pritchard, *Polynesian Reminiscences: Or, Life in the South Pacific Islands* (London: Chapman and Hall, 1866), 202–03.

2.
'Death of Mr Peter Rasmussen', *Sāmoanische Zeitung* 17, issue 42 (20 October 1917).

3.
'Flash Harry of Savai'i, *New Zealand Herald* vol. XXXIX, issue 12152 (24 December 1902): Supplement.

4.
EJ Wakefield, *Adventure in New Zealand from 1839 to 1844 With Some Account of the Beginning of the British Colonisation of the Islands* (Wellington: Whitcombe & Tombs, 1908), 322.

5.
AW Murray, *Forty Years' Mission Work in Polynesia and New Guinea: From 1835 to 1875* (J Nisbet & Co, 1876).

Historically Sāmoan tufuga tattooed Tongans, and there are records of tufuga tā tatau tattooing Europeans from the earliest encounters. But more recently the tattooing of non-Sāmoans has become a matter of controversy among leaders in Sāmoan communities.

Over time there have been many reasons why non-Sāmoans have acquired a tatau. For some it was a symbol of their relationship to Sāmoans and their incorporation into Sāmoan society. In 1832 John Williams encountered an English sailor named Jerry who was memorable not only for his accounts of his efforts to convert Sāmoans to Christianity but also for his tattooed belly and navel. 'Old Tom Franklin' lived among the Sāmoans for at least twenty years in the mid 1800s and had received the tatau: 'He had been a hero in their old fights, and, a strong, active young fellow, with a fine curly head of hair, he had been rewarded by the chiefly title and rank of Vavasa, and a bevy of wives.'[1] Danish-born Peter Rasmussen was shipwrecked in Sāmoa in 1860; his obituary recalls:

> On one occasion, he submitted to the torture of being tatooed from head to foot. This not only saved his life, but as it was a chief's tatoo, it gave him rank and chieftainship amongst the islanders. Being very tall, muscular, and well built, when stripped he presented a most imposing and quaint appearance. In 1888 while on a holiday visit to San Francisco, he went into a swimming bath. No sooner had he stripped to enter the water than he was surrounded by the bathers, one of whom offered him $50 per week, and all travelling expenses paid, if he would allow himself to be exhibited.[2]

'Flash Harry', a deserter from a British warship, was 'tattooed in every respect like a Sāmoan'. Aged about thirty, clean-shaven with light red hair, Harry was the 'pet protégé of one of the most powerful chiefs in Savai'i'. He roamed Savai'i with an armed group of young Sāmoan men and allegedly 'committed four atrocious murders', but managed to avoid all attempts by the military authorities to capture him. He later left Sāmoa, but was beheaded at Numa Numa on Bougainville Island after the captain of the ship had kicked him ashore.[3]

For others tatau was a souvenir of their travel and adventures. Some individuals were tataued passing through Sāmoa, or while living there for a short time. Explorer, writer and colonist Edward Jerningham Wakefield recalled travelling through New Zealand in the early 1840s and meeting two characters who had escaped from a local jail: 'One of them, an American named McLeod, had assumed the name of Mickey Knight … He spoke the native language very well, had with him a native wife from Thames, and had been tatued from the knees to the hips at the Navigator Islands [Sāmoa].'[4]

Murray, a missionary in Sāmoa, reported that in 1844 Captain Bell, commander of visiting British man-o'-war the *Hazard*, 'wished to take home in his own person a specimen of Sāmoan tattooing'. The locals at Pago Pago were initially not keen to tattoo Bell, so Murray acted as a negotiator; he explained that 'what Captain Bell wished them to do for him was a very different thing to tatooing as they had been accustomed to practise it in their heathen state'. However, he also makes clear in his account that he took care to guard against the Sāmoans regarding the incident as giving 'a sanction to heathen tatooing'.[5]

MARK ADAMS

Mark Adams has documented the work of the 'āiga sā Su'a for over forty years. In the following extract, written in 1997, anthropologist Nicholas Thomas considers the significance of Adams' work at a point when Sāmoan tattooing was at its most visible internationally.

1.
Nicholas Thomas, 'Marked men
Art Asia Pacific 13 (1997), 66-73.

Mark Adams's tattooing photographs are somewhat exceptional within his corpus. Though he has long been concerned with questions of cultural history and cultural difference, most of his work that I know addresses sites rather than practices or traces and monuments rather than people. Consistently, however, his photography is striking for its absolute attention to context. Not the isolated artefact, body or motif, but the localised object, the person in the room, the mark on the leg, the limbs intertwined over a bloodstained cushion and a pandanus mat.

It is always evident that the site is not Sāmoa but Auckland. His images' titles are the addresses of the houses in which the tattooing took place, or the addresses and dates, or the names of the people present. This reverses the long tradition of ethnographic romanticism typified by Robert Flaherty's 1920s film *Moana*, where Sāmoan tattooing and life is generally reinvented, purified, and out of time. In Adams' work, tattooing proceeds in Polynesian living rooms, amidst televisions and wooden kava bowls, framed family photos bearing shell necklaces, cheap furniture and floral fabrics. Cultural continuity is manifest, despite migration and modernity.

If the images of disembodied tattoos epitomise colonial ethnology's propensity to dissect, Adams' work amounts to a far more positive exercise in cross-cultural imaging. He is not an anthropologist, but the ethics of these photographs are those of the most honest anthropology. They are the upshot not of a casual visit but sustained engagement. Their production was not Mark's project alone, but the outcome of collaboration and negotiation. There is no attempt to claim a false identification with a 'native point of view', but rather a sympathetic effort to foreground and convey an indigenous aesthetic ... They are extraordinary photographs, to my mind, for at once possessing an absolute grasp of light and detail, while oddly resembling snapshots of people posing in intimate domestic circumstances.

— Nicholas Thomas

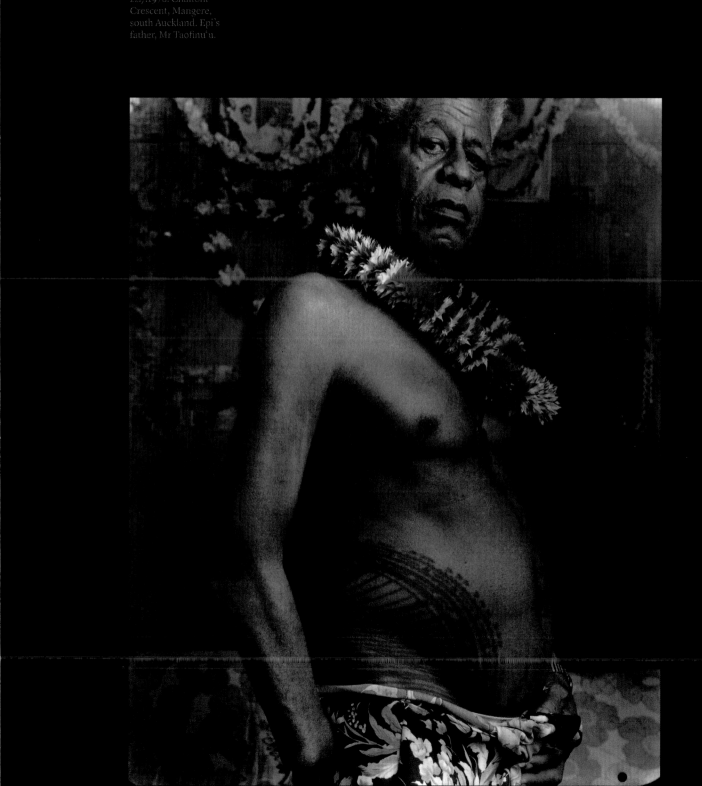

Fig. 23
22.7.1978. Chalfont
Crescent, Mangere,
south Auckland. Epi's
father, Mr Taofinu'u.

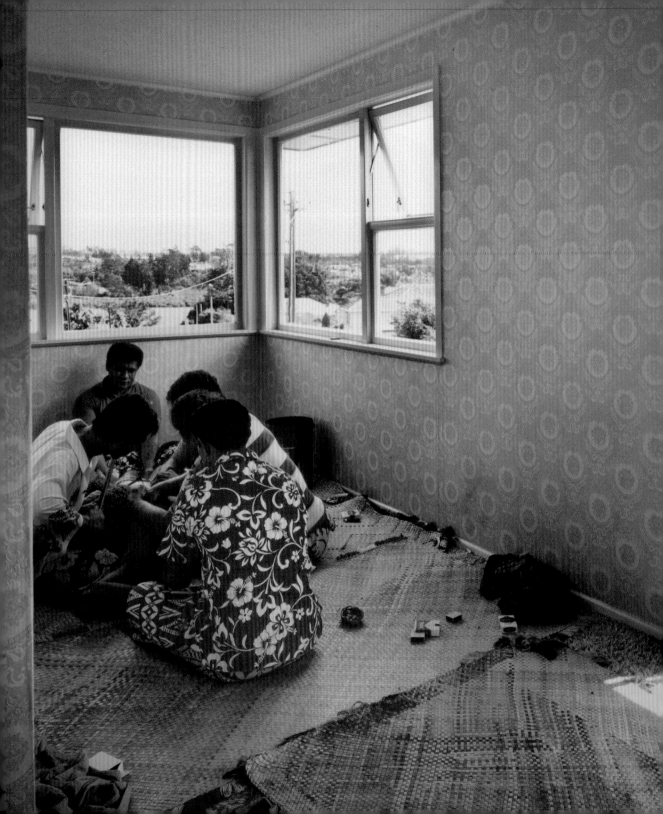

Fig. 24
27.2.1982. Te Atatu South,
west Auckland. Tattooing
Seoseo Tuigamala.
Tufuga tātatau: Su'a Tavui
Pasina Iosefo Ah Ken.

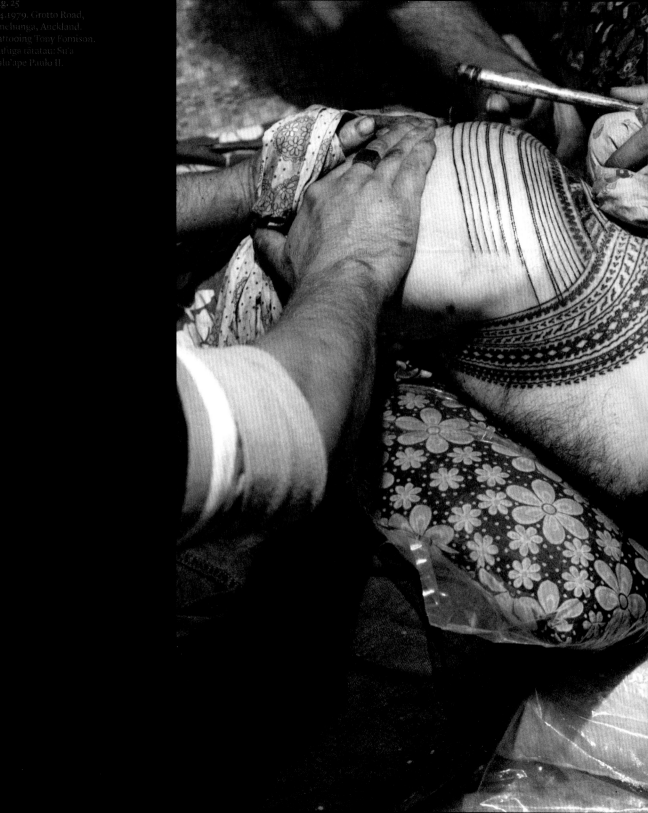

Fig. 25
3.4.1979. Grotto Road,
Onehunga, Auckland.
Tattooing Tony Fomison.
Tufuga tātatau: Su'a
Sulu'ape Paulo II.

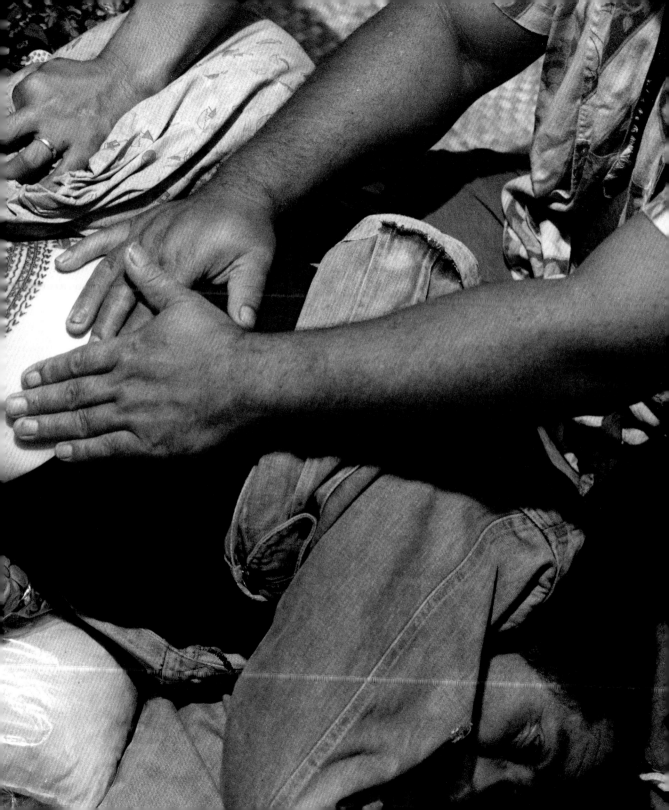

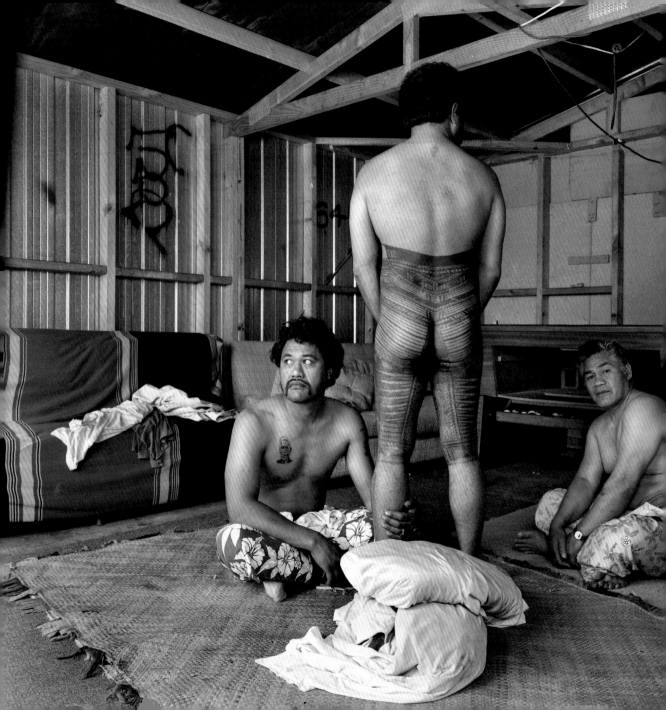

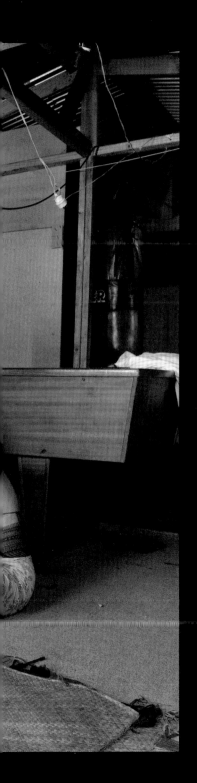

Fig. 26
19.11.1991. Velvet
Crescent, Otara, south
Auckland. Fatu Feu'u.
Tufuga tātatau: Su'a
Sulu'ape Paulo II.

Fig. 27
13.2.1982. Farringdon
Street, Glen Innes,
Auckland. Faiga Mamea.
Tufuga tatatau: Su'a
Sulu'ape Petelo.

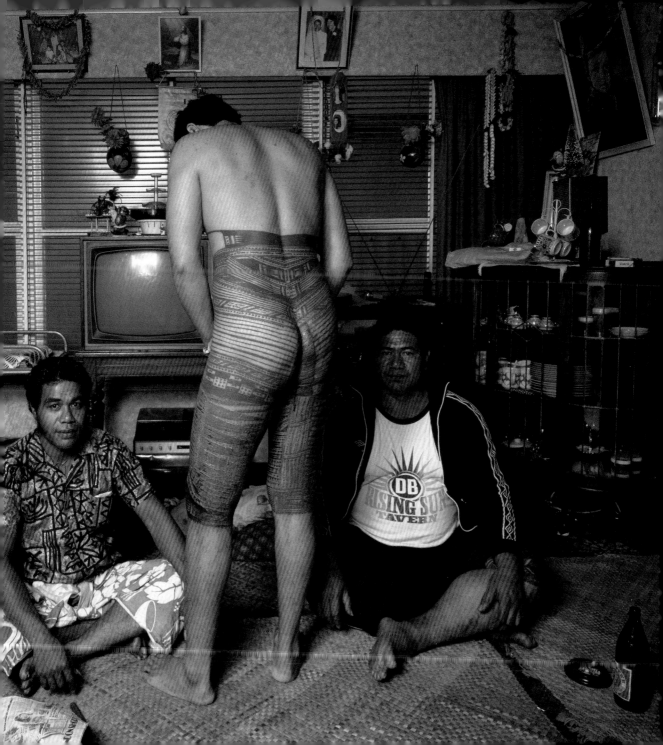

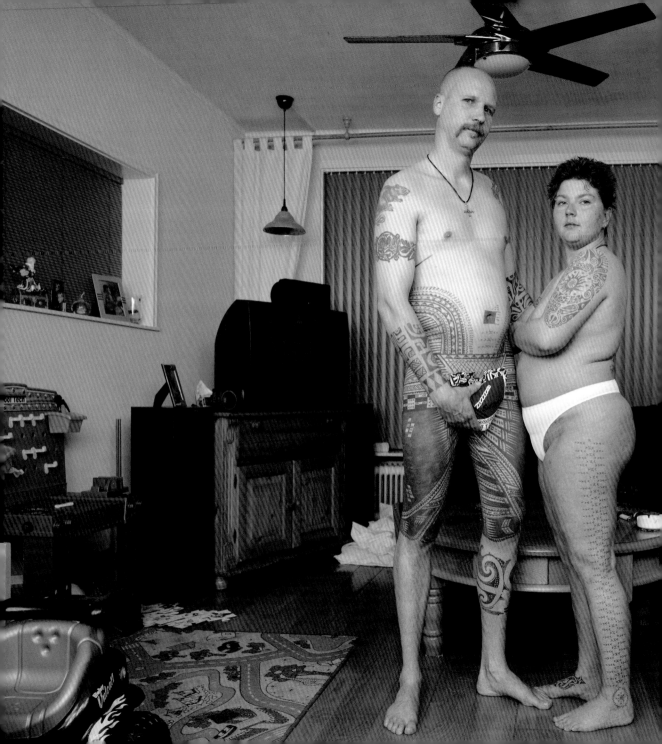

Fig. 28
21.5.2002. Vaalkenswaard,
Eindhoven, Netherlands.
Rene and Carina Persoons.
Tufuga tātatau: Suʻa
Suluʻape Paulo II and
Suluʻape Michel Thieme.

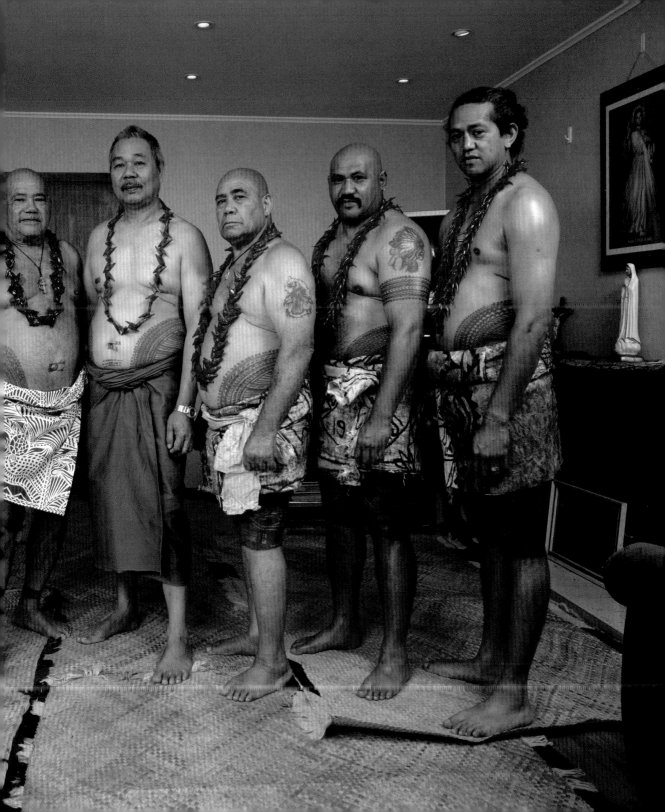

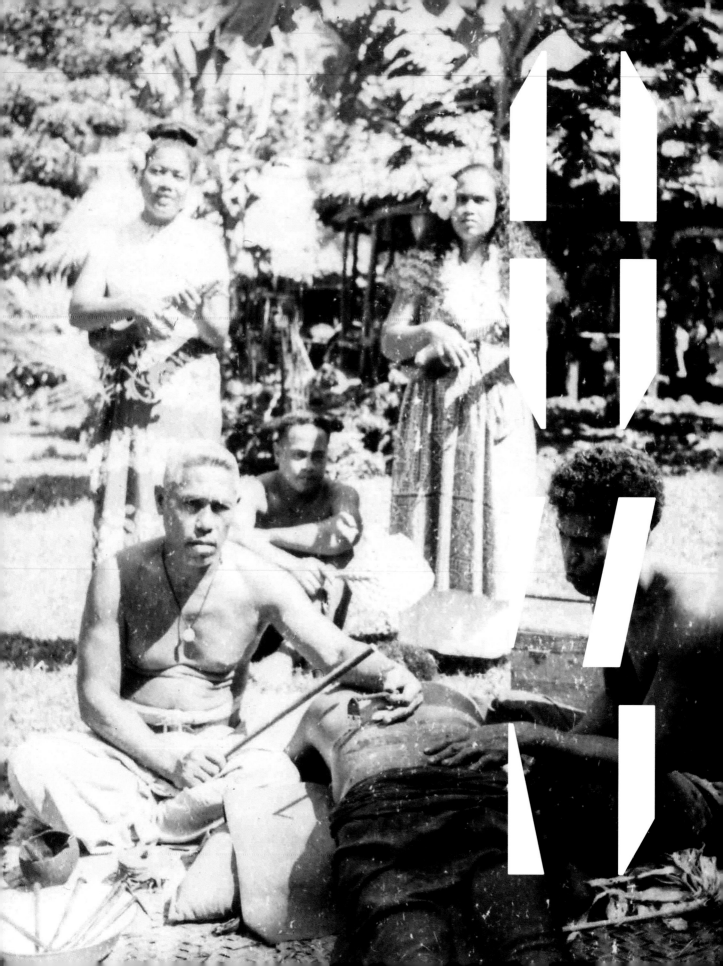

TATAU: PERSISTENCE AND CHANGE

1900—2000

Fig. 30
Tattooing scene photo-
graphed c. 1960s by Jutta
Merensky (later Gethen).

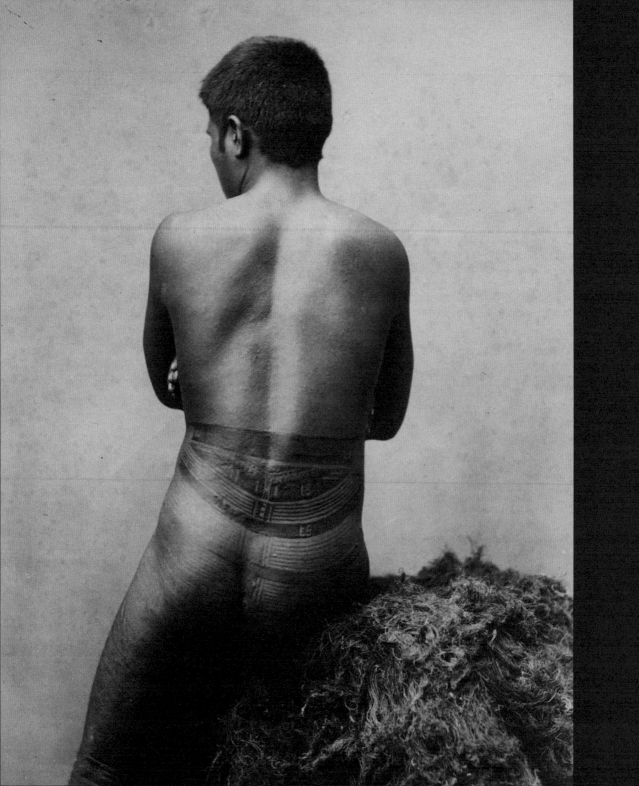

In the twentieth century, Sāmoans and non-Sāmoans, Pacific Islanders and non-Pacific Islanders made and remade tatau. As in previous centuries, tatau was a highly conspicuous element of Sāmoan culture. It attracted the attention of a range of observers and commentators who left a rich body of ethnographic texts, photographs and films that help us trace Sāmoan tattooing and its many stories and journeys.[1] When we bring all these sources together and analyse them, we are presented with a complex history of tatau as a dynamic and changing practice shaped by people and events within the Sāmoan archipelago and well beyond it.

Through the colonial enterprises of Germany and New Zealand in Sāmoa, and then the Second World War, tatau persists as a constantly present but changing aspect of Sāmoan visual culture and society. After the Second World War, processes of decolonisation led to Sāmoa's political independence from New Zealand in 1962, and a renewed interest in tatau as a process of culture and a symbol of the nation. By the late twentieth century Sāmoans were emigrating and settling in urban centres overseas, forming a major diaspora – and taking tatau with them.

◄ • ►

By 1899 the people of Sāmoa had experienced several decades of unrest and conflict as rival local political factions sought power. As well as fighting each other, Sāmoans found themselves in the middle of a struggle between the imperial powers of the United States, Germany and Great Britain, who were vying for control of the archipelago. At a critical point in this period of tension the more powerful nations reached an agreement and Sāmoa was annexed: Savai'i and 'Upolu (Western Sāmoa) went to the Germans and Tutuila and Manu'a (Eastern Sāmoa) went to the United States; Great Britain gave up its claim. Germany's interest in Sāmoa centred on the economic opportunities of the coconut plantations and in particular the development of the Germany-based company Deutsche Handels- und Plantagengesellschaft, which had operations elsewhere in the Pacific. For the United States, Tutuila provided a strategic location for a naval base and harbour at Pago Pago.

Fig. 31
Tattooed Sāmoan c. 1900, photograph by Thomas Andrew.

1.
JB Stair, *Old Sāmoa; or Flotsam and Jetsam from the Pacific Ocean* (London: Religious Tract Society, 1897); Felix von Luschan, *Beitrag zur Kenntnis des Tätowierung in Samoa* (Verhandlungen der Berliner Gesellschaft für Anthropologie, Ethnologie und Urgeschichte, 1896); ES Craighill Handy and Willowdean Chatterson Handy, *Samoan Housebuilding, Cooking, and Tattooing* (Honolulu: Bernice P Bishop Museum Bulletin 15, 1924); Te Rangi Hīroa (Peter Buck), *Samoan Material Culture* (Honolulu: Bernice P Bishop Museum Bulletin 75, 1930); Noel L McGrevy, 'O Le Tatatau, Traditional Samoan Tattooing', unpublished manuscript (Auckland: Culture Consultants Ltd, 1989); Sean Mallon, Peter Brunt and Nicholas Thomas (eds), *Tatau: Samoan Tattoo, New Zealand Art, Global Culture* (Wellington: Te Papa Press, 2010); Sébastien Galliot, 'Ritual Efficacy in the Making', *Journal of Material Culture* vol. 20, no. 2 (2015): 101–25.

TATAU

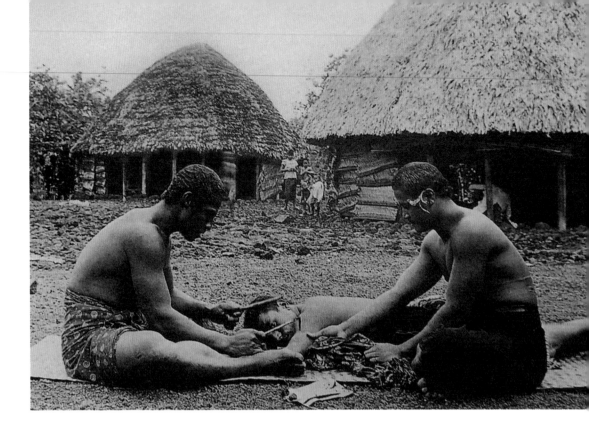

Fig. 32
An unusual photograph
(c. 1900) depicting the
tattooing of a man's
arm rather than the
legs or abdomen.

Germans had settled in Sāmoa in the last decades of the late nineteenth century. They established large estates with extensive coconut and cocoa plantations. After Sāmoa's annexation, a new colonial government and bureaucracy were set in place that expanded German business interests and influenced the local culture and society. Like their earlier counterparts, German officials became part of Sāmoan social and cultural life and subject to its various relationships and obligations. Some married Sāmoans and became involved in the politics of the community. They were active participants in the interactions between matai, families and villages. They learned the language and studied the history of the archipelago and its people.

A few went to the extent of receiving a tatau as a visible mark of their engagement with Sāmoan society and culture – including at least three officials: the second governor of Sāmoa, Dr Erich Schultz; his customs official, Rudolph Berking; and Wilhelm Osbahr, the district administrator for south 'Upolu in 1914. According to Sāmoan historian Tony Brunt, who interviewed descendants of these men, Schultz became fluent in Sāmoan and wrote books on Sāmoan customary law and proverbs, and Berking was 'a generous and public spirited man who commanded broad community respect'.[2] Osbahr had a pe'amutu – an unfinished tatau that covered only one leg – and while it was frowned upon to have an unfinished tatau the locals of Poutasi still held him in high esteem.[3]

As prominent officials, wearing the tatau was not only a very public expression of their commitment to Sāmoan culture, it was also an indication of their acceptance by Sāmoans. It may have reflected their curiosity and admiration for the artform. However, as historian Georg Steinmetz notes, some German officials would strategically appropriate indigenous cultural symbols in order to build connections and advance political relationships and interests among the Sāmoan community – for example, the first German governor, Wilhelm Heinrich Solf, would have been an impressive sight in his white military

2.
Berking was tattooed in the village of Luatuanu'u, not far from his plantation at Letogo. Tony Brunt, 'To Walk Under Palm Trees: The Germans in Samoa: Snapshots from Albums', http://germansinSamoa.net/page-11/.

3.
Ibid., 71.

uniform and hat, but even more so with the regalia of the Sāmoan tulāfale (orator chief). Indeed, he was known for using the fue (flywhisk) and toʻotoʻo (orator's staff) when addressing groups of Sāmoans on formal occasions.[4] His use of Sāmoan language and expressions was an effective tool of persuasion and a means of building rapport and connection.

Similarly, his officials wore the tatau, enhancing their social status among Sāmoans. A non-Sāmoan undertaking the painful process of tattooing and committing to a permanent marking of the body would attract curiosity among Sāmoans – with some admirers and possibly a few critics. Despite this, the colonial encounter was never straightforward: while German officials were wearing tatau and other artefacts of the Sāmoan cultural elite, they were at the same time bedecking their indigenous Sāmoan staff in 'special badges and buttons, cockades, flags, portraits of the Kaiser and other accoutrements signifying that they served at the pleasure of the Germans'.[5]

Not all Sāmoans were comfortable with the German colonial presence and its increasing influence in Sāmoan society. Steinmetz argues that German colonisers were 'straightforwardly repressive' in Sāmoan internal politics. They were interested in preserving aspects of Sāmoan indigenous culture but also in controlling it.[6] For example, they put regulations in place to manage cultural practices such as the matai title system, the distribution of ʻie tōga and the game of kilikiti – a Sāmoan version of cricket. With regard to the matai title system, the German administration established a Lands and Titles Commission to make rulings in disputes between Sāmoans about their lands and matai titles – an area of Sāmoan cultural life that was usually the preserve of the leaders of districts or villages and the heads of families.[7] This restructuring of indigenous Sāmoan government had longterm effects on society: it altered indigenous processes of decisionmaking and shifted the balance of power in favour of the colonisers.

The administration also attempted to control the distribution of ʻie tōga, highly culturally valuable fine mats presented – often in the hundreds – at ceremonies such as weddings, funerals and matai title bestowals. ʻIe tōga were also part of clients' payments to master housebuilders and tattooists on completion of their work. According to Malama Meleisea, Solf considered the ceremonial exchanges of ʻie tōga and the associated gatherings and feasting a 'wasteful extravagance',[8] but he underestimated the importance of ʻie tōga in Sāmoan society and how they symbolised relationships and Sāmoan ideas of prestige, status, dignity and respect. As Meleisea argues, 'Just as the Sāmoan economic system was symbolically maintained by the distribution of ʻie tōga, European opposition to "fine mat" distribution symbolised their desire to control the Sāmoan economy.'[9]

German concerns about the economy also motivated their attempts to control the number of kilikiti matches, which often extended over many days and involved between 100 and 200 people per team; they worried about the impact of kilikiti on productivity, distracting Sāmoan workers from plantation work and other economically valuable tasks. Their solution was to restrict kilikiti games to Wednesday and Saturday afternoons.[10]

4.
Georg Steinmetz, *The Devil's Handwriting: Precoloniality and the German Colonial State in Qingdao, Samoa, and Southwest Africa* (Chicago: University of Chicago Press, 2008), 353–54.

5.
Ibid., 333.

6.
Ibid., 331–32. For other analysis of the German influence see HJ Hiery, *The Neglected War: The German South Pacific and the Influence of World War I* (Honolulu: University of Hawaiʻi Press, c. 1995) and Malama Meleisea, *The Making of Modern Samoa* (Suva: USP, 1987).

7.
Malama Meleisea, *Lagaga: A Short History of Western Samoa* (Suva: USP, 1987), 114.

8.
Meleisea, *Making of Modern Samoa*, 51.

9.
Ibid., 52.

10.
Safua Akeli, 'Reconfiguring Cricket Culture in Colonial Samoa', in *The Lives of Colonial Objects*, edited by A Cooper, L Paterson and A Wanhalla (Dunedin: Otago University Press, 2015), 281–85.

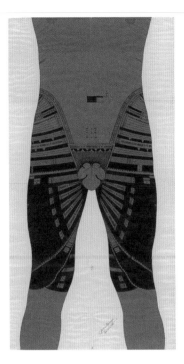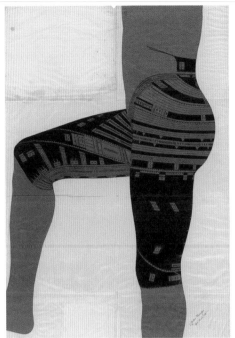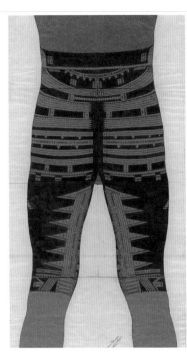

Fig. 33
Drawings of tatau
by Julius Henninger,
Apia, Sāmoa 1916.

Of these three examples of German interventions in Sāmoan customs, their attempts to control the distribution of 'ie tōga appears to be the only one connected to tattooing directly, and then only in a minor way. Europeans considered 'ie tōga a form of currency, in which the price of an 'ie tōga and a tatau could be fixed precisely.[11] The government's attempts to control the distribution of 'ie tōga may have had some bearing on how people paid for tattooing and participated in the accompanying ceremonials. The Germans did not target tattooing specifically, probably because they did not consider it a major economic activity. Nevertheless, the production of tattoos was part of the indigenous village economy and connected to customs of honouring relationships and showing respect between different groups of people. The 'ie tōga were integral to these transactions.

In 1908, growing Sāmoan discontent with the government's interference in their customs manifested itself in the establishment of an anticolonial movement called Mau o Pule (the opinion of Pule). Pule was the collective name given to a number of influential orator groups on the island of Savai'i. The Mau o Pule movement was led by Lauaki Namulau'ulu Mamoe (d. 1915), a tulāfale from Safotulafai, the political centre of the Fa'asaleleaga district on Savai'i. Historians have described him as a 'highly skilled tactician, agitator, organiser and orator'.[12] Lauaki worked tirelessly to secure a greater say for Sāmoans in how they were governed by the Germans. Eventually his resistance to the colonial authorities led to his arrest. In 1909 the administration exiled him to Saipan in the Mariana Islands along with nine other matai and their families. In his absence the influence of the Mau o Pule diminished. Lauaki never made it back to Sāmoa to revive the resistance efforts of his people: when the New Zealand colonial administration attempted to repatriate him in 1915 he died on the journey home.

Nevertheless, the idea of a resistance, a kind of nationalist movement within a colonised and increasingly multicultural Sāmoa, was deep-seated. It is surprising

11.
In an article written in 1892, Thomas Andrew mentions that for tattooing 'Payment is generally in mats from thirty to one hundred dollars being charged according to the rank of the native.' (*Auckland Star* vol. XXIII, issue 276, 19 November 1892, 12).

12.
Albert Wendt, http://nzetc.victoria.ac.nz/tm/scholarly/tei-WenGua-c4.html.

then that in this highly politicised and culturally contested milieu the tatau does not seem to have been a visible symbol of Sāmoan nationalism. Based on photographic evidence it appears that despite his position of leadership and high public profile, Lauaki was not tattooed and neither were other senior leaders of the Sāmoan political elite. Furthermore, historians of the period make no mention of tatau as a prominent symbol of Mau o Pule. This is a point we will return to later in this chapter.

Another group of people to arrive in Sāmoa in the early twentieth century were Chinese – whose contribution to Sāmoan tattooing would become obvious in later decades. Their place and influence in Sāmoa had troubled beginnings. In the late 1800s, small numbers of Chinese had settled in Sāmoa and become part of the growing multicultural community. Then from 1903, German owners of large estates specifically recruited Chinese people to work on their plantations as indentured labourers; previously, they had brought in men from the Solomon Islands, Caroline Islands and other Pacific islands to work on their properties.[13] Most of the Chinese labourers came from the southern provinces of Fujian and Guangdong, departing for Sāmoa from the ports of Swatow and Hong Kong.[14] Many of them experienced harsh working conditions and cruel treatment from their overseers. They faced racist attitudes and laws directed at them first by Sāmoans and then by the German and New Zealand colonial governments. Conditions were so intolerable that the Chinese government set up its own consulate in Sāmoa to look after the interests of its people.[15]

By 1914 and the outbreak of the First World War there were 2184 Chinese and 877 Melanesian indentured labourers in Sāmoa. Although it was officially discouraged by the government, Chinese intermarried with Sāmoans. They learned the language and acquired matai titles, and some went on to establish successful businesses, specialise in trades and influence local customs and material culture. They also made an enduring contribution to Sāmoan cuisine with the introduction of contemporary favourites such as sapasui (chop suey), keke puaʻa (pork buns) and of course laisa (rice). And they made a less visible – but intriguing – contribution to tatau. We don't know to what extent settler Chinese engaged with tattooing or what purposes it served them and their integration into Sāmoan society. What we do know is that the part-Sāmoan descendants of Chinese settlers went on to influence the production of Sāmoan tattooing from the 1970s and into the 1990s, when names like Ah Ken and Ma Ching became prominent in Sāmoan tattooing circles.

It is unclear whether other nationalities who worked on plantations were tattooed. Men and women from the Solomon Islands, Marshall Islands, Caroline Islands and Gilbert Islands (Kiribati) who came to work in Sāmoa had their own distinctive body marking and adornment practices that may have travelled with them.[16] Tui Sakila from Mussau Island in the Bismarck Archipelago recalled nose and ear piercing being practised on Sāmoa's plantations, as well as the teaching of magic spells.[17] On public holidays the labourers would wear their regional costumes and present concerts to each other and European audiences.[18] However, there is no evidence to suggest tatau

13. Malama Meleisea, *O Tama Uli: Melanesians in Western Samoa* (Suva: USP, 1980); Malama Meleisea, 'The Last Days of the Melanesian Labour Trade in Western Samoa', *The Journal of Pacific History* vol. 11, no. 2 (1976): 126–32.

14. Ben Featunaʻi Liuaʻana, 'Dragons in Little Paradise: Chinese (Mis-) Fortunes in Samoa, 1900–1950', *The Journal of Pacific History* vol. 32, no. 1 (1997): 29–48.

15. Ibid., 33.

16. Historian Clive Moore briefly discusses the cultural practices of Solomon Islanders in overseas plantations in *Making Mala: Malaita in Solomon Islands, 1870s–1930s* (Canberra: ANU Press, 2017), 133–34.

17. Tui Sakila, in Meleisea, *O Tama Uli*, 36.

18. Mala Pasi Tavita, in Meleisea, *O Tama Uli*, 29.

TATAU

19.
Meleisea, *O Tama Uli*, 48.

20.
Steinmetz, *The Devil's Handwriting*, 306.

served as a marker of incorporation for the plantation workers into the local community as it did for a few Germans and other Europeans.

The relationship between Sāmoans and Melanesians was different from that between Sāmoans and the colonisers. There were powerful moments of solidarity, but also avoidance and confrontation. Meleisea describes Sāmoan attitudes to the Melanesian labourers as ambivalent: it was 'not easy for them to fit the Melanesians into their traditional scheme of rank and status'.[19] Steinmetz argues that the influx of Solomon Islanders and other Melanesian labourers 'provoked a reaffirmation of Sāmoan distinctiveness that would sometimes seem racist and undermined the traditional Sāmoan openness to outsiders'.[20] Reserving tatau for Sāmoans may have been part of this process.

<div align="center">◄ ● ►</div>

21.
Damon Salesa, 'A Pacific Destiny: New Zealand's Overseas Empire, 1840–1945', in *Tangata o le Moana: New Zealand and the People of the Pacific*, edited by Sean Mallon, Kolokesa Māhina Tuai and Damon Salesa (Wellington: Te Papa Press, 2012), 97–121; Damon Salesa, 'New Zealand's Pacific', in *The New Oxford History of New Zealand*, edited by Giselle Byrnes (Oxford: Oxford University Press, 2009).

22.
Michael Field, *Mau: Samoa's Struggle for Freedom* (Auckland: Polynesian Press, 1991); Salesa, 'A Pacific Destiny'; Meleisea, *Lagaga*.

23.
Field, *Mau*.

24.
'Influenza in Samoa', Ministry for Culture and Heritage, updated 20 December 2012, https://nzhistory.govt.nz/culture/1918-influenza-pandemic/Samoa.

25.
'How the Epidemic Began', *Samoanische Zeitung* 18, no. 47 (December 1918).

On 30 August 1914 New Zealand troops landed in Apia and took control of German Sāmoa. Britain had requested the invasion, and New Zealand (as part of the British Empire) was quick to move: the New Zealand government had its own colonial ambitions and was looking to extend its influence in the Pacific and build a mini-empire of its own in the region.[21] The landing and occupation went unopposed by the Germans, who had been expecting it.

The New Zealand colonial administration, like the Germans before it, them had a difficult relationship with the people of Sāmoa.[22] There were a number of events that had implications for tatau as part of Sāmoan culture in general. One serious incident took place during the worldwide influenza pandemic in 1918. On 7 November the disease arrived in Sāmoa from Auckland aboard the *Talune*. Instead of quarantining the ship, the colonial authorities allowed passengers to disembark and the highly infectious disease spread quickly among the local Sāmoan population.[23] The impact was devastating: 8500 people (or 22 percent of the population) died.[24] A report from the government inspection of Vaimoso village paints a sombre picture of the devastation caused:

> Every house was closed up with mats, and inside, in the gloom within, the suffering of the inmates was pitiable to behold. Some lay writhing on the ground, some were found covered with mats, sweltering and agonizing beneath; others suffered in silence uncomplainingly. Here and there a sheet or tapa cloth covering a form recumbent and still, indicated only too well that the fell disease had finished its work: already several deaths had occurred.'[25]

A report to the New Zealand parliament noted that the influenza pandemic in Sāmoa had had an enormous effect on development and trade. What is not so easily measured is the knowledge that was lost with the death of matai, artists and other cultural

leaders; in one startling statistic, only seven of the twenty-four members of the Fono a Faipule (a council of district representatives to the colonial government) survived the pandemic.[26]

The New Zealand military occupation of Sāmoa lasted until 1921, when it was replaced with a civil administration. But the colonial relationship continued to be deeply unsettled and uncertain. As previously with the German colonial administration, some Sāmoan leaders were unhappy with the policies of the New Zealand governors – especially the new laws and regulations relating to the authority of matai and rights to matai titles.[27] The government wanted to control particular businesses and trade. From 1923 it placed restrictions on malaga (travelling parties), in part to avoid disputes among Sāmoans over the ceremonial distribution of 'ie tōga that took place at such events. Historian Damon Salesa argues that the government recognised that malaga were heavily politicised, and their ongoing importance 'troubled colonial intentions of controlling and disciplining Sāmoans and Sāmoan politics'.[28] In 1926 the rules relating to malaga were reviewed by the government, who retained the prohibition on malaga involving the presentation of 'ie tōga. They relaxed the rules a little by permitting people to use 'ie tōga for buying or selling, and as payment for work done, such as tattooing or housebuilding.[29] The prohibition against giving 'ie tōga eventually led to its substitution at feasts, weddings and funerals with large quantities of siapo (decorated barkcloth).[30]

The rise of an anticolonial movement called the Mau was a direct response to continued government interference in important Sāmoan cultural activities, and the lack of consultation and power sharing. Led by Taisi OF Nelson, EW Gurr and AG Smyth, the Mau's policy was one of peaceful non-cooperation with the New Zealand authorities. It gained widespread but not total support among Sāmoan people. This support was strengthened in 1929 when, during a peaceful march in Apia, gunfire from New Zealand troops killed nine members of the Mau including prominent leader Tupua Tamasese Lealofi III. Afterwards, New Zealand troops tried to hunt down the membership of the Mau. The men took refuge in the mountains while the Women's Mau, which grew to 8000 members, continued demonstrating and encouraging resistance among the Sāmoan population.[31] The following year the Mau was declared a seditious organisation, but a change of government in New Zealand in 1935 saw this declaration revoked.

One might imagine that tatau, again because of its associations with leadership and service, would be a powerful symbol for this new Mau organisation, but it does not appear to have been appropriated for political purposes. The uniform of the Mau – a purple lavalava with white stripes – the public marches, resistance songs and even the distinctive headquarters at Vaimoso were the symbols and activities that gave the nationalist movement visibility. In the 1920s tatau was connected to specific gendered roles and duties important in fono and the ceremonial events of village life. All members of the Mau could wear the uniform and participate in its activities, but not everyone could wear a tatau or malu; they could only

26.
'Samoan Influenza Obituaries', Ministry for Culture and Heritage, updated 20 December 2012, https://nzhistory.govt.nz/media/photo/Samoan-influenza-obituaries.

27.
Meleisea, *Lagaga*, 133.

28.
Damon Salesa, '"Travel-happy" Samoa: Colonialism, Samoan Migration and a "Brown Pacific"', *New Zealand Journal of History* vol. 37, no. 2 (2003): 171–88, at 75.

29.
Keesing, 'The Taupou System of Samoa', 327.

30.
Te Rangi Hiroa, *Samoan Material Culture* (Honolulu: Bernice P Bishop Museum, Bulletin 75, 1930), 283.

31.
For the Women's Mau see Lisa P MacQuoid, 'The Women's Mau: Female Peace Warriors in Western Samoa', Plan B Paper candidate for Master of Arts Pacific Islands Studies (University of Hawai'i at Manoa) 15 April 1995, http://scholarspace.manoa.hawaii.edu/bitstream/10125/21186/1/MacQuoid_1995.

32.
A-04 Trade Between New Zealand and Fiji, Tonga, Western Sāmoa, and Cook Islands, (Report of The Commission to Inquire into the Conditions of), Untitled, 1 January 1920, http://paperspast.natlib.govt.nz/parliamentary/AJHR1920-I.2.1.2.5.

33.
Alison Devine Nordstrom, 'Popular Photography of Samoa: Production, Dissemination and Use', in *Picturing Paradise: Colonial Photography of Sâmoa 1875 to 1925*, edited by Blanton Casey (Southeast Museum of Photography, Daytona Beach Community College, 1995), 11–41.

34.
Nordstrom, 'Popular Photography of Samoa', 31.

35.
Max Quanchi, 'The Imaging of Samoa in Illustrated Magazines and Serial Encyclopaedias in the Early 20th-Century', *The Journal of Pacific History* vol. 41, no. 2 (2006): 207–17.

36.
Nicholas Thomas, 'The Beautiful and the Damned', in *Pirating the Pacific: Images of Travel, Trade and Tourism*, edited by Ann Stephen (Haymarket: Powerhouse Publishing, 1993), 46; Nordstrom, 'Popular Photography of Sāmoa', 21–22.

37.
Carl Marquardt, *The Tattooing of Both Sexes in Samoa* (Auckland: R McMillan, 1984).

38.
It is possible that tattooing does not show up well in nineteenth-century images. However, high-resolution scans of glass plate negatives from the period show this is not the case.

Figs. 34 and 35
Contrasting images of tattooing, one involving no stretchers in a village setting (above), the other photographed on the porch of a European-style house (below).

be acquired after coming of age and through service in chiefly fono and other ceremonial contexts.

◄ • ►

Sāmoa and its people are captured in film and photography around the turn of the century, but the representation of tatau is limited and ambiguous. From the late 1800s and during the colonial administrations of Germany and New Zealand, tatau is conspicuous by its relative absence from the photographic record compared with other subjects and topics, although in 1920 New Zealand government officials reported, 'Tattooing is universally practised.'[32] During the colonial period, resident photographers John Davis, Andrew Tattersall and Thomas Andrew were creating images of Sāmoa's landscapes, people and events.[33] Some of them were made for Sāmoans, who, according to historian Alison Nordstrom, 'understood and enjoyed the novelty of photography … as clients of the photographer'.[34] Photographs made for tourist and overseas markets circulated widely as postcards or were reproduced to illustrate newspapers and magazines.[35] As artefacts they were key to making Sāmoa familiar to people in the United States and Europe, and many ended up in museums and archives.

Among the hundreds of photographs of Sāmoa in private and public collections, there are very few of tattooed people or tattooing. The few that do exist are of limited ethnographic value. For example, in the photograph (see page 107, top) of a tattooing operation the setting appears to be a village environment, the tufuga tā tatau is in mid strike – but there are no toso (skin stretchers) involved in the procedure. This crucial but missing part of the tattooing process suggests that the scene has been especially set up for the photograph. This was a common practice among photographers of the time, who often posed indigenous people dancing, playing games or acting out activities such as fishing or cannibalism. Photographers employed props and specially arranged or posed settings to construct often stereotyped views of Pacific peoples, where 'fantasies of the "exotic" and the "savage" are conspicuous'.[36] It was part of the theatre and fiction of the image-making process to excite the curiosity of magazine readers. On the other hand, in Andrew's photograph *Tattooing Samoa* we see a toso present, stretching the skin for the tattooist to commence his work.

Another characteristic of the photographic record is the absence of posed studio portraits of tattooed men and women. Andrew's *Tattooed Samoan* (see page 98) is a rare example of a studio portrait of a tattooed person that has been purposefully posed to give the best view of the tatau. A few photographs from the late 1800s feature tattooed Sāmoans at the Chicago World Fair and there are a small number of images in the ethnological literature such as those used by Marquardt.[37] Surprisingly, the tatau is even missing in studio portraits of key Sāmoan leaders in the late 1800s and the colonial period, some of whom were involved in the indigenous resistance movements Mau

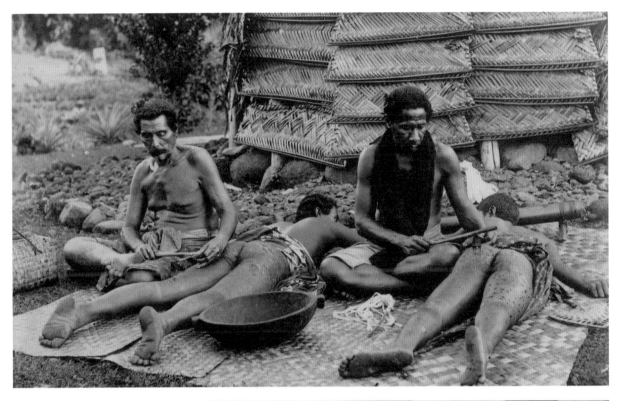

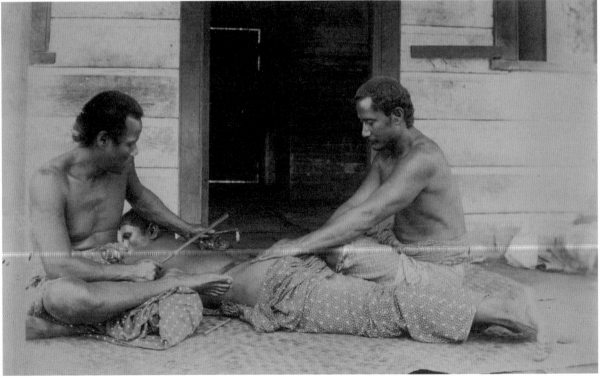

TATAU

CINÉMA-
BIBLIOTHÈQUE

JEAN PETITHUGUENIN

MOANA

Roman d'amour inspiré par le célèbre film
de ROBERT J. FLAHERTY

Prix :
3 fr. 50

NOMBREUSES et SUPERBES
ILLUSTRATIONS DU FILM

Editions JULES TALLANDIER
75, Rue Dareau. PARIS (XIVᵉ)

a Pule and the Mau.[38] Did these important leaders in Sāmoan society not go through this supposed key rite of passage as young men? The absence of tatau raises questions around who actually was tattooed in Sāmoan society in the early twentieth century – questions that are further highlighted by the documentary film *Moana of the South Seas*.

Moana of the South Seas was made in 1926 by the pioneering American filmmakers Robert and Frances Flaherty. It was filmed in Safune on Savai'i over the course of a year in 1923–24 with the intention of depicting the everyday life of villagers in the islands. The Hollywood motion picture studio Paramount Pictures funded the filmshoot in the hope it would be as commercially successful as the Flahertys' previous production *Nanook of the North* (1922). Most of the scenes in the film were staged and specially set up for shooting. A key sequence depicts the tattooing of Moana, the title character – perhaps the first time the activity was captured as a moving image. There is footage of an older woman preparing candlenut soot to make the tattooing ink; the staging of special dances; and the tattooing operation itself. The intertitles offer commentary on tattooing as a rite of passage, with statements such as: 'There is an ordeal through which every Polynesian must pass to win the right to call himself a man' and 'The deepest wisdom of the race has said … that manhood shall be won through pain.' Anthropologist Margaret Jolly noted several aspects of the film that contradict the intertitles.[39] First, not many of the young men who appear in the film were tattooed; and second, tattooing appears to be missing from the bodies of many adult members of the village who appear in various scenes. If, as other accounts suggest, tattooing was a rite of passage in Sāmoan society and such an important stepping stone in a man's life, why are so many of the men who appear in this documentary not tattooed?[40] One could argue that the basis for casting the characters may not have required tattoo as a necessary aspect of their role, but there are several scenes, including a group dancing, where many non-tattooed men are captured on camera.

One reason why there are so few photographic depictions of the Sāmoan tattooing operation from the early twentieth century may have been that tattooing was not an everyday occurrence, and that it took place in families or villages that were not always known or accessible to the photographers based in Apia.[41] Even Thomas Andrew, a longtime resident photographer and businessman in Sāmoa, had to employ a guide on a journey to Malie, a village located close to Apia – and the guide was a Wallis Islander![42] It is difficult to believe that he would have been in a position to photograph tattooing as often as he may have wanted to if his travel and local knowledge were constrained in this way.

The absence of tattooed people in photographic and film representations may also relate to Christianity's restrictions on tattooing throughout the latter half of the 1800s. The older Sāmoan leaders depicted in the photography of the German and New Zealand colonial periods were a generation of men living out the legacy of the Christian churches' discouragement of tattooing. Augustin Krämer remarked in 1903 that the only untattooed men were a few missionaries 'who however often enough make up for it later on'.[43]

Fig. 36
Jean Petithuguenin wrote the French novelisation of Robert and Frances Flaherty's film *Moana of the South Seas* (1926). The book's cover depicted a woman and her malu that were not referenced in the film.

39.
Margaret Jolly, 'White Shadows in the Darkness: Representations of Polynesian Women in Early Cinema', *Pacific Studies* vol. 20, no. 4 (1997): 125–50.

40.
Other accounts that emphasise tattooing marking a transition to manhood include 'A Cruise in the Southern Seas', *Otago Daily Times*, issue 18411, 24 November 1921, http://paperspast. natlib.govt.nz/newspapers/ ODT19211124.2.82; Martin Dyson, *Samoa and the Sāmoans*, 1882, http://nla.gov.au/nla. obj-101243022.

41.
See Thomas Andrew, 'Samoa and the South Sea Islands', *Auckland Star* XXIII, issue 276, 19 November 1892, 12, http:// paperspast.natlib.govt.nz/ newspapers/AS18921119.2.96.

42.
Thomas, 'Samoa and the South Sea Islands'.

43.
Augustin Krämer, *The Samoa Islands, Vol. II* (Honolulu: University of Hawai'i Press, 1995), 67.

44.
In *From Sāmoa With Love?* Hilke Thode-Arora published black and white photographs showing men's tatau. The photographic processing at the time seems barely able to reveal the tattooed marks even though many of the men were actually tattooed. See Hilke Thode-Arora (ed.), *From Samoa with Love? Samoan Travellers in Germany 1895–1911: Retracing the Footsteps* (Museum Fünf Kontinente, 2014).

45.
Handy, *Samoan Housebuilding, Cooking, and Tattooing.*

This doesn't explain the reported prominence of tattooing among the Sāmoan touring troupes at the Chicago World Fair and in European cities in the late 1800s. Arguably, in the context of these exhibitions, where many cultures are on display, tatau was a distinctive marker of Sāmoan culture and valuable because of its visibility. If tatau was indeed popular in early twentieth-century Sāmoa and universally practised, as New Zealand government officials claimed, it may have been among a younger generation of men and women who were less prominent in the Sāmoan leadership and social elite and perhaps therefore less visible in the photographic record – at least in those images created in a studio setting.[44]

<p style="text-align:center">◄ • ►</p>

If the photographic and film record of tatau was partial and unreliable, a close reading of the documentation of tatau by ethnologists gives us a more useful insight into tattooing in this period. In 1924, ESC and WC Handy published *Samoan Housebuilding, Cooking, and Tattooing.*[45] The section on tattooing is very short, but two sets of drawings by the authors offer a visual touchstone for assessing aspects of continuity and change. They highlight how both men's and women's hands were tattooed at

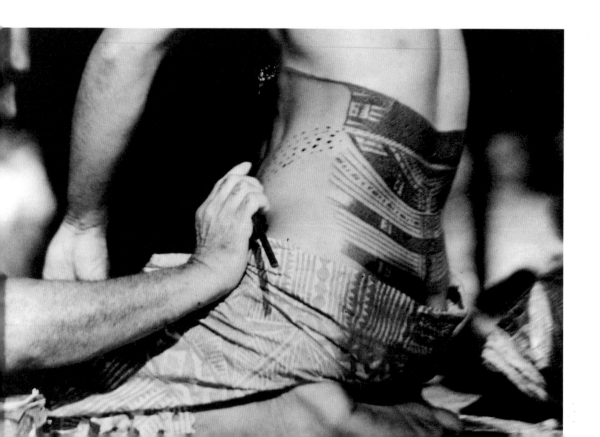

the time. Te Rangi Hīroa (Peter Buck) gives a very precise description of tatau in the late 1920s:[46] his research, published in 1930 in *Samoan Material Culture*,[47] was based on six months' fieldwork in Sāmoa where he studied the material culture and related practices. He covers a wide range of topics from canoe- and housebuilding to making garments, body ornaments, fishing equipment and mat weaving. In his discussion of tatau he describes the manufacture of tattooing tools, the tattooing operation, the motifs and the associated customs. His description of Sāmoan tattooing draws attention to the tatau as a custom undergoing change; no previous account specifically addresses this. He highlights the transformation of tatau in response to changes in Sāmoan society through education and literacy, and he gives insight into how the producers of tatau are innovating, competing with each other and altering their practice to meet customer demand.[48]

At first glance the tattooing procedure appears to have continuity with past practices as described by Stair, George Turner and Krämer. Echoing the intertitles of *Moana of the South Seas*, one journalistic account of the time claims that to be tattooed was 'to be deemed a man'.[49] There is a process of commissioning a tufuga tā tatau, making ceremonial presentations, celebrating at the completion of the tatau, and the bestowal of new responsibilities and social status on the tattooed person. The autā retained the same form and function and was still made from a small bone or pig's tusk comb attached to a turtleshell plate, lashed to a wooden handle. A full tatau could be completed very quickly over three or four days, although tufuga tā tatau preferred to spread the work over several weeks to allow time for the patient to rest and heal. The festivities that accompanied tattooing were less elaborate. The sham fights and wrestling of earlier times were replaced by young men with modern musical instruments playing 'melodies … diffused from foreign music halls' who would sit around their friend being tattooed and sing to distract him from his pain.[50]

According to Te Rangi Hīroa a young man was normally tattooed at the age of sixteen, although there is a record of Mulitalo Lemi of Mauga receiving a tattoo at the age of thirteen in 1930.[51] This is just one example that hints at the heterogeneous nature of Sāmoan tattooing, that there was variation and that it was not practised in precisely the same way throughout Sāmoa. A further example supporting this argument is Te Rangi Hīroa's observation that young men would get tattooed with the punialo tattoo design, comprising 'a triangular unit in the middle line with the base upwards and the apex resting on the pubis, the point being indeterminate and lost as it were in the pubic hair'.

It is usually tattooed in youth some years before the age of regular tattooing is reached. In modern times, it is used as a test. Young men desiring to be tattooed, yet fearful of the pain, have the *punialo* tattooed and if they can stand the pain, they go on with the full tattooing later. Many young men are to be seen with the *punialo* unit alone. They could not summon up the courage to go on with the major operation.[52]

Fig. 37
A film still from Robert Flaherty's *Moana of the South Seas* (1926) showing a tufuga setting his tattooing guidelines on the title character.

46.
Te Rangi Hīroa was trained as a medical doctor but was later employed as a professional anthropologist by the Bernice P Bishop Museum in Hawai'i and went on to be director. He was also Bishop Museum visiting professor of anthropology at Yale University. See MPK Sorrenson, 'Buck, Peter Henry', Dictionary of New Zealand Biography Te Ara – the Encyclopedia of New Zealand, http://www.TeAra. govt.nz/en/biographies/3b54/ buck-peter-henry.

47.
Te Rangi Hīroa, *Samoan Material Culture* (Honolulu: Bernice P Bishop Museum, Bulletin 75, 1930).

48.
Bruce Cartwright, who accompanied Te Rangi Hīroa to Tuila in 1927, also wrote about tattooing from first-hand experience. His notebooks are in the library at the Bernice P Bishop Museum in Honolulu.

49.
'The Mysterious Rescuer', *Evening Post* CXXV, issue 84, 9 April 1938, http://paperspast. natlib.govt.nz/newspapers/ EP19380409.2.147.13.

50.
Hiroa, *Samoan Material Culture*, 661.

51.
McGrevy, 'O le Tātatau', 82.

52.
Hiroa, *Samoan Material Culture*, 646.

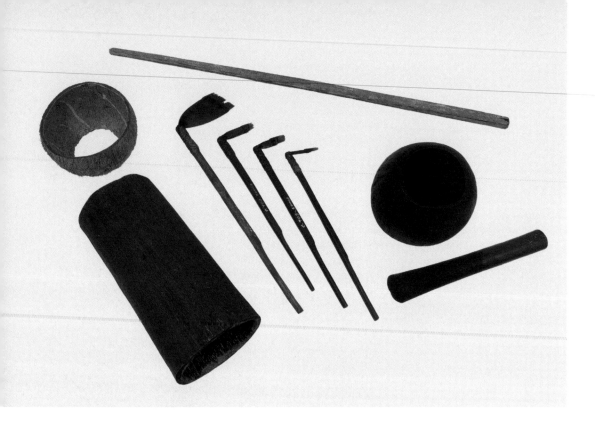

Fig. 38
Au (tattooing tools)
collected by Te Rangi
Hīroa in Sale'aula,
Savai'i in 1928.

53.
See other nineteenth-century
tattoos on page 72.

54.
This according to Noel McGrevy's
documentation of the lineages of
tattooists of the sā Su'a and sā
Tulou'ena.

55.
Hiroa, *Samoan Material Culture*,
657.

This practice of getting a 'tryout tattoo' disrupts the time-honoured process of getting a tatau as described in the historical literature. It allows individuals and their families to skirt around the very formal procedure of approaching a tufuga, commissioning the tatau and enduring the lengthy, painful process of receiving it. It also suggests that getting tattooed is a choice – a so-called rite of passage in order to 'be deemed a man', but one that is optional if you don't feel up to it. A means of testing out the process of tattooing was not a practice that only began in the 1920s and 1930s, and not restricted to getting the punialo.[53] Failing to complete a tatau solicited scorn and ridicule and brought shame to the individual and his family. With the punialo a family could avoid the embarrassment of an unfinished tattoo – although it seems good deeds and good character could also overcome the stigma of a pe'amutu (incomplete tatau).

The most valuable aspects of Te Rangi Hīroa's account are the drawings and descriptions of the tatau and the names of various motifs. Through analysis of the tattoo motifs he reveals the contested nature of tattooing in Sāmoa, alerting us to the fact that even within the family lines of tufuga tā tatau there were different schools of thought. It is clear that tattooing was a creative process and subject to change. Te Rangi Hīroa highlights how tufuga tā tatau were active agents for innovation in their craft, who could accommodate new and novel ideas and disregard well-established ones. One of his informants was a young tufuga tā tatau named Faioso from the 'āiga sā Su'a, who supplied him with detailed drawings of tatau that were published in his account;[54] another Sāmoan, Edmund Stehlin Jr from Savai'i, who was an interpreter and guide for Te Rangi Hīroa, supplied him with drawings of the malu.[55]

Faioso was part of a younger school of tufuga who were moving towards breaking up the dark areas of the men's tatau by introducing more ornamentation. As Te Rangi Hīroa explains, this took the form of fa'aila – small window-like design elements

Fig. 39
A young tufuga tā tatau
named Faioso from the
'āiga sā Su'a supplied several
detailed drawings of the tatau
to anthropologist Te Rangi
Hīroa Peter Buck in 1930.

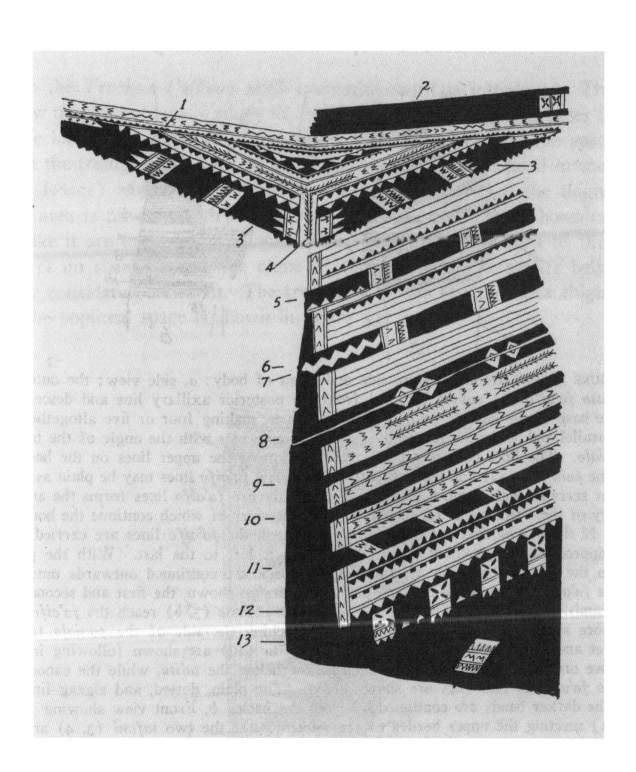

TATAU

56.
Ibid., 644.

57.
Ibid.

58.
Ibid., 655.

59.
Ibid., 658.

60.
Ibid., 656. This may have been
the case in the 1920s, but by the
1990s, as described on pages
273–75 and 295 attitudes had
shifted and the malu became
more visible across a wider
spectrum of Sāmoan society
than before.

61.
A-04 Trade Between New
Zealand and Fiji, Tonga, Western
Samoa, and Cook Islands (Report
of the Commission to Inquire into
the Conditions of), Untitled, 1
January 1920, http://paperspast.
natlib.govt.nz/parliamentary/
AJHR1920-I.2.1.2.5

62.
Administration of Western
Samoa, Handbook of Western
Samoa (Wellington: Government
Printer, 1925), 52.

63.
Hood, Notes of a Cruise, 124.

64.
Krömer, The Samoa Islands,
Vol. II, 68.

that framed certain motifs and isolated skin imperfections such as birthmarks.[56] He writes, 'The younger generation of tattooing artists maintain that they do better work than the older school because they introduce more ornamentation lines and break up the monotony of the wider dark bands.'[57] There was an element of co-creation in these innovations. Te Rangi Hīroa explains how individual matai and others were in a position to afford and commission more detailed work from tufuga tā tatau. And he quite rightly suggests that there was a vested interest in particular classes of matai, creating what he calls 'artificial distinctions' between themselves and other matai.[58]

These innovations in Sāmoan tatau design are evidence of individual tufuga being creative, seeking distinctiveness and responding to new demands from (and perhaps competing for) their clientele. Influenced by Western education, the younger school were also introducing letters from the Roman alphabet into their tattooing. In the process they were abandoning, even forgetting, terms for older motifs. For the motifs called vaetulī and vae'ali (see pages 220–221) younger tufuga were using the Sāmoan name for the letter V – vi – and the old motif would be renamed fa'avi ('like the v'); similarly, the gogo (tern motif) was reworked to produce the letter M, or mo, and the motif is called fa'amo; the letter N is nu and the motif is called fa'anu.[59] In this way, in little more than a generation, introduced language and images were superseding the indigenous terms for describing tatau.

Te Rangi Hiroa also gives us some insight into how tufuga tā tatau thought about the malu or women's tattoo. The cultural significance of the malu is rarely commented on in ethnographic literature, and his comments are brief. He implies that tufuga at the time considered the malu differently than the tatau; as well as being less elaborate and involving less ceremony and no presentation of a fusitā (a large 'ie tōga) to the tufuga, 'the tattooing of a girl is often used as an opportunity for a student to try his prentice hand', although the daughter of a high-ranking matai would require the services of an expert tufuga.[60] This suggests that not all women who were seeking the malu were of high social status, and if malu was reserved for higher ranking women in the past, by the 1920s it was available to people of lower social status.

The early New Zealand administration of Sāmoa seems to have produced no official documentation of Sāmoan tattooing. In 1920, as mentioned above, a New Zealand government report noted that 'Tattooing is universally practised',[61] and in 1925 the administration published a Handbook of Western Samoa, which stated that 'the art of tattooing' is in 'vigorous survival', but allocated only seven lines to the topic.[62]

Sāmoan tatau actually varied in practice across the archipelago. It was more prevalent in some locations than in others, and not every village had a tufuga tā tatau. On Manu'a there was an ambivalent relationship with tattooing: for religious reasons the matai there banned tattooing in the 1860s, so young men approaching manhood journeyed west to Tutuila to be tattooed – although they were forbidden by law to return home[63] (see chapter 2). By the 1890s it seems that this law had been revoked and young men were allowed to return to Manu'a on condition they paid a fine to the

church.[64] A newspaper report from 1897 records the shipwreck of a group of people including two men who were returning to Manu'a after being tattooed in Tutuila.[65] In the 1920s, Te Rangi Hīroa noted a general ban on tattooing in Manu'a.[66]

The archives and other ephemera from the period of the New Zealand administration offer a few further tattooing-related insights. For example, customers who were eager to be tattooed might struggle to pay for the services of a tufuga tā tatau. A 1928 government report records the following regarding non-payment for tatau:

> The Samoan tattooer frequently has been paid for his services in a section of land, when the family whose male members were being tattooed had not sufficient 'fine mats' or other property to pay for the services of the tattooer. So also with a Sāmoan house-builder.[67]

In the twenty-first century women often seek to have their hands tattooed, but in the 1920s, both men and women were tattooed on their hands.[68] The hands are, of course, a highly visible part of the body to display tattoos; they are seen especially in ceremonial occasions where 'ava (kava) is mixed by the women and presented to honoured guests by sogā'imiti (tattooed men). In the 1920s, only the right hand of males was tattooed, and by the early 1950s the practice was less evident; perhaps even discontinued.[69]

➤ • ➤

The Second World War had a huge impact on the Pacific Islands. The presence of foreign troops exposed Pacific peoples to all kinds of new ideas and greatly transformed their societies and cultures; arguably there had not been such an intense transformation since the arrival of Christianity – and certainly not over such a short period. In some places war was devastating to local cultural practices; in others it facilitated cultural renewal and innovation.[70] Sāmoans were confronted with new cultural values and social practices as well as new technology, clothing, music and cuisine. In this milieu the local and the global came together in an unprecedented way – and tattoos from different artistic traditions marked the moment.

The war that had raged in Europe since 1939 expanded into the Pacific in 1942 when the Japanese imperial forces attacked the US Navy Pacific fleet at Pearl Harbor in Hawai'i. The United States entered into the war soon afterwards and, very quickly, the threat of invasion by Japan became a concern for Sāmoa. The archipelago was a strategic point for communications, transport and trade with other parts of the Pacific, and it needed protection. The United States had maintained a naval presence in Tutuila since 1900, but on 'Upolu and Savai'i the New Zealand colonial administration provided a defence force of only 157 men to cover 250 miles of coastline. To address this situation the United States negotiated to defend the whole Sāmoa archipelago from possible invasion.[71]

65.
In 1897, two men from Manu'a returning from being tattooed in Tutuila were part of a group of 22 Sāmoans who were shipwrecked on Nanumea. 'Terrible Experience of Samoans', *Otago Daily Times*, issue 10943, 26 October 1897, http://paperspast.natlib.govt.nz/newspapers/ODT18971026.2.67.

66.
Hiroa, *Samoan Material Culture*, 636.

67.
Western Samoa (Report of Royal Commission Concerning the Administration of), Appendix to the Journals of the House of Representatives, 1928 Session I, A-04b, page 183.

68.
Hiroa, *Samoan Material Culture*, 659; Handy, *Samoan Housebuilding, Cooking, and Tattooing*, 24.

69.
See illustration on page 118.

70.
Sean Mallon, 'War and Visual Culture 1939–1945', in *Art in Oceania: A New History*, edited by Peter Brunt and Nicholas Thomas (London: Thames & Hudson, 2012), 326–47; Geoffrey White and Lamont Lindstrom (eds), *The Pacific Theater: Island Representations of World War II* (Honolulu: University of Hawai'i Press, 1989); Lamont Lindstrom and Geoffrey White, *Island Encounters: Black and White Memories of the Pacific War* (Washington & London: Smithsonian Institution Press, 1990).

71.
James C Rill, *A Narrative History of the 1st Battalion, 11th Marines During the Early History and Deployment of the 1st Marine Division, 1940–43* (New York: Merriam Press, 2003), 30.

TATAU

Fig. 40
Tourists from the SS
Franconia observe
tattooing during a world-
cruise stopover in 1934.

Initially, US servicemen landed in Sāmoa in great numbers: according to one assessment, the headcount of troops based on 'Upolu and Tutuila fluctuated from 14,371 in 1942 to 9491 in 1943 and, by early 1944, only 2080.[72] This influx of men and equipment at a level not seen before in Sāmoa was disruptive and sometimes destructive to the patterns of everyday life. Culturally, new forms of entertainment and commerce came with the troops, exposing locals to new ideas, products and markets, some of which persisted long after the war. The economy received a tremendous boost and Sāmoans benefited from employment opportunities such as labouring, entertainment and selling goods and services to support the troops.

The cultural exchange was not all one way, either. According to Staff Sergeant Milburn McCarty Jr, a combat correspondent in Sāmoa, the marines or 'malini' were quick to pick up phrases in the local language: 'They mix Sāmoan freely with their English, and no conversation goes more than a minute without some native word popping out.'[73] The influence of the Americans extended to tattooing, too. In the British Museum, there is an interesting example of this in a portfolio of fifty-two detailed drawings of tatau made by Jack W Groves between 1949 and 1952.[74] The drawings offer tantalising glimpses of continuity, change and innovation. They include examples of tatau across half a century; the oldest tatau depicted is from the 1890s and there are several from the 1920s and late 1930s, all drawn from life.

Some of Groves' drawings point to the influence of American troops stationed in Sāmoa during the Second World War. Tattooing was an established practice in the US military and particularly in the navy, but it underwent a revival during the war at home and abroad. For new servicemen tattooing was a means of signalling their association with certain ships, battalions or regiments, as well as ports they had visited and battles they had fought.[75]

Groves invested much determination, patience and attention to detail in creating such a valuable collection of drawings. He remarks on the great reluctance among Sāmoans to show their tatau to foreigners. The full tatau is seldom seen in its entirety in everyday life; it is glimpsed only in part during ceremonies, performances or while a person is bathing. It is usually beneath a lavalava or covered by a shirt; even when a person is sitting cross-legged, only the knees might be visible beyond the edge of the garment.

One motif that stands out in Groves' drawings is that of an American bald-headed eagle incorporated into the punialo motif, just above the groin – perhaps a symbol of patriotic sentiment and commitment to the US and Allied cause.[76] Groves points to a wider adoption of the American eagle into the tatau:

> There is a strong tendency nowadays to display the American Eagle in a tattoo design actually as the whole or part of the punialo. This would seem to be the result of occupation of the American troops during the war. There seems to be nothing incongruous to the Samoan mind in the spread eagle appearing in what is entirely a fa'aSamoa decoration and it is quite impossible to convince them of it.[77]

72.
R Franco, 'Sāmoans, World War II, and Military Work', in *Remembering the Pacific War*, Occasional Paper series 36, edited by Geoffrey M White (Honolulu: Center for Pacific Islands Studies, University of Hawai'i, 1991), 173–79, at 176.

73.
Milburn McCarty Jr, 'Even In Samoa They're Interested In "Teines"', *Marine Corps Chevron* 2, no. 38 (25 September 1943): 4, http://historicperiodicals. princeton.edu/historic/cgi-bin/ historic?a=d&d MarineCorp-sChevron19430925-01.2.31&e=---- ----en-20--1--txt-txIN------#

74.
This portfolio and the notes were previously viewed and cited by researcher Noel McGrevy. It was misplaced before being rediscovered in the museum by Sāmoan artist and researcher Rosanna Raymond. I am grateful to her for making a copy of the manuscript available to me.

75.
David McCarthy and HC Westermann, *HC Westermann at War: Art and Manhood in Cold War America* (Newark: University of Delaware Press, 2004), 31–32.

76.
The symbol of an American eagle with a crest was incorporated into the sign outside the barracks of American Sāmoa's Fitafita Naval Guard Unit in 1944.

77.
Jack W Groves, 'Notes on the Samoan Tattoo (pe'a) with Original Diagrams and Illustrations by the Author', unpublished manuscript held at the Ethnography Department, British Museum, n.d.

SAMOAN TATTOO. RIGHT HAND.

J.W.GROVES.
APIA. OCT 1930

LAUMUA. AMALOSOTA.

Fig. 41
Men and women
were tattooed on the
hands up until the mid
20th century. Jack W.
Groves, *Right Hand,
of Laumua Amalogota,*
Apia, Sāmoa, 1950.

Fig. 42
Fitafita Colour Guard,
American Sāmoa,
December 1944. The eagle
in the signage may have
inspired a unique tattoo
(see fig. 44 page 121).

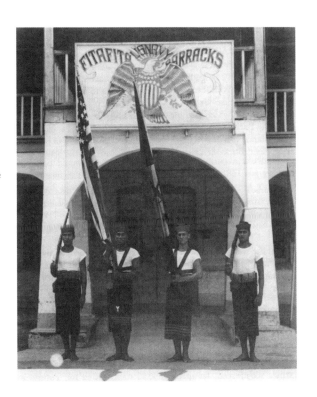

78.
2d Lt Jim G Lucas, PRO, 'Loyalty
of Native Split by Tattoos', *Marine
Corps Chevron* 3, no. 28 (15 July
1944): 8, http://historicperiod-
icals.princeton.edu/historic/
cgi-bin/historic?a=d&d=Marine-
CorpsChevron19440715-
01.2.56&srpos=1&e=-------en-
20--1--txt-txIN-tattoos------
(accessed 13 March 2017).

79.
Lindstrom & White, *Island
Encounters*, 174.

Groves gives limited contextual detail with this drawing, but he does record that 'miscellaneous work' was done first and the owner of the tattoos only later decided whether to get a full tatau. There were other 'fancy' motifs on the owner's thighs but the tatau had covered them over. Groves included this tatau in his manuscript as a 'curiosity' and withheld the name of the owner. He also provides a sketch of a punialo featuring a dagger, flowers, a pair of hands clasped in a handshake and the words 'true love' tattooed on Paina Mulinu'u of Taugamanono in 1938.

The incorporation of foreign symbols into or alongside indigenous tattooing forms also occurred in other parts of the Pacific during the war. In Saipan in the Mariana Islands, 'One native interned by Marines on their march up the coast of Magicienne Bay today was divided in his loyalties. Tattooed on his chest were the American and Japanese flags, staffs crossed.'[78] In another part of Micronesia the Japanese rising sun featured on indigenous bodies.[79] The appearance of the American eagle as part of the punialo, and Sāmoan indifference as to whether it is a fa'asāmoa decoration or not, reminds us that tatau was not a static or fixed practice: the formal aspects of tattooing could incorporate the influences of the outside world.

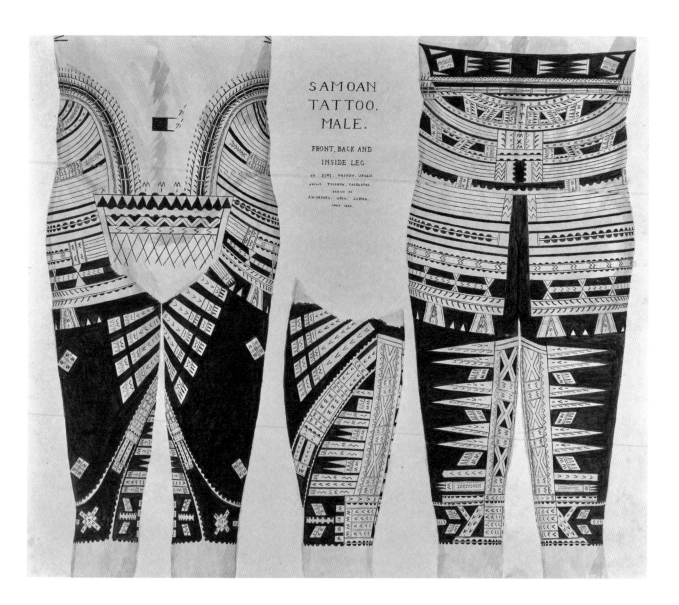

SAMOAN
TATTOO.
MALE.

FRONT, BACK AND
INSIDE LEG

OF SIMI. VAIUSU. UPOLU.

ARTIST. TUISAVA. FALELATAI.

DRAWN BY
J.W.GROVES. APIA. SAMOA.
JULY 1950.

Fig. 43
The tatau of Simi from Vaiusu,
Upolu, by Tuisava of Falelatai.
Drawn by Jack W. Groves, July
1950, Apia, Sāmoa.

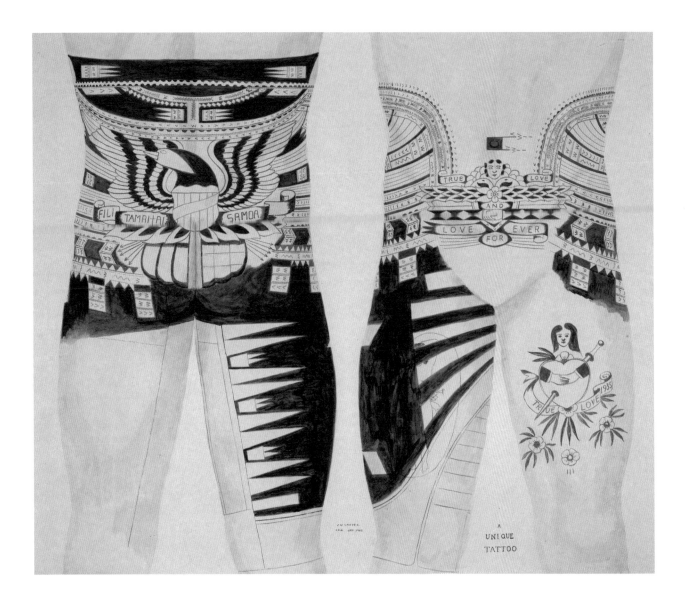

Fig. 44
'There is a strong tendency
nowadays to display the American
Eagle in a tattoo design actually as
the whole or part of the punialo.'
Jack W. Groves, *A Unique Tattoo*,
Apia, Sāmoa, 1952.

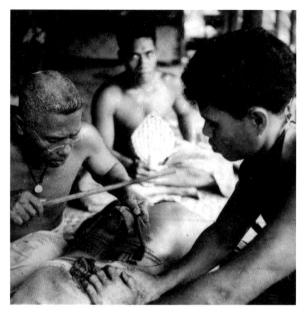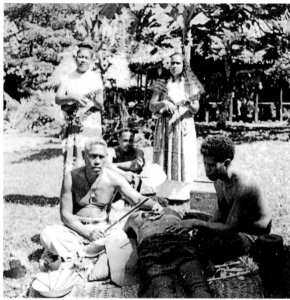

Fig. 45-48
Tattooing in Sāmoa
c. 1960s. Photographs
by Jutta Merensky
(later Gethen).

In the context of national fervour and political transformation in the lead-up to the declaration of Sāmoa's political independence in 1962, tatau was one of a number of cultural productions that became prominent symbols of Sāmoa, the nation. Writing at the time of independence, Suʻapaʻia signals the importance of tatau and the conservatism of tufuga concerning its function in ceremonial contexts:

> [Tufuga] insist that the honor of the chief council be protected, by not letting any untattooed person serve them in chiefly assemblies. They argue that it has been an ancient custom, and an unclean, untattooed boy is not supposed to meet on equal terms with the ones that are tattooed who are in their manhood and will protect the honor and respect of the chiefs.[80]

80.
Suʻapaʻia 1962: 77.

If this account is accurate then there would hardly be reason for a resurgence of tatau at the time of independence. Suʻapaʻia is not more specific but it is likely he is referring only to a particular village or district.

Further evidence that 1962 was a point of revival for tatau comes from anthropologist Tim O'Meara, who made a study of Sāmoan planters in the early 1980s: he links young men's renewed interest in tatau with the time of Sāmoa's independence.[81] He recalls seeing only one woman and no men over the age of forty with a tattoo, and notes that 'none of the older chiefs have tattoos and virtually all of the young men become chiefs – with or without tattoos'. Furthermore, three new tattooists began work within the ʻāiga sā Suʻa during this period. Suluʻape Paulo I trained his nephew Suʻa Faʻalavelave, who began tattooing on his own in 1962.[82] Faʻalavelave Petelo began tattooing around 1963-64, and his cousin Suʻa Suluʻape Paulo II began in 1967, aged seventeen. Paulo remembered Faʻalavelave well, and the start of the revival:

81.
Tim O'Meara, *Samoan Planters: Tradition and Economic Development in Polynesia* (Fort Worth, Texas: Rinehart and Winston, 1990), 72–76.

82.
McGrevy, 'O Le Tatatau', 85.

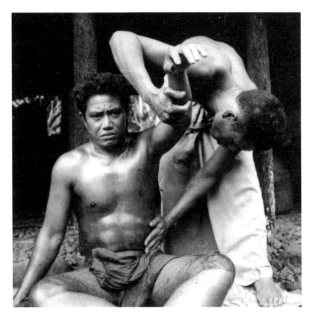
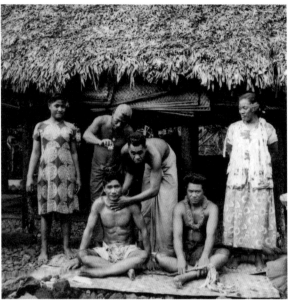

T A T A U

I think he started around 1963–64, everyone was talking about him because he was really coming on real strong. That was the resurgence of tattooing in Sāmoa, that was the exact time … he had been brought up in my family, but he left to look after his parents in a village called Samatau, on the northern side of the island.[83]

We can only speculate on what may have influenced a renewed interest in tattooing in the lead-up to Sāmoa's political independence. Perhaps people retreated to tatau as part of a backlash to colonialism and non-Sāmoan values in a way they hadn't at earlier points in New Zealand's colonial administration – for example during the activity of the Mau a Pule and the Mau. The renewed interest in tatau around independence may have related to its power as a distinctive symbol, a very public expression of commitment to the nation of Sāmoa through a process of bloodletting and experiencing pain. In effect, the resurgence of interest in tatau can be understood as a re-marking of the nation state – a process of connecting the past to the present; the real – precolonial – Sāmoa to the new postcolonial Sāmoa that was being reborn or revived.

Since the war a small American presence in Sāmoa has persisted. In the late 1960s American Peace Corps volunteers were deployed in Sāmoa to develop tourism and other infrastructure; they assisted with small business ventures, and community and education projects. The impact of their presence was similar to that of their military predecessors who had occupied Sāmoa during the war.[84] The volunteers helped develop the tourist industry in very structural and hands-on ways, but they also embodied and constituted the tourist industry themselves, and were eager to collect mementos of their time in Sāmoa.

One tufuga, interviewed in the 1970s by the *Pacific Islands Monthly*, claimed to have invented a form of tattooing known as pe'apisikoa (Peace Corps tattoos) in the form of

83.
Sean Mallon, '"A Living Art": An Interview with Su'a Sulu'ape Paulo II', in *Tatau: Samoan Tattoo, New Zealand Art, Global Culture*, edited by Sean Mallon, Peter Brunt and Nicholas Thomas (Wellington: Te Papa Press, 2010), 51–61, at 51.

84.
Sean Mallon, 'Tourist Art and its Markets 1945–1989', in *Art in Oceania: A New History*, edited by Peter Brunt and Nicholas Thomas (London: Thames & Hudson, 2012), 384–409.

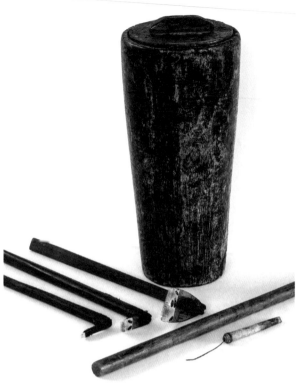

TATAU

Fig. 49
Su'a Sulu'ape Paulo I.

Fig. 50
The autā (tattooing tools)
of Su'a Sulu'ape Paulo I.

85.
Felix von Luschan, *Beitrag
zur Kenntnis des Tätowierung
in Samoa* (Verhandlungen
der Berliner Gesellschaft für
Anthropologie, Ethnologie und
Urgeschichte, 1896), 553; and
also 'South Sea Island Show at
Chicago', *Samoa Weekly Herald*
vol. 2, issue 57 (30 December
1893): 3.

taulima (armbands and wristbands) and tauvae (anklets), with the Peace Corps volunteer market in mind. The taulima does indeed have a visual affinity with the pe'a, but it is only through its incorporation of key motifs and the fact that it is rendered with the au. The protocols and rituals associated with receiving it are not the same as for the pe'a. The relationship between the two forms may appear (at least in this context) to go no further than that.

The taulima has not received much attention in the ethnographic literature, but it appears to have been part of the tattooists' repertoire from at least the 1890s. There is a newspaper account of Sāmoan men in Chicago with tattoos on their arms; and in the same period, Felix von Luschan observed a group of thirty Sāmoan women visiting Berlin who were tattooed with armbands and wristbands, although they did not figure in the drawings in his publication or in Marquardt's book.[85] The limited discussion of taulima in the ethnographic records may be because, at the time, this form of tatau was not considered to be as culturally significant as the tatau. Furthermore, that a tufuga in the 1970s would claim to have 'invented' taulima suggests that it was not widespread in Sāmoa or even in the memory of contemporary people.

Nevertheless, the taulima very quickly became an important form of tatau in Sāmoa and for Sāmoans living abroad. At the same time as the pe'apisikoa was emerging in Sāmoa, in Hawai'i a similar tattoo form, called the 'Hawaiian band', was being

developed by tattooist Mike Malone, who was partially inspired by seeing Sāmoan tattoos in Honolulu.[86] It, too, took the form of an indigenous-inspired design that wrapped around the arm. The Hawaiian band became a much sought-after symbol of cultural identity in a period of cultural revival in Hawai'i and elsewhere, where kānaka maoli (native Hawaiians) had limited access to indigenous forms of tattooing.

One of the early Peace Corps volunteers to Sāmoa was a woman in her seventies named Elsie Bach; Sāmoan academic and writer Albert Wendt remembers training her for her work as a volunteer in Hawai'i before she went to Sāmoa. Bach was very active in the community in Sāmoa: she taught at the Sāmoa Teachers Training College in Apia and formed relationships with the 'āiga sā Meleisea in Poutasi, Faleālili and the 'āiga sā Su'a of Lefaga. She was tattooed with a malu and honoured with the Sulu'ape matai title.[87] The tatau has been referred to as a set of markings that is worn and given meaning through the wearer's service in specific cultural settings. Being tattooed is often seen by people as an expression of the wearer's preparedness to serve. Sometimes the service rendered can qualify somebody for an honour such as a matai title or a tatau regardless of whether or not they are Sāmoan.

In Bach's case, being tattooed with a malu was perhaps an acknowledgement of someone seen to have served Sāmoa and Sāmoans in her capacity as a volunteer, but it was also, according to Wendt, an acknowledgement of a relationship, a 'bloodletting', that connected her to Sāmoa, to 'āiga, and to a culture that she admired.[88] Indeed, the experience of Peace Corps volunteers elsewhere has featured similar processes around developing relationships and forming connections to people and places through objects or practices of cultural value, such as the hair braiding sought after by Peace Corps volunteers among the Tuareg people in Niger: having their hair braided and wearing local jewellery and fabrics are ways in which Peace Corps workers make over 'their American bodies into Nigerian ones' and assimilate into the local culture,[89] if only temporarily.

A legacy of the Peace Corps presence in Sāmoa is that the pe'apisikoa travelled internationally on the bodies of young Americans who were posted to Sāmoa and then returned home. It was a marker of identity and experience for them – a memento of their travel and of their worldliness. The pe'apisikoa identified them as having a specific relationship to the local Sāmoan cultural setting. It incorporated them in a limited way into Sāmoan society – but it also singled them out and distinguished them from tourists and pālagi who were not in the Peace Corps. Wearing a Peace Corps 'uniform' such as an island-patterned shirt and puletasi could arguably serve the same purpose, but these accoutrements were not as distinctive or as permanent as a tattoo.

The development of pe'apisikoa is an example of how visitors to Sāmoa influenced the local production of tattooing. The difference between that and earlier exchanges is that the intensity of demand for a tattoo by Peace Corps volunteers created a non-indigenous commercial context and transaction around Sāmoan tattoos to which tufuga had not been previously exposed. Peace Corps volunteers helped create demand for a specific tattooing form that remains popular with tourists to Sāmoa and with Sāmoans

86.
Ed Hardy and Joel Selvin, *Wear Your Dreams: My Life in Tattoos* (New York: St Martins Press, 2013), 188–89.

87.
Albert Wendt, 'Afterword: Tatauing the Post-colonial Body', in *Inside Out: Literature, Cultural Politics and Identity in the New Pacific*, edited by V Hereniko and R Wilson (Lanham, Maryland: Rowman and Littlefield, 1999), 409.

88.
Ibid.

89.
Elizabeth Davis, 'Metamorphosis in the Culture Market of Niger', *American Anthropologist* vol. 101, no. 3 (1999): 485–501, at 492.

TATAU

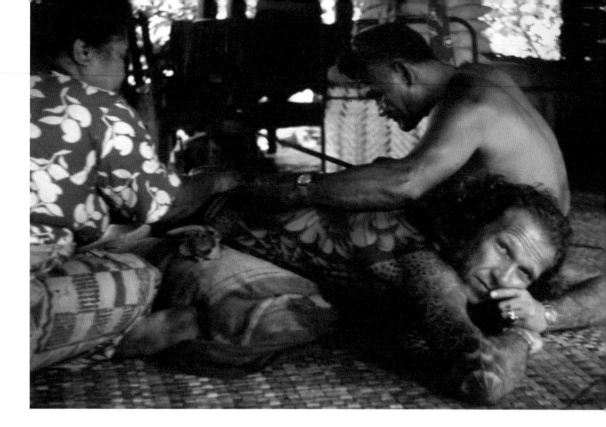

Fig. 51
American tattooing icon
Lyle Tuttle was tattooed in
Sāmoa in 1972. 'I wanted
some of the "real stuff"
put on', he said. The
tufuga was Suʻa Liʻo
Tusiʻofo from Siʻumu.

across the diaspora. In 2009, nearly forty years after the first volunteers arrived, volunteers were still being tattooed on postings to Sāmoa: a training manager jokingly referred to the process as the 'tag and release program' – a reference to the practice of catching fish, tagging them with a plastic strip inscribed with location data and releasing them back into the sea.[90]

In the decade immediately post-independence the international profile of Sāmoan tatau continued to grow. For example, it was made compulsory for members of the Tagiilima choir that visited the Vatican in Rome in 1971. Later in the 1970s, well-known American tattooist Lyle Tuttle visited Sāmoa and acquired a sample Sāmoan tatau and a matai title.[91] In an interview published in 1989 he recalled his experiences:

> Then when I got tattooed in Sāmoa, I got a really bad infection. I hate the tropics and I hate the bugs in the tropics. People who live in the tropics have learned to tolerate bugs, especially in the primitive cultures. I saw one Sāmoan guy let this fly crawl on his face and take a goddamned drink out of his eye for Christ's sake! That's how used to insects they are. So when the tattooer was working on me, they wouldn't brush away the damn flies. I mean I saw pictures after it was over and the goddamn flies were all over my open wounds – drinking out of the incisions like hogs in a trough. Two days later, I had this infection start happening. I hopped on a plane, flew over to America, and got a shot of penicillin in the ass and everything turned out okay. But it was those goddamned flies, not the tattooer, that gave me the infection![92]

90.
http://seereeves.blogspot.
co.nz/2009/01/tatau.html,
5 January 2009.

91.
V Vale and Andrea Juno, *Modern
Primitives* (RE/Search, 1989).

92.
http://www.prickmag.net/
lyletuttleinterview.html.

◄ • ►

In the late twentieth century Sāmoans were emigrating and settling in urban centres overseas in ever increasing numbers. Over several decades, a significant transnational Sāmoan population developed into a diaspora. As much as the many arrivals and developments in Sāmoa in the postwar era through the processes of foreign aid, tourism and commerce, the movement of people and ideas into and out of Sāmoa was also important for the history of tatau.

Tatau figured prominently on these 'global cultural flows', in which information, ideas, people and their cultures traversed the world in new, multiple and more complex ways than ever before – and Sāmoan tattooists and tattooed people were active voyagers on these currents, forming what globalisation theorist Arjun Appadurai might call a 'tattooscape'.[93] Air and sea travel became cheaper and more accessible in the decades after the Second World War, and Sāmoans emigrated to settle in urban centres in New Zealand, Australia, Hawai'i and in California.[94] New Zealand was the most popular destination because of its geographical proximity and its colonial ties to Sāmoa and other Pacific islands. Small numbers of people from Sāmoa, Niue, Tokelau and the Cook Islands had been travelling there since the late nineteenth century seeking education, employment, business opportunities, new experiences as travellers, and to join family members who had migrated earlier. In the 1960s and 1970s New Zealand needed people from the Pacific to address labour shortages, and people had been moving there in numbers.[95] In 1966, there were 11,842 Sāmoans living in New Zealand; in 1971 there were 22,198.[96] As Sāmoan communities became established in New Zealand cities, so too did the contexts for their language, customs and culture. It was in these conditions that a demand for tatau emerged from New Zealand-based Sāmoans.

Tufuga tā tatau went where Sāmoan people settled and they took their tools with them. Tavui Pasina Sefo Ah Ken was the pioneer of Sāmoan tattooing in New Zealand-based Sāmoan communities in the early 1970s – and possibly the first tufuga tā tatau to establish himself outside Sāmoa. He left Sāmoa for New Zealand in 1972. During the day he worked in a factory and on weekends and in the evenings he tattooed people. His first tatau in New Zealand was for Pasina Willie Betham in 1973, followed by Fune Betham. Once these men were tattooed and Tavui's presence became known, other people asked to be tattooed. They included Peter Young, who was tattooed in 1974 when he was still at high school. Anthropologist Noel McGrevy records that Tavui was joined briefly by his nephew Pasina Ita'ifafo that same year before his cousin Su'a Sulu'ape Paulo II (Paulo) joined him in Auckland.[97] Paulo followed a similar pattern of work as Tavui – he worked in a factory during the day and tattooed at night and on the weekends. Tavui and Paulo became the most prominent tattooists in the Sāmoan community in New Zealand through the late 1970s and 1980s.

McGrevy describes Tavui as unassuming and quiet, whereas Paulo appears to have been more outgoing and formed relationships that got his work noticed outside the Sāmoan community. Paulo was just one tufuga, but he made an impact and left a lasting legacy. The quality of his work, his personality, and the high-profile

93.
Arjun Appadurai, *Modernity at Large: Cultural Dimensions of Globalization, Vol. 1* (Minneapolis: University of Minnesota Press, 1996).

94.
Franco, 'Sāmoans, World War II, and Military Work', 173.

95.
K Māhina-Tuai, 'A Land of Milk and Honey? Education and Employment Migration Schemes in the Postwar Era', in *Tangata o le Moana: New Zealand and the People of the Pacific*, edited by Sean Mallon, Kolokesa Māhina Tuai and Damon Salesa (Wellington: Te Papa Press, 2012), 161–78.

96.
The New Zealand Official Yearbook 1976, https://www3.stats.govt.nz/New_Zealand_Official_Yearbooks/1976/NZOYB_1976.html#idchapter_1_9158.

97.
McGrevy, 'O le Tatutau', 91.

people he tattooed combined to give Sāmoan tattooing a heightened presence in the New Zealand arts and culture scene. Among the prominent Sāmoans he tattooed were painter and sculptor Fatu Feuʻu and activist and lawyer Fuimaono Norman Tuiasau.

The emergence of Fatu Feuʻu as a painter in New Zealand contemporary art circles gave tatau and Sāmoan culture visibility in the art world. His exploration of Sāmoan siapo motifs and the symbols of tattooing in his painting and prints was influenced by his interactions with New Zealand artists who encouraged him to look to his cultural heritage for inspiration in his art practice. Feuʻu exposed the deep cultural roots of Sāmoan tattooing in history and mythology to New Zealand artists and their followers – including painter Tony Fomison (1939–1990). This helped them to engage with not just the aesthetics, or the images and motifs of Sāmoa, but also the society and its values. Feuʻu was the first of several contemporary artists of Sāmoan descent to explore tatau in their work. He would be followed by others such as Michel Tuffery, Lyle Penisula, Greg Semu and Angela Tiatia, to name a few.

Fomison was the first pālagi to receive a tatau from Paulo, and it marked a special relationship between the two artists. In an interview in 1981, Fomison told McGrevy that 'people who understand the custom respect you when they realise you have the peʻa', and he relates a story of how some Polynesian youths who accosted him one night on the street ended up walking him home after he lifted his shirt and showed them his tatau.[98] Having received the tatau gave Fomison a measure of recognition in the local Sāmoan and Polynesian communities where he lived in Auckland. He was a close friend of Fuimaono Tuiasau, and they were tattooed together in 1979–80.[99]

The history of Tavui Pasina Sefo Ah Ken, Suʻa Suluʻape Paulo II and their tattooing practice has been documented by New Zealand photographer Mark Adams. He was instrumental in giving Sāmoan tattooing visibility and in documenting its history in Auckland through an extensive body of photographic work that eventually spanned more than forty years.[100] Tatau contributed to and helped sustain Adams' deep interest in colonial history, cultural difference and exchange. His collaboration with Sāmoan tufuga in New Zealand over forty years documented the sites, contexts and processes of their work (see portfolio, page 81).

Renowned New Zealand tattooist Roger Ingerton is another non-Sāmoan with an association with Paulo that began in the 1970s. For many years he ran a small studio in upper Cuba Street in Wellington. A narrow entrance led past walls covered in tattoo flash (designs) and four black-and-white framed photographs of what looked like the front and back of a tatau or peʻa: it was a machine-rendered peʻa that Ingerton had tattooed on a Pākehā. Over his career, and before he met Paulo, Ingerton had gained a reputation as one of the preferred non-indigenous tattooists to tattoo Polynesian-inspired designs. His work contributed to the widespread appeal and appreciation of Polynesian tatau imagery, especially in New Zealand. Ingerton said of Paulo:

> Suluʻape Paulo demonstrated Samoan tatau at a tattoo artist gathering in Auckland in the early 1970s. He blew everyone away with what he did. I received

Fig. 52
Tianigi; 1988; Michel Tuffery; woodcut on tapa cloth; tapa; woodcut; New Zealand.

T A T A U

98.
Ibid., 145.

99.
Peter Brunt, 'The Temptation of Brother Anthony: Decolonization and the Tattooing of Tony Fomison', in *Tattoo: Bodies, Art and Exchange in the Pacific and the West,* edited by Nicholas Thomas, Anna Cole and Bronwen Douglas (London: Reaktion Books, 2005), 123–27; Ian Wedde (ed.), *Fomison: What Shall We Tell Them?* (Wellington: Wellington City Gallery, 1994).

100.
Mallon, Brunt & Thomas, *Tatau.*

101.
This interview extract originally appeared in Sean Mallon with U Fecteau, 'Tatau-ed: Polynesian Tatau in Aotearoa', in *Pacific Art Niu Sila: The Pacific Dimensions of Contemporary New Zealand Arts*, edited by Sean Mallon and Fuli Pereira (Wellington: Te Papa Press, 2002).

some sample Sāmoan taulima designs from him. There was a friendship there, a collaboration between tattoo artists. Collaborations are still going on. I'm doing a small part to keep this ancient art going. Keeping patterns alive. I do a lot of modern Pacific Island interpretation. I tattooed a palagi in 1972, this was a very learned man who knew what designs he was getting and their significance. I've done a few pe'a since then. Some of these were in conjunction with Sulu'ape Paulo. He was an innovator. He was mixing different cultural designs while using traditional Sāmoan skills. He was doing new things and taking it to the world.[101]

Ingerton was a non-Sāmoan tattooing insider reaching out to Paulo in a different way to Fomison. Fomison was an artist who was trained in another tradition of image making and, while he had a love of tattoos, he was primarily exploring the politics of cultural boundaries. Ingerton was investigating the same cultural territory, but shared with Paulo the practice of inking the skin. His reaching out to Paulo and learning about tatau made Sāmoan motifs accessible to non-Sāmoans at a time when Sāmoan tattooing was still mainly restricted to the Sāmoan community and was less visible to the wider public.

Fig. 53
Autā (tattooing tools) made by the late tufuga tatau Su'a Sulu'ape Paulo II.

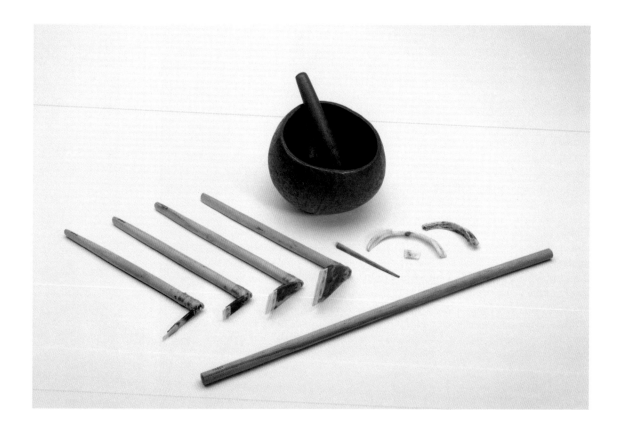

While there were plenty of Sāmoans leaving Sāmoa and moving to New Zealand, there were some Sāmoans moving back to the islands. Sāmoan–Chinese tattooist Steve Ma Ching was born in New Zealand but raised in Sāmoa through the 1970s; he went to school at Chanel College near Apia and then to St Josephs. Reflecting on tattooing in Sāmoa during this period, he gives us an insight into other tattooing practices in Sāmoa outside the 'āiga sā Su'a and sā Tulou'ena:

> In Samoa, even at school you'd have guys coming into school every now and again and they'd have their pe'a done. These were young guys around fifteen or sixteen, even younger ... So in Samoa, you are just exposed to it. A lot of the boys in the village would get tattoos ... [They would get] eagles, snakes, I remember one of the guys in my class had a tattoo of the dragon on a vermicelli packet for chop suey ... there used to be a gang in Samoa back in the day that used to call themselves VGV and one of my mates was a member of it and it [the tattoo] was like a clump of grass with three mushrooms coming out. I never found out who did it, but it was the old su'isu'i method – you know where the guy stitches it into him. It's a technique where the tattooist uses a pin or needle and tap-tap-tap in a stitching pattern, not actually going under the skin but onto the surface. There was one guy, I can't remember his name but his lines were as good as a machine tattoo ... Even the teachers in my school used to get armbands and other tourist tattoos to take back to their homeland as a souvenir of their stay in Samoa. Seeing this got me interested [in tattooing], and realising that you didn't have to get the whole pe'a.[102]

102.
Steve Ma Ching, interview with Sean Mallon, Auckland, May 2013.

On his return to New Zealand in 1982, when he was sixteen, Ma Ching worked during the day in a shoe factory in Auckland and in the evening and the weekend at the Mt Albert Tattoo Studio, where he trained with tattooist Sailor Geoff Kelly. Through the 1980s Ma Ching didn't specialise in any particular style of tattooing. Rather, he worked across genres, tattooing customers with what they asked for. He had bills to pay, and there just wasn't the demand for Sāmoan or Polynesian-inspired tattoos from studio-based tattooists. In the early 1980s, according to Ma Ching, Sāmoans and other Pacific Islanders were not seeking cultural tattoos – 'they wanted the eagles, the tigers'. The commercial tattooing scene was not the place to go to find indigenous tattooing. He knew of no other Polynesian people in the tattoo industry at this time and thinks he may have been the first Sāmoan or Polynesian person employed in a commercial tattoo studio in New Zealand. In 1987, at the age of twenty-one, Ma Ching opened his own shop, Unique Tattoos, in the Queen Street Markets. After the markets closed down around 1990 he was invited to join New Zealand tattooing pioneer Merv O Connor at the Auckland Tattoo Studio. In 1995, Ma Ching opened Western Tattoo in New Lynn, Auckland, where his clientele would change and Sāmoan and other Polynesian styles would become more popular.

◄ • ►

103.
Makiko Kuwahara, *Tattoo: An Anthropology* (New York: Berg Publishers, 2005).

Not all the activity related to Sāmoan tā tatau was centred on Sāmoa or Sāmoan communities in New Zealand. People and events in places further afield were influential in sustaining the practice at home and abroad. While tufuga tā tatau were establishing themselves in Auckland, other Sāmoa-based tufuga were contributing to cultural revival efforts in Tahiti, where tattooing had been discontinued since the nineteenth century.[103] This particular revival process (and there may have been others) began in 1981 when tufuga tā tatau Lesa Li'o from Siumu village in Sāmoa tattooed twenty-one-year-old Ioteve Tuhipuha Puhetini from Rurutu in the Austral Islands in Eastern Polynesia. Ioteve travelled to Sāmoa with Tavana Salmon, who was the leader of the Polynesian Revue, a dance troupe based in Waikīkī, Hawai'i. When they arrived, their Sāmoan contacts, Asi Ekeni – Sāmoan minister of sports, culture and youth at the time – and Taumuafono Leatigaga Sio, arranged for the men to meet Lesa Li'o.

104.
Apelu Tunumafono, 'Reviving an Old Art for $35,000', *Pacific Islands Monthly* (January 1982): 23.

After studying photographs and drawings of old Marquesan tattoo designs, Li'o took six weeks to reconstruct a Marquesan tattoo on Ioteve which started at the neck and shoulders and extended the length of the body down to the ankles. The project cost Tavana about $35,000 but he considered it 'money well spent'.[104] Later in 1982, and building on this initial exchange, Tavana invited three Sāmoan tattooists to demonstrate the use of Sāmoan tattooing techniques at the Musée de Tahiti et des Iles and the annual Bastille Day celebrations in Tahiti.

105.
Jane Freeman Moulin, 'What's Mine Is Yours? Cultural Borrowing in a Pacific Context', *The Contemporary Pacific* vol. 8, no. 1 (1996): 128–53; Carol S. Ivory, 'Art, Tourism, and Cultural Revival in the Marquesas Islands', in *Unpacking Culture: Art and Commodity in Colonial and Postcolonial Worlds*, edited by Ruth B Phillips and Christopher B Steiner (Oakland: University of California Press, 1999), 317–33.

106.
Tricia Allen, 'Tatau: The Tahitian Revival', http://tattoos.com/tatau-the-tahitian-revival/ Kuwahara, *Tattoo*, 83, 185.

107.
Makiko Kuwahara, 'Making Multiple Skins: Tattooing and Identity Formation in French Polynesia', PhD thesis, 2003, 56–57.

108.
Ibid., 56.

The Sāmoans, including Lesa Li'o, returned to the event each year from 1983 to 1985, and had three Tahitians working with them. These encounters within the contexts of the museum and cultural festival in Tahiti mirrored the renewed interest in tatau around Sāmoa's political independence, and contributed to renewed local interest in the use of indigenous tattooing tools. Ironically, the annual Bastille Day celebrations were the catalyst for the public expression of indigenous Tahitian cultural identity in an artform other than music and dance or carving – which themselves had undergone tremendous change and been shaped by influences from other cultures of the Pacific.[105] For a short time, Tahitians engaged in a tattooing revival using indigenous tools, until public health and hygiene regulations eventually restricted their use.[106] Tavana and Raymond Graffe were among those who took up using the tools.[107]

The Sāmoan influence in the revival of tattooing in Tahiti highlighted the shared heritage between Pacific peoples – in their experiences of colonisation but also in technology (the tools are very similar in design and technique), language (the word for tattooing in Tahiti is also tatau), and customs. The tattooing of Ioteve showed how Sāmoan tatau practice could be a resource for the revival of other tatau traditions and – perhaps inadvertently – serve political agendas in other parts of the Pacific where there had been cultural loss or suppression of indigenous practices. A legacy of this project was realised through Ioteve's prominence as a dancer of Ia Ora na Tahiti and his winning of a Tane Tahiti (Mr Tahiti) contest, where the public display of his tattooed body inspired other Tahitians to get tattooed.[108]

From the mid 1980s and through the 1990s Sāmoan tattooists were sought out by tattooists and tattooing enthusiasts from America and Europe. Organisers of tattoo conventions flew them to locations in the United States and Europe to demonstrate their tattooing skills. Su'a Sulu'ape Alaiva'a Petelo's entrée into Europe came in 1983 when people from *National Geographic*, including New Zealand filmmakers, visited Sāmoa and interviewed him about his life as a schoolteacher, tufuga tā tatau and family man. Based on that visit, *National Geographic* produced a publication called *Blue Horizons* and screened the 1983 documentary *Signatures of the Soul*, fronted by actor Peter Fonda. The book and documentary sparked the interest of American tattooing statesman Don Ed Hardy, who also appeared in the documentary.[109] In 1985 Hardy invited Alaiva'a to attend *L'Asino e la Zebra* (the donkey and the zebra) – a major month-long tattooing convention to be held in Rome during May, where he joined high-profile tattooers including Horiyoshi III from Japan, Pinky Yun from China, and Americans Lyle Tuttle and Leo Zulueta.[110]

Alaiva'a's first trip to a convention was, in his own words, a disaster. He travelled by air via Fiji, Hawai'i and Canada, where he was stopped by border officials who questioned who he was, where he was going and where he was from. He had to convince them that he was a tattooist, and they even asked him to show them his tattoo. Fortunately, Alaiva'a remembered that Ed Hardy was going to meet him, and when officials paged him, Ed and Alaiva'a met for the first time. After experiencing visa problems at the Italian border, Alaiva'a finally reached his destination. However, he didn't tattoo in Rome as there was no one to stretch for him. He recalls:

> Everybody was working and I couldn't do anything, so I told them I had to go back, I can't do anything. I would have brought someone to stretch if I had known that I had to work here. They said, Well, we will give you the money if you come and model. I said, how much? They said $1000 US. I said why not? I'll do that! That's what I did, I modelled![111]

Alaiva'a remembers that he was well received at the convention by everyone involved. Whenever he modelled on stage the people would take out their cameras. Four of them were modelling – Alaiva'a, a Japanese man, American Bill Salmon and Horiyoshi's wife, Mayumi Nakano. Alaiva'a was supposed to model for two weeks but he pretended to be sick after just one week – he was suffering from a combination of culture shock, home-sickness and the cool climate. Nevertheless, he took home some permanent mementos of this visit in the form of tattoos by Hardy and Hawai'i-based American Kandi Everett, who was also at the convention. Alaiva'a's journey and short stay in Rome was a key moment for Sāmoan tufuga in their engagement with the Western tattooing milieu: it would open the door to new international audiences and to transformations in tatau.

Between 1986 and 1989 Alaiva'a had to turn down several invitations to overseas tattooing conventions because of his commitments as vice-principal at Chanel College in Apia. In 1990 he had an opportunity to travel again when Dutch tattooist and convention organiser Henk Schiffmacher (aka Hanky Panky) invited him to Europe to

109.
Signatures of the Soul – Tattooing Today, New Zealand On Screen, http://www.nzonscreen.com/title/signatures-of-the-soul-tattooing-today-1984

110.
Hardy & Selvin, *Wear Your Dreams*, 210–13.

111.
Su'a Sulu'ape Alaiva'a Petelo, interview with Sean Mallon at Faleasiu, Sāmoa, December 2002.

TATAU

tattoo at the second Annual Amsterdam Tattoo Convention at Paradiso, all expenses paid. This time Alaiva'a requested a Sāmoan to assist him with skin stretching. His host advertised in the local paper calling for any Sāmoans to come to the convention site. No one appeared, so Schiffmacher offered two of his own apprentices to stretch for Alaiva'a, and this arrangement worked out well. The Dutch tattoo enthusiasts who visited the convention appreciated the tufuga's presence, and were intrigued by his distinctive tools and style of tattooing. Alaiva'a was kept busy tattooing, with visitors and clients questioning him intently, wanting to know the names and meanings of every motif and design. Schiffmacher has his own recollections of when people first witnessed Alaiva'a's tattooing in Europe:

> They just loved it … they thought it was the craziest thing they'd ever seen. First it was the tools, they thought it was just brutal, but they all lined up for a beating … it had that initiation aspect which other tattooing did not have, so it was 'this shit is really serious!'[112]

112.
Henk Schiffmacher, interview with Sean Mallon, Amsterdam, 2004.

The first pieces that Alaiva'a and later Paulo made in Europe were only small bands like the pe'apisikoa, slabs of motifs or little fillings of various outlines. People wanted to experience the feeling of the Sāmoan tools. The tufuga needed guidance in some of the business transactions because they didn't know what to charge the customers; nevertheless, business was brisk and lucrative. Schiffmacher recalled, 'They put a European guy next to [the tufuga] to charge them [the customers] and he was "charging sky high" … So they went home with a stack of money, they were really, really happy when they went home.'

Into the 1990s, tattooists and tattoo convention organisers such as Schiffmacher and Berlin-based Frank Weber arranged for Alaiva'a and Paulo (and a toso or two) to travel on the major European tattoo convention circuits. The Europe-based chapters of the Hells Angels motorcycle clubs coordinated most of the activity at these events, so extensive networks were in place to manage and share the costs associated with supporting the tufuga as they travelled around Europe. Sāmoan tufuga tā tatau became like celebrities in the European tattooing community, attracting a large contingent of tattoo enthusiasts and the curious. Some of Schiffmacher's conventions attracted between 3000 and 4000 visitors a day. In the late 1990s, Alaiva'a's European convention schedule was often booked out well in advance.

The tufuga's trips to Europe didn't always revolve around tattooing conventions, though. For Paulo, there were occasions when people would organise an itinerary where he could stay and work out of tattooing shops or private homes in other European cities such as Madrid and Berlin. Amsterdam was a regular stop for Paulo; he would stay with local people such as Michel Thieme (aka Captain Caveman), a tattooist and tribal art dealer. He also spent a lot of time at Schiffmacher's Amsterdam Tattoo Museum contributing to the public programmes with lectures and tattooing demonstrations. A typical visit might involve Schiffmacher organising a two-week stay for Paulo, booking appointments for him in advance. There would be a schedule

and Paulo would know that on a particular given day a woman might be coming in the morning for a small shoulder piece, and a man in the afternoon for a large leg piece. This arrangement with the tufuga aligned well with Schiffmacher's vision for the museum, where visiting tattooers would give 'tattoo freaks an opportunity to come and see or get a souvenir from a different part of the world'.[113]

> Evening after evening he tattooed Captain Caveman and many others in the Tattoo Museum while explaining every new piece of pe'a he tapped in. The greatest moment was when Michel's […] pe'a got finished in the museum; prayers, rituals, the ceremony and the breaking of an egg on the spot where once Michel's fontanel had been. With tears in my eyes I realized that this is what I had worked for all my life. This was the real museum.[114]

In an interview in 1999, Paulo described the response to his work in Europe:

> Fantastic, fantastic. So it was 1996 I first started travelling … I went to Italy and Berlin and then later in the following years, up till now, I have been going all over Europe. […] In the first few conventions I went to, I had nothing to put into the competitions, but the years later – 1997, 1998 and maybe this year – I started putting work in because by then I had work around Europe to put in competitions. Just last year, I went to four conventions, one in Lucerne in Switzerland, one in Bologna in Italy, Malmo in Sweden and Berlin and I won four first-prize trophies in all of them. Twice to Barcelona, both first prizes, and once in Madrid. And many other places my work had been winning top prizes … in England and some in America.[115]

Reflecting on their first tours to Europe, and Amsterdam in particular, Schiffmacher recognised how challenging and transformative it was for the tufuga. He considered Paulo an ambassador for Sāmoan tattooing, but he suggests Paulo's and Alaiva'a's experiences in Europe opened up their own world as much as they were opening up Europeans' eyes to the Sāmoan world through tatau.

> The Samoans when they came here first, it was very difficult for them, because we had the tattoo shop and museum in the middle of the red light district, with all the women behind the windows … They [the tufuga] didn't want to work on Sunday … they had to go to church. So actually we were, by broadening their view, we were actually shaking the foundations of their view on life. The first couple of times they didn't want to do anything on Sunday, but then later on they started to mind less … For them, morally it was in the beginning very heavy to be in such a liberal society, liberal to [see] drugs and sex … it was kind of strange for them.[116]

The European tattooing world didn't just attract the tufuga tā tatau; sometimes the natives of Europe came to the tufuga tā tatau. Auckland and Sāmoa became destinations for people wanting to be tattooed. Sāmoan tā tatau answered the call of the wider world, but it also drew the wider world in to Sāmoa. It is easy to get accustomed

113.
Ibid.

114.
Henk Schiffmacher, 'In Memoriam: Paulo Suluape "The chief is dead, long live the chief!"', July 2002, http://www.tattoomuseum.com/top/memorial.html.

115.
Mallon, 'A Living Art', 57.

116.
Henk Schiffmacher, interview with Sean Mallon, Amsterdam, 2004.

TATAU

Fig. 54
Pencil drawing made by Su'a Sulu'ape Paulo II while recovering in hospital in Amsterdam in 1999, and then gifted to Sulu'ape Michel Thieme.

to talking about the global traffic in ideas and culture from the point of view of Europe or other metropolitan centres, but, as we have seen in chapter 1, for example, from at least the 1700s people from outside Sāmoa, such as the Tongans, would come to Sāmoan tufuga as much as the tufuga went to them. A simple centre-periphery model of exchange for tatau begins to crumble when we become aware of a longer history of the movement of people and ideas both in and out of Sāmoa.[117]

In the 1990s, some tattooers and clients from Europe visited the tufuga at home in Sāmoa or in New Zealand: Schiffmacher, for example, visited Paulo in New Zealand and Alaiva'a Petelo in Sāmoa. He wanted to visit the 'Navel of the Tattoo world' and recalled that the trip '… was amazing, full of warmth, hospitality and the traditional beating that goes along with the tatau, which I will not easily forget.'[118] Paulo invited tattooist Pili Mo'o to visit him in New Zealand for an extended stay, and others just turned up unannounced. Two brothers, John and Marwan Atme from Sweden, visited Paulo in Auckland in the early 1990s and, like Mo'o, lived with him and received a tatau. Michel Thieme, who had developed a close relationship with Paulo while hosting him in Amsterdam, visited and tattooed with him in his shop in Otara, South Auckland. Similarly, in Sāmoa, tattooing enthusiasts from Europe were always turning up unannounced in taxis at Alaiva'a's house looking for him. As one observer recalled, some tourists would go 'straight to his place and they were behaving like they were visiting the Dalai Lama … He [Alaiva'a] was laughing about that.'[119]

Closer to home, another brother in the family, Su'a Sulu'ape Petelo, accumulated a history of travel that saw him tattooing across the Sāmoan diaspora on a regular basis. He first went to Hawai'i in 1977, where he tattooed five people; in 1987 he was tattooing in Long Beach, California where, according to McGrevy, he had fifteen people at various stages of being tattooed.[120] Throughout the late 1980s and early 1990s he was commuting between Australia and New Zealand, before settling in Sydney in 1995 and tattooing a growing Sāmoan community that was emerging in the city's suburbs. A fourth brother, Su'a Sulu'ape Lafaele, was known for his work in Sāmoa, where he was based on the island of Manono.[121]

117.
See Mallon, 'Sāmoan Tattooing, Cosmopolitans, Global Culture', in *Tatau: Samoan Tattoo, New Zealand Art, Global Culture*, edited by Sean Mallon, Peter Brunt and Nicholas Thomas (Wellington: Te Papa Press, 2010), 15–32.

118.
Henk Schiffmacher, 'In Memoriam: Paulo Suluape "The chief is dead, long live the chief!"', July 2002, http://www.tattoomuseum.com/top/memorial.html.

119.
This observation was made by Sébastien Galliot during his fieldwork in Sāmoa and recalled in an interview conversation with Brent McCown in 2015.

120.
McGrevy, 'O le Tatatau', 86.

121.
Unasa LF Va'a, 'Tatau: From Initiation to Cultural Symbol Supreme', *Proceedings of Measina a Sāmoa Conference 2 & 3* (2008): 91–119, at 107.

The growth of Sāmoan populations overseas had a profound influence on the practice of tatau. As scholars have noted for Sāmoan society and culture in general, tatau has transformed and been shaped by the distinctive social conditions and circumstances of different places. Growing up Sāmoan in Los Angeles brings with it a different set of experiences than growing up Sāmoan in Auckland or Honolulu. The diaspora is not one that is disconnected from Sāmoa; it is transnational, as people claim and maintain connections to Sāmoa even if many of them have not been there. Many of these connections are social and are strengthened through communication on social media, by email and telephone, and through sending remittances,[122] but also through constant travelling or malaga, attendance at funerals and weddings, and through membership of village, school, church and other cultural associations.[123] These transactions involve the transfer or circulation of money, labour, knowledge and information. People and resources move to and fro on these transnational networks, and tatau – like other cultural activities – is shared and contested, reproduced and often transformed.

In Auckland and other centres of the Sāmoan diaspora, the Sāmoan community were active agents in shaping tatau and how it looked and what it meant in the skin and in society. The taulima as a legacy of the Peace Corps interest in tatau became the most popular form of tatau across the diaspora in the late 1980s and through the 1990s. It served as a marker of identity for young people of Sāmoan descent in cities such as Auckland, Sydney, Honolulu and Los Angeles. If the occasion of Sāmoa's independence had seen renewed interest in tatau, arguably as a backlash to colonialism, the 1990s was a period where an unconscious resistance to the forces of globalisation of culture was mobilising. Sāmoans were embracing some aspects of being Polynesian or a Pacific Islander in the multicultural and transnational communities they were living in, but they were also resisting – strategically at times – a pan-Polynesian identity and seeking out cultural specificity in the so-called cultural melting pot.

In 1995, when Steve Ma Ching opened Western Tattoo in New Lynn, he was one of a growing number of machine tattooists working in Sāmoan communities in Sāmoa and American Sāmoa, Hawai'i, the United States and New Zealand. It is difficult to be precise about the exact numbers of machine tattooists, as many of them worked privately from home. They were prolific producers of tatau who built on the work of the tufuga tā tatau, giving Sāmoan tatau forms visibility and relevance in the twenty-first century. Some of the most prominent machine tattooers of Sāmoan and Polynesian designs in 2018 began their careers in the 1980s and 1990s. Many of them have a connection to the Sulu'ape family, even though they are based in tattooing shops or studios and work almost exclusively with tattooing machines. Some, over the course of their careers, have transitioned from home and garage-based operations to more professional premises. Some have moved from rudimentary technology to state-of-the-art tattooing machines.

122.
A remittance is money sent home to Sāmoa to assist family members with paying school fees, expenses for church or home building and other cultural events such as weddings and funerals.

123.
SI Lilomaiava-Doktor, 'Beyond "Migration": Sāmoan Population Movement (Malaga) and the Geography of Social Space (Vā)', *The Contemporary Pacific* vol. 21, no. 1 (2009): 1–32. For historical precedents, see Salesa, '"Travel-happy" Samoa', 171–88.

TATAU

124.
'Sir Q's Tattoos', in *Frank 151,
Chapter 35: Samoa* (2012), 69–70.

In 1989 Akiu 'Q' Sale, who was born in American Sāmoa but raised in Hawai'i, began tattooing his friends using a needle and thread in a technique known as su'isu'i. He progressed to a homemade tattooing machine and later opened the first tattooing studio in Tutuila, American Sāmoa, called Q's Tattoos.[124] In 1998 Sale moved back to Hawai'i and, after working in several tattoo studios, he opened House of Ink. In the early 1990s Sāmoan/Irish/Sicilian Sulu'ape Steve Looney began tattooing friends at high school in Anaheim, California, using a homemade tattooing machine. He had spent much of his youth in American Sāmoa and was very much inspired to pursue art by his art teacher, To'afa Iosua. He went on to be a professional tattooist and eventually opened his own studio, Pacific Soul Tattoo, in Honolulu. In 2001 he met Su'a Sulu'ape Alaiva'a, with whom he developed a strong working relationship; he eventually received a tatau and the Sulu'ape title.

Aside from the tattooists who moved from their bedrooms and garages to studio settings there were still many backyard tattooists who were quite prolific in their output and were accessible in neighbourhoods that were distant from more commercial premises. The establishment of tattooists in professional studios allowed for a different kind of relationship between tattooists and the tattooed person in which the client could have a greater say in the customisation of the tatau; the process could be customer-led or co-designed, or left to the imagination of the tattooer.

125.
Malagamaali'i Lavoa Vui Levi
Fosi, interview with Sean Mallon,
November 2002.

Regardless of who was making the tattoos, most taulima that were fashionable in this period were narrow bands of motifs, placed around the upper arm or the wrist. Before the arrival of the pe'apisikoa, most Sāmoans in Sāmoa would have preferred to be tattooed with a taulima around the wrist[125] or, sometimes, a tauvae (anklet). Most taulima in the late 1980s were very simple bands featuring only a few repeated motifs found in the male tatau such as talalaupaongo – the thorned edge of the pandanus leaf; mulialiao – the muli (end) of the aliao (conch); and vae'ali – the legs of a bamboo headrest. Tufuga tā tatau Su'a Vitale Fa'alavelave, who was tattooing pe'a and malu from his home in Wellington, produced his own photocopied sheets of tattoo flash (designs) highlighting the variation and forms of taulima, and even an example of the pe'a and malu, that customers could commission from him.[126]

126.
They ranged from $50 to $100
for a taulima, $500 for a malu and
$1000 for a pe'a.

Ma Ching looked to his own tatau for inspiration in designing his taulima for customers, isolating particular elements and creating new compositions. By the mid 1990s the format of the taulima had expanded to accommodate a wide range of images symbolic of Sāmoan society and culture. They included tanoa fai 'ava (kava bowls), nifooti (cane knives), fue (flywhisks) and fale (houses) – and the Sāmoan national crest or coat of arms. Occasionally, text rendered in a flowing script reminiscent of Hispanic tattooing styles in the United States, or in Old English-style font, would spell out 'Sāmoa' or family names.

Taulima were usually small and affordable. In New Zealand in the late 1980s the cost of a tattoo was around $50, but by the late 1990s it had risen to around $100. The price was often negotiated on a case-by-case basis. Sometimes this could depend on the size

of the person as well as the quality and extent of the work. In 1999, I witnessed a terse negotiation while conducting an interview with Suʻa Suluʻape Paulo II in his garage studio in South Auckland.

> We had been talking for about 45 minutes when a carload of teenagers who had probably just finished their day at school pulls up outside the house. The biggest boy climbs out of the car and ambles up the driveway to the studio's sliding door. Pushing his head in just through the doorway he says to the tufuga: 'A few of the boys want to know how much it will cost to get our taulimas done.' The tufuga looks him up and down for a few seconds then says: 'I will do them for $150.00 each. Come back tomorrow, I'm busy.' As the boy slopes off down the driveway I ask the question: 'Didn't you just say a minute ago that a taulima costs $100.00?' The tufuga replies: 'Didn't you see the size of that guy's arms, they are wider than my legs!'[127]

127.
Mallon & Fecteau, 'Tatau-ed', 10.

In New Zealand, the taulima was also informally and (incorrectly) called a sogāʻimiti, a term usually referring to the customary role of the tattooed male but here reduced to mean a tattoo. The occasional renaming of the taulima in this way highlights how Sāmoans could be agents for the transfer as much as the transformation of knowledge relating to the tatau. People would ask a person with a taulima, 'Oh, how much was your sogāʻimiti?' as they reached forward and rubbed the person's tattooed upper arm. In reality, the taulima was not a licence to perform the role of the sogāʻimiti. Taulima don't carry with them the same social responsibilities as the tatau and malu that relate to duties such as mixing and serving ʻava in Sāmoan ceremonies. Nevertheless, Sāmoans were also responsible for developing the taulima into a tattoo that carried a range of meanings for those who wore it. With the growing popularity of taulima the complexity of Sāmoan identities became visible in many ways – it was more than a souvenir of travel or cultural encounter.

The taulima and text-based tattoos that became popular in the 1990s were mechanisms for many young people to address issues of cultural distance, displacement and disconnection from the homeland of their parents. Taulima served the cultural needs and reflected the diverse experiences of contemporary Sāmoans who were often the second- or third-generation descendants of Sāmoan immigrants, and the children of Sāmoans who had intermarried with non-Sāmoans. It is in these multicultural conditions that Sāmoans of Chinese descent whose ancestors came to Sāmoa at the turn of the century began wearing their identities and bloodlines in a public way. Young Sāmoan–Chinese turned to Chinese cultural motifs and figures, they incorporated them into their own Sāmoan-style compositions and approached tattooists to have them tattooed. In multicultural societies where cultural identities and distinctiveness were important, Chinese motifs and imagery began to emerge within Sāmoan tattooing as second- and third-generation Sāmoans chose to claim and express their part-Chinese ancestry and identities.

In the 1980s and 1990s, with the popularity of martial artist and Hong Kong movie star Bruce Lee, it was cool to be Chinese – and this cultural pride only increased as Chinese martial arts films and other aspects of cuisine, fashion and culture became more globalised and popular. People gravitated towards the most culturally distinctive motifs, including dragons and Chinese calligraphy. Hermann Taufale, who is of Sāmoan–Chinese descent, designed his own taulima based on a composition of Sāmoan/Polynesian motifs that included the first letters of his children's names, a stylised Silver Fern to highlight his connection to New Zealand, and the Chinese Zodiac sign of Gou (dog) representing the year he was born (1970).

New Zealand Sāmoan Paul Lefaoseu also honoured his Sāmoan–Chinese roots and his relationship with his deceased twin brother Peter by getting tattooed with Chinese characters representing the phrase, 'I eat from the same bowl as my brother'. This acknowledged how he and his brother as twins had shared and were nurtured in their mother's womb together for nine months, as well as the time they spent together in the world before his brother's death.[128] This claiming of distinctiveness by contemporary Sāmoan–Chinese within a celebrated Sāmoan cultural practice resists the early-twentieth-century history of discrimination against Chinese and their segregation from mainstream Sāmoan society – although even in the twenty-first century there are still racist attitudes towards, and ambivalence about, the valuable historical contributions and the contemporary presence of Chinese in Sāmoa.

Diasporic Sāmoans' use of tatau to explore and mark their cultural heritage was mirrored by Sāmoans in Sāmoa using tatau to express their identity in the homeland. This wasn't a new process for Sāmoa – as we have seen, tattoos of all kinds have served this role across time. But whereas youth in the 1980s were interested in eagles, snakes and tigers, in the 1990s people were inspired by and looked to their experiences of global popular culture, its imagery and ideas. In 1996 I encountered a young man in Apia who wore a tattoo of the Nike 'swoosh' above his taulima. These two symbols side by side on the arm of a Sāmoan in Sāmoa formed a striking contrast that signalled a worldliness, a connection to other people and places that is so often not considered the experience of indigenous people.

But to what extent did it indicate a global awareness? The images and associations of the Nike brand are no doubt attractive to the young Sāmoan. To some degree it was probably a way for this man to attain the unattainable. Acquiring a pair of anything genuinely of the Nike brand would be difficult in Sāmoa at the time, but branding oneself with this symbol could be seen as potentially a powerful statement of, or desire for, worldliness – an incorporation into an idea or sense of being that is bigger than Sāmoa. The Nike brand is marketed globally to epitomise success and the sporting lifestyle; it is perhaps no surprise that young people are attracted to it and that this young Sāmoan was wearing it.

The taulima was not enough for some people. Sāmoan fashion photographer Greg Semu, who lived in Auckland in the mid 1990s, was tattooed by Paulo with half sleeves

Fig. 55
Taulima (armband) featuring the global sports apparel brand Nike, Apia, Sāmoa, 1996.

128.
Hermann Taufale, correspondence, 2000; interview with Paul Lefaoseu, July 2017.

TATAU

covering both his arms from shoulder to elbow. Reflecting on this rupture of the standard taulima design, he said:

> the taulima … I felt was fashionable but wasn't enough of a statement for myself personally, it was a connection with my roots as with fa'aSamoa and my heritage and I just thought a taulima wasn't enough. I wanted to show that I was serious about making this connection.[129]

Aside from his full tatau, Semu's distinctive tattooed sleeves were a precedent, a sign of things to come. The size and placement of the extended sleeve offered more opportunities for tattooists to experiment with their compositions, expanding their canvas and creativity. Into the 2000s, with many young people seeking the tatau and actively shaping how it looked on the skin and what it stood for, a new generation of tufuga tā tatau would step forward to play an active role in some of this work. Su'a Sulu'ape Peter, the oldest son of Alaiva'a Petelo, would take up residence in Auckland. He would innovate with his design and rendering of taulima, changing the flow and juxtaposition of the tattooed lines and groupings of motifs, pushing out beyond the confines of the narrow band to cover more of the upper arm and shoulder.

◀ • ▶

Cultural festivals played a role in stabilising the practices associated with tatau. They also created circumstances for new developments. In the postwar period, cultural festivals were contexts for celebrating local, national and regional identities. Art and other cultural practices were the media of choice through which cultural persistence and innovation were celebrated and displayed.[130] The South Pacific Festival of the Arts, now the largest and most high-profile regional festival, was established in 1972 in Suva and is hosted by a different island nation every four years. Its initial aims were to preserve traditional cultural practice by sharing and exchanging culture between the Pacific Island nation states. In 1996 it was held in Apia, Western Sāmoa.

Planners for the festival intended to have a guard of honour made up of 600 tattooed men for the formalities of the official welcome – and if they couldn't find them, one of the organisers joked 'we are going to have to draw the tattoos on'.[131] Special fales were built on Apia's waterfront for tattooing demonstrations. They were a popular attraction for festival goers and were monitored by bright puletasi-wearing Peace Corps workers, some of whom were also receiving tattoos. A couple of the young female American Peace Corps volunteers were tattooed with the malu motif in the hollow behind the knee. This was controversial among the New Zealand-based Sāmoans who witnessed it; they quietly expressed their disgruntlement and in some cases disbelief at the Americans' appropriation of a key female motif and the tufuga's willingness to tattoo it. It was a clear demonstration of how the producers of tatau were implicated in the processes of tatau moving between cultures and on to non-Sāmoan bodies.

129.
'Tatau: A Journey, Part 1', TheCoconet TV, 31 October 2013, https://youtu.be/DSipr5t4Gg.

130.
S Mallon, 'Tourist Art and Its Markets 1945–1989', in Art in Oceania: A New History, edited by Peter Brunt and Nicholas Thomas (London: Thames and Hudson, 2012), 384–409.

131.
Chris Peteru, 'The Pacific's Grand Cultural Celebration', Pacific Islands Monthly vol. 66, no. 9 (1996): 47.

Fig. 56
Sogā'imiti (tattooed men)
at the Festival of Pacific
Arts in Apia, Sāmoa, 1996.

In a throwback to earlier practices, lama (tattooing pigment) was being prepared in a small coconut-frond shack behind the faleo'o (small house) where the tattooing took place. By the 1990s candlenut soot was rarely used for making lama; soot from a kerosene lamp was more common. Alaiva'a attributed this development to his father Su'a Sulu'ape Paulo I: 'My father decided to have something else and he started getting the soot out of a kerosene lamp, and he used Bluo as one can never mix carbon with water. The Bluo makes the dye last and keeps it shiny.'[132] Steve Ma Ching recalls the use of Bluo laundry brightener when he received his tatau from Pio Fa'amau in Auckland in 1989. Elsewhere, changes in materials such as lama used for ink have been attributed to the loss of rainforest and access to plants such as candlenut.[133]

One of the most memorable scenes at the festival was a group of young women from Sāmoa College, who were celebrating getting their malu together. They were posing for photographs and dressed for the occasion in a uniform comprising necklaces, white T-shirts and yellow-patterned lavalava modestly hitched up to reveal the malu to onlookers. Similarly, in this context – an occasion for cultural pride – the Sāmoan dance troupe was all tattooed, presenting to audiences the complete Sāmoan male and female dancer.

The international influence on tatau in Sāmoa revealed itself in other small ways during the festival. To address concerns around hygiene standards, Dettol and a toothbrush were used to clean the tattooing tools and to wash a man's tatau at a water pipe, and Perspex was used in the construction of the au, supposedly to aid the cleaning of

132.
Jennifer Grimwade, 'Revival of an Ancient Art: Tattoo Tricks Catch on Again Among Samoans', *Pacific Islands Monthly* vol. 63, no. 9 (1993): 42–43.

133.
Inga Stünzner, 'The Man with the Double Tattoo', *Talamua, the Samoan Monthly Magazine* (Feb 1998), 36.

Fig. 57
Young women of Sāmoa College with newly tattooed malu, Festival of Pacific Arts, Apia, Sāmoa, 1996. From left: Fetutasi Faleao Filo, Fa'ani Tavui Toatasi, Salota Tafaoali'i, Foini Samuelu, Fiailoa Tafaoali'i and Tosega (front).

Fig. 58
The preparation of lama (tattooing pigment) involves burning candle-nuts and collecting the soot from the underside of a stone. Festival of Pacific Arts, Apia, Sāmoa, 1996.

Fig. 59
In the 1990s, tufuga incorporated acrylic, nylon and other synthetic materials into the construction of their tattooing tools to improve hygiene.

the tools. Indeed, the establishment of a small fale for the public display of tattooing was itself an outcome of the festival's requirement for Sāmoan culture to be performed for tourist audiences in an accessible way.

Other events helped stabilise tatau and establish its importance within the culture for new generations of Sāmoans overseas. In New Zealand, an exhibition called *O le Tatau Samoa* at the NEW Gallery, Auckland, featured the photography of Greg Semu and the tatau of Su'a Sulu'ape Paulo II. It was a landmark exhibition that celebrated and made tatau visible to a new generation of Aucklanders, especially when a selection of images from the portfolio was published in the Auckland-focused but nationally distributed *Metro* magazine.[134] Through his gritty black-and-white photography, Semu had documented his own journey of getting the tatau. His project could be described as autoethnographic and about the possibilities of photography, but it was also an argument for understanding tatau as art – an aspect not missed by Keith Stewart, art critic for the *Sunday Star-Times*:

> At this point [the photographs] make the four-dimensional art of tatau, from one that has breadth, depth, width and time, into another two-dimensional form that is set in a specific time. It makes tatau part of the wider, less personal art of photography and further, part of the spiritual-gallery house art of western Europe and pakeha New Zealand.[135]

Tatau also had a growing public profile in Australia, where it was demonstrated in public programmes at the Powerhouse Museum in Sydney and as part of events organised by Leo Tanoi of Eye-Land Style Productions, including the tattooing of taulima at a nightclub called Kinselas. Taking Sāmoan culture to new urban contexts, Tanoi was concerned with using tatau as a focal point for strengthening a sense of

134.
Greg Semu, 'O le Tatau Samoa: The Tattooing of the Samoan People', *Metro* 177 (March 1996).

135.
Keith Stewart, 'A Rare View of the Pacific Way', *Sunday Star-Times*, 24 March 1996, F2.

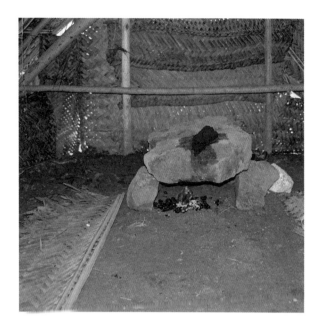

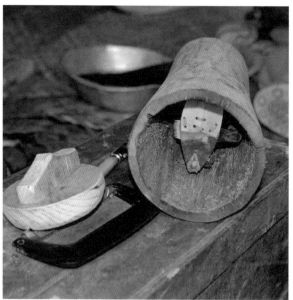

Sāmoan identity among young people.[136] At the Pacific Wave Festival in Sydney in November 1996, Sāmoan tattooing featured in a theatre production called *Tatau: Rites of Passage* devised by ZEAL Theatre Company, Sydney, and Pacific Underground from Christchurch, New Zealand. A highlight of this play was the actual tattooing of Sāmoan Fa'amoana Ioane on stage by Su'a Sulu'ape Paulo II. According to Anton Carter:

> The story followed the journey of a troubled Samoan man who loses his sense of self in the harsh realities of life in the New Zealand prison system. After 25 years in this environment, the culture of that system becomes his culture and his way of life. The turning point comes with his father's death and the opportunity to go through the painful process of receiving the Sāmoan male tatau or pe'a.[137]

Tatau: Rites of Passage was a critical success, and was performed in New Zealand as well as Australia. Oscar Kightley, from Pacific Underground, reflected on the importance of the Pacific Wave Festival in Australia and a theatre performance like *Tatau* for audiences there:

> I think the scene over here is very interesting. It's like Auckland 15 to 20 years ago … Australians are so ignorant they view Pacific Islanders as still running around in grass skirts – and that is why the Pacific Wave Festival was so important. We have demonstrated that we have living, breathing, vibrant cultures full of problems and happy moments.[138]

136.
Liz Thompson, 'Eye-land Style: Resurrecting Samoan Culture', *Pacific Islands Monthly* vol. 66, no. 7 (July 1996): 53–54.

137.
Anton Carter, 'Taking Centre Stage: Pacific Theatre in New Zealand', in *Pacific Art Niu Sila: The Pacific Dimensions of Contemporary New Zealand Arts*, edited by Sean Mallon and Fuli Pereira (Wellington: Te Papa Press, 2002), 124.

138.
Lili Tuwai, 'Celebrating the Pacific: Sydney's Pacific Wave Festival Dispels Stereotypes and Common Myths About Island Cultures', *Pacific Islands Monthly* vol. 67, no. 1 (1997): 52.

◄ • ►

Fig. 60
The 1996 theatre
production *Tatau: Rites
of Passage* involved
Fa'amoana Ioane being
tattooed on stage by Su'a
Sulu'ape Paulo II.

139.
Leulu Felise Va'a, *Saili Matagi:
Samoan Migrants in Australia*
(Suva: Institute of Pacific Studies,
University of the South Pacific
& National University of Samoa,
2001).

However, the more tufuga tā tatau worked beyond their community, the more people in the Sāmoan communities in Sāmoa and abroad felt that tatau was being misappropriated and coming under threat. In the late 1990s Su'a Sulu'ape Paulo II was troubled by the public scrutiny and debates. Three areas of criticism stood out in this period: Sāmoan community discomfort with the commercialisation of tattooing; the tattooing of non-Sāmoans, especially pālagi; and the tattooing of a woman with a male tatau. Sāmoans, especially in New Zealand, were concerned about losing Sāmoan tattooing to the outside world.

This was understandable given the long history of cultural appropriation in the Pacific and worldwide by indigenous and non-indigenous people. The changes in tattooing practices and customs were seldom attributed to changes within Sāmoan society itself. The history of tatau was not widely known, and apart from among academics and professional historians, a critical understanding of change was not part of popular discourse. Much of the threat to tatau and its practices was seen to come from tufuga tā tatau and non-Sāmoans, when in fact the most active instigators of change were Sāmoans seeking to be tattooed.

For several years Paulo had drawn criticism from Sāmoan community leaders and matai in New Zealand for his acceptance of cash for his tatau work: they preferred that he abide by the fa'asāmoa way of being compensated for services rendered – that is, with 'ie tōga and other customary goods. Traditionalists insisted that the commercialisation of Sāmoan tattooing was unacceptable. It was a strange accusation for people involved in Sāmoan customary practices to make, because cash was and still is widely accepted as being part of many important transactions in Sāmoan society: matai title bestowals and weddings are just two examples where cash is included in the gifts and valuables exchanged between participants.[139] In my conversations with Paulo, he argued that in South Auckland it was impossible to survive without a portion of his work paid for in cash.

> I have opted for cash only here. I have a list of about ... maybe close to 50 people – we did it in the Samoan way ... and I will wait for the last day and they will come and give me payment in Samoan terms and they run away. So I have wasted all this time. I use power, I have to pay bills too, you know.

Some clients did not have access to customary goods like 'ie tōga, or the time or community networks to accumulate them. Cash was more convenient. Paulo recognised that clients' financial or social circumstances varied and flexibility was required to maintain his practice. Despite his trying to be accommodating, some clients didn't pay in time – or at all – in fa'asāmoa goods or in cash. In his defence he argued:

> They criticise me for going commercial here, but if I go back to the real Sāmoan way there would probably be families sitting on the road under a tree without houses here, because if I like a house I will say 'I would like to take this house with me' but it is not just a house it's anything ... anything. [By this Paulo means

T A T A U

146

that if he was to abide by his critics and seek fa'asāmoa forms of payment, then he could demand a house or anything else he saw fit as payment for his work.][140]

On this particular point Paulo may seem to have been taking some creative licence in his reference to 'the real Sāmoan way', but he was actually correct – there are historical precedents for seizing property for payment of a tufuga tā tatau's services.[141] The realities of working in New Zealand led Paulo to conduct his business in new ways to suit local circumstances, to seek new markets for his work, and to respond to the changing needs and requirements of his clients. This included not rushing the work.

> I have got pe'a that I have been doing for the last year. I am not in a rush to complete the pe'a and get the cash. I am more concerned about the health of the people and their jobs to feed their families, because you realise that you don't eat po'a. When people get too big a piece and they get sick and they get fired from their jobs . . . they don't come home and say, 'Let's cook this pe'a and feed the family.' Be sensible about it. I think that is the way to go about doing pe'a in New Zealand. Here you don't have plantations, you have to work, and I tell people that. But there are people that want to rush.[142]

In 1996, Paulo set up a small tattooing studio in a shopping mall in the South Auckland suburb of Otara. This seemed to operate like any other tattoo studio except there were woven pandanus mats on the floor and no chairs. The storefront was ceiling-to-floor plateglass windows, the walls were covered in tattoo flash lit by intense white fluorescent light. The client would be sprawled on the floor with the tufuga tapping away and toso sitting cross-legged around them with arms stretched out. In this environment, sometimes the commercialisation and selling of tatau was blatant, and the production streamlined.

Michel Thieme, who lived with Paulo for a while, recalls a production-line approach on one particularly busy day when he was involved in finishing off taulima and pe'a for Paulo using an electric tattooing machine. Paulo also occasionally worked with tattooing machines, especially to render smaller motifs. It was not a common practice for tufuga tā tatau to deploy tattooing machines in such a way, so this approach might have understandably offended customers who wanted their tatau to be done with indigenous tools and within certain cultural conditions that didn't degrade the process for them.

For Paulo, criticism for tattooing non-Sāmoans with the pe'a seems to have surfaced several years after tattooing the New Zealand artist Tony Fomison in 1980. It became more intense through the 1990s, when the Sulu'ape brothers were tattooing internationally and news media started reporting on their work. Paulo defended his work in this area, and referred to the long history of Sāmoan tufuga tattooing non-Sāmoans. This history was important to him, because Paulo had ambitions to share his knowledge of tattooing with other Pacific peoples and to teach them how to make tattooing tools and use them. For example, he established connections with Māori, who have their own tradition of tattooing in tā moko.

140.
This material comes from an interview between Su'a Sulu'ape Paulo II and Sean Mallon; see Mallon, 'A Living Art'.

141.
Western Samoa (Report of Royal Commission Concerning the Administration of), Appendix to the Journals of the House of Representatives, 1928 Session I, A-04b, page 183.

142.
Mallon, 'A Living Art', 60.

TATAU

Fig. 61
Poster for the South Pacific
Tattoo Show, Auckland,
New Zealand, 1998.

In 1995, in an effort to strengthen cultural connections between Māori and Sāmoans, Paulo gave a tatau and gifted tattooing tools to Māori carver Vern Rosieur. The ceremony attracted much interest in the Māori community and featured on national television. Paulo had also developed a close friendship with tā moko artist Inia Taylor and worked from Taylor's studio, Moko Ink, in Grey Lynn. He tattooed several other Māori with full pe'a, including a Catholic priest, Anthony Brown. Like his ancestors before him who had tattooed non-Sāmoans for centuries, Paulo was continuing to share the practice, and it was a trend that would be maintained.

Scrutiny of Paulo's practice intensified when it became known in the community that he had tattooed a woman with the male pe'a; he and other Sāmoan cultural experts were interviewed on New Zealand national television about the matter. The woman had approached him many times over four weeks and after he refused each time, she finally said that if he didn't do the work she would find someone who would. Paulo relented and referred in his media interview to the history that the women originally had the tatau and not the men. He was supported in his argument by Sāmoan academic Galumalemana Alfred Hunkin, who referred to a popular song about the legend of Taemā and Tilafaigā, but another academic, Afamasaga Maria Williams, saw the tattooing of a woman with the pe'a as a violation of the male and female gender roles in Sāmoan society.[143]

143.
This interview was featured as part of the documentary *Tatau: A Journey*, directed by Lisa Taouma, 2004.

Some leaders in the Sāmoan community saw Paulo's tattooing of non-Sāmoans with the pe'a and malu as undermining its cultural significance. In the face of this criticism, Paulo attempted to justify his practice and assert his authority over it. One public display of his authority over tatau was a Sāmoan tatau competition and show held at the Apia Way Nite Club in Auckland in July 1998.[144] Initiated and run by Paulo, the competition was a high-profile event; advertisements in local Sāmoan-language newspapers, on radio and on posters at the time described it as the 'inaugural South Pacific Tattoo Show'.

144.
A VHS video of the grand final was commercially available and titled *The Grand Final: The Annual South Pacific Tattoo Show 1998*, produced by Video-Aau Productions.

Despite the inclusive-sounding title the competition was specifically for people with Sāmoan tatau, with trophies, cash and travel prizes for Mr Tattoo Sāmoa NZ and Miss Tattoo Sāmoa NZ. The Auckland competition was followed a few weeks later by another in Wellington. As far as I am aware they are the only two shows of this kind held to date in New Zealand, although local business people who sponsored the South Pacific Tattoo Show originally intended it to be an annual competition. In this first year, the winners of the New Zealand final would compete in the grand final held in Apia, Sāmoa. The contestants were Sāmoan and non-Sāmoan men and women tattooed with either the pe'a or the malu, wearing a short 'ie lavalava that revealed the wearer's pe'a or malu to the best advantage.

When called out by the MC, participants walked into the middle of the dance floor, surrounded on three sides by the audience, who reacted by laughing, cheering or clapping. The audience was made up of local Sāmoans and a few non-Sāmoans who were mostly from the local tattooing community. The panel of judges comprised community

leaders and an apprentice tufuga as a scrutineer. There were twelve judging categories for tatau and seven for malu. These categories focused not only on the aesthetic appearance of the tatau, but also on the wearer's ability to perform a range of skills important for the tāupou (high-ranking young woman) or the sogāʻimiti (tattooed man). The women had to perform the ceremonial mixing of ʻava, and then a siva (dance). The male contestants were required to demonstrate proficiency in ritual performances relating to the ceremonial serving of ʾava to matai, dancing and speechmaking.

Despite the fact that the judging criteria focused on a detailed knowledge of Sāmoan protocol, the competition attracted contestants who were obviously not versed in the performance of this protocol. They included a non-Sāmoan and one or two part-Sāmoans who reverted to caricatures of bodybuilding poses to show off their tatau. This encouraged laughing and cheering from the crowd but offered little dignity to the tattooing. In most cases, the non-Sāmoan and part-Sāmoan contestants did not even attempt to perform the faʻasāmoa requirements.

One contestant who was reluctant to be there at all told me that he took part in the competition to honour the tufuga who had tattooed him, rather than to attempt to win anything. I found out later that several contestants, including the non-Sāmoans, had been invited by Paulo to take part because of the quality of their tatau. Prizes awarded in the competition included the Suluʻape belt – a very wide belt with a huge flat, decorated buckle, similar to wrestling or boxing title belts. There were also various trophies, and airfares to Sāmoa to enable winners to compete in the grand final.

Officially, the South Pacific Tattoo Show was designed to identify the best examples of Sāmoan male and female tattooing. The competition emphasised competence in the knowledge and skills of those who wear the tattoo in Sāmoan cultural contexts – the sogāʻimiti (tattooed men) and the tāupou (daughters of matai). It also focused on the quality of the tatau markings. Beyond this, the competition provided an opportunity for other wider and more pressing issues to be addressed. For Suʻa Suluʻape Paulo II, the tufuga who was running the tatau competition, the event would have been both timely and politically advantageous. The high profile of the South Pacific Tattoo Show and the packed venues were useful to Paulo as an affirmation of the place of tatau in the cultural territory of faʻasāmoa, the very system of custom and protocols he was being accused of breaking away from.

The competition reinforced his tattooing practice as an important cultural practice of faʻasāmoa, and faʻasāmoa was reinforced as integral to tatau. While the competition may have been an effort to placate critics in the Sāmoan community, however, it was also a defiant reassertion of authority of the tufuga tā tatau over his craft. Paulo's invitation to specific non-Sāmoans with peʻa to take part in the competition signalled his intention to show off some of his best work. It also affirmed that he was in control of what he was doing: he could tattoo non-Sāmoans, and no one could say otherwise. Consider the comment he made several months later, addressing criticism directed toward his work on non-Sāmoans:

[Tatau] has become a mark of a Samoan overseas and elsewhere, but it actually belongs to me and my family, we gave it to the Sāmoan people and we decide who and how the job is to be done. They don't tell us … I don't recall any time that a Malietoa or a Mataʻafa or a Tuiaʻana or anybody royal directed us on how to do the work …[145]

145.
Mallon, 'A Living Art', 55.

During the same interview Paulo told me that he considered the 1998 tatau competition more as an 'educational thing' than a competition. He was referring to an important outcome of the videotaping of the event, when Sāmoan youth organisations acquired copies of the tape to use in their education programmes. While this was a positive outcome of the show, it had not been the original intention – the competition was originally organised to select contestants to represent New Zealand Sāmoans at the 1999 Sāmoa-based tatau convention and competition that would be part of the annual Sāmoan Teuila Tourism Festival. When Paulo arrived in Sāmoa the arrangements were different from what he had expected, and the planned tatau competition was abandoned.

Although the competition in Sāmoa did not take place, the New Zealand-based show probably stabilised Paulo's position as a tufuga tā tatau in both countries. After all, his credibility was under threat – negative gossip was circulating, and his work had attracted public criticism on local Sāmoan talkback radio programmes. In addition, a new tufuga had just started working in South Auckland in direct competition with him and had allegedly begun publicly criticising him. The fact that Paulo was able to organise a tatau competition, and select a contingent to compete in Sāmoa, may have taken some of his critics by surprise.

The transnational competition for dominance among producers of tatau is also implicated in the cancelled tatau competition. Questions surrounding who controls the meaning of tatau and where the centre and expertise for tatau production are located are at the heart of rivalries between leading tufuga. The struggle for political and cultural capital in Sāmoan society and within the sā Suʻa is a key driver of these rivalries. It seems that there is little point holding a tatau competition when it is likely that either Paulo or his brothers had done most of the tatau work on those competing. So what was really at stake here?

The tattoo show and its competitive aspects are more likely to have been contests of 'cultural proficiency' in a context where the meaning and the constitution of culture were the subject of increasing anxiety. The demands of various interest groups and the criticism they directed toward Suʻa Suluʻape Paulo were probably part of the reason why the South Pacific Tattoo Show took place. The show may have been intended to stabilise and to legitimise Paulo's role and practice but it also highlighted the instability, or at least the contestedness, of his position and authority in Sāmoan society and over his own trade. The circumstances surrounding this event suggest that Paulo had to perform his role according to certain expectations. He had to re-establish himself within the boundaries of widely perceived Sāmoan cultural norms. What emerged was a clear difference between how he saw his role and what the Sāmoan community expected.

TATAU

146.
Grimwade, 'Revival of an Ancient Art', 42.

147.
Stunzner, 'The Man with the Double Tattoo', 40.

148.
See, for example, Va'a, *Saili Matagi*, 184.

149.
Bob Baxter, 'Le Tatau – Tattoo Millennium Convention', *Skin and Ink: The Tattoo Magazine* (2000): 36–46; Vinnie Myers, 'The Tatau's Endless Journey', *International Tattoo Art* (May 2000): 14–17; H Popo, 'Samoa Tattoo Convention', *Tattoo Life: The First Global Tattoo Magazine*, no. 5 (1999).

If there were any thoughts that tatau was somehow more stable in Sāmoa as opposed to elsewhere, there is evidence that it was not universally important or practised in the same way everywhere in the archipelago, and was perhaps even under threat. For example, in 1990 a village on Savai'i made it compulsory for all men to have the pe'a. Why would a village need to do this if tatau was well embedded in society?[146] A sense of loss was evident when, in 1998, after being tattooed for the second time, Sāmoan matai Malagama'ali'i Lavea Vui Levi Fosi was quoted as saying: 'If I don't offer my body as a page for a writer to write on, we could lose it.'[147] There was clearly a need to create opportunities for tatau to be made and later given meaning and action.

The growing popularity of tatau alerted people to what it offered as a sociopolitical resource, a vehicle for cultural activism but also as a means to advance group or individual social status and ambitions. This can be seen in the way tatau was utilised in projects of national and international prominence by the social and cultural elite who organised, dominated and participated in them. The stipulation that wearing a pe'a be part of the criteria for participation in key cultural contexts, such as dance troupes and national touring groups, suggests that tatau (like other aspects of Sāmoan custom) could be a focus or a vehicle for promoting not only Sāmoan cultural identity but also social advancement or prestige.[148]

Outside the 'āiga sā Su'a and 'āiga sā Tulou'ena the most public expression of the importance of tatau was the national Sāmoan tatau organisation Mālōfie – a word from the oratorical language of the chiefly elite that refers to the arts of tattooing. The Mālōfie association was initiated by Su'a Sulu'ape Petelo in 1985 after his visit to the tattooing convention in Rome. It was important at the time because it enabled Sāmoan tattooists to open communication lines with other international tattooing associations and convention organisers. Sāmoa needed a national association, because funding from some overseas event organisers would not be directed to individuals.

Mālōfie lapsed around 1989, but it re-emerged after the first tatau convention in Sāmoa in 1999. The New Zealand Sāmoa Mālōfie Association Inc. was established soon after. The investment of time and effort in maintaining Mālōfie helped sustain knowledge and customs relating to tatau – and it brought other benefits to those who participated in its activities. It was not enough that the organisation existed: Mālōfie had to be proactive in creating situations and circumstances where tatau could be practised and displayed.

Fig. 62
Tatau as a symbol of the nation: Tattooed members of the Sāmoan National Dance Troupe perform at Apia, Sāmoa, 2001.

Between 8 and 12 November 1999, Le Tatau–Tattoo Millennium Convention was held in Sāmoa. It was an unprecedented event that brought together seventy tattooers from twenty countries and was well covered in the international tattooing magazines. The programme of activities and overall organisation of the convention were highly praised.[149] On the opening day a parade through Apia was followed by speeches, a ceremonial presentation of 'ava, dance performances and tattooing demonstrations. It was described as a celebration featuring tattooists using the au or tattooing machines.

Over the following week there were seminars, debates about issues relating to tatau, and opportunities for fellowship. Later, convention participants travelled to the village of Falealupo on Savai'i and visited the place where Tilafaigā and Taemā came ashore with the original tools for tattooing. Stories were told, the history of tatau was celebrated and a future for tatau imagined. It is fitting that the millennium was marked by such an event, celebrating the survival of tatau in Sāmoa and its recognition as part of a global history of tattooing and an international community of tattooers.

Not long after the convention, on 25 November, Su'a Sulu'ape Paulo II was killed at his home in Auckland.[150] His death and his funeral were covered in the national and international media. The sense of loss at his passing was palpable across the Pacific, the United States and Europe. A tribute from the Amsterdam Tattoo Museum proclaimed 'The chief is dead, long live the chief!'[151] If by the end of the twentieth century one of the great Sāmoan tattooing masters was dead, the popularity of tatau was only increasing. The 'āiga sā Su'a had family members tattooing in Sāmoa, Australia and New Zealand. Su'a Sulu'ape Alaiva'a Petelo and his sons were at the forefront of a series of new connections with the European and American tattooing milieux that would present further opportunities and challenges for tatau into the new century.

150.
'Wife Jailed for Manslaughter of Tattooist', New Zealand Herald, 20 July 2001, http://www.nzherald.co.nz/tony-stickley/news/article.cfm?a_id=143&-objectid=201213 (accessed 23 August 2017); The Queen v Epifania Suluape NZCA 6 (21 February 2002) In the Court of Appeal of New Zealand, CA249/01, http://www.nzlii.org/cgi-bin/sino-diop/nz/cases/NZCA/2002/6.html?query=tuvalu*.

151.
Henk Schiffmacher, 'In Memoriam: Paulo Suluape "The chief is dead, long live the chief!"', July 2002, http://www.tattoomuseum.com/top/memorial.html.

T A T A U

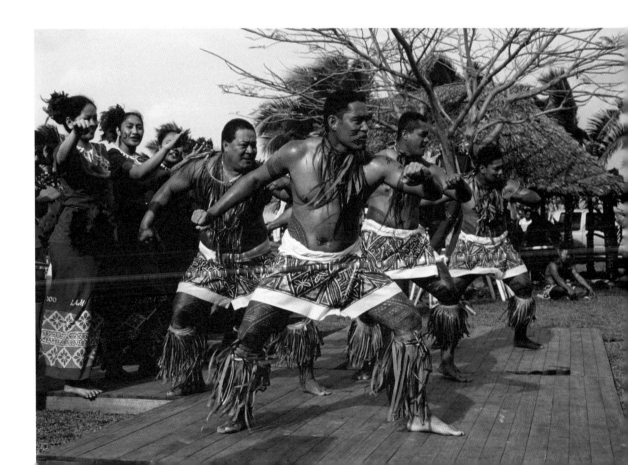

Tatauing the post-colonial body

Maualaivao Albert Wendt

Meanings

Much has been written about Sāmoan tatauing but little about the actual meanings of the terms tatau and malu.

The word tatau has many meanings:

1. **tā** – *to strike, referring in this case to the rapid tapping action when tatauing.*

2. **tau** – *to reach the end, to anchor/moor a boat or canoe, to fight. So, tā plus tau could mean 'let's fight', 'let's go to war', or 'striking until we reach a conclusion'.*

3. **tatau** – *also means appropriate, apt, right and proper, balanced, fitting.*

4. **tātā** – *to strike repeatedly (each tufuga tā tatau has his own rhythm, each person being tataued works out a rhythm to combat/withstand the pain); u – to bite, or the sound of suppressed pain as you clench your teeth to try and withstand the pain.*

5. **tatau** – *also means to wring the wetness/moisture/juice out of something. (Apparently, this is what happens when you're being tataued – the blood and pain are being 'wrung' out of you. Also, after long periods of pain you feel totally 'wrung out'!)*

The woman's tattoo is called a malu.

1. **malu** – *to be shaded, to be protected. (The malu is also the motif which is unique to the malu.)*

2. **malu** – *coolness.*

3. **malu** – *soft, to soften.*

The common name for tatau is pe'a, flying fox, my favourite winged creature, a combination of rat and furred bird that perceives the world/reality from an upside-down position (and usually at night using radar!). There are many proverbs, myths, legends and stories about the pe'a and its role in society and the universe. For some 'āiga and itūmālō the pe'a was their war atua.

The tatau is called a pe'a because of its dark charcoal colour, the colour of the flying fox. It is also a reflection of the courageous, cheeky nature of the flying fox. Recently, John Pule told me that the tatau looks like a flying fox with its wings wrapped around its body as it hangs upside-down, its head withdrawn. However, I prefer my observation: if you look at the tatau frontally, the male genitals, even with a penis sheath, look like the pe'a's head, and the tatau spreading out over the thighs and up towards the navel and outwards looks like its wings outstretched. The expression is 'Fa'alele lau pe'a!' Let your flying fox fly! Show how beautiful and courageous you've been in enduring the pain of the tatau, parade it for all to see. The sexual connotations are very obvious.

Vā

Important to the Sāmoan view of reality is the concept of vā (wā in Māori and Japanese). Vā is the space between, the betweenness, not empty space, not space that separates but space that relates, that holds separate entities and things together in the Unity-that-is-All, the space that is context, giving meaning to things. The meanings change as the relationships/the contexts change. […] A well-known Sāmoan expression is 'Ia teu le vā.' Cherish/nurse/care for the vā, the relationships. This is crucial in communal cultures that value group, unity, more than individualism; that perceive the individual person/creature/thing in terms of group, in terms of vā, relationships.

1. **manava (mana/va)** – *stomach (mana – power; va – space)*

2. **manava** – *breathe*

3. **vasa** – *ocean (vā – space; sa – forbidden/sacred)*

4. **vanimonimo** – *space that appears and disappears*

So tatauing is part of everything else that is the people, the 'āiga, the village, the community, the environment, the atua, the cosmos. It is a way of life that relates the tufuga tā tatau to the person being tataued and their community and history and beliefs to do with service, courage, masculinity, femininity, gender identity, sexuality, beauty, symmetry, balance, aptness, and other artforms and the future because a tatau or a malu is for the rest of your life and when you die your children will inherit its reputation and stories, your stories, stories about you and your relationships. The tatau and the malu are not just beautiful decoration, they are scripts/texts/testimonies to do with relationships, order, form and so on. And when they were threatened with extinction by colonialism, Sāmoa was one of the few places where tatauing refused to die. Tatau became defiant texts/scripts of nationalism and identity. Much of the indigenous was never colonised, tamed or erased. And much that we now consider indigenous and postcolonial are colonial constructs (e.g. the church).

Originally published in *Span* 42–43
(April–October 1996): 15–29

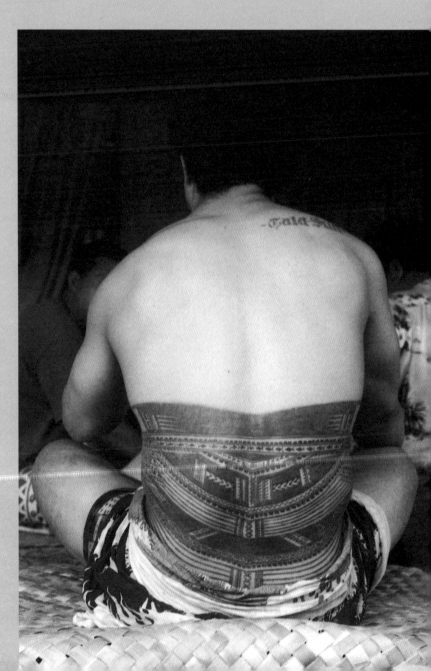

Fig. 63
The back of Tala Su'a
during his tattooing
in Salelologa in 1997
by tufuga tā tatau Su'a
Loli Misitikeri.

Fig. 64 (above)
Autā (tattooing tools)
mounted with pig tusk.

Fig. 65 (below)
Au nila, tattooing tools mounted
with steel needles. Collection of
Tuigamala Andy Tauafiafi and
Sapphire Aitcheson.

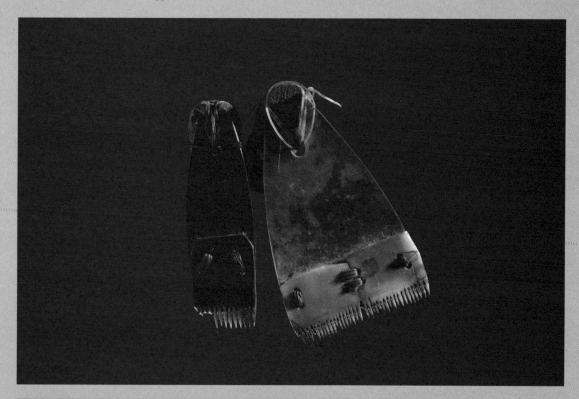

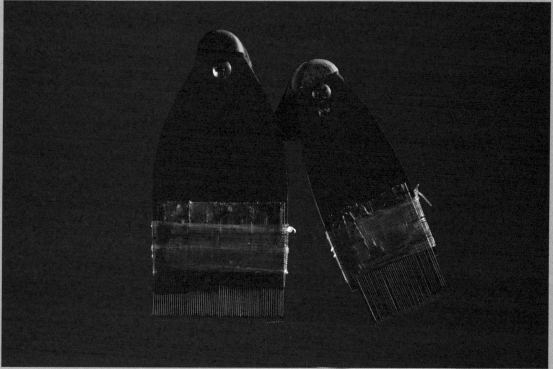

Tattooing tools: Continuity, change and cultural loss

Sébastien Galliot

In the early 1980s Polynesian tattooing was rediscovered and revived through the involvement of Sāmoan experts at a local/Polynesian level and at an international level, through contacts with Tahitians such as Tavana Salmon and Western tattoo practitioners such as Ed Hardy, Leo Zulueta and Mike Malone. But the tattooing revival reached a turning point with the global surge in the use of hand-tapping tattooing tools and non-electrical hand-driven tattoo techniques,

As part of the globalisation of Polynesian imagery and tattooing techniques, Sāmoan tufuga tā tatau have been experimenting with various materials and techniques for making their tools in order to meet the needs arising from their mobility, their cultural encounters and – perhaps even more crucially – their encounters with the Western market. As they interacted with and built networks with this specific market, particularly in Western countries, Sāmoan tattooists had to reflect not so much on their designs and the implications of cultural appropriation as on the very practical and technical aspects of their activities – that is, the manufacture of tattooing tools. This involved a two-step transformation process. While the first step rested on an indigenous logic of change, the second was the result of more external forces.

Museum collections and early narratives refer to a period between 1800 and the mid 1900s in which Sāmoan autā or tattooing tools were made from four main materials: light wood (hibiscus or bamboo) for handles, turtleshell for the plate, and boars' tusks or human bone for needles. These different parts were lashed together with 'afa (sennit), a fibre made from coconut husks. Several other tools were used to shape the handle, to drill the turtleshell plate and the bone, and to sharpen the needles. The lama or black pigment used for tattooing was invariably made from the kernel of the candlenut (*Aleurites moluccanus*) after a long combustion process.

The first step – using new materials to make tattooing tools – occurred in the 1980s.

The turtleshell plate was replaced with Perspex or other resistant plastic material. This change could be called indigenous because even though the newly adopted materials were imported, the rationale behind the manufacturing method remained unchanged: materials were adopted for their availability and their usability or robustness. The handle of a toothbrush could be shaped into a plate that would hold the few teeth of the au mono (the narrowest instrument). The sennit was invariably replaced by nylon fishing line – a material that was obviously more resistant to wear and tear and easier to tie. The use of metal nails to fix the handle to the plates had the effect of reducing the importance of lashing the handle to the plate. During the same period, the lama made from candlenut soot began to be replaced by kerosene soot collected from lamps and some tufuga began using Indian ink.

The second step in the transformation of the tattooing process arose from a heightened concern about the risk of infection from using contaminated tools. This was a result of both the AIDS pandemic in the 1980s and the increasing number of tufuga who were travelling and living outside Sāmoa. This important switch in the material aspects of the tattooing practice has consequences for the way the whole ritual has been understood. While a prime purpose of the tattooing operation was for an individual to handle the pain and to go through a sometimes lethal body modification, there was now a focus on the improvement of safety procedures.

In order to control the risk of infection, the Sulu'ape family introduced ultrasonic autoclaves combined with cold chemical sterilisation powder. It became standard practice to use latex gloves and to wrap pillows in plastic. Following the same logic, there has been a move in the last decade to replace the pigs' tusks with steel needles that are easily removable and can be sterilised; pigs' tusks cannot be heated. The handle is in most cases still made of wood, but tufuga have experimented with other methods of assembling the tools; in some cases the whole handle has been replaced with synthetic materials that have similar mechanical properties but can be sterilised. The use of steel needles is also so widespread nowadays that it has rendered the work of preparing pigs' tusks and lashings obsolete, leaving some people concerned about the loss of long established indigenous skills.

'I didn't think that I would be one…': An interview with Su'a Sulu'ape Alaiva'a Petelo

Sean Mallon
Sāmoa, December 2002

Su'a Sulu'ape Alaiva'a Petelo is the senior and leading tufuga of the 'aiga sā Su'a. In 1985 he travelled internationally for the first time when he was invited to attend *L'Asino e la Zebra* (the donkey and the zebra), a major month-long tattooing convention in Rome. Since then Alaiva'a has toured the world tattooing in Sāmoan communities. He has been a much sought-after and award-winning guest at European and United States tattooing conventions. In this interview from 2002, Alaiva'a recalls how he began his working life as a science teacher only to take up tattooing full time:

SM: When did you first start getting interested in tattooing?

SAP: That is a pretty hard question to answer. When I graduated from teachers training college I dedicated all my time to teaching and to creating methods of how to deliver my subject [science] in the school [Chanel College, Apia]. That was 1975, and that's when I started going back to my village. I went away from '68 until '75. I wasn't really interested in tattooing. I didn't think that I would be one — be a tattoo artist — until one time Paulo started tattooing people in one of the villages down the road towards the airport. He started ten people and then went back to New Zealand and didn't finish any of them. The group found out that Paulo was back in New Zealand and so one of them who is related to me through my sister's marriage came home and asked my father if he could finish them. By then my father [Paulo I] couldn't do any tattooing because his sight was not that good, even if he used glasses … So he sent my younger brother to go to Falelatai, where Fa'alavelave, one of our cousins who used to tattoo, lived, to ask him to come home and finish these people. I overheard him telling my younger brother to go, and then I told my brother, 'Don't go … this is our chance!' But up until then I wasn't really interested. It was just an instant chance … I told my brother not to go but to get everything prepared for the next day. I was going to school and after school … by about 2 pm we should be starting.

It happened that the next day my father was away … and then after school I came home and my brother was there mixing the pigment and getting everything prepared and then the next thing was the design — it wasn't in my head. So I said to my brother, 'Take off the side of your lavalava and show me the side,' and then I copied everything from my brother onto this guy. We worked from there, and then onto the other side that same day. My father came home at night and saw what we had done and said, 'Wow! How did you do that?' I said, 'I copied the whole thing from Lafaele's pe'a …' and he said, 'Now, you go on, go on and finish him!' so we went on. It was hard work because I had to look at my brother's pe'a and then work from there. After, that guy went back to his village and showed the people that were not finished his pe'a and then the whole group came down, including David Tua's father. I was about 22.

SM: Was that the first time you had tattooed?

SAP: Yes, that was the first time. Well, I did some practice before I started tattooing. I used to grab my father's tool when I had time and then start tapping it onto my legs. Then I stole one of his tools when I was at boarding school. I took the smallest tool and tattooed belly buttons on my school mates, and that was all. I don't know … I just picked it up. I saw how he worked and then I worked from there.

SM: After you did your first pe'a you said the whole group from the village came to see you?

SAP: Yes, that is when I started to like tattooing. But I had to wait for school breaks. We have three terms here. So when school breaks ... we'd go to the village and tattoo as much as we could in two weeks and then go home when school starts again. We'd come back the next holiday. We finished that group. In 1977 I started to do tattooing as a part-time job. I'd go to school in the morning and then after school I'd come home and tattoo some people. It carried on until the second term that starts in June and that's when I decided to quit teaching because there was too much demand for tattooing.

In the '70s it was like an epidemic, especially in our district. Everybody wanted to get tattooed, ranging from 18 years to 30 years old. It was just like an epidemic: if one sees another with a pe'a he will come and ask me for a pe'a too. It was just like challenging between one village 'aumāga [association of young men] and the other.

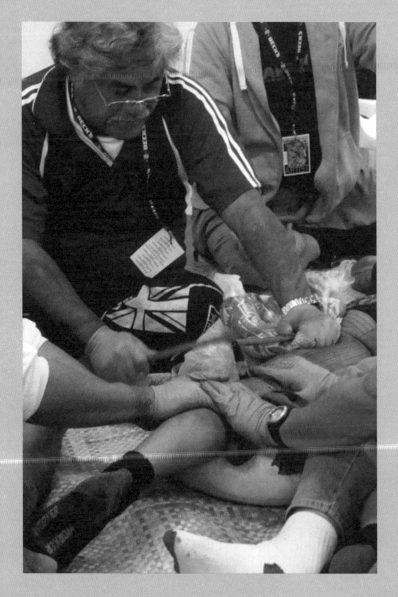

Fig. 66
Zanto Zandbergen being tattooed at the Auckland Tattoo Convention, New Zealand, 2009. Tufuga tā tatau: Su'a Sulu'ape Alaiva'a Petelo. Photograph: Sean Mallon.

TATAU

A tufuga begins his work: An interview with Su'a Sulu'ape Paulo II

Sean Mallon
Auckland, March 1999

Tufuga tā tatau Su'a Sulu'ape Paulo II was born in Lefaga in 1950 and is one of four brothers to take up tattooing. From the late 1970s he was the one of the most active and highly visible tufuga tā tatau, sought after in Sāmoa, New Zealand and Europe. At times a controversial figure in his community, he maintained a strong practice among Sāmoans, but also created circumstances to share tatau across many cultures.

SP: I can't quite remember, but I think I had fancied being a tattooist well before I went to school, and that would be about three or four years old. I was growing up and my father would walk away and leave his tools in a bowl in the house. I would just grab the tools and pretend to tattoo someone. Years later I started to tattoo young guys in the village. Eventually when I was in Moamoa, at the boarding school, I took some of my father's tools with me and tattooed the boys.

SM: So was there any pressure from your family to pursue this?

SP: No there was no pressure at all, the only pressure came on years later. I think it was 1967. I was travelling back home on the bus after a football game, on a Wednesday before Easter weekend … A cousin of mine who had started tattooing, I think he started around 1963–64, everyone was talking about him because he was coming on real strong. That was the resurgence of tattooing in Sāmoa, that was the exact time. His name was Fa'alavelave Petelo; he had been brought up in my family but he left to look after his parents in a village called Samatau, on the northern side of the island. He had tattooed this young man standing in the bus, and one old man and the young man were talking, and something was said about me and my brothers not having the guts to take it up. It made me angry, but not against my cousin who is an adopted brother, but mainly I was angry about my older brothers and myself, because I realised that this old man was right. So while I am saying that I was angry, the anger was not directed at my cousin at all; I was happy for him in a big way, but I was angry at myself. For what was said in the bus was quite right and none of my own brothers had guts

enough to take it up. And I decided then and there that I would take it up when I left school.

SM: How old were you at that stage?

SP: Seventeen.

SM: What was the reaction of your father?

SP: I wasn't really overawed by the fact that I was able to tattoo a real person, a real pe'a. I had been tattooing little pictures here and there, but this time I was actually tattooing someone who was getting the pe'a. My father had started the back, but then I did the leg and there was a gap between the back and the leg, but I left it to my father to complete. It is hard to explain now but it was like I didn't have any brains, to be honest, I was just … all I had was just my eyes in my head, that was all I could remember. I couldn't remember if I had any brains. I just had my eyes glued to the spot where I was tattooing to make sure it was all right and all correct. And the guy is still around, he is in New Zealand now.

SM: And what was the reaction to your first pe'a?

SP: I don't know about my brothers, but my father was a hard man to please, a very hard man to please. He didn't say anything. All he said to me was 'okay, okay'. He didn't say to me 'that's good, that's very good', or something like this, all he said was 'okay, that's okay'. I know that we had done many other things that he was able to do – he used to be a housebuilder, a boatbuilder, a tattooist, he even used to make jewellery – rings from gold coins from the German times. So if you were able to make something that he used to make, he never said to you that it was perfect, he never said that kind of thing.

GREG SEMU

Greg Semu is a contemporary Sāmoan
New Zealand photographer who was tataued
in 1995. He has since produced series of works
based on his tatau. Art curator Ron Brownson
reflects on Semu's photographic practice
and his place in a history of people tattooing
images and making images of tatau.

Greg Semu was the first contemporary Samoan New Zealand photographer to receive the traditional Samoan peʻa. Designed and drawn by the late tufuga tā tatau Suʻa Suluʻape Paulo II, the artist's peʻa extends over his lower torso, upper legs and shoulders. It is a remarkable peʻa, with sharp definition and finely executed pigmented drawing. After Paulo completed the tatau in 1995, and following his advice, Semu bathed the peʻa frequently daily, ensuring its rapid healing and an all-over clarity to the tufuga's designs.

Greg Semu's peʻa permanently transformed his body visually, culturally, spiritually. He began inhabiting an extraordinary tatau and the tatau began inhabiting him. They have become integrated into a single being; knowing what he was given, Greg remains both grateful and proud. His Samoan peʻa provides him with a uniquely designed identity that serves to mentor his art with confidence and assurance.

He regularly combines his peʻa's reality within his photography practice. In 1995, Greg Semu undertook an extraordinary three-part self-portrait project which reveals his peʻa, observed from front, side and back. Using black and white photographs, toned with gold and selenium, the images channel visual procedures belonging to the physiognomic anthropology as practised by the German scientist Carl Marquardt for his 1899 publication *Die Tätowirung Beider Geschlechter in Samoa* (The Tattooing of Both Sexes in Samoa). Moody, and deliberately employing a reduced depth of focus, Greg Semu's photographs hold a different mirror to Marquardt's practice and counter nineteenth-century images with a sensuality and self-possession to destabilise the European perspective within the anthropologist's gaze.

In 2012, Greg reprised the approach used in his self-portraits of two decades earlier in a commission from Auckland Art Gallery Toi o Tāmaki. Here the images were in colour and lit with an incisive clarity and uniformity. Greg challenged Marquardt again – seeking to produce images of a peʻa which could become a standard from which Paulo's design, precision and detailed drawing could be observed on Greg's body which was, two decades later, even lighter in physical weight. His creative agenda was clear – were these not the clearest images of a tatau yet printed?

— Ron Brownson

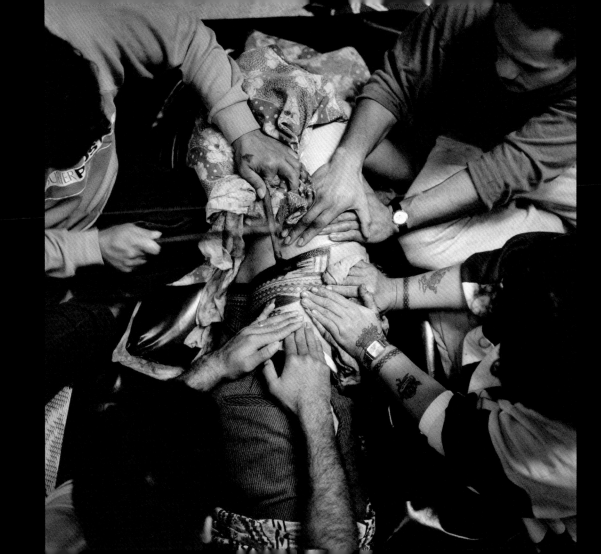

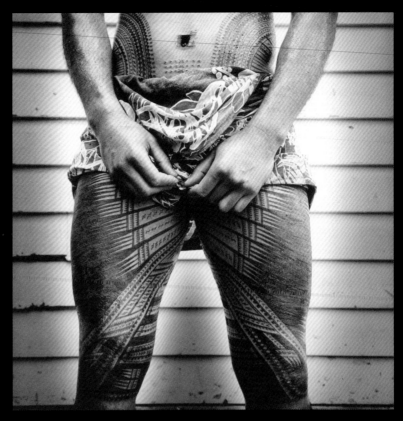

Fig. 68
Pe'a, Nouma Kiriau, 1995.

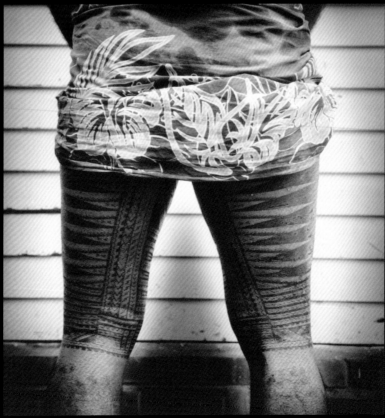

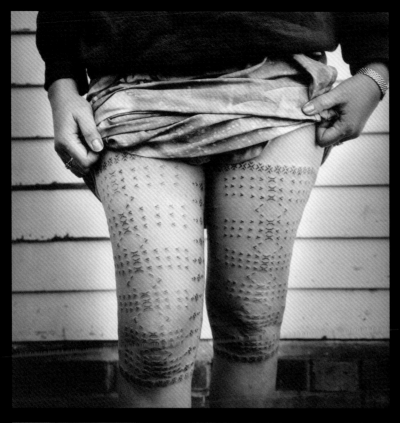

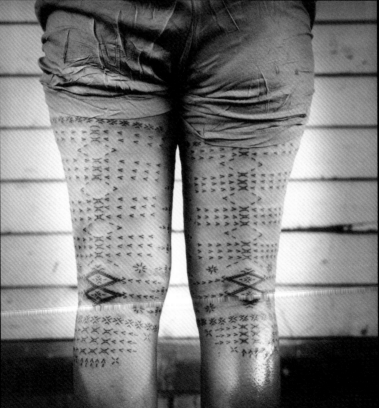

Fig. 69
Malu, Foketi Lusa, 1995.

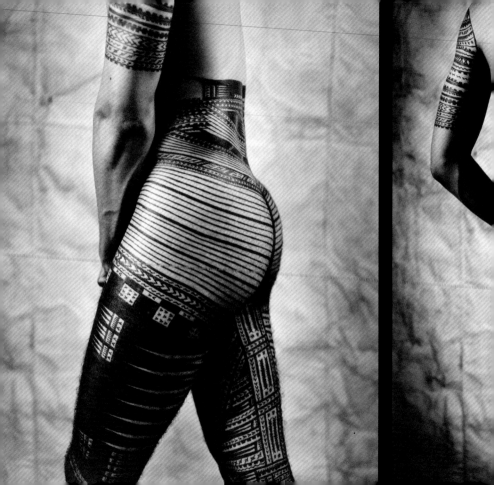

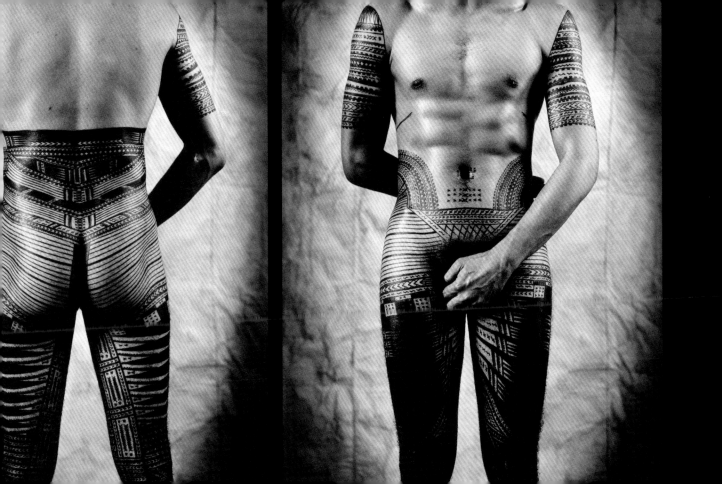

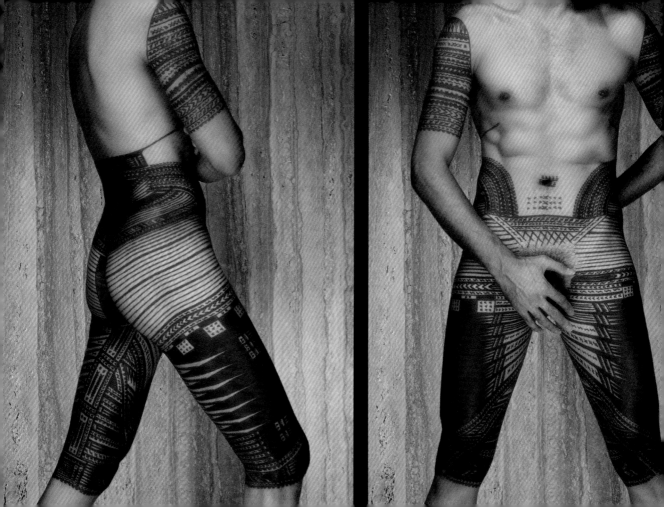

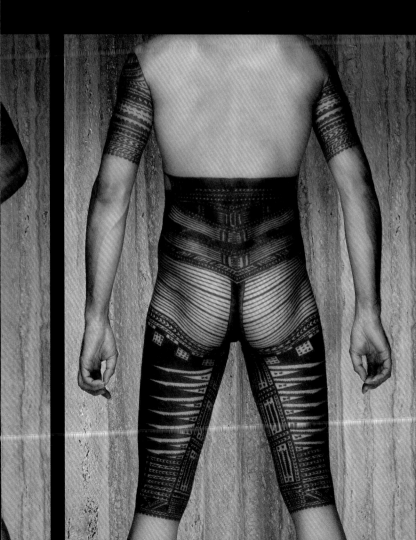

Fig. 73-75
*Self-portrait with pe'a, Sentinel
Road, Herne Bay,* 2012.

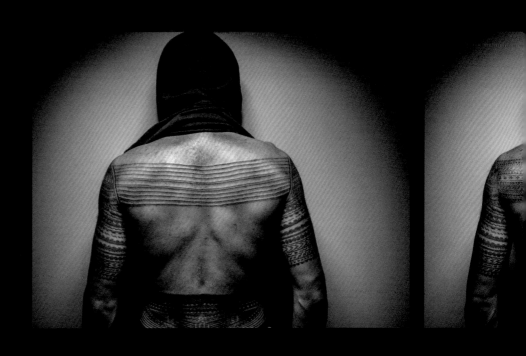

Fig. 76–78
Earning My Stripes, 2015.

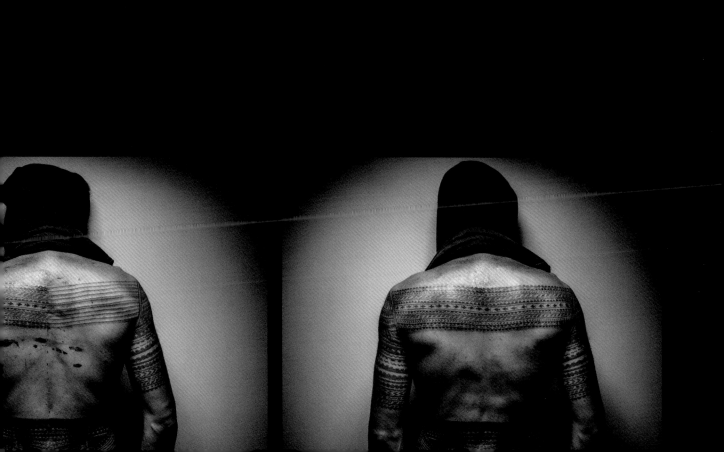

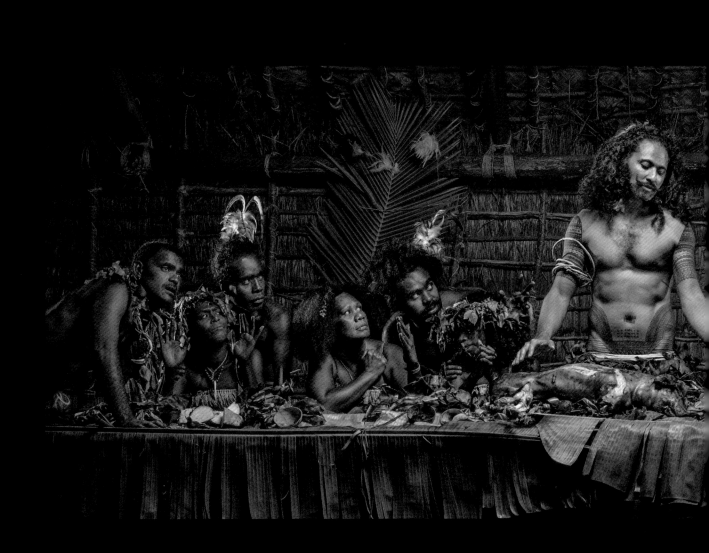

Fig. 79
*The Last Cannibal
Supper, because tomorrow
we become Christians,*
revisited 2017.

Fig. 80
*After Hans Holbien the
Junger – Dead Body of
Christ*, retouched 2018.

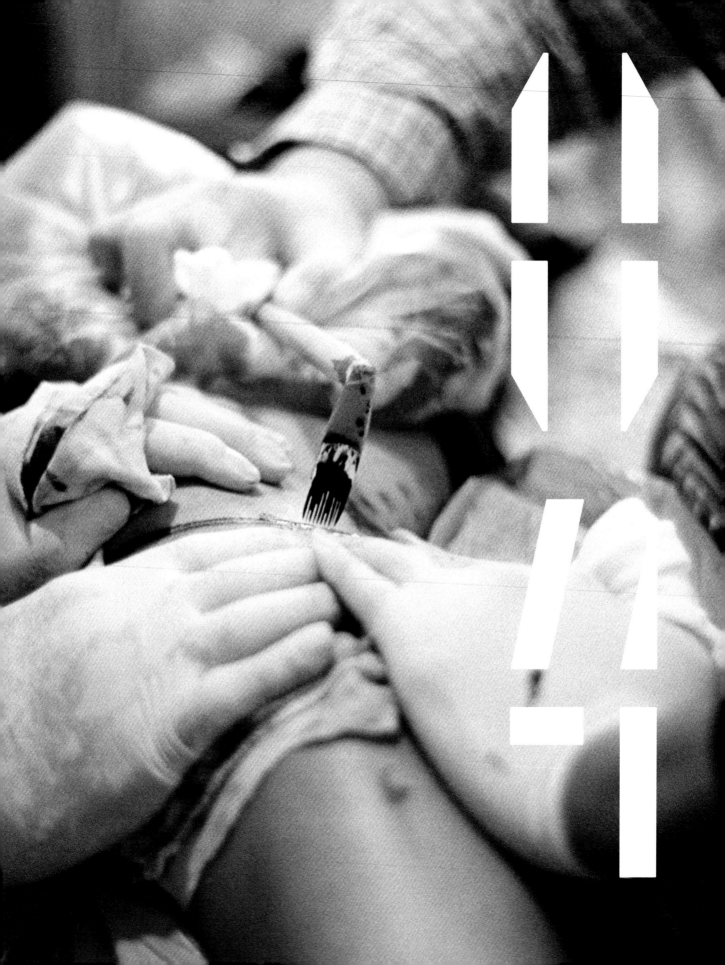

TATAU AS A RITUAL INSTITUTION
2000 — 2010

Fig. 81
A tattooing session in Point
Chevalier, Auckland, New
Zealand, in 2007. Tufuga
tā tatau: Tuilaʻasisina Peni.

TATAU

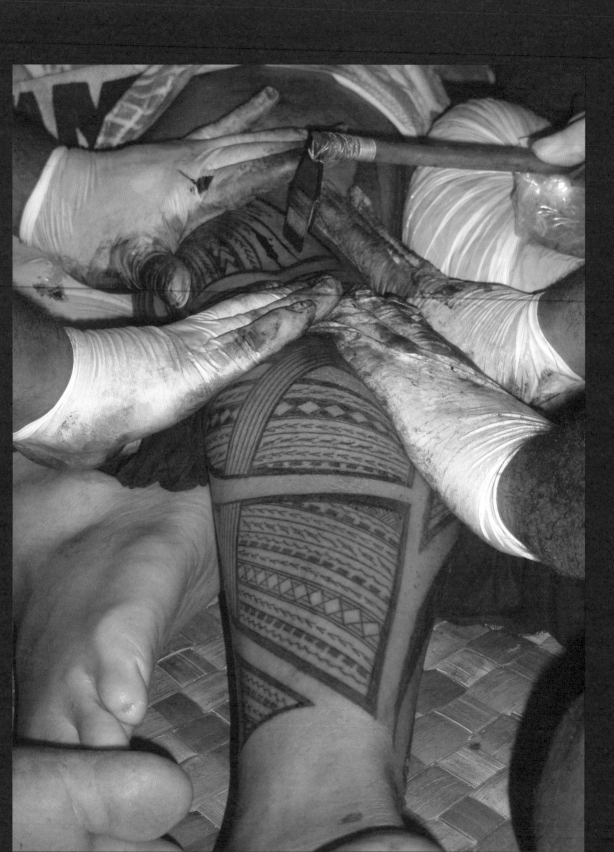

Tufuga tā tatau are certainly the most renowned and dynamic class of tufuga or expert craftsmen in Sāmoa, where membership is based primarily on a genealogical link with a founding ancestor. In the case of ritual tattooing, the two main lineages of tufuga tā tatau – Su'a and Tulou'ena – were established during encounters between the female guardian deities Taemā and Tilafaigā and the chiefs Tapu and Auva'a. Although there are some uncertainties about the existence of a strict continuum in these genealogies, Sāmoan practitioners refer nonetheless to one of these two clans to define their professional identity. And we will see in due course that new lineages have recently been created.

Membership of a body of tufuga tā tatau involves a number of ceremonial prerogatives that acknowledge their high ceremonial status. All categories of tufuga – tattooists, housebuilders and canoebuilders – must be addressed according to a shared vocabulary of respect. As experts they are ceremonially addressed as agaiotupu (sovereign's attendant), mātaisau (craftsman, carpenter), matua o faiva (senior of the craft) and lātū o le faiva (in charge of the craft). They also share a corpus of honorary terms for some of their belongings and for family members which, although they differ from the polite term used for ali'i and tulāfale (orator), still stand as a clear oratory marker of high status (see page 181).[1]

Fig. 82
Su'a Sulu'ape Peter improvising on a full leg at the 5th International Samoa Tatau Festival 2012.

➤ • ➤

Accounts of Sāmoans bearing tattoos go back as early as the first encounters with Europeans during the discovery voyage of Roggeveen in 1722, but the first accounts of the organisation of the craft and descriptive drawings were not made until the following century.[2] Reverend JB Stair, stationed on the island of Savai'i in the 1840s, described tufuga as forming a 'fraternity'. Other observers such as Augustin Krämer and Marist fathers of the Catholic Church described the profession as a 'guild', analogous to the professional brotherhoods of medieval Europe. To the extent that the transmission of a specific trade is either by inheritance and embodiment – when, for example, apprentices are the relatives of the master – or through companionship, and given that the apprenticeship includes toolmaking and tool use, body techniques and ritual prescriptions and ordinances, reference to a guild or fraternity is appropriate.

1.
See GB Milner, *Samoan Dictionary* (Auckland: Pasifika Press, 2001), 8, 137, 98.

2.
See C Wilkes, *Narrative of the United States Exploring Expedition During the Years 1838, 1839, 1840, 1841 1842, Vol. II* (Philadelphia: Lee & Blanchard, 1845), 141; JB Stair, *Old Samoa; or Flotsam and Jetsam from the Pacific Ocean* (London: Religious Tract Society, 1897), 158–64; RPA Monfat, *Les Premiers Missionnaires des Samoa* (Lyon: E. Vitte, 1922), 71–72.

TATAU

Oral tradition relates that some chiefs were given the 'atoau (basket of tools) by the aitu Taemā and Tilafaigā. This mythical episode in the history of Sāmoan tattooing represents a founding event for the two main lines of tufuga and suggests at the same time a supernatural dimension to the profession. The two clans are addressed as 'o le falelua o le 'āiga tufuga (the two founding houses of the tufuga's kin). The Su'a and the Tulou'ena clans are also respectively addressed as 'āiga sā Su'a and 'āiga sā Tulou'ena. Thus the vernacular terms 'āiga (extended family) and fale (house) – using French anthropologist Claude Lévi-Strauss's concept of 'société à maison' – better describe the organisational structure of this socio-professional entity.[3]

To understand the nature of this profession it is helpful to consider the mode of existence of these aitu or mythical beings. In ethnographic accounts collected in the nineteenth century,[4] Sāmoan deities and supernatural beings were believed to emanate from artefacts and natural objects such as stones, trees, animals, sharks' teeth and conch shells. According to local custom, a genealogical link between titled individuals and deities also granted them a leading role in worshipping at and maintaining the sites, the species and the artefacts that were considered sacred because they were the dwelling places of deities and spirits.

The Sāmoan language has several terms for different types of supernatural entities: atua, tupua, aitu, sauali'i. Stair defined tupua as 'deified spirits of deceased persons of rank ... spiritual beings, the more exalted of whom were supposed to become posts in the house or temple of the gods at Pulotu'.[5] Thus, in various locations of the archipelago, several tupua lived in rocks or within other natural elements. Also, according to Stair, the aitu category of beings:

> included all the many deities whose aid was invoked by the different order of priests. This comprises war gods, family gods as well as the tutelary deities of the various trade and employment. Every family had its own particular *aitu* or tutelary deity, who was usually considered to inhabit some well-known familiar object.[6]

George Turner classified Taemā and Tilafaigā as superior and war deities at the village level around which cults were organised, but he did not specify whether they belonged to the tupua or the aitu category. In the 1920s anthropologist Margaret Mead[7] understated the difference between these two types of beings and reduced it to a mode of relationship. She regarded tupua as more intimate and connected to specific persons or families, and the aitu as having a sphere of influence that could be applied to large areas, and their power – either harmful or benevolent – was more widespread. Following this argument, tupua would embody social order and a higher level of dignity while aitu would be positioned on the side of the multitude and disorder, and were at an inferior level of supernatural beings.[8] That being said, Taemā – described as a guardian deity connected to the profession of tattooing, who is believed to dwell in a tree and is genealogically linked to Su'a – embodies qualities of the aitu category as defined by Stair.

3.
For Lévi-Strauss, 'maison' designates 'a legal person who owns a domain consisting of both tangible and intangible assets, which perpetuates the transmission of his name, his fortune and his titles in real or imaginary line, held as legitimate only if this continuity can be expressed in the language of kinship or alliance and, more often, the two together'. See C Lévi-Strauss, 'Nobles Sauvages' in *Culture, Science et Développement: Contribution à une Histoire de l'Homme. Mélanges en l'Honneur de Charles Morazé* (Toulouse: Privat, 1979), 48 (trans. Sébastien Gaillot). Lévi-Strauss coined the term 'société à maison' to describe kin groups that cannot be explained through recourse to classic kinship concepts such as lineage, descent and so on.

4.
George Turner, *Sāmoa: A Hundred Years Ago and Long Before* (London, 1884); Stair, *Old Samoa*, 158–64.

5.
Stair, *Old Samoa*, 36.

6.
Ibid., 37.

7.
In 1925, Margaret Mead undertook four months of fieldwork in American Sāmoa, mainly in the Maun'a group.

8.
This idea is also present in V Kneubuhl, 'Traditional Performance in Samoan Culture: Two Forms', *Asian Theatre Journal* vol. 4, no. 2 (Autumn 1987): 167; see also JM Mageo, 'Community and Shape Shifting: Samoan Spirits in Culture History', in *Spirits in Culture, History and Mind*, edited by JM Mageo and A Howard (New York: Routledge, 1996), 32–33.

9.

SPECIAL TERMS OF ADDRESS FOR TUFUGA:

ENGLISH TERM	COLLOQUIAL	FORMAL
craftsman, expert practitioner	tufuga	*mātaisau, matua o faiva, agaiotupu, matai tufuga, o le lātū o le faiva*
tools	mea faigaluega	*fa'atufugaga*
spouse	'ava	*meana'i tāua*
tattoo	tatau, pe'a, malu	*mālōfie, la'ei o le tāne, la'ei o le teine*
residence/estate	fale	*Apisā, Malaetā (village)* *— Mapuifagalele (Falealupo)* *— Lalotalie (Salelāvalu)* *— Lalofau (Faleālili)* *— Fa'amafi (Safata)*
fine mats	'ie tōga	*fusitā*
cooked pig	pua'a vela	*manufata*
title	suafa matai	*suafa tā pe'a:* *— u'a ('Upolu)* *— Tulou'ena (Savai'i)* *— Li'aifaiva (Safotu)*
kava name	igōa ipu: various names are linked with high-ranking titles	*igōa ipu:* *sā Su'a: logo taeao/pa'ū tafa ua lava* *Tulou'ena: tāpafua (without a kava title)*
meal	'āiga	*talisua*
green coconut	niu	*vailolo*
to look at	va'ai	*silasila*
sponsor/ official host	taufale/taufalemau	*taufale/taufalemau*
to tattoo	tā le tatau / tā le malu	*pa'ū le mālōfie*

TATAU

Whereas the mythical journey of the Siamese twins Taemā and Tilafaigā includes several meetings on the islands of Savai'i and 'Upolu, apparently only two meetings gave birth to the tufuga clans that are still active today. Other encounters mentioned in the oral tradition tell that the skill was not transferred, but the meetings have nonetheless resulted in the creation of malaetā (ceremonial ground associated with tattooing) (see previous page). As tufuga tā tatau were – and still are – described as itinerant practitioners, these malaetā are best understood as memorials and places of worship, rather than as a ceremonial ground where the initiation ritual of tattooing takes place.

The different holders of suafa tā pe'a (tattooing titles) tend to focus on the order in which Taemā and Tilafaigā assigned the 'atoau during their mythical voyage, but the issue is very difficult to resolve and is still a matter of disagreement between the Su'a and Tulou'ena holders, whose respective oral traditions tend to diverge. To further complicate the situation, the use of the Su'a title is challenged within the branch of tufuga belonging to the 'āiga sā Su'a, and the use of Tulou'ena by some tufuga outside Sāmoa is also disputed.

The generic cultural principles behind the transmission of tattooing titles are strictly controlled by their holders, who tend to assign priority to close relatives – usually through the male line of the extended family, but also often according to seniority, experience in the practice, individual aptitude, and skill accentuated by a long apprenticeship over several years. Thus, legitimate access to a tattooing title requires prior expertise in aspects ranging from technical skills in toolmaking to the implementation of ritual procedure and the precise memorisation of the way traditional motifs are arranged on the body to form a standardised image. It presupposes artistic skills, and demands an unswerving dedication to a master. Moreover, eligibility to the profession of tufuga depends on three prerequisites: 1) having completed one's own pe'a; 2) holding a matai title; and 3) having received a formal benediction from a master. The latter also applies to tufuga fau fale (master carpenters), and usually takes place in a fafano – a ceremony during which the master hands the apprentice a toolkit, gives his blessing and wishes him good fortune, or fa'amanuia. The handing down of the tools symbolises the genealogical link with the guardian deities of the trade: through this action, the mythical episode during which the first tools were granted to Su'a or Auva'a, according to the respective oral traditions, is re-enacted.[9] All this obviously serves to limit the number of legitimate practitioners available at any one time.

In the second half of the twentieth century the number of tufuga tā tatau per capita in Sāmoa decreased dramatically, from approximately one per 11,000 inhabitants in 1973 to one in 30,000 in 2017.[10] This reduction can be explained by the optional nature of the tattooing ritual, and by the development of wage labour at the expense of customary duties and service, which were one of the major social motivating factors behind getting a pe'a or a malu. The decrease could also be explained in terms of business strategy, since this ritual status is very lucrative for the most talented tufuga tā tatau. Anyone now can learn about tattooing motifs via the countless websites

J Abercromby, 'Samoan Tales', *Folklore*, no. 2 (1891); J Fraser, 'Some Folk-songs and Myths from Samoa', *Journal of the Polynesian Society*, no. V (1896); Augustin Krämer, *The Samoa Islands, Vol. I* (Honolulu: University of Hawai'i Press, 1994), 151–52.

10.
Noel L McGrevy, 'O le Ta Tatau: An Examination of Certain Aspects of Samoan Tattooing to the Present', Master's thesis, University of Hawai'i, 1973, 78.

11.

dedicated to Polynesian and Sāmoan tattooing, but the supernatural sanction associated with the art, together with the complexity of the tools and the implementation and structure of the pe'a and malu, mean that most outsiders of the trade continue to rely on Sāmoan experts to complete their apprenticeships. It is as if this ritual art cannot be assumed without the embodied knowledge of the expert.

◀— • —▶

According to the oral tradition collected in the nineteenth century, the 'āiga sā Tulou'ena foundation is located in the village of Falealupo on the island of Savai'i. It was born of the encounter between chief Auva'a and Taemā and Tilafaigā. From his stay with the tufuga Tulou'ena Peni Fa'amausili for five days in South Auckland in 2003,[11] the Sāmoan scholar Unasa Felise Va'a relates that Auva'a used to perform tattooing in a cave known as Analega. One day the cave became so hot that he went outside to carry out his task and apologised to the cave, using the expression 'Tulou-aega!' – from which the term Tulou'ena originated.[12]

Currently the Tulou'ena clan includes only a few practitioners, and it has had no representative in Savai'i since 2001; only Tulou'ena Peni Fa'amausili, his son and one of his apprentices, Laulu Tulou'ena André, are still active, and they are based in Otara in South Auckland. Peni's brother Fa'aofonu'u Pio transferred his skill to his son Moemoe before he passed away. Two other tufuga, Maleko Palea and Tuifa'asisina Peni, were operating in South Auckland in 2007 and claimed membership of the Tulou'ena clan – although this is somewhat controversial.

The genealogical roots in Savai'i attributed to the Tulou'ena clan seem to be retained only in theory. In the early 1970s Noel L McGrevy located several tufuga based in Savai'i,[13] but since 2001 informants have been asked about the current whereabouts of heirs, and it seems that none of them had any suli (successors). Tufuga Ioane, identified by McGrevy as one member of the Tulou'ena, had a son named Vaipou Vito, whom Sébastien Galliot met briefly in Vaitoomuli, Savai'i, in 2001. Vito, who was no longer tattooing, still carefully kept a toolkit but had not instructed any of his sons. Of course, the conditions in Savai'i, where there are fewer opportunities for paid work than in 'Upolu, have contributed to many potential workers leaving their villages and even the country in the Sāmoan diaspora.

But while the 'āiga sā Tulou'ena seems not to have any living representative currently in Savai'i, tattooing has not totally disappeared from the island. The late Su'a Loli Tikeri was a matai in the village of Vaipu'a in the Salega district. He had been a tufuga since 1987 and had performed the ritual for his community in Savai'i and overseas. He had followed an apprenticeship among the Su'a clan, with Sulu'ape Alaiva'a and Fa'alavelave Vitale, and was related to Sulu'ape Alaiva'a through his wife. Thus, his apprenticeship in 'Upolu with a member of the Su'a clan qualified him to be addressed

UF Va'a, 'Five Days with a Master Craftsman', *Fashion Theory* vol. 10, issue 3 (2006): 297–313.

12.

In the Sāmoan oral tradition, there are several occurrences of names originating from the verbal contraction of events.

13.
Noel L McGrevy, 'O le Ta Tatau: An Examination of Certain Aspects of Samoan Tattooing to the Present', Master's thesis, University of Hawai'i, 1973, 78.

TATAU

Fig. 83
Suʻa Suluʻape Alaivaʻa Petelo (right) with his former apprentice Suʻa Loli Misitikeri, in Apia, Sāmoa, 2012.

Fig. 84
Tuifaʻasisina Peni tattooing a malu, Point Chevalier, Auckland, New Zealand, 2007.

as Suʻa during his work as a tattoo master – just like his son, who has now taken up the craft. Another tufuga, known as Tafili, was said to be based in the north of Savaiʻi, but enquiries have turned up no further information about him.

Each of these tattooing clans identifies with distinctive oral tradition and customs or tulāfono o le ʻāiga. As we have seen, their ritual office is associated with honorifics and distinctive terms of address. The existence of an honorific address for the tufuga acknowledges status and privileges that are usually restricted to high chiefs and orators in a ceremonial assembly of titled individuals. In a society that assigns a strong value to the proper use of respectful terms, the existence of honorific and esoteric terms surrounding the tufuga is central to understanding the social positioning of this body of practitioners within the hierarchy of titles.

The appropriate faʻaaloalo (respectful address) for the Toulouʻena is: 'Lau fetalaiga Liʻaifaiva ma lo tou ʻāiga sā Toulouʻena!' ('Your venerable orator Liʻaifaiva and your sacred clan Toulouʻena!') Toulouʻena Peni Faʻamausili gives a slightly different formula: 'Afio mai lau afioga Toulouʻena, o le matua o faiva faʻapea le falelua o le ʻoutou ʻāiga tufuga!' ('May Your Highness Toulouʻena, elder of the craft, welcome to the two founding clans of the tufuga!') Members of the Toulouʻena regard Auvaʻa as their first ancestor for the genealogy of the craft in Savaiʻi. Still, given the scarcity of data available for the history of this trade, and according to our own fieldwork in Savaiʻi, other non-related families of tufuga may have been present there until recently.

With its roots in ʻUpolu, the ʻāiga sā Suʻa is a branch from which a large group of tufuga has formed. The title Suʻa probably originated in the oral tradition in which Tapu (a chief from Safata) made a gift of uʻa (unfinished barkcloth) to Taemā and Tilafaigā. According to this tradition the base fibre (uʻa) was still wet (susū) when he presented it – hence susū uʻa (wet fibre), shortened to suʻa. Members of the Suʻa tattooing clan are addressed as follows: 'Lau susuga Suʻa ma le falelua o le ʻāiga sā Suʻa!' ('Your honour Suʻa and the two estates of the Suʻa family!')

As with the high-ranking aliʻi or sacred title holders, tufuga can be granted the privilege of having an ʻigōa ipu (literally cup name, i.e. a special title used to call them during the kava ceremony). The oral tradition relates that in order for the twins to pass the craft on to the people they encountered during their travels, they should agree to receive the first cup of kava – which, in Sāmoan protocol, is a great honour reserved for important guests and high-ranking aliʻi. Contemporary tattooing opening and closing ceremonies sometimes start with a taumafa ʻava (a formal drinking of kava). On these occasions, tufuga are called out by their ʻigōa ipu, which of course distinguishes them from tāpafua guests – those who do not have a kava name.

Two of these 'igōa ipu can be used to highlight Su'a as a tattoo expert. According to Su'a La'ai, interviewed in 2005, the 'igōa ipu for the Su'a from the village of Gagaifo o le Vao is 'Pa'ū i tafa ua lava', meaning 'remains enigmatic' or, literally, 'fallen on the side'; 'that's enough!' It is also used for the kava cup of matai who hold the Tapu title from Saga district. The other 'igōa ipu for the Su'a's kava cup is 'Logotaeao', which is also the generic kava name for most of the Su'a matai title holders.

<center>◄ • ►</center>

While the Tulou'ena title seems to be restricted to the ritual function of tufuga tā pe'a, the case is quite different for the Su'a. In fact, the title Su'a can be attributed both to the ritual office of a tattoo specialist and to the head of a clan. As an ancestral clan name the title Su'a exists in the fa'alupega (the ceremonial address of a person or a social group in a specific area) of several villages: in Salelologa, Salelāvalu, Amoa Sasa'e, Papa, Gagaifo and Vaipu'a. Thus, most of the current Su'a title holders are not invested with the ritual status of tufuga tā tatau. Likewise, the tufuga who is called Su'a may very well have no obligation or link with those who hold the Su'a title as matai. The oral traditions that tell of encounters – but suggest intercourse – between Taemā, Tilafaigā and Tapu or Su'a should be understood as a mythical link that legitimises the use of this title during the actual performance of the tattooing ritual. In contemporary practice the title Su'a is applied to tufuga tā tatau as a ceremonial term of address strictly in the context of the tattoo ritual; among the tufuga tā tatau the title seems to be separate from any political function or land rights. During our survey only Su'a La'ai from the village of Gagaifolevao held the status of both high chief and master tattooist – so he is the only tufuga to attend village councils under this title. That said, nowadays it seems to be the norm to address a tufuga using the Su'a title – in fact, it is so widespread that on several occasions it has become a polite term for 'master tattooist'. Su'a and Tulou'ena are generally used today as honorary and professional titles, irrespective of the suafa matai, or chiefly titles whose rankings are crucial to the political organisation of Sāmoa.

One of the reasons for occasional conflict between Su'a tā pe'a (tattooing title) holders is the increase in the number of practitioners affiliated with the Su'a clan since the 1970s. In the second half of the twentieth century, changes in the transmission of the craft occurred from the district of Lefaga through Sulu'ape Paulo I, who was trained by his friend's father, Tapu Taimata; he then trained one of his sons and a nephew who, in turn, trained a large number of other tattooists – giving birth to sixteen tufuga over two generations. Thus, unlike other families in which the tattoo business was transmitted from father to son for one or two individuals per generation, the craft has spread more rapidly among Sulu'ape Paulo I's extended family.

This exceptional increase in one family is explained by the artistry of some of its members. It can also be linked to a favourable social and historical context. Indeed, until the 1960s body marking remained largely associated with the chiefdom. But as we have seen,

it assumed a considerable cultural value at the country's independence in 1962 and with the subsequent establishment of a diaspora in New Zealand and Australia. Between 1970 and 1980 the settlement of tufuga from the Sulu'ape family in New Zealand increased this process, especially under the aegis of Su'a Sulu'ape Paulo II. By opening a tattoo studio in Auckland, agreeing to tattoo pālagi, travelling overseas to attend various conventions, organising the first international tattoo convention in Apia in 1999, and showing an openness to sharing his knowledge, Su'a Sulu'ape Paulo II can be considered the first tufuga to have combined the double attributes of ritual expert and modern tattoo artist.

◀ • ▶

Although tufuga are still the agents of a rite of passage, their key skills now are primarily technical. Their craft consists not only in reproducing a complex standardised image on the body but, unlike most Western tattooists, they must also know how to make their own tools – including sometimes their own machine tools[14] – and mix their own dyes. Moreover, they are the repositories and custodians of the knowledge associated with ritual restrictions and procedures – the position of the body, the ordering of the application of motifs on the body, and specific body therapy such as massages during the process of tattooing, but also removal of skin marks by using tattooing needles without ink. The most learned have a good command of oral tradition and the interpretation of ornamental motifs.

Finally, the ritual knowledge of a matua o faiva (senior craftsman) is both practical and doctrinal, but the technical prevalence of their skill has led most observers to describe them as craftsmen rather than ritual experts. The reason for this is their expertise in the hand-tapping technique that is required by the use of Sāmoan tattooing combs. This very complex and somehow counterintuitive technique necessitates a long apprenticeship that must be served with a recognised member of a tattooing clan.

The main material components are the au tā tatau (tattoo needle) and the sausau (striker or mallet). A tufuga possesses between three and five different sizes of au tā tatau depending on the way they position ornamental designs. The au mono (caulking needle), the narrowest tool, is used mainly to create small decorative forms; the au sogi 'asofa'aifo (curved rafter needle) is used to tattoo curved lines on the abdomen and sometimes for filling in large motifs; the au sogi 'asossasa'o (straight rafter needle) is used mainly to prick straight lines and delineate zones (vāega) of the tattooing; and the widest tool, au tapulu, derives its name from the solid black area on men's outer thighs – its main purpose is to blacken this particular area.

Each tool is associated with a special mode of percussion, and this makes the sound environment an important factor for guiding the apprentice. Before they experiment with the tools, apprentices learn how their masters operate by watching and also by listening to the rhythmic sequences. Strikes on the au mono tend to be composed of short and rapid

14.
For example, the auvili – a pump crankshaft used to make holes; or the vatu'e – a file made of sea-urchin spines used to sharpen the needles.

TATAU

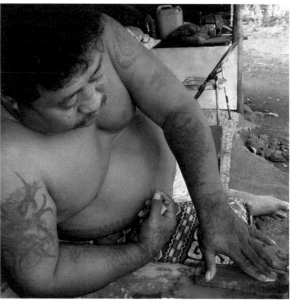

Fig. 85
Sections of boars' tusks before grinding.

Fig. 86
Su'a Loli Misitikeri grinding a boar's tusk on a whetstone.

strokes, while percussion on the widest tool, the au tapulu, is heavier, longer and more regular. Because of its width, this tool can be activated by a heavier sausau or striker. This aspect of the apprenticeship, especially the idea of considering the sound environment as part of the learning process, can be unconscious. However, discussions with tufuga show that they accord a real importance to the sound produced by their instruments. In particular, over the last ten years while they have been experimenting with different materials to adapt handles to mounting steel needles in place of those made of boar's tusk, some innovative metal handles were rejected because of the sound they produced.

Although the composition of Sāmoan tattooing tools seems at first glance to be rudimentary, it requires a delicate shaping of each fitting part, and the assembly itself requires a strict operational sequence. The tool is composed of a handle, a holed piece of Perspex or turtleshell and a holed piece of flattened boar's tusk (nifo pua'a) in which the needles are sharpened one by one with a file made from sea-urchin spine (vatu'e).

The bone material has interesting properties for the tattooing operation because this kind of ivory is very hard wearing and strong even when it is cut into 1mm sections. It allows the shaping of extremely fine teeth for the tattooing comb that won't break under the countless blows of the sausau. The boar's tusk has to be extracted from the jaw before the animal is cooked, otherwise it will be unfit for toolmaking, as this material can be altered by heat. This came to the fore over recent decades, when the tufuga became more concerned with hygiene: eventually they found that cold sterilisation was the only acceptable option to satisfy foreign customers, and they upgraded this aspect of the craft in the Sāmoan diaspora.

Transforming nifo pua'a into tattoo needles is a staged process: first the tusk is extracted from the jaw and cut into sections which are polished and pierced; then a flat

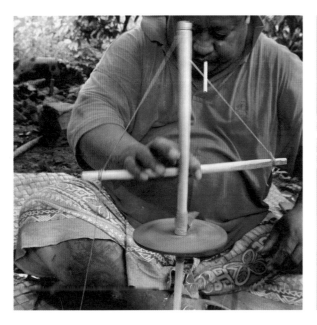

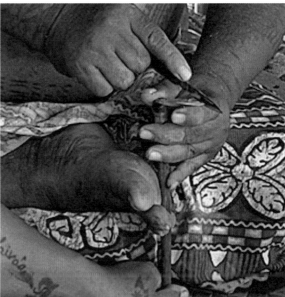

piece of ivory is fixed to support the plate; the plate and bone are fixed to the handle, and the teeth are designed and sharpened.

◄ • ►

In most cases Sāmoan tufuga use imported inks that conform to international standards of health and hygiene. Indian ink is an acceptable option, and some tufuga use lama kaleseni, an ink produced from kerosene soot. Recently the Sulu'ape family collaborated with an American tattoo supplier to release a black tattoo ink called 'Suluape Black'. On rare occasions the tattooing can still be done with the indigenous pigment called lama Sāmoa – a powder made from the collected soot of burnt nuts from the candlenut tree *(Aleurites moluccanus)*, which turns into a black pigment when mixed with water. Production of the lama used to be the responsibility of the tattooed person's family. According to Tui atua Tupua Tamasese Efi (Sāmoa's head of state from 2007 to 2017) it was made soon after the birth of the recipient of the tattooing and was kept until they reached the age where they could receive a tattoo. Tufuga are expected to know how to transform the lama nuts into a black pigment.

There are a number of rules for making lama, and their observance can in turn affect the ritual. As in many parts of Polynesia, the tattoo pigment is made from the kernel of the nut. In Sāmoa, the candlenut tree is called lama. Collecting the nuts was left to children, but the rest of the process – in particular the combustion – required special procedures because of the belief that the smell of the burning kernels can attract evil aitu or spirits. The women in charge of the burning process were preferably nofotāne (women residing in their husband's household). They carried out the burning in a

Fig. 87
Su'a Loli Misitikeri using an auvili (pump drill) to pierce hole on the planished tooth.

Fig. 88
Su'a Loli Misitikeri preparing the spacing of the needles.

189

15.
In the Sāmoan context, the notion of tāpua'i is crucial to understanding the representations of action. The tāpua'i in this case involves placing oneself in a meditative exercise to determine the success of an action. See E Ochs, *Culture and Language Development. Language Acquisition and Language Socialization in a Samoan Village* (New York: Cambridge University Press, 1988), 78.

Fig. 89
Lama nuts (*Aleurites moluccanus*) used to manufacture tattooing pigment.

Fig. 90
Most contemporary tufuga tā tatau use steel needles and commercially produced black ink.

dedicated shelter, continuously tāpua'i le afi[15] (taking care of the fire with silent prayer) to make sure the fire didn't go out. The fire had to be closely attended for fear that a spirit might come into contact with the nuts and alter the pigment or, more precisely, inhibit its blackening properties.

Changes in the pigment can occur while the tattoo is healing or after it has healed – this is called lama'avea, and it is generally attributed to some supernatural agency. It can be attributed to poor combustion of the seeds, but it most often indicates inappropriate behaviour by the tattooed person or a member of their family, or an infringement of one of the fa'asā (taboos or ritual proscriptions) imposed by the tufuga. The lama'avea is both an indicator and a symptom of something that has gone wrong during the ritual. There are crucial procedures that guide the correct conduct of the participants and their involvement in this aesthetic and ritual enterprise.

Lama making is done according to a sequence that begins with collecting the nuts, sun drying and then roasting them, making the heart stone, cracking the nuts open and threading the seeds, burning them over the fire and collecting the soot. Making lama kaleseni – ink made from kerosene soot – follows the same process, but the soot is stored in a large metal biscuit tin rather than on a flat stone.

◄ • ►

The toso are essential to the tattooing ritual. They are the assistants who stretch the skin to create tension, which is crucial to the procedure and ensures that the pigment remains in the skin. It takes two or sometimes three people to perform this task for the

tufuga. The toso not only stretch the patient's skin but also assist the tufuga before, during and after the operation by making tools, cleaning and storing them, preparing the rest of the equipment, and attending the patient with therapeutic massages. Some may also be designated to perform ceremonial functions – notably speaking on behalf of their master during the gift-giving after the tattooing.

The tattooing technique – the handling of the tools, the type of percussion and the different stages of construction of the image – is much the same for all tufuga but also allows for specific variations in the ornamental designs as well as in the order in which they are applied on the body. For that reason, it is essential that the tufuga has experienced and reliable assistants who are accustomed to their master's working habits. Assistants are not necessarily apprentices – they may not intend to pursue a career in tattooing – but every apprentice must have been an assistant at some stage. This important distinction helps us understand how the ʻautufuga (the tufuga and his helpers) is structured as a work group. Whatever their rank within the hierarchy of their village, all toso must obey and carry out a tautua (service) function.

Moreover, there is a hierarchy at play among the stretchers themselves – and that is demonstrated by the allocation of duties during the operation and the level of remuneration they receive from the tufuga and the patient's family during the

Fig. 91
A tattooing session
in Point Chevalier,
Auckland, 2007.

TATAU

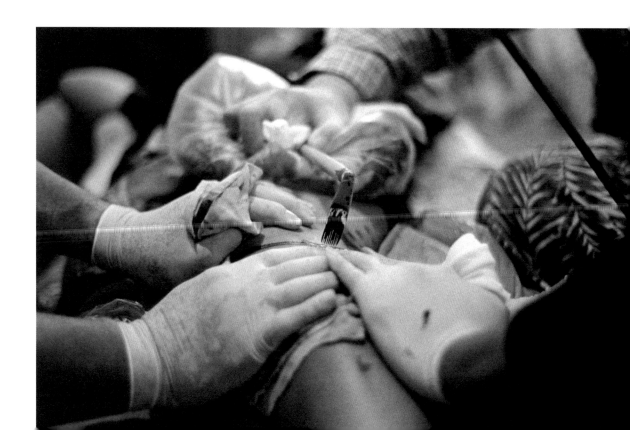

closing ceremony. Facing the tufuga, the most experienced assistant secures the right tension of the skin on an area of the patient's body that the tattoo artist cannot always see. A second assistant is positioned beside the tufuga so that the latter can always control the position of his less experienced hands and correct it if necessary.

A third assistant, who is more mobile, is responsible for various non-specialised tasks such as renewing soiled fabrics, lighting cigarettes, or occasional skin tensioning. He is often recruited from the patient's family and is not formally acknowledged for his work during the closing ceremony. He is nonetheless an important agent and helps our understanding of the organisation of the 'autufuga. The position of third toso is the first step in an apprenticeship. It is often performed by young boys from the tattooist's family, who can be called to do other household tasks apart from those related to the tattooing. The role of stretcher normally begins later on, in early adolescence, when a young man's experience starts to be acknowledged among his kinsmen.

Most of the work groups we studied between 2001 and 2017 tend to limit the transmission of the craft to their talented family members, but these days foreign tattooists from various backgrounds often approach tufuga to do an apprenticeship. They have usually acquired skills on their own account and they contact the tufuga in order to improve them. The international tattooing community in general values the skills that the Sāmoan tufuga embodies. For some Westerners having regular contact with and being acknowledged by a Sāmoan expert tattooist can also be a way of gaining verbal authorisation to use Sāmoan iconography while enhancing their profile and displaying their commitment to a traditional and ancient art within local and international tattoo scenes.

Two cases illustrate this. The first concerns the tattoo artist Wilson Fitiao, who operates out of American Sāmoa; he was trained in fine art and siapo (tapa) decoration by renowned siapo artist Mary Pritchard in the 1970s before he took up tattooing to generate some additional income. A turning point in his career came when he travelled from American Sāmoa to Western Sāmoa to continue his training in the Sāmoan hand-tapping technique with Suluʻape Lafaele, one of the Suluʻape brothers who was based in the island of Manono. He described his time with Lafaele as follows:

> I wanted to learn from a master, someone who belonged to a clan known for their tattoos and known for their mastery. So I went to Suluʻape Lafaele two years ago. He is the youngest of the Suluape clan, who are well known for their work … The first thing I was told to do, if I wanted to become his apprentice, was to cut my hair. I had a rasta style. Believe me that was a sacrifice! I still have some people who don't recognise me now. But it's been worth it! For the next three months I helped him light his cigarette and watched. A very humbling experience. I was told to do nothing else. My pride really took a blow. But I knew this was the right way.

Kasala Sanele was born in Falealili in southern 'Upolu and raised in New Zealand. He defines himself as a self-taught tufuga. By 2009 he had already completed numerous pe'a and malu and could thus be considered experienced. He met Su'a Sulu'ape Alaiva'a on two occasions in Auckland and in Las Vegas to undergo training. This was a humbling experience as his task consisted of sitting beside the stretchers and fanning the group. According to Sulu'ape, giving his approval was not a big issue because of Kasala's talent and his village of origin, Saleilua Faleālili, which is connected with the tattoo oral history through the voyage of Taemā and Tilafaigā.

These cases indicate two fundamental elements of fa'asāmoa regarding the transfer of the trade. The first centres on the mode of transmission through a master/apprentice relationship, which consists primarily of the step-by-step acquisition of non-verbal knowledge: through service, the apprentice progressively learns the technical and cultural rules of the craft. Even though Wilson Fitiao and Kasala Sanele were not beginners, they were still given the office that is normally assigned to newcomers. In other words, experience outside the master–apprentice relationship is not taken into consideration; the tufuga seeks to test the commitment and patience of the candidate, before he learns anything.

Second, both of these cases show that the new practitioners are neither forced nor strongly encouraged to approach an elder or matua o faiva; rather, they feel the need for the approval of a recognised elder of the profession – if not to receive a title from him, then at least to be granted more legitimacy, to avoid criticism and gain respect from other practitioners. This last point is a sensitive issue: some tufuga practising in New Zealand have had their ritual expertise questioned as a result of uncertainty about their legitimacy to practise; about whether they have been endorsed by a matua o faiva; and whether they have completed a traditional apprenticeship with a master.

This kind of learning model shares many features with anthropologist Jean Lave and educational theorist Etienne Wenger's concept of a 'community of practices'. Applied to the learning process that tufuga tā tatau usually go through, it means that learning is simultaneous with making. Moreover, the apprentice is learning through socialisation, visualisation and imitation, and achieves importance in the work group through a 'legitimate peripheral participation',[16] starting with basic, non-specialised tasks and progressively acquiring skills, know-how and the specific culture and values of the group. Once recognised by the work group, these skills and knowledge grant the apprentice access to higher levels of technical knowledge and movement up the group hierarchy.

16.
J Lave and E Wenger, *Situated Learning. Legitimate Peripheral Participation* (Cambridge: Cambridge University Press, 1991)

◄ • ►

A constant of all human societies is the shaping of a person's body by various social agents and institutions (the kin group, the husband, the shaman, the church, etc.),

Fig. 92
The interior of a fale
Sāmoa (Sāmoan house)
showing the aso (rafters)
and an analogy between
the architectural skills of
a master carpenter and
a master tattooer.

17.
A Gell, *Wrapping in Images: Tattooing in Polynesia* (Oxford: Clarendon Press, 1993).

throughout their existence and according to various criteria such as the acquisition of physical and cultural skills, status and so on. Nineteenth-century accounts of Sāmoan tattooing have described it as a rite of passage linked to access to sexual reproduction and membership in the 'aumāga – the group of untitled men who are responsible for service to and defence of the village. Tattooing in Sāmoa therefore simultaneously marked political subjection and individual bravery in a paradox that led anthropologist Alfred Gell to describe Sāmoan tattooing as 'passive heroism'.[17]

As we have seen, after the 1830s, missionaries and colonials provoked major social and political change in Sāmoa. With the widespread adoption of Christianity, the Sāmoans abandoned their (few) objects of worship and the religious practices dedicated to a pantheon of gods. They also abandoned a number of public ritual performances involving the body and sexuality. The disapproval and official bans by a range of missions focused particularly on pōula (night dancing), faʻamāseiʻau (public deflowering ceremony) and tā tatau. As we have also seen, the latter resisted suppression.

In Sāmoa, where most indigenous bodily interventions were replaced by ritual actions based on the Christian liturgy (such as baptism or marriage), tattooing – which also borrows some of its sequences from Christianity, such as the blessing of the samāga by a pastor or a preacher – at times continues to be a rite of passage central to the shaping of Sāmoan masculinity and femininity that relates to an ancient pre-Christian past. Its effectiveness is guaranteed by an ordered series of actions as well as by the visual effect of the resulting assemblage of tattooed motifs.

◄ • ►

Nineteenth-century sources describe Sāmoan tattoo as a collective and public initiation ritual that took place on the malae, the ceremonial ground. For the chiefs who organised it, it reproduced and renewed the force of the village (o le mālosi o le nu'u) – and its task force who were responsible for looking after the plantation, harvest and warfare.

The Sāmoan tattooing ritual was sponsored by a high-ranking chief who legitimised and reaffirmed his political authority by activating an extensive network of alliances and through the public display of wealth and material resources. At the same time, this guaranteed him the participation of the patients' families in further ceremonial exchanges and the involvement of the co-initiated in the task force. For novices, this was a prerequisite for sexual activity and probably also for enrolment in inter-clan conflict.

The few ethnographic descriptions of the tattooing ritual in the mid nineteenth century were produced in the context of recurring wars between clans; this may explain the political and warlike aspect of the ritual at that time. Apart from the accounts of Stair and Krämer, observers who wrote about Sāmoan tattoo did not provide any detail on the organisation of the ritual. Krämer himself relied heavily on the testimony of a single informant whose English translation has proved to be highly questionable. This means there is neither extensive ethnographic description nor anthropological analysis of the contemporary practice.

Unlike his predecessors Stair and William Pritchard, Krämer's published account was reproduced alongside the Sāmoan version of his informant's recollections, along with German and English translations of his text that contain several inaccuracies. The original Sāmoan version offers interesting detail on the nature of the contract between the tufuga tā tatau and the host group. It mentions that when a chief decided the time had come for his son to be tattooed ('fa'a pa'ū le mālōfie') he would send one of his tulāfale (orators) to approach a tufuga. The orator would explain the reason for his visit – 'le alo o le ali'i' (tattooing the chief's son) – and he would then present a fusitā or fine mat. Once an agreement was reached, the tufuga would gather his attendants and 'they would all go to the chief's house' ('latou o'o i le fale o le ali'i'), where 'kava, pork and food in abundance were prepared for distribution' ("ua fai le 'ava, 'ua tao le pua'a, e fai ma sua ma mea'ai tele lava ua lafoa'i').

Later on the chief's son, wrapped in five to ten 'ie tōga, met with the tufuga and unwrapped the mats in front of him as an introductory gift. The tufuga proceeded to draw the very first lines in the middle of the recipient's back – called ano le tua – and 'asked the chiefs if it suited them' ('Se ā so 'outou silasila i le tua o le tama nei?'). The tufuga started the actual tattooing by pricking the motifs on the patient's back in a precise order: 'asofa'alava, pulatama, 'aso e tasi, pula, 'aso, tafagi. The first session was followed by the tattooing of the orators' sons. Krämer adds that some were tattooed inside the house while others were operated on outside. 'The operators were less careful about the tattooing of these subordinates than the high chief's son' ("a 'e lē tā 'ia lelei, e gata i le alo o le ali'i').

The next day the young initiate would come back wrapped in another five 'ie tōga which he would again unwrap in front of the tufuga, who then carried on with the following motifs: 'asofa'aifo, 'aso, saemutu, 'aso e lua, saemutu, 'asofa'avaetuli, 'asotali'itu, fa'aila, selu (which terminated the session around the upper thighs). The same motifs were applied to the orators' sons. The next day, the presentation of 'ie tōga was repeated and the operator worked on tattooing the lower part of the body with the following motifs: tapulu, fa'amuli'ali'ao, fa'avala, fa'aila. The penultimate session was organised in the same fashion with the last sections: fusi, fa'atala-laupaogo, fa'aatualoa, gogo, ulumanu, fa'avala, ta'aila, fa'amuli'ali'ao and atigivae. On the last day, more 'ie tōga were presented by the young man ("ua toe lā 'ei mai fo'i le tama 'ie tōga') and the tufuga ended the tattooing with the navel motif (pute).

Krämer's Sāmoan informant tells us that several days passed before the group of tattooed men had recovered ("ua te'a mai aso tele, 'ua mālolosi le 'autatau'). The tattooist would then inform the supporters that they could prepare for the final ceremony (umusāga). Food gifts of taro, pork, fish, fai'ai, palusami and ripe bananas were gathered for distribution. During the umusāga, the young men were invited to sit ('saofa'i') in the house. The tufuga then walked in front of the group, placed a fagu (coconut shell vessel) on the head of the ali'i's son and hit it. If it broke, that meant life and good fortune for the group; if not, a death would occur. After the ceremony, many 'ie tōga were presented to the tufuga. If he found the gift appropriate, he accepted it. But if he refused it, he could take with him everything he had used during his residence in the village – namely, the furniture on which he slept, mats, ali (wooden headrest) and ta'inamu (mosquito net).

18.
Hiroa, Samoan Material Culture, 640–41.

The observations of Te Rangi Hīroa (Peter Buck) thirty years after Krämer's[18] portray a different process: he distinguishes between the tattoo procedure for the orators' sons and that of the ali'i's son. For the former, one simple visit was needed to arrange the operation, and this could be done without much ceremony. For the latter, the ali'i was expected to offer a fusitā to the tufuga in order to secure a contract with him. Te Rangi Hīroa adds that the tufuga would then arrive to start his work and would be brought an offering of food ('le momoli o le tufuga') – a pig – that would be divided between the chiefs and their tulāfale (orators). According to Te Rangi Hīroa, momoli was much appreciated and allowed the tufuga to enhance his status – in particular if he was not a titled chief himself.

These observations reveal a ritual that reflected the ranking in village leadership and within the established 'aumāga. In other words, the order in which the initiates were tattooed (the sons of ali'i first, then the sons of the tulāfale) as well as the care and quality of their respective pe'a, could make hierarchical positioning between the two classes visible. At this stage it is important to note that the hierarchical distinction between the mānaia (the ali'i's son) and the sons of the tulāfale could only be noticed during the ritual itself – by comparing tattoos from a single ritual. If any hierarchical distinction actually existed in the visual aspect of the pe'a (male tattoo) it could only be a contextual and relational one, not an absolute codification of rank through specific designs.

◄ • ►

ʻO LE FESOʻOTAʻIGA – THE FORMAL MEETING WITH THE TUFUGA
Despite the rapid modernisation of communication technology in Sāmoa in the twenty-first century,[19] making contact with an expert tufuga is still done in the faʻasāmoa way in many instances. A matai from the recipient's family (a father or an uncle) meets with the tufuga tā tatau in person (aʻami le tufuga) with a tāuga – a donation of money, food or ʻie tōga. This constitutes a tacit agreement between the two parties. When the person receiving the tattoo is related to the tattooist this agreement can occur with less formality, via a phone call for example. The same applies if the appointed tattooist is a beginner in the trade – in that case, he usually practises his skills by working on relatives and members of his village community. The talent of the practitioner will then spread by word of mouth before he is entrusted with more prestigious duties.

The reasons for choosing one practitioner over another vary, but field research shows that social closeness is a key criterion: the presence of an expert tattooer within an extended family or in the village has an impact on the number of tattooed people in the immediate surroundings of the tufuga. His extended family and the villagers would naturally choose him because, as a village matai, the tufuga has responsibilities towards his fellow villagers, including the duty to contribute to the wellbeing of his community and, ultimately, to make himself more accessible and more accommodating.

Another common situation, also linked to social proximity, is to approach a tufuga by means of an intermediary who either has an intimate link with the tufuga or is someone who has a good knowledge and command of oratory.

The reputation of the practitioner is another factor in deciding which tufuga to choose. Nowadays tufuga can advertise their skills and take appointments on social media or through a website – making the quality of their work more widely visible.

Apart from the cost and the tattooist's skill, it is crucial to establish a peaceful and friendly relationship during the ritual period – and this does not always involve a huge expense to the recipient's family. In order to ensure the quality of the relationship, maintain its ritual framework and ultimately not put the ritual process in danger, a person from the recipient's family is appointed to be the taufalemau or master of ceremonies.

ʻO LE TAUFALEMAU – THE MASTER OF CEREMONIES
Apart from the tufuga, the tattooing ritual is supervised under the leadership of a taufalemau – a role that is barely mentioned in the ethnographic literature. The taufalemau performs the kind of ceremonial office that has been documented elsewhere for housebuilding.[20] He is the master of ceremonies, the guardian of the operation, the one who oversees the harmony of all participants in the ritual context of the tattooing. He is the representative of the recipient's ʻāiga and the one responsible for the dignity of his group involved in this event. As an intermediary between

19.
Such as extensive use of online social networks and mobile phones.

20.
JE Buse, 'Two Samoan Speeches', *Bulletin of the School of Oriental and African Studies* vol. 24, no. 1 (1961): 104–15.

TATAU

the tattooist and the rest of the household, he holds together (faʻamau) the people involved in the gathering.

Because the appointment of a tufuga requires the establishment of a specific protocol, it is preferable that the taufalemau has previously had the operation himself. He must also hold a matai title, since formal communication with tufuga requires a good command of the ceremonial forms of address reserved for title holders. The oratorical skills and chiefly status of the taufalemau are also essential for the preparation and conduct of the anointing ceremony and the final presentation of gifts to the tufuga. Specifically, while the tauleleʻa (untitled men) are preparing the last stage of the ritual the taufalemau is responsible for collecting goods from members of his group – ʻie tōga, money and food – to be distributed to the ʻautufuga.

As verbal exchanges between the family of the one being tattooed and the tufuga are fairly limited and are conducted very carefully during the tufuga's presence in their household, the taufalemau ensures his family's appropriate care of the tattoo expert and maintains the best possible relations, both verbal and behavioural, with the ʻautufuga. Comparisons between the role of today's taufalemau and historical accounts of the hierarchical organisation of the ritual and the existence of patronage by a senior leader reveal that today it seems to be limited in most cases to the taufalemau's own extended family – indicating a tightening of the social framework of ritual performance. There are nonetheless some exceptional cases involving taufalemau when the operation is collective and when it involves high-ranking individuals – for example during the tattooing of Ronald, son of Prime Minister Tuilaepa Aiono Sailele Malielegaoi in 2004, and at a communal tattooing initiation ceremony in the village of Saleimoa in 2005.[21]

21.
See *Tapu* (March 2005) for Ronald, and *Sunday Samoan* (1 May 2005) for Saleimoa.

FAʻAPAʻIA LE GALUEGA – CONSECRATION OF THE WORK
A short ceremony of consecration is held at the start of the tattooing ritual: this brings together the tufuga and his attendants, the taufalemau and the members of the recipient's family, and the household where the transaction takes place. The ritual context is set up either through a kava ceremony (taumafa ʻava) or through a prayer by a clergyman, the taufalemau or the head of the family. A morning meal is usually shared after the event.

ʻO LE APISĀ – THE SACRED DWELLING
In the nineteenth and twentieth centuries tattooing took place in the malae, the central ceremonial area of a village, and was the public recognition of the emergence of a new cohort of skilled young males in the village. In the twenty-first century, tattooing tends to be performed in semi-private spaces. The tattooing area, when the operation is held in a Western-style house or overseas, is set up at the back of the fale, in the living-room or in a garage. Wherever it takes place, the ritual space created by the tattooing operation requires a formalisation of the relationships between all attendants. The behaviour, the clothing and the seating positions must conform with the rules dictated by the tufuga tā tatau.

Some accounts of rituals in the 1950s and 1960s mention that a special tattooing house or apisā was built solely to accommodate the tufuga and for the completion of his work, which could take from several weeks to a couple of months. The Sāmoan word api usually denotes a lodging place but it is unclear whether the apisā was used only as a dwelling for the tufuga, as described by JE Buse, or if it was also where the entire ritual took place. The suffix sā denotes a sacred status conferred on the person of the tufuga and his belongings during the ritual.

Siaosi Selesele, a Methodist pastor, is himself tattooed on the nostril – he wanted to experience the pain and to feel less ashamed of showing his upper body at public gatherings (as he puts it). He spent seven years in the district of Tafua (the south-eastern peninsula of Savai'i) and was involved in several communal tattooing rituals that were organised at that time for large groups of young taulele'a. He met different tufuga from the Su'a or Tulou'ena clans and was asked to bless the samāga pe'a (anointing ceremony) on occasions. In the following extract he describes how the ritual agreement was communicated between the hosting village and the tufuga.

> They invite people, these tattooing people, to come and do the tattooing. They talk over how many, and they like to use the house for those people, the people from the community and make one place for these people to come.

When he was asked if there was a special formal ceremony where the 'āiga keep in touch with the tufuga and ask him to come, Siaosi said:

> Yeah, before you look for the tufuga, you talk to these people how many people because every tattoo must have [a] pair [a ritual partner] (maua le soa). And then you talk about bringing fine mats, make a tāuga [basket of cooked food or some money]. Money giving to these men, and ask them: please we come and ask you can come to my community and prepare to tattoo six or eight people and they make the agreement, and pay the respect by giving fine mats and an amount of money maybe hundred tala or something like that. So this man is willing to come and work in the community. So in the community they have a special house for him and call it apisā. And they provide food for him and all that looking after … even those people who are having tattooing they must respect him too. He can bring his wife and stay in the apisā. So that's how things happen like that. That's why people welcome him and started his work. So when he started to finish up and sama le pe'a [apply turmeric powder mixed with oil to the tattoo as a healing balm] you can provide maybe ten people or eight people, these people have what you call fine mats. They call it fusitā. So fusitā, money, some food, let the faife'au [the pastor] come and set up the prayer so that they bless these people and bless the man who was doing the special ceremony and say goodbye. Love of God or something like that. You can go and come back. This is how the Samoan maintain the relationship. It's like kinship relationship. E feiloa'iga a tupu, toe fa'amāvae a tupu [The formal meeting of important chiefs, the formal farewell of important chiefs], feiloa'i, fa'amāvae, always occasions like that.[22]

22.
Siaosi Selesele, interview with
Sébastien Galliot, Tuaefu, Sāmoa,
2005.

T
A
T
A
U

Today, most tattooing operations are restricted to the households of the recipients – the tufuga is hosted there only during the day, and returns to his own house at the end of the working day. In a variation on this, in certain circumstances the tufuga is not permanently hosted within the initiate's group but instead accommodates the person getting the tattoo in his own household. In either case, maintaining an appropriate relationship in the form of a tausiga (providing food, cigarettes and pocket money on a daily basis) is always crucial.

MAUA LE SOA – THE RITUAL PARTNER

There must be at least two people receiving a pe'a or malu at any one time. For this purpose, novices will enter into a fesoasoani (partnership). Fesoasoani is built on the Sāmoan term soa, a partner, which in this context is someone who shares the risk and the pain. Most of the time, it involves men and women having their tattoo during the same period, and thus performing the tāpua'i for their respective soa. Here again, the organisational features of the ritual subsume widely shared cultural understanding of the consequences of the actions which take place during the tattooing.

Tattooing is a special kind of bloodletting ritual that involves making an image. In pre-Christian Sāmoa, bloodletting and night time (pō) were circumstances that were conducive to the circulation of aitu (roaming spirits) that caused mental disorder and unexplained skin diseases. The institution of the soa partnership was perhaps a social device to reduce this risk of spirit attack. As a result of Christianisation this kind of explanation for misfortune occurring during the tattooing is now less meaningful. Instead of being linked to the presence of supernatural entities, the interpretation of the soa ritual partnership relates more generally to a custom of tāpua'i which, in its current meaning, is a more common notion for the encouragement of actions of every kind – not just the tattooing ritual but other everyday actions such as driving a vehicle, fixing a lawnmower or playing a game of rugby, for example. In each case, the local understanding of the action includes those who are physically involved and those who are silently watching and supporting the agents with congratulatory sentences.

'O LE MEANA'I TĀUA – THE TATTOOIST'S SPOUSE

Lexicographer George Milner defines meana'i as a polite term used to address or refer to the spouse of a carpenter, craftsman or builder.[23] A similar term is sometimes used during contemporary tattooing closing ceremonies. As Siaosi Selesele notes, the tufuga's wife can be part of the hosted group with her husband; that is, she could come and reside with her husband during the whole ritual, which could last several weeks. Similarly, her ceremonial status is acknowledged by the respectful term meana'i tāua during elite communication. In Sāmoa, where a high cultural value is attributed to oral knowledge and its proper implementation, such terms are far from trivial. The meana'i tāua shares this privilege with the tulāfale's wife and ali'i's wife, who are addressed as tausi and faletua respectively.

The following edited extracts from interviews relate to the indigenous understanding of this character.

23.
Milner, *Samoan Dictionary*, 143.

Like the relationship in building a fale and tattooing, because the wife of the tattooist, she was the one that used to go out … because … the tattoo should come with its own lama, because when the boy is born the grandmother starts burning the lama for the baby boy. And leave it to cool down until he's in his late teens; by the time he gets his pe'a the grandma is already gone but that was her gift to the boy. But if these people came and they have no lama, it was the tufuga's wife's job to make enough lama. That's why they are called meana'i tāua.

Meana'i tatau, meana'i, is also known as if you have the staple food, taro, bread-fruit, banana, yam or tamu [giant taro, *Alocasia* sp.]. The meana'i eat the good food like fish, pork. And because this woman does a lot to help in the work, that's why she is recognised for her work. So, when the samāga [closing ceremony] comes, it is also known that what is given to her is mostly for her and the husband. So she gets a portion with hers and he also gets a portion with his. So in the real samāga fa'aSāmoa the meana'i portion of the goods is nearly as much as [for] the tufuga.[24]

This interview with a title holder of the Afamasaga clan adds some information about the tufuga's spouse.

SG Did you have your samāga with this person? [The reference here is to a young man unrelated to him.]

TA Yeah, after our pe'a and then Lafaele excuse for come tomorrow. And then he came with his wife and some other guys for ready for the sama.

SG Why is the wife of the tufuga so important for the samāga?

TA The wife of the tufuga is called the meana'i tāua. She is a very important person. [Tattooing a] pe'a is like building a fale, house. Every picture of the pe'a is the house. And in building the house it is very important for the tufuga to bring his meana'i tāua for the tāpua'iga, for the sharing, cause it's good to be there for the safety of the tufuga and you know, it doesn't make him fall down or something like that. It's good luck for the carpenter, you know what I mean. And when they have fa'aulufalega and the sama they always give the present for the wife first and then the tufuga.

Tāua means very important person in the eye of the tufuga. Lafaele's wife, she was at Manono. She didn't come at the first day of the starting of the pe'a. So she had to remain there. She came in time for the sama. Because if she comes during the work, it will make me sore. It's a belief, and there are a lot of things you're not supposed to do. Lina's father [Sulu'ape Alaiva'a] and his brothers they know all these rules relating to the tattooing of the pe'a. But they told me some of the rules are not worried about now, even getting tattooed by myself – you know that rule – because usually everybody has to be tattooed in pairs. So now you can be tattooed one at a time.

24.
Malagamaali'i Lavea Vui Levi Fosi, interview with Sébastien Galliot, Apia, Sāmoa, June 2005.

TATAU

Practically speaking, the spouse of the tufuga does not undertake any ritual work but from a ceremonial standpoint she is considered as taking part in tāpua'i, even from a distance. The first interview extract refers to making the lama, a challenging task that was usually left to the nofotane (a woman residing at her husband's household). Interestingly, she can be considered as a possible source of threat; for example if anything goes wrong in the relationship between the parties, her supernatural power will affect the lama and its degradation into the patient's skin.[25]

SĀ O LE GALUEGA – THE RULES OF THE RITUAL

The tattooing operation is governed by two kinds of rules – the prescriptions (tulāfono) and the proscriptions (fa'asā). These apply differently depending on whether one is in a passive state (the patient) or taking part actually or virtually in the transformative action of the ritual. There are a range of prohibitions and general rules for the tattooist and the supporting group.

Everyone must wear an 'ie lāvalava – in general, the only suitable garment for everyday village life. No shorts or trousers are allowed in the ritual space. There are no details about the origin of this rule but its enforcement is probably a reaction to Western clothing and the increasing number of visitors who are unaware of Sāmoan customs. In Sāmoa, every formal gathering engenders de facto a ritualised mode of interaction – and the creation of a virtual hierarchical space within which speech and behaviour switch to formal mode. People attending must remove their shoes, be free of any adornments such as hat, ula (necklace) or sei (flower behind the ear), and must sit cross-legged (fātai). People are not permitted to drink or eat anything in the ritual space – although smoking is routine.

The tufuga usually sits in a segregated corner of the room with his equipment. Apart from him and his helpers, other participants in the operating space form the 'autāpua'i (those who encourage the action by silent prayer). During the tattooing session, which can extend over several weeks, a large number of family members can attend and perform the tāpua'i. This, besides silent worship, manifests through acts of empathy towards the novices and the tufuga – for example by waving a fan to keep away the flies and provide fresh air for the wound and the operators, or by holding the patient's head, hands or feet to relieve or distract them from the pain.

The following extract from an interview with the father of a future sogā'imiti gives some insight into the practices associated with tāpua'i.

Faifili It's very important for people that are supporting, all the people that are sitting around beside this people that are actually doing the work … It's very important for us, supporters, to say this words, a sort of encouraging for the guy who is laying down to have a pe'a done and to … a sort of thanking the man who is doing the job and the guys that are doing the other job like pulling the skin and wiping the blood. The main thing to understand is encouragement.

25.
Afamasaga Joe (brother-in-law of Sulu'ape Alaiva'a's daughter Lina), interview with Sébastien Galliot, Levi Saleimoa, Samoa, April 2005.

TATAU

SG Is it what you call tāpuaʻi?

Faifili Tāpuaʻi. Yes, the word for tāpuaʻi is worshipping.[26]

26.
Levave Faifili, interview with Sébastien Galliot, Savalalo, Sāmoa, 2001.

Another essential element of tāpuaʻi consists of repeating affirming phrases during the operation:

Mālō le sisila [silasila]!*Congratulations for what we are seeing*

Mālō le tali au!*Congratulations on accepting the tattooing needles*

Mālō le sausau!*Congratulations on the striking*

Mālō le aʻao solo!*Congratulations to the working hands*

Mālō le toso!*Congratulations to the stretching assistants*

Mālō le onosaʻi!*Congratulations for the patience*

Mālō le taʻoto!*Congratulations for the lying down*

The assistants and tufuga invariably answer:

Mālō le tāpuaʻi!*Admirable is your tāpuaʻi*

The work of the tufuga is generally described as sacred or restricted (faʻasā). While faʻasā can mean forbidden, it is better expressed as 'sacred', as in the phrase: O sā ma faigatā o le galuega. E leoleoina ilāmutu o le galuega (The work of the tufuga is sacred and difficult. It is protected by ilāmutu).[27] In this context, ilāmutu refers to the descendant of the female founding ancestors of a clan – that is to say, the tufuga as a descendant of the twin aitu Taemā and Tilafaigā, with whom a covenant has been established.

27.
Tufuga Suʻa Laʻai, interview with Sébastien Galliot, Gagaifo, Lefaga, 2005.

The patient is subject to a set of ritual rules (faʻasā). They must: observe the gendered nature of the tattooed marks – i.e. men should wear a peʻa and women a malu; complete the tattoo once it has been started; refrain from shaving or cutting their hair; have a partner (soa) to share the pain and to reduce the risk of a malevolent spirit attack; refrain from having sexual intercourse; not wear body ornaments or perfume; refrain from sleeping in a Western-style bed.

This last rule relates to the patient's physical response to the trauma: one direct effect of a tattoo is that it causes a warming of the unhealed parts. The body is said to be mū (hot or burning), and sleeping on a mat on the floor allows better ventilation of the wounds. In addition, the application of nonu leaves (*Morinda citrifolia*) can draw out the heat from the tattoo.

Fig. 93
Tattooing operation in Savalalo, Sāmoa, 2001. Tapua'i (silent worship-ping) is materialised by actions of support and release towards the tattooing group and the patient. Photograph: Sébastien Galliot.

After each tattoo session the patient's body is washed and massaged at regular inter-vals in order to extract the excess pigment and lymph. After each session, the patient is required to take a short walk every day at sunset. The tufuga and his assistants are very careful about the healing process. At the beginning of each session they examine the work that has been done the day before and check the state of the skin in order to evaluate how the next tattooing session should be conducted and what advice should be provided to the patient.

The main consequence of non-compliance with the rules imposed by the tattooist is lama'avea. This alteration of pigment is said to cause death and is still understood as a curse.[28] Several cases of severe infection and death have occurred in Sāmoa, New Zealand and Australia. Richard Moyle recalled that, while he was doing fieldwork in Sāmoa in 1968, four young men died in Palauli (Savai'i) as a direct result of blood poisoning after having been tattooed – it was widely believed that substitution of the contents of torch batteries for the candlenut soot was the cause. Recent instances of infections in Australia and New Zealand have been covered by medical and general media. For example, in 2006 a tufuga who was allegedly involved in transmitting a bacterial infection that necessitated a major skin graft gave his opinion as follows:

> I do not want to comment on the two individual cases that were linked to me but suffice to say that in this work there is a reciprocal relationship between the tufuga (myself) and the 'āiga (family). I have a duty of care to ensure hygiene and the individual/family have an obligation to follow the instructions that are set by me in relation to the healing process. If these instructions are not strictly followed then sickness may occur.[29]

28.
The same term, avea, is used in Wallis and Futuna Islands and refers to death caused by an infringement of tapu. S Grand, *Tahu'a, Tohunga, Kahuna: Le Monde Polynesien des Soins Traditionnels* (Tahiti: Au Vent des Îles, 2007), 214.

29.
'Vindication for Tufuga', *City Life* (11–17 September 2008): 4.

The healing of the wound depends on strict compliance with all these rules so that the final appearance of the tattoo also works as an index of the patient's behaviour beyond the transaction itself. The state of the tattoo during the healing process – and more generally the way the skin looks – is believed to say a lot about the morality and behaviour of the person. Papala (wounds) and scars – especially if they are unusually large or unexplained – are interpreted as a sign of misconduct regarding sexual behaviour or the infringement of a taboo.

The importance of the pricking of the skin, the pain inflicted and the eventual tattoo as a finished artefact are no less symbolically and culturally central to the institution of tattooing in Sāmoa than the process of healing – particularly nowadays, when the use of an indigenous and painful technique of tattooing and the display of a finished pe'a or malu take place in a global context where other less invasive and painful tattooing techniques and body ornaments are possible. Among Sāmoans and non-Sāmoans, the process plays a prominent part in shaping one's identity and grants the tattooed person a wealth of cultural experience.

So far we have been examining how the different agents, their status and the rules they follow during the process of inscribing the body with a pe'a or a malu are all part of a specific ritualised behaviour. In this ritual, the technical actions, the tools, the ink, the participants (human and invisible entities) and the formalised speech are all focused on the making of an embodied artefact, which in turn indicates that the transformative action of the ritual is effective.

An unfinished pe'a – a pe'amutu – on the other hand, is considered shameful because it is a visible sign of cowardice, and also because it shows that the ritual failed to transform the patient – and this failure discredits the whole family. This is not an anthropological assertion about Sāmoans as individuals but rather a recognition that members of the patient's family are directly responsible for maintaining proper relations with the ritual expert. A completed pe'a or malu – more broadly and ceremonially called mālōfie – also contributes to the public display of one's family mamalu (dignity).

The ritual itself is focused not only on the operation and the pain inflicted on the patient. In fact, the principle of tāpua'iga, which organises relations between the 'autufuga, the ta'oto (the patient) and 'autāpua'i, is at the core of a communion with the divine and with invisible entities to which members of a sacred circle (sitting in the room where the tattoo takes place) participate in order to ensure a successful outcome

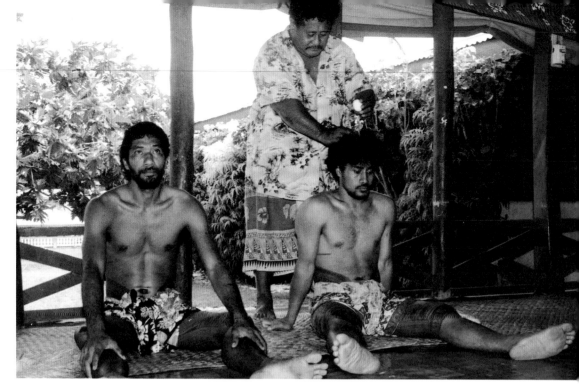

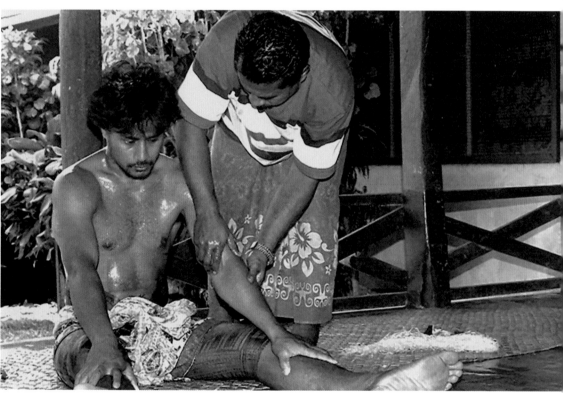

THE FINAL CEREMONIAL SEQUENCES
These days a large number of overseas tattooists reproduce the pe'a and malu outside the strict ritualised context described above, but the Sāmoan tattooing ritual still includes other sequences that are compulsory if the ritual is to be properly accomplished: the release of the patient's samāga, and the ceremonial presentation to the tufuga and his work group, the umusāga.

SAMĀGA – THE CLOSING CEREMONY
There are some differences in the performance of this last step of the ritual, depending on the rules of the sā Su'a and the sā Tulou'ena. The following description is based on direct observations during fieldwork in the company of Su'a clan members (Su'a La'ai, Su'a Sulu'ape Alaiva'a and Su'a Loli Tikeri).

The samāga ceremony involves anointing the tattooed person's body with sama – a mix of ground turmeric and coconut oil. But it also implies several other actions. In fact, the samāga tatau is a formal gathering of the tufuga, the patients and the senior members of their family, including the taufalemau. It usually begins with a tatalo or prayer (performed by a pastor, a priest or the head of the 'āiga) and a vi'iga (hymn). This is followed by the lulu'uga, so called in reference to the act – described in the nineteenth century by both Stair and Krämer[30] – of breaking a gourd and sprinkling the initiates with coconut water. Although the actions performed during the lulu'uga do not require technical expertise – and even if the tattooing has been done by a younger member of the tattooing clan – the importance of this action usually requires the presence of and monitoring by a matua o faiva (senior expert). This is one reason why some people who have received their pe'a overseas wait for an occasion to go back to Sāmoa to be anointed by a matua o faiva.

The contemporary lulu'uga in use among the Su'a clan takes a similar form: the tufuga stands in front of or behind the initiate and applies part of the contents of an egg to the top of the patient's head while murmuring. Sometimes the tufuga urges the initiate to honour his family and his village and to act as a responsible and mature person. These injunctions are followed by a wish for good fortune and a blessing. The rest of the egg is sometimes given to the main toso, who swallows it.[31]

The lulu'uga is said to release the patient from the fa'asā imposed on his behaviour during the initiation. It formally acknowledges the transformation of the initiate and his reintegration into the community. Although this gesture seems to pursue the same goals as the ancient form of lulu'uga – and the tufuga tā tatau sometimes explains this part of the samāga as a rebirth – there is also a possible parallel with the Christian baptism during which the head of the newborn is anointed with a mixture of oil and balsam.

The next step is anointing the sogā'imiti's body with sama. Turmeric is well known in Polynesia for its healing properties as well as for its use in transition rites connected with birth, pregnancy, chiefly status and funerals. In Sāmoa, this task is entrusted to assistants who anoint the sogā'imiti's whole body, or the legs of a newly tattooed

Fig. 94
The ancient ritual action of lulu'uga (sprinkling / taboo removal), performed nowadays by rubbing the top of the sogā'imiti's head with the contents of an uncooked egg. Photograph: Sébastien Galliot.

Fig. 95
Samāga, the anointment of the sogā'imiti with a mixture of turmeric powder and coconut oil, has the double purpose of neutralising the pigment's potentially nefarious action and preparing the initiate's body for display.

30.
Stair, *Old Samoa*.

31.
This custom seems to have emerged during the twentieth century. However, we have not been able to link it with historical sources.

TATAU

woman. The act is a blend of the pragmatic and the symbolic. It is said to fa'amamā le sāsā o le lama – which can translate as 'to purify the body from the omen of the pigment'; this has the dual purpose of soothing the patient's body after physical trauma and releasing it from the supernatural sanctions linked to the properties of the lama (the ink) – in other words, the action aims at neutralising the forces contained in the lama.

Then comes the distribution of scented lei as tokens of happiness and affection. This is often followed immediately by a taualuga (a solo dance performed at the end of an important task), which both displays the newly tattooed bodies and represents a performative recognition of the task that has just been completed.

While pain inflicted on the patient is a key component of the tāga (tattooing operation) and part of the ritual, it is nonetheless important to stress the emotional element of the samāga. This occasion, marked in most cases by discreet crying and tears from the patient and his close relatives, terminates a long, painful and difficult process involving care, concern and significant expense on the part of the sponsoring family. These final attentions to the patient's body cause great relief and allow every participant to express their feelings of love, contentment, pride and gratitude.

THE UMUSĀGA – THE FORMAL GIFT PRESENTATION FOR THE COMPLETION OF THE WORK

The umusāga is usually held on the same day as the samāga. Sometimes participants move to the pa'epa'e, the yard in front of the house, but more often they remain where the samāga has been performed. This gathering shares many of the organisational elements – the configuration of space and body techniques – that are used for greetings[32] and, more specifically, when a housebuilding is completed in Sāmoa.[33] It is closely related to a Sāmoan inauguration ceremony of a faletele (the big roundhouse that requires the work of a tufuga and his team), in that these ceremonial exchanges are not focused on the public display of reciprocity between 'āiga or villages but rather on appreciation and gratitude for an accomplished ritual work. In this respect, there is no fixed price but the taufalemau is generally aware of the acceptable minimum that he will have to gather among the kin group of the sogā'imiti. In some cases, a sogā'imiti who might not have been collectively sponsored by his kin is allowed to pay for the operation at a level agreed by the two parties before the operation; this method is sometimes called fa'apapālagi (the European way) or fa'atupe (in cash). This stands in contrast to fa'asāmoa, which designates a more formal and customary way as described below.

Like other ceremonial distributions of money in Sāmoa, the display of wealth varies according to the rank of the people involved in the tattooing ritual, and also according to the wealth that the tattooed person's family has planned to display. These days people get tattooed at different stages of life – the patient (male or female) can be either a young and untitled individual (taule'ale'a), a respected title holder (matai), a successful businessman or a notable person appointed to a high position in government. Although it has never been addressed as such in anthropological literature, the umusāga dedicated to the completion of a pe'a or a malu is associated with redistributive activities

32.
A Duranti, 'Language and Bodies in Social Space: Samoan Ceremonial Greetings', *Anthropologist* vol. 94 (1992): 657–91.

33.
Buse, 'Two Samoan Speeches'.

that commemorate important life events, and has its own distinctive features. When the ritual involves several individuals from a village it takes the form of a village-sponsored redistribution, and when it involves people from a specific descent group it is more likely to be an 'āiga-sponsored event.

The umusāga mainly consists of the presentation by the taufalemau of various categories of goods – food, fine mats, cloth, money – accompanied by ceremonial speeches that address each item in a formal way, indicating its provenance and sometimes its monetary value. Gifts or lafo can also be presented to special members of the 'autāpua'i (participants who were part of the tāpu'ai) and those who attend the samāga, such as a high-titled matai, a government representative or a foreigner with special status. Although the items distributed by the taufalemau may vary in quality and quantity, the ceremony is nonetheless performed in a given order. Research in different locations in Savai'i and 'Upolu has shown that the formal rewarding of the ritual work requires a certain category of ceremonial goods that can be – and often are – combined with a cash donation.

If the meana'i tāua attends this event, she would first receive the introductory items of the sua (formal presentation of food): the vailolo (a green coconut ready for drinking and a piece of barkcloth or a can with a small amount of money fixed to it, a box of crackers and several yards of printed cloth), an 'ie tōga (fine mat) and sometimes more printed fabric. The main part of the distribution then goes to the tufuga, and each item is addressed using vocabulary specific to his status of ritual expert. In due course, his spouse would again receive another lafo in the form of a fine mat or cloth (a T-shirt or more printed fabric).

The five umusāga recorded in 2005 typically featured:

1. The vailolo (a bank note attached to a can, a bottle of soda or a coconut).

2. A roll of printed fabric.

3. A plate of food (either a local food cooked in the Sāmoan umu or a box of crackers and a can of corned beef).

4. Manufata (a large roast pig) presented in a woven basket or on a special gurney.

5. 'Ie o le mālō (a small fine mat).

6. O le fusitā (a large fine mat especially dedicated to the tattooing of each patient).

7. O le tōfā (a quantity of large fine mats presented to celebrate the physical, social or material components of the ritual). This includes an 'ie o le mageso (fine mat of itchiness presented to the spouse of the tufuga), tofa o le 'āiga mālōfie (the fine mat of the group of tattooed people), other mats (of the lālaga category which are smaller in size and lower in quality) dedicated to the tufuga's toolkit, and 'ie tōga (fine mats for special participants – high-ranking chiefs or high-status persons).

8. Pāsese (literally passage), usually presented in the form of cash to cover travelling expenses; it is also intended to cover the cost of the operation. Various amounts of money are presented to the tufuga's assistants according to their rank in the work group.

9 Lafo: a gift of a large 'ie tōga to the tufuga's assistants and his commissioned orator.

10. Fa'aoso: a food gift – generally several boxes of tinned fish (pusa apa), corned beef or a basket of raw taro – presented to the tufuga.

11. Mea alofa: gifts of less ceremonial importance such as T-shirts or 'ie lavalava.

In return, the tufuga's commissioned orator, who speaks on behalf of his patron and his work group, expresses his gratitude for the valuables that have been presented as well as for the noble attitude and the good treatment they have witnessed during the whole ritual. Meanwhile one of the assistants, who can be a matai of lesser rank or an experienced taule'ale'a, stands in front of the house and announces loudly, to the whole village, what and how much has been given to the tufuga tā tatau for his work. This constitutes the last ceremonial stage of the whole ritual. It is usually followed by an informal feast and distribution of cooked food to the participants.

The umusāga shares some features with the basic schema of ceremonial exchange in Sāmoa, but it includes a language shift in that several of the 'ie tōga are addressed in ceremonial terms reserved for the ritual status of the tufuga and his specific trade.

Another noticeable feature of the umusāga is the status switch that is demonstrated both through this specific presentation of goods and through the exclusive use of the tattooing title, whatever the rank of a person's matai title. The ritual context introduces a switch in the everyday hierarchy of social organisation. As a ritual expert and as a host, until the end of the umusāga the tufuga temporarily ranks higher than anyone else present. This special status can be understood by going back to oral traditions recorded in the nineteenth century: in the story of Taemā and Tilafaigā, an injunction was made to Su'a that if he accepted the trade of tattooing from these supernatural entities, then he should also receive the first kava cup (the highest ceremonial honour that can be granted to an individual) wherever he travelled to perform it.

Tattooed pastors in the Congregational Christian Church of Sāmoa

Sébastien Galliot
Vaigaga, Sāmoa, and Apia, Sāmoa, 2005

During his 2005 fieldwork for his doctoral thesis, Sébastien Galliot was referred by Lau Asofou Soʻo to an old friend who was one of the few tattooed pastors. Below is an extract of an interview with Tautua (the pastor), and another extract from an interview conducted the same year with Reverend Oka Fau Ola, chairman of the National Council of Churches in Sāmoa at the time.

SG: When you had your tattoo, were you already studying theology?

Tautua: I knew it's not allowed in the church. I'm the son of the pastor. If I have a tattoo on, if I decide to put on a tattoo, my father would be blamed. Then he would lose his job as a pastor. That's why I did it behind them knowing. I just decided myself and did it myself.

SG: Was he angry about that?

Tautua: Yes, he was very angry. My case was based on one condition: if I don't finish this tattoo, then I won't be allowed in the family anymore. So I have to finish the tattoo. Well, that's the only reason why I decided to put the tattoo on myself. I'm proud of being a Sāmoan. I enjoy living as a Sāmoan, doing all the services for the matai and the family, and I really like the life in the village. There's nothing special about it, I just want to have this on as a true Sāmoan. It's a mark of a true Sāmoan. Now I have become a pastor, but before I didn't know I would become a pastor, so I was thinking that after my tattoo I would go back to the village and raise my family, you know. I'll get a lot of money making a plantation. We have land there to plant crops, we have the sea to get fish., I didn't have a tattoo for entertainment or something like that, you know. Actually, I'm not interested in siva [Sāmoan dance].

SG: In your opinion do the young people who get tattooed do it for a different reason than before?

Tautua: Well, there are some young people with the tattoo who do not know how to … cook Sāmoan food, to serve the ʻava ceremony. That is the actual service of a man with a tattoo. And the only person to serve in the house of matai. I didn't mean to have my tattoo because of those things. I wanted to have a tattoo for my identity as a Sāmoan.

SG: In your church, if somebody has a peʻa, does he have a special penalty or do you accept it easily?

Tautua: Well, if you take the Holy Communion in the church and later on you're found with a tattoo, a new tattoo, on, you'd be penalised for three months. Not that that is a very serious penalty – it's just to penalise for the sake of the rule.

SG: Is it the same in the other churches?

Tautua: I don't know about the Catholics, but the Methodists, yes, it's like the same. Two or three months ago I was invited to the aufaipese [choir] of Letogo; the pastor told me that if you're a deacon you have a heavier penalty.

Well, if you have a tattoo when you're a deacon and the church finds you're having a tattoo then you lose your post as a deacon for a certain amount of time, three months or so. It's not that serious a penalty. It's just to show the people of the congregation that it's sin to shed the blood. I only had my tattoo when I was adopted to the family. I was taken away from my parents. If I was still with my father and mother I don't think I would be able to have this tattoo.

SG: Why?

Tautua: Because they don't allow me. I was taken away because of my uncle wanted to raise me as his son, he wanted me to have the taste of what is going on in the family not in the faifeʻau Pastor family. And that's how I had this feeling of having, like, to have this tattoo.

Reverend Oka Fau Ola: Some of the people became members when they already wear a peʻa, but those who go and have the tattoo after being members are excommunicated definitely until they feel sorry and contact the minister and the elders: if they accept that person he is accepted to membership again.

SG: Is that why you can have a theological education at Malua even if you have been tattooed prior to your admission?

Reverend Oka Fau Ola: Yes, some of the people enter Malua after they already have the tattoo, a lot of them, because they already have the tattoo before they become members and so they wear the peʻa. But, if they do it while in the college they are expelled from the college and excommunicated from the church membership.

Tattooing the fa'afafine body[1]

Maria Carolina Vesce

In memory of Lani (Empress Elle La Coeur de La Mère)

1.
The word fa'afafine means 'in the manner of a woman'. It is usually applied to an effeminate man who is permanently or temporarily cross-dressed. See D McMullin, 'Fa'afafine Notes: On Tagaloa, Jesus and Nafanua', in *Queer Indigenous Studies: Critical Interventions in Theory, Politics, Literature*, edited by QL Driskill, C Finley, BJ Gilley and SL Morgensen (Tucson: University of Arizona Press, 2011), 81–94; N Besnier and K Alexeyeff (eds), *Gender on the Edge: Transgender, Gay and Other Pacific Islanders* (Honolulu: University of Hawai'i Press, 2014); JM Schmidt, 'Being "Like a Woman": Fa'afafine and Samoan Masculinity', *Asia Pacific Journal of Anthropology* vol. 17, nos 3–4 (2016): 287–304.

2.
'Fa'afafine Told: Tattoo and Die', *New Zealand Herald*, 6 December 2007.

3.
In this case I have used an invented name to protect my friend's identity.

4.
Pamela, Auckland, 12 November 2015.

5.
Allan, Apia, 28 July 2015.

6.
Ripa, Apia, 21 August 2015.

'Fa'afafine told: Tattoo and die' read the headline of an article published in the *New Zealand Herald* about the controversy surrounding the case of a malu fa'afafine.[2] In the article, the president of the Sāmoa Fa'afafine Association categorically condemned both the fa'afafine and the tufuga, accusing them of 'playing with an extremely sacred art'.

In 2015 I decided to spend three weeks in Auckland in the hope of interviewing Pamela,[3] who, after overcoming her initial reticence, began her story as follows:

> This was my boyfriend's present for me, because I got a boyfriend before and he's the one who paid for my malu […] I remember when I was young I desired to become a business woman and to have a malu, and he knew. So one day, he came and told me 'Wednesday don't go anywhere' and I asked him 'why?', because I didn't know […] Then, on that day he came to pick me up at nine in the morning and we went to his fale. And I was shocked, because the tufuga was there, and all his sisters were there and one of them was charged to wipe the blood.[4]

For Pamela, the gift of the tatau represented a gesture of love, an ode to and a recognition of her femininity. It represents the actualisation of her dreams and the fulfilment of her personal aspirations: it is something exceptionally individual.

As a form of body manipulation that redefines the self as feminine, the malu is founded on and has an effect on symbolic codes that are quite different from those at work in the case of gender reassignment surgery, yet it would seem to be sustained by the same logic of efficacy and to produce the same practical effect. Unlike the surgeon, the tufuga does not play a 'thaumaturgical' role, he does not cure or heal; and yet, his intervention is generative since by inscribing gender, he ascribes it, and for doing so he is either praised or condemned. He manipulates an external surface, but such manipulation acts on the inside, and thus produces a gendered persona.

The majority of those interviewed were absolutely opposed to the idea that a fa'afafine be allowed to wear a malu: 'They're not entitled' was the usual comment.

When asked about the possibility of combining being a fa'afafine and being a sogā'imiti, Allan, a pe'a fa'afafine, Sāmoan choreographer and intellectual of great renown, said:

> If someone asks me, for example the queens … if you ask me 'Why did you get a pe'a?' I twist it around and I cheekily say 'oh, didn't you know? Taema and Tilafaiga came to tatau the women and then when they saw the clam they came up and they forgot their song and they ended up tatauing the men. So I'm a woman making things right, because we the women were supposed to be tattooed with the pe'a, not the men!'[5]

Allan destabilises the reference points and catches the interlocutor off guard, as if he has been placed before a riddle or a puzzle that needs to be solved. Permanently disconnected from the body and from its sexed self, gender casts off its causal function and asks to be redefined in a dialectic manner. To explain the choice of becoming a sogā'imiti, another fa'afafine, Ripa, said:

> As the only male in a family of eight girls … of seven girls … yes, seven girls … it is my duty to share the pain they go through when they're in labour, you know, giving birth. And also, it is a measina [cultural treasures] for my doctoral degree because having a pe'a will give you the authority to speak about every issue, and protect you almost like a shield.[6]

Ripa's words echo one of the most well known proverbs relating to the Sāmoan art of tattooing: 'Tupu le tane ta le tatau, tupu fafine fanafanau'.[7] Duties and responsibilities are inscribed within a network of exchanges that are defined and adapted to the logic of social reproduction: since the fa'afafine are biological males, the tattoo must stand for them as an equivalent to labour. It completes their education, gives them the right to speak, prepares them for service, is necessary for access to power, and provides protection. However, it is the bestowal of the title rather than the tattoo itself that settles the debt to one's sisters, by guaranteeing the right of inheritance to their children.

The feagaiga[8] relationship, the mutual covenant implying respect and protection that binds siblings of the opposite sex, is absolutely central to the issue, and in the case of Pamela, the presence of her boyfriend's siblings fills the void produced by the potentially fatal absence of her own family members. In the case of fa'afafine, the attribution of a moral value to the tattoo still moves along the service/protection axis, and nevertheless manipulates, transforms and reinterprets practices and relationships to produce the desired effect. Unlike the two pe'a fa'afafine, Pamela's tattoo is not one which wraps and protects; rather, it is a tattoo that exposes and excludes. Although acquired according to the fa'aSāmoa, it is perceived as an individualised tattoo, one that breaks the rules and disqualifies the subject.[9]

7.
'The boys grow up and get tattoo, the girls grow up and give birth'.

8.
S. Tcherkézoff, 'The Illusion of Dualism in Samoa: "Brothers and Sisters" Are Not "Men and Women"', in *Gendered Anthropology*, edited by T del Valle (London: Routledge, 2016), 54–87; 'Sister or Wife, You've Got to Choose: A Solution to the Puzzle of Village Exogamy in Samoa', in *Living Kinship in the Pacific*, edited by C Toren and S Pauwels (New York: Berghahn, 2015), 166–85; L Latai, 'Changing Covenants in Samoa? From Brothers and Sisters to Husbands and Wives?', *Oceania* 85, no. 1 (2015): 92–104; P Schoeffel, 'Daughters of Sina: A Study of Gender, Power and Status in Samoa', PhD thesis, Australian National University, 1979; 'The Samoan Concept of Feagaiga and Its Transformations', in *Tonga and Samoa: Images of Gender and Polity*, edited by J Huntsman (Christchurch: Macmillan Brown Centre for Pacific Studies, 1995), 85–106.

9.
I am indebted to Yuki Kihara for encouraging me to consider the va (relationships of space) between Pamela and her tufuga.

TATAU

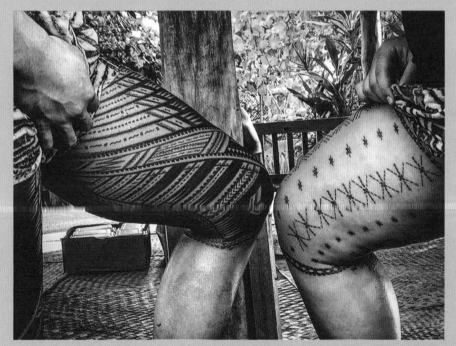

Fig. 96
Male and female tatau by Li'aifaiva Imo Levi.

The apprentice

Sébastien Galliot
Vaea Hotel, Apia, 7 June 2012

Fig. 97
'With stretching, you have two stretchers but they don't do the same job. The stretcher next to the tufuga would be the less experienced stretcher, and the more experienced stretcher would be opposite the tufuga ...': Li'aifaiva Imo Levi, 2012.

Imo is a young tufuga tā tatau who undertook work under the Li'aifaiva tattooing title. At the time of this interview he was in an apprenticeship with the Sulu'ape family in Sāmoa.

SG: How did you start stretching?

LI: My father and [Su'a Sulu'ape Alaiva'a Petelo] have been friends for a very long time. And it was easy to approach him about me wanting to take up tattooing. Also, because of my family lineage which is the second family of the tattooing in Safotu – the Li'aifaiva clan – Sulu'ape he accepted it. I was in New Zealand for university, three years of civil engineering, and by then my passion for tattooing was so strong. My father was actually against it, he wanted me to go on and finish up my degree. It was all on me: when I was growing up, my father always told me about our tattoo connection. You never really think about it when you're young, but after getting my pe'a at seventeen, it just grew on me and I developed my interest in tattoo. Especially living away from my culture, living in New Zealand ... I left home at fifteen for a rugby scholarship and I think I felt a kind of loss of connection with my cultural side. So, I started stretching. We approached Sulu'ape Alaiva'a and he made a joke. His first joke was: 'Anybody who wants to start tattooing, he has to be whipped in the head first!' So I didn't really start stretching at all. I had to sit and observe, you know, with the fan and just watch. I did that for a solid two months. And I was eager to jump on and start stretching but it wasn't until one guy didn't show up – one of the stretchers didn't show and [Sulu'ape] just told me: 'Yep!' [...] It's frustrating for them trying to correct while working. So it's best for you to observe so when you jump on you have a fair idea what's going to happen. I was only tapili [fanning] and watching and it's funny – I would try to help with preparing the solos [wiping tissues] or preparing the pillows but they wouldn't [let me]. I guess you have to gradually gain the trust of the stretchers first, before you gain the trust of the tufuga. So, everything was progressive, you can't just jump. It is from just observing and doing chores, doing the run-around jobs. I've been progressively doing the pillows and now they're very comfortable, now they put a lot of the responsibilities on me. I've

been stretching for a year and a half now.

SG: Who are the tufuga you are working with at the moment?

LI: I kind of sit between the old man Alaiva'a and Pita. I split my time with them. I'm the only one of the tosos that jumps between them. I enjoy that because they have different styles, they want different things. If I stretch with more tufuga I can pick up and learn faster.

SG: According to you what are the main steps of apprenticeship?

LI: With stretching, you have two stretchers but they don't do the same job. The stretcher next to the tufuga would be the less experienced stretcher, and the more experienced stretcher would be opposite the tufuga, because then the opposite stretcher would straighten the lines and correct the lines. The one next to the tufuga would just be the puller, you know, he gives it the tension. Then the guy opposite would be more technical, and the tufuga trusts the opposite stretcher.

SG: So do you actually follow the instructions of the other toso or the tufuga's instructions?

LI: The other toso first and if he doesn't get it right, then the tufuga would say something. So the stretcher opposite from the tufuga, it's his responsibility to look after you.

SG: What about the making of the au? Do you already know how to make them?

LI: At the very start they gave me two au [hand-tapping tools] to start with. Pita [Sulu'ape] started by going off and doing taulima. The message I took from that is, you get up and go! You can't wait around for that blessing! And that's the best way to learn: you learn as you go. So, I've been playing

around with the au and practise what I see every day. I first practised on myself. I tapped the tool on my leg without any ink. I tap until it bleeds and that way I can tell. I just tap as it bleeds, just for the lines and the technique, trying to get it steady. That was part of the apprenticeship. Every day that we take aside, we would spend a whole day making tools, making new tools, helping them and observing … I've helped making the au nila [steel needle tool] and the au nifo pua'a [boar's tusk needle tools]. They were not hiding secrets, so I can make tools now. But I won't, I feel it's not right.

SG: I've seen other tosos being struck by the sausau, or pricked with the au during stretching when they were not doing it right. Did it happen to you as well?

LI: Yes! Many times. I find it's the best way to learn … by the au and with the sausau. He actually marked me but luckily it was this part of the skin so it didn't really hold the ink well. That was from the old man [Sulu'ape Alaiva'a]. But when they do that you learn better, you learn, you pick up, you know not to do that again. It's not spoken. They do not tell you what to do. When they get really frustrated that when you don't get it after numerous times, they would pull your hand, they would just put your hand where it should be and you would think, 'Oh, okay, that's what you want!' He doesn't actually tell you, 'Okay, this is why you do this.' No – he kind of expects you to pick it up yourself. It's more of a throwing you in a deep ocean and you've got to swim. You've got to do it on your own. But I'm thankful and grateful for that because if I was school-fed, I'd probably lose motivation. It keeps me on my feet and I'm constantly learning.

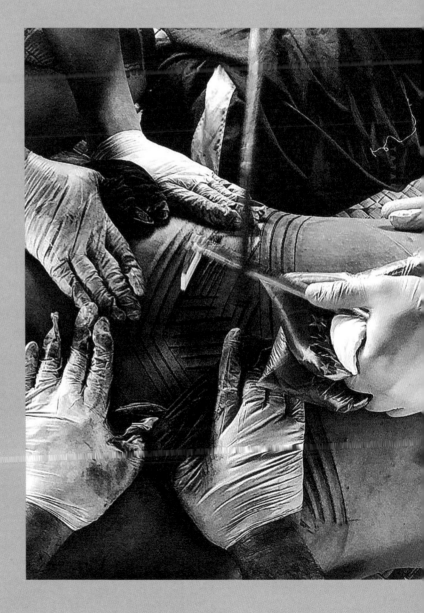

Tatau and Alagā'upu: A lineage of charting and continuation

Le'ausālilō Lupematasila Fata 'Au'afa Sadat Muaiava

1.
Pulatama is the 'lengthened black triangle' under the va'a (boat) design on the back. Tama means 'child'. Pulatama represents one's immediate family.

2.
The pulatele is the larger of the two triangles. Tele means 'large'. The pulatele represents one's extended family.

3.
The swift movement of the centipede is used here to describe one's service. 'Sogā' means an 'attendant'. This is the origin of the term sogā'imiti.

4.
Seupule Tuala Tuita'asauali'i Onofiatele Leaoaniu Afutoto (2012), 'O 'Auega 'o le Aganu'u Samoa Sa'afi'afiga 'o Tū ma Agaifanua: po tala a Sāmoa. Methodist Church in Samoa, Sāmoa.

Tatau and alagā'upu (proverbs) are cultural attires of the Sāmoan self in the sense that both are used to endow personal relations. While the tatau signifies a commitment to tautua (service), alagā'upu is the ethereal reward of tautua. There are two types of Sāmoan proverb: alagā'upu and muāgagana. Alagā'upu are proverbs that have originated from a historical event. The tatau has contributed an exceptional amount to the repository of alagā'upu, such as 'tu'utu'u mālū e pei 'o 'upu 'i le lagitatau', a proverb that makes reference to the massaging of the tatau. Unlike alagā'upu, muāgagana are proverbs that are formed from the natural environment.

When reflecting on the use of the tatau in alagā'upu, I am immediately drawn to the idea of the tatau as gafa (lineage). I argue that the tatau has created its own gafa comprised of people who are recipients of the tatau. But the tatau gafa is not independent. In fact, the tatau gafa exists within gafa. To illustrate, my father, for instance, was tattooed by Sulu'ape Alaiva'a, whose brother Sulu'ape Paulo tattooed my father's eldest brother. Sulu'ape Petelo, Sulu'ape Alaiva'a and Sulu'ape Paulo's brother tattooed my brother, two sisters and cousins. Sulu'ape Alaiva'a's sons tattooed my wife, her sister, aunty and cousins. My late uncle and I were tattooed by Su'a Fa'alavelave Vitale and Su'a Vitale, who are father and son, and are relatives of the Sulu'ape family.

The idea of a tatau gafa existing within gafa is manifested in the alagā'upu 'e fai 'o le pulatama, 'a'o le pulatele'. In my own tatau journey, for instance, it was shared with me that my gafa was symbolised by the pulatama[1] and pulatele,[2] which represent my immediate and my extended 'āiga. In addition, it was shared that my gafa was also symbolised by both 'asofa'aifo (abdominal designs), which are respective representations of my father's (rightside) and mother's (leftside) 'āiga. In light of this, the tatau as gafa 'within' gafa has created a paradigm for continued representation of both inheritance and identity for Sāmoans.

I was once told that the tatau, if stripped and laid flat, is a pe'a (flying fox). The pe'a points to the notion of roles and responsibilities. In this sense, the tatau is also used in alagā'upu as a 'chart of deeds'. This is evident in alagā'upu such as ''ua fetaui ulumanu' (the bird heads are in alignment) and ''o le fa'aatualoa a sogā' (a centipede-like attendant)[3] Though the ulumanu (birds) and atualoa (centipede) are figurative illustrations, the designs are actually representations of 'unity' and the 'sacred space between a sister and her brother(s)', respectively.

Sāmoans were profound observers of nature and used their observations to construct social ideals. So the observation that the atualoa, which lives outdoors and only enters the house for 'shelter' from the rain, for instance, is used to personify the brother–sister relationship in Sāmoan culture, where the sister is the 'malu' (shelter) of the family. Other designs with rooted epistemological meanings include fa'a'ila (family house); fa'aululaufao (industrious); fa'apefu (enlightenment); fa'amuliali'ao (fishing); fa'aulutao (bravery); 'asofa'aifo (family connection); atigivae (vigorous) and pute (to live and die for family).[4] As a chart of deeds, the tatau serves as a quintessential reminder of the social ideals of the self.

Sāmoans, even before the transition to Christianity, believed in the afterlife. This idea of a continued 'life' is depicted in alagā'upu of the tatau. Take for instance, the proverbs "o le lagimālōfie a tapa'au' (the clothing of chiefs) and "o le lagimālōfie a tiasā' (the clothing of the sacred mound – grave). The word 'lagimālōfie', which consists of mālōfie and lagi, for example, refers to the respectful term for tatau and the funeral rights of an ali'i sili (paramount chief), respectively. The use of the term lagi provides a sense of perpetuality. In this sense, the lagimālōfie is depicted as the cultural lā'ei (clothing) of a person's agaga (spirit) to the afterlife. In addition, it is very common to hear among Sāmoans the saying "ua na'o le tatau 'e te alu ma'ua 'i le lu'uyamāu, meaning the tatau is the only worldly possession one takes to the afterlife.

In all, the use of the tatau in alagā'upu is metaphorical. The tatau and alagā'upu have a timeless marriage that privileges connectedness to oneself, 'āiga and the afterlife bound by an ethos of service and commitment.

Fig. 98
Autā (tattooing tools) from the collection of the Museum für Völkerkunde, Berlin.

TATAU

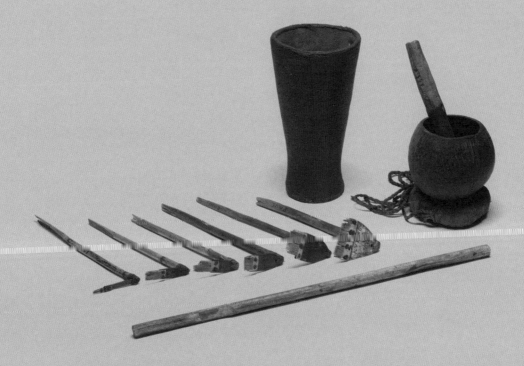

The iconography of tatau

Sébastien Galliot

TATAU

Tatau and malu consist of two standardised configurations of patterns. Each reiterates an invariable model of zoning the body with specific vāega (zones, or groups of motifs).

The construction, or 'ava'ega, of a male tatau follows a very rigid plan, prescribed by tradition and within which the expert has a little freedom to introduce ornamental variations. The 'ava'ega usually starts with the va'a motif on the back and ends with the pute on the navel. In between these motifs, the tufuga performs a succession of vāega over a period of five to ten days, depending on his timetable and the tolerance of the ta'oto (the one laid down).

The construction of a female malu is quicker, and has more variations. However, it also proceeds through a standardised construction and can be conceived as a horizontal or vertical arrangement of mamanu (pattern motifs), most of which derive from female iconography. Some mamanu, however, are common to men and women. The popliteal area, at the back of the knee, is always marked with a single or a double malu, the lozenge-shaped design which (just like the black triangle in the middle of a man's back called pe'a) entertains a metonymical relationship with the malu as full tattoo.

A tatau or a malu, as a whole, does not refer to anything outside of itself. Rather, it is the outcome of the repetition of a prototype which is stored as a mental image in the tufuga's mind (his māfaufau) and exists temporarily on a body surface. Thus, tatau and malu belong to a category of images for which there are no referents. Local discourse sometimes associates the shape of the pe'a with that of the flying fox[1] and the shape of the malu with the sections of a Sāmoan house. There is clearly no unified cultural perspective, however, on the resemblance between the pe'a and the flying fox, or between the malu and an actual Sāmoan house. A closer look at the smaller units that constitute the overall images suggests the depiction of elements of fauna, flora and material culture. The mamanu have names and shapes that suggest a closer likeness with the material and natural environment.

In Figs. 100 and 101, va'a (canoe), pe'a (flying fox) and ulumanu (animal's head), as well as fa'amuliali'ao (end of a Trochus shell), gogo (frigate bird), alualu (jellyfish), atualoa (centipede) and anufe (caterpillar) exist outside the tattooed image, and their shapes as tattoo motifs recall the shapes of the natural objects they stand for. Although obviously different, male and female iconographies seem to be guided by a similar figurative technique. The male tattoo presents itself as a combination of artefacts, animals and plants, but the female version is more oriented towards celestial bodies (stars) and animals (caterpillar, jellyfish, frigate bird). They use the surface of the human body to make visible a dense network of entities. The quasi-systematic repetition of patterns produces a dynamic effect in the way different items are ordered.

Although the application of pattern intensified during the twentieth century, the overall structure of the image – i.e. the configuration of the vāega – has remained the same since the first detailed descriptions made by German ethnographers,[2] and by the following generation of anthropologists and observers.[3] The naming of the vāega has been very consistent but their meaning and possible symbolic content is much more unclear. While the shapes of some vāega, such as the va'a or the ulumanu, show a link with their names (the va'a has an obvious canoe shape and the triangle shape of the ulumanu suggests the beak of a bird), other vāega like lausae or the tafani are much more difficult to interpret. Their meanings are either obscure or lost (lausae), or just broadly descriptive; tafani seems to denote the sides or flanks (tafa).

The uncertain meanings of the mamanu or ornamental units pose problems of another kind. At this level one notices an enrichment of the repertoire, and a tendency to fill the vāega with more designs than were recorded in the nineteenth

1.

Albert Wendt, 'Afterword: Tatauing the Post-colonial Body', in *Inside Out: Literature, Cultural Politics and Identity in the New Pacific*, edited by V. Hereniko and R. Wilson (Lanham, Maryland: Rowman and Littlefield, 1999), 399–412.

2.

Felix von Luschan, *Beitrag zur Kenntniss der Tattowirung in Sāmoa* (Verlag von A. Asher and Co. Berlin, 1897), 551–61; C Marquardt, *The Tattooing of Both Sexes in Sāmoa* (Auckland: R McMillan, 1984). Translation of *Tätowirung beider Geschlechter in Sāmoa* (Berlin: D Reimer, 1899).

3.

ES Craighill Handy and Willowdean Chatterson Handy, *Sāmoan Housebuilding, Cooking, and Tattooing* (Honolulu: Bernice P Bishop Museum Bulletin 15, 1924); Te Rangi Hiroa (Peter Buck), *Sāmoan Material Culture* (Honolulu: Bernice P Bishop Museum. Bulletin 75, 1930); Jack Groves, see fig. 41).

4.

Claudia Forsyth, 'Sāmoan Art of Healing: A Description and Classification of the Current Practice of the Taulāsea and Fofō', PhD thesis (San Diego: United States International University, 1983); Sulu'ape Paulo II, *Meaning of the Pe'a in Fomison: What Shall We Tell Them?*, edited by Ian Wedde (Wellington: Wellington City Gallery, 1994), 77; Sean Mallon, *Sāmoan Art and Artists: Measina a Sāmoa* (Honolulu: University of Hawai'i Press, 2002).

5.

Sulu'ape Si'i Liufau, 'Tatau Motifs' in *Tatau: Marks of Polynesia*, edited by Takahiro Kitamura (Los Angeles: Japanese American National Museum, 2016), 193–99.

century. However, unlike the vāega, mamanu or ornamental units can be classified in two different categories. Old designs (atualoa, alualu, anufe, fa'avae'ali, fa'atala laupaogo, etc.) which were already noticed by the first European observers tend to have stable shapes, names and meanings. There is also a high degree of correspondence between their shape and what they stand for (that is, they have a higher degree of iconicity).

More recent designs not only have less iconicity but they also take different names depending on the tufuga who uses them. Moreover, apart from their relative iconicity, their symbolic content varies greatly, to the point that the interpretation of the repertoire is dependent on each tufuga's individual ability to elaborate deep meanings for the ornaments he uses and sometimes creates. Published accounts of the meanings of the tatau and malu motifs include those by Li'o Tusiofo (1982) and Su'a Sulu'ape Paulo II (1994 and 2002).[4] At the time of writing the most recent interpretation of Sāmoan tatau motifs was written and published by Sulu'ape Si'i Liufau in 2016.[5]

Fig. 99
A selection of motifs commonly found on tatau, which tufunga reinterpret with many variations.

T A T A U

'alu'alu – *jellyfish*	
anufe – *caterpillar*	
aveau – *starfish*	
atualoa – *centipede*	
talalaupaogo – *thorned edge of the pandanus leaf*	
fetu – *star*	
upega – *net*	
gogo – *tern (seabird)*	
vae'ali – *legs of bamboo headrest*	

The tatau (pe'a)

Fig. 100
The application of the male tatau starts from the back at waist level and goes down to the knees. The vãega (zones, or groups of motifs) are as below. Tatau modelled by Faimasulu Larni Fiti. Tufuga tã tatau: Su'a Sulu'ape Paulo III.

pute
navel

talipute
tali means response and pute means navel motif

fa'aulutao
like the points of a spearhead

'asofa'aifo
curved lines

punialo
puni means closure (and alo is the respectful word for male offspring or son)

fusi
a belt, strap or band

'asotali'itu
tali is to hold up and itu means side

tapulu tele
the outer area of the thigh

lausae
the outer area of the thigh

fusi
a belt, strap or band

ulumanu
literally the head of an animal

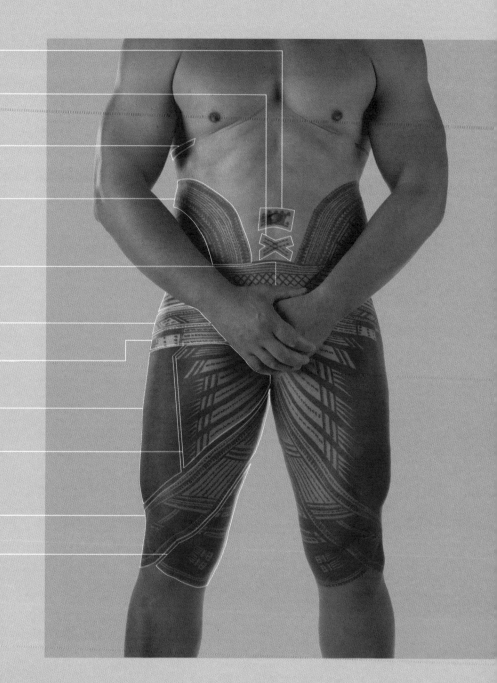

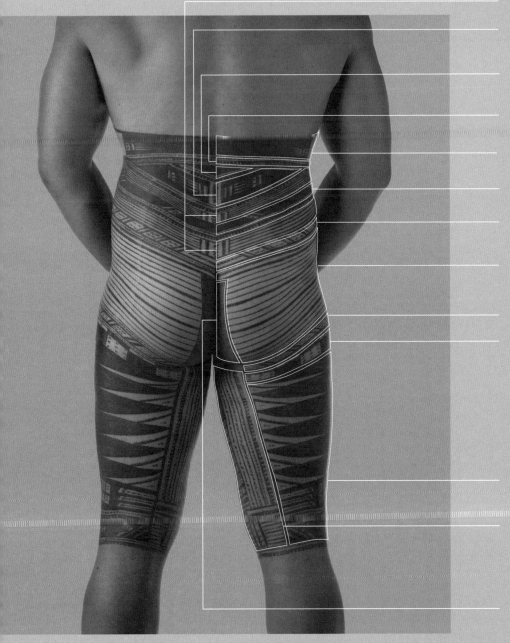

'asolaiti
another set of small lines

pula tele
*the larger part below the
small black triangle*

pula tama
*also known as
the tama'i pe'a*

'asoe tasi
*the rafter / line that
stands alone*

va'a
canoe

tafani tapulu
dark borderline

tafani teu
decorated borderline

saemutu
*thin tattooed lines that run
across the buttocks*

fusi
a belt, strap or band

'asotali'itu
*tali is to hold up
and itu means side*

fa'amuliali'ao
*the pointed ends of
the conch shell*

atigivae
*the section behind the
knee. (This part of the
tattoo was not ornamented
in drawings from the
nineteenth century)*

fa'apefu
*the area between
the buttocks*

TATAU

The malu

Fig. 101
The application of the female malu starts from the knees and works up to and finishes at the top of the thighs. The vāega (zones, or groups of motifs) are as below. Malu modelled by Tupe Lualua. Tufuga tā tatau: Su'a Faumuina.

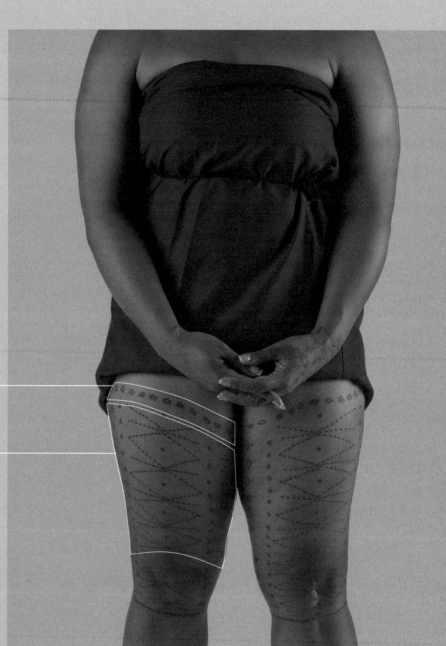

fusi
a belt, strap or band of tattooed motifs at the top of the thigh

fa'alanuma'ave'ave
the tattooed area on the front of the thighs

TATAU

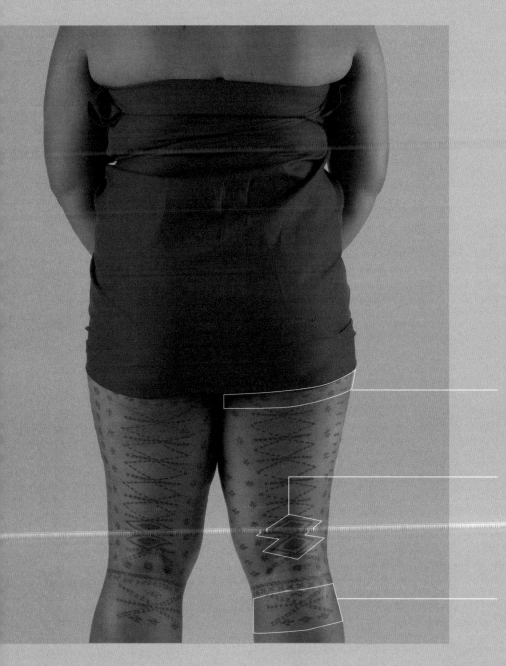

fusi
*a belt, strap or band
of tattooed motifs at
the top of the thigh*

malu
*the most prominent
design of the female tatau
is a single or a double
malu, a diamond-shaped
motif usually positioned
in the popliteal area
behind the knee*

tali malu
*the tattooed area
below the popliteal
area behind the knee*

'Don't try to defeat the au'

Sébastien Galliot
Levi/Saleimoa, Sāmoa, 18 October 2005

Joe Afamasaga Toleafoa is a member of the Church of Latter-day Saints. He was tattooed in 1991 by Sulu'ape Lafaele. Here he recounts his experience of being tattooed.

JAT: When I was young, my father, who is the chief of my tribe in Fasito'otai, reckoned that without this he's not complete as a chief. Which is true, this is our lavalava. I only put this on in 1991, when I was over forty something years old. I came back from America in 1988 and lived there until 1989, and then I met my Sāmoan wife. And I said to her I want to have tattoo. And I'm the only son of my dad, I'm the next head of the family. So I have to go through it. So that's how we went to see [Sulu'ape] Lafaele. We booked Lafaele and then Lafaele came to Siusega and put this on me. For sure, I felt sorry for myself. When I first heard the au was when Lafaele asked me, 'Okay, come! Sit! Face other way!' And then Lafaele was measuring the thing. I thought 'Oh! That's very easy!' So he asked me to lie down. Even the way you lie down, pillow here, pillow there, and you feel the pain in the stomach for five hours. Sole! Especially my weight. I'm skinny now but at that time I was so fat. Big! It's not good on fat people but if you're fat without a pe'a, boy! You look like an old lady! After he did the back I said, 'Excuse me, I just want to look at it in the mirror.' I went inside my house because he did it at the small fale at the back, and I looked at it. And I was thinking about the pain I have now. But it's from here to here [from the back to the knees] you know what I mean. And then I said: 'No!' And then my wife came in and she says: 'Don't say no!' I want to stop and she says to me, 'You can do it. The other guys do it, you can do it.' I sat there about ten minutes. And said: 'Okay, if I don't finish, I won't see my 'āiga no more.' Lafaele told me some ideas to help me. He said: 'Just let it go, don't try to defeat the au. And then I was just smoking – I don't smoke at all. I was very … I don't want to remember

that pain. At the end, Lafaele came with his wife and some other guys for the sama. The wife of the tufuga is called the meana'i tāua. Very important person. Pe'a is like building a fale, a house. Every picture of the pe'a is the house. And building the house is very important for the tufuga to bring his meana'i tāua for the tāpua'iga, for the sharing, because it's good to be there for the safety of the tufuga and, you know, it doesn't make him fall down or something like that. It's a good luck to the carpenter, you know what I mean. Lafaele's wife was at Manono. She didn't come at the first day of the starting of the pe'a. She has to remain in there. And she came at the time for the sama. Because if she comes during the work, it makes me sore. It's a belief, and a lot of things you're not supposed to do. Not shaving, you know, when you put [the tatau] on you let [your hair] grow until you finish. If you go for a walk early in the morning you have to go in pairs. It was very good because Lafaele stayed at my house. And he helped me with massaging at midnight (fofō) because he says to me if you're not really good on this fofō, you'll get more pain you know, because the liquid comes out. Oh man! I'm telling you something, the pain when the au is kissing to your body is nothing compared to the pain of that fofō at midnight. After when they fofō you sleep good.

SG: Does your father have one?

JAT: Oh yeah, my dad, in an olden way. Li'o from Si'umu tattooed him. And then when my dad looked at my tattoo he says to me oh, you got a beautiful malu. I said, why do you say that? He says there's a lot of designs, but at that time, no!

SG: I have met people who tried to explain to me that some designs were related to their family. Do you know if there are any special designs in your pe'a that are related to your family?

JAT: There are no designs related to my family as far as I know, because Lafaele put on his own designs. The other guy named Fa'alavelave (Falelatai), they've got their own designs and the Sulu'ape, they've got their own designs. But there were no designs related to any of my family, no. The only thing that he told me was that the other guy named Li'a is holding eighteen 'asofa'aifo [abdominal designs], but he put on me twenty-one. So I said, what's so important? And he said, 'Oh, you know, hardly anybody walks around here with the 'aso of twenty-one and it's hard to beat that many 'aso.'

SG: Is the number of 'asofa'aifo according to your rank in the hierarchy?

JAT: No, it's according on how big you are. (laughter)

JOHN AGCAOILI

John Agcaoili is a freelance photographer and
cinematographer and the co-founder of Darkside
of the Moon, a production company based in
California. In this remarkable series of portraits
he captures the work of the present generation of
tattooers, many of whom use tattooing machines.

In 2014, the Japanese American National Museum in Los Angeles produced the ground-breaking exhibition *Perseverance: Japanese Tattoo Tradition in a Modern World*. They followed it in 2016 with *Tatau: Marks of Polynesia*. In this extract from the exhibition catalogue, curator Takahiro Kitamura explains the rationale for the exhibition, and his choice of John Agcaoili as the project photographer.

'Well before the advent of electricity, Sāmoa and Japan both developed very distinctive methods of tattooing by hand ... Both Sāmoan and Japanese tattoo cultures later integrated the use of the electric tattoo machine. Despite this paradigm shift, and it's one that is not necessarily negative – the machine has allowed for an expanded artistic expression and more detailed line work – both the Japanese and Sāmoan cultures still place a high value on the ability to tap, or hand poke. In an effort to show the global impact of Polynesian tattooing, both due to the migration of Polynesians as well as an appreciation of the art form by outsiders, we photographed artists in Sāmoa, New Zealand, and, in the United States, California, Hawai'i, and Nevada.

'The exhibition required a unique type of photographer ... with tattoo documentation it helps when the photographer is also a tattooed person as this bond helps to establish trust with the subjects. The shared experience and respect for tattooing also gives the photographer a better "eye" to document tattoo art. John Agcaoili fulfilled all of these qualifications completely, but ultimately it was his enthusiasm and commitment to his projects that made him our exhibition photographer and we are extremely grateful to him for this.'

— Takahiro Kitamura

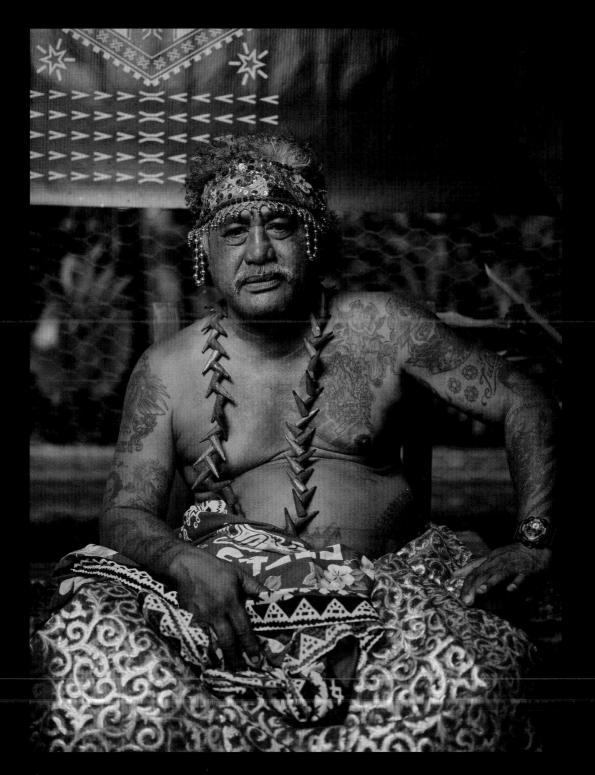

Fig. 102
Su'a Suluʻape Alavaʻa Petelo,

Fig. 103-104
Malu by Su'a Sulu'ape
Paulo III (Sāmoa).

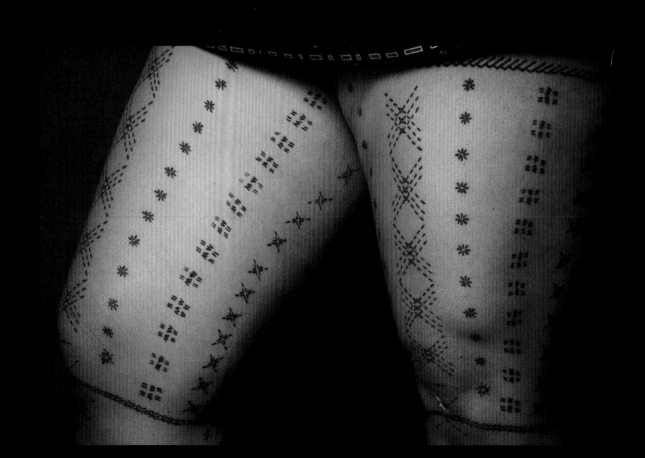

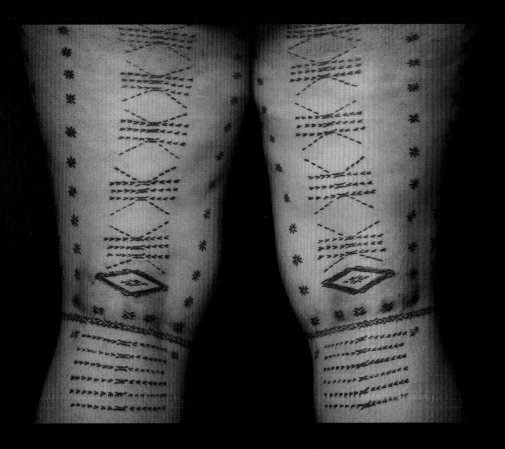

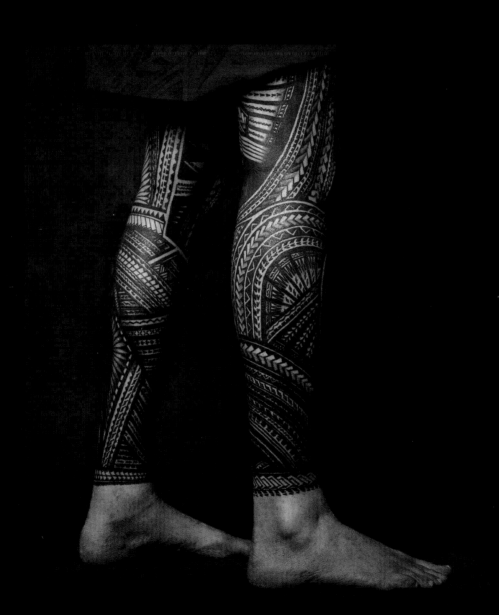

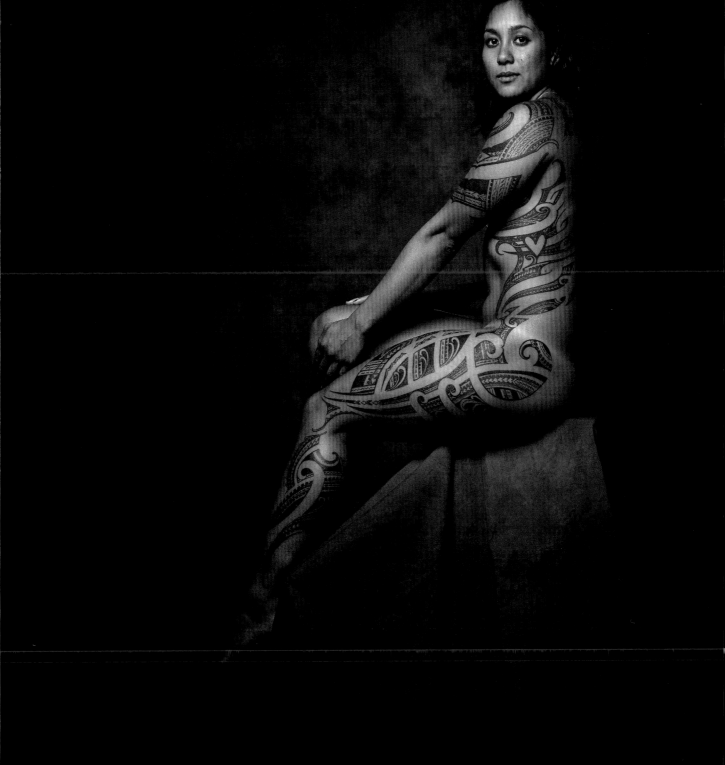

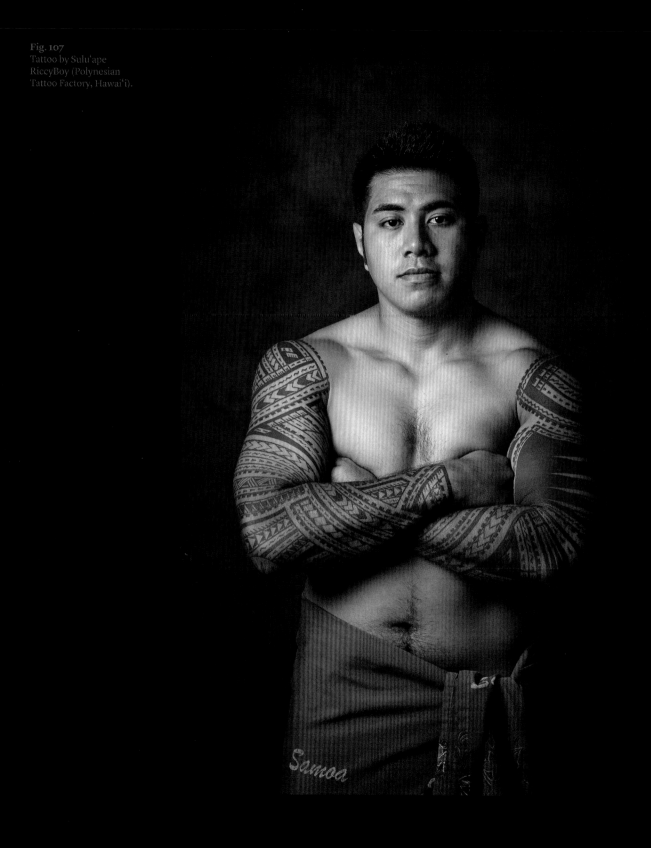

Fig. 107
Tattoo by Sulu'ape
RiccyBoy (Polynesian
Tattoo Factory, Hawai'i).

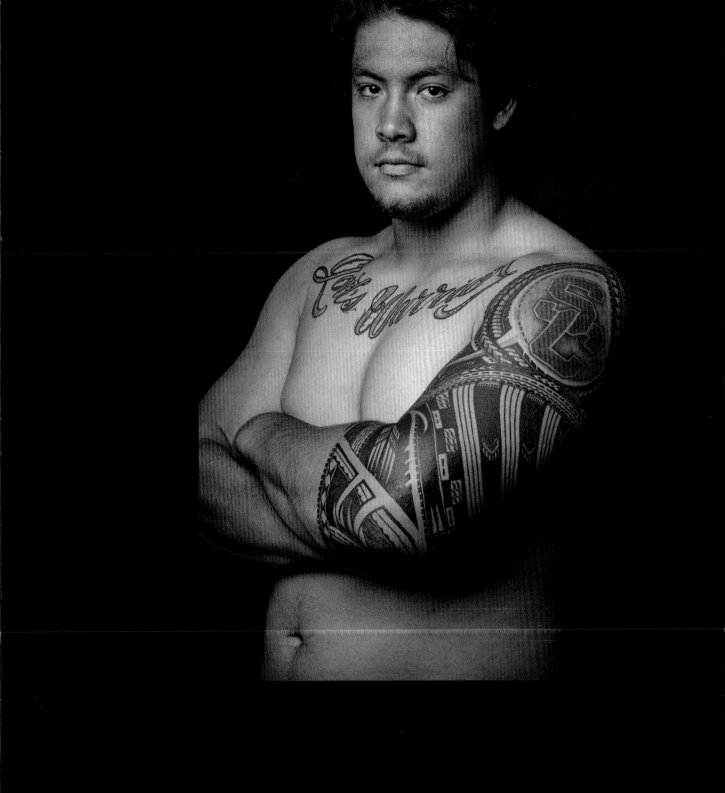

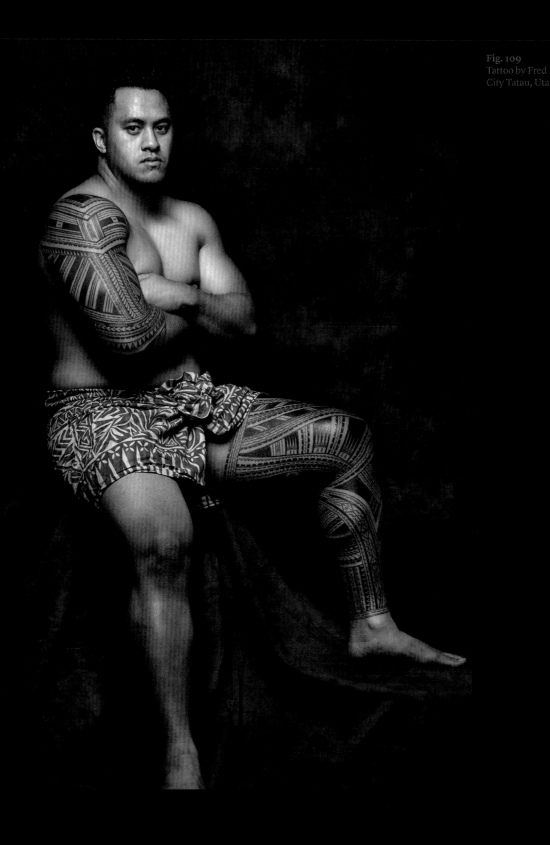

Fig. 109
Tattoo by Fred Frost (Frost
City Tatau, Utah).

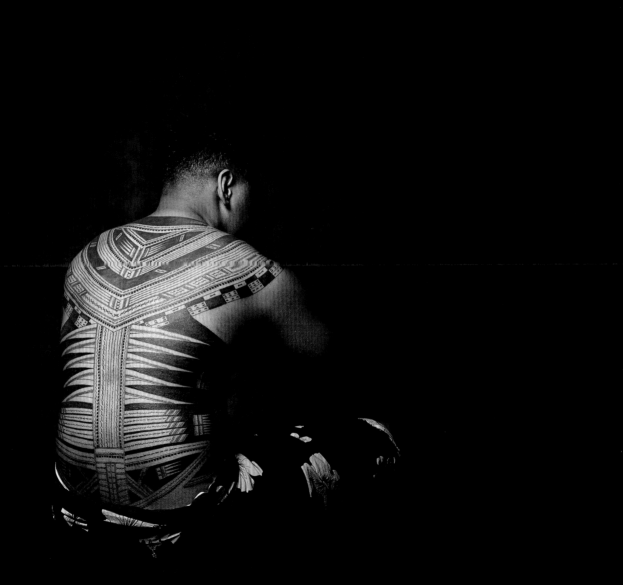

Fig. 110
Tattoo by Tuigamala Andy
Tauafiafi (Taupou Tatau
Studio, New Zealand).

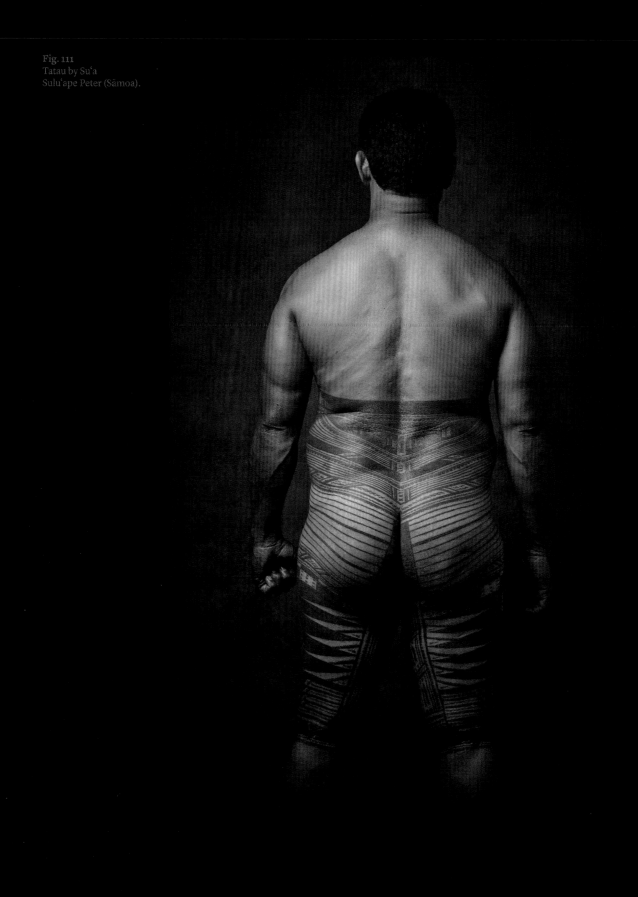

Fig. 111
Tatau by Su'a
Sulu'ape Peter (Sāmoa).

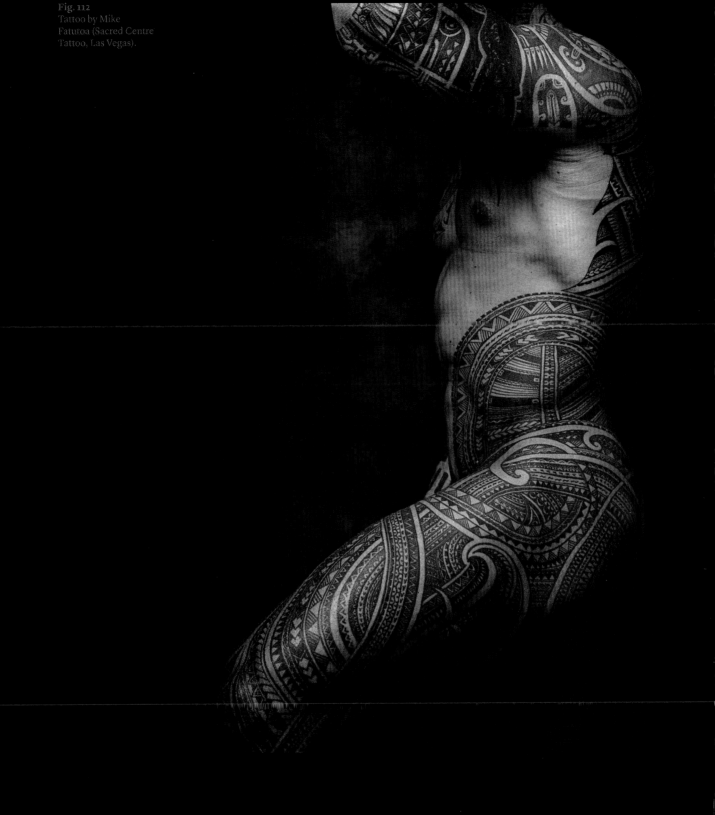

Fig. 112
Tattoo by Mike
Fatutoa (Sacred Centre
Tattoo, Las Vegas).

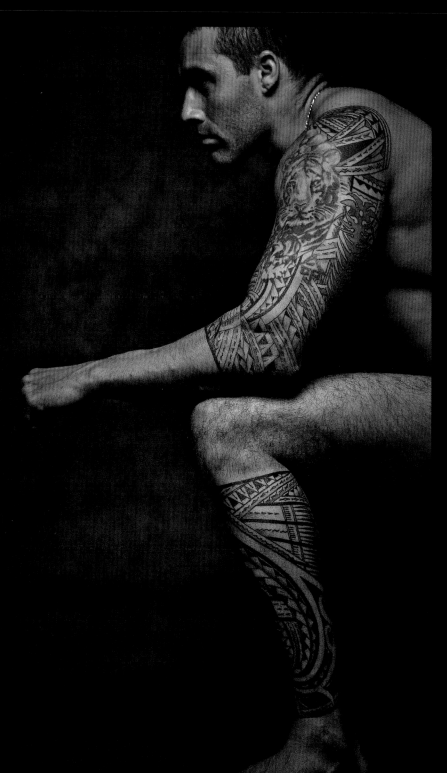

Fig. 113
Tattoo by Pat Morrow
(True Markings Tattoo
Studio, Australia).

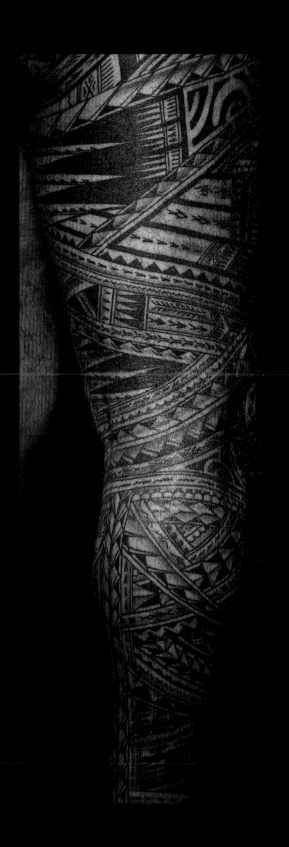

Fig. 114
Tattoo by Steve Ma
Ching (Western Tattoo
Studio, New Zealand).

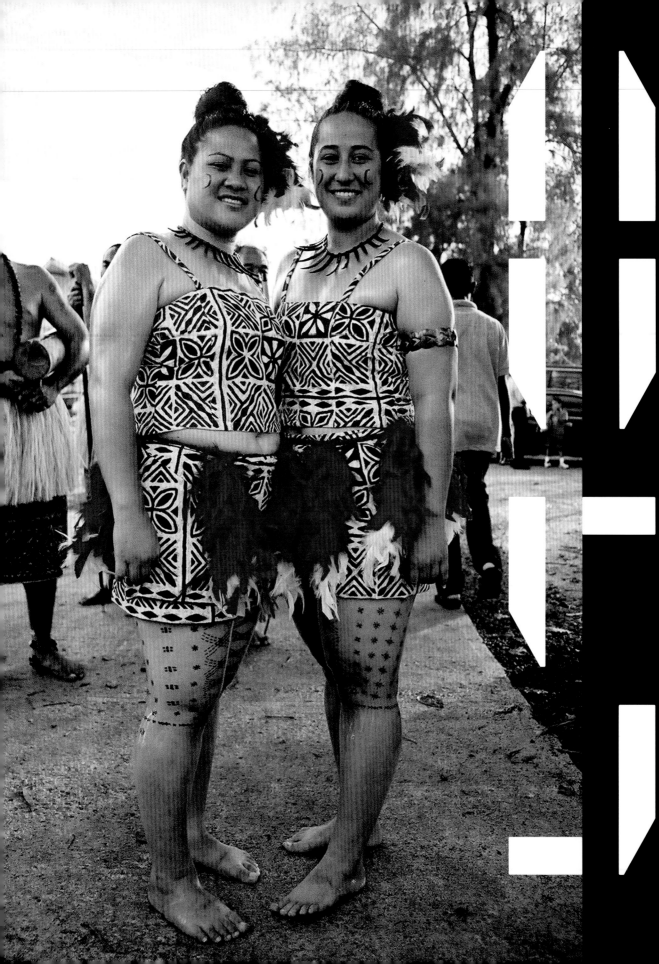

TATAU AND ITS GLOBALISATION
2000—2017

Fig. 115
Tatau as a cultural symbol
of the nation. Members of
Sāmoa Contingent, Ninth
Pacific Festival of the
Arts in Palau, 2004: Ana
Kalolo (left) and Karene
Faʻasisila (right).

TATAU

Fig. 116
Mr Godinet in front of
his Fale Tapea (House of
Tattoo), Savalalo markets,
Apia, Samoa, 2002.

In 2002 in Apia, the capital city of Sāmoa, there were two tattooing shops. Like the stereotypical image of tattoo parlours in the West that are often found in grimy back alleys and red-light districts where rent is cheap, the Apia tattoo shops were in a rundown semi-industrial area of town near a large fruit and produce market. The streets in this part of town were memorable for their litter, open drains and hungry-looking dogs. The tattoo shops were on the periphery of the market and situated about 100 metres apart.

One of the shops was a small rectangular shed with a single window and door. It sat alongside a dusty track, almost crushed into a corner; noisy trucks converted into buses would veer past it, carrying loads of passengers out of the market and back to the villages. A notice in perfectly rendered blue gothic lettering announced 'tattoo fale tapea' (house of tattooing). The other shop looked out on to the street through a row of windows with heavy wooden shutters. Inside dozens of A4 sheets of tattoo flash (designs) fixed with bright red tape lined the pale blue walls. Both shops were in an environment where business is intense, where goods are sold, where transactions of all kinds take place.

I visited both of the Apia tattoo shops, walking first up to the fale tapea.[1] Peering inside I could see a long wall covered with dozens of images that customers could choose to have tattooed on their bodies. As I leaned in the doorway, the proprietor approached me and we struck up a conversation. Looking at his wall of tattoo flash, I could see that they ranged from Marquesan tattoos to hearts and roses; there were Christian symbols and the skull and crossbones, and a drawing of the Sāmoan male peʻa. I asked the owner what designs were most popular with his local Sāmoan clientele. Without hesitation he pointed to a black and white outline of the Statue of Liberty.

I had a similar experience in the other tattooing shop. The walls there were also a catalogue of international tattoo flash, from military insignia to cartoon characters. Two young men in their late teens were in the shop and I asked them what tattoo designs were the most popular in Apia at the moment – what tattoos they and their friends were interested in. Both pointed to the abstract black curved lines of a neotribal pattern that probably originated in US tattooing circles and – here in a Sāmoan tattoo shop – was most likely copied from a tattooing magazine. A few minutes later three women emerged from the tattooing room, one of them proudly wearing a bright red rose freshly tattooed on her shoulder. Seeing this woman tattooed with a red rose, and discovering that the most popular contemporary designs originated in the United

1.
Sean Mallon visited Apia in 2002. These two tattooing shops are no longer operating.

TATAU

Fig. 117
Fifita's (left) tattooing
shop in Savalalo markets,
Apia, Sāmoa, 2002.

States, highlighted some contradictions that I thought were worth investigating further. Within contemporary Sāmoan society tattooing is well established as emblematic of Sāmoan culture – it is an indigenous practice with a long history. There are distinct male and female forms of tatau that are widely and positively upheld in Sāmoan society as symbols of Sāmoan culture. Yet in spite of this reification of tatau in Sāmoa, my experiences in Apia's tattoo shops suggested that tattoos originating from other countries are somehow relevant to Sāmoan society. It reinforced the idea – argued throughout this book – that tattooing in Sāmoa is not just about Sāmoan tatau, and that Sāmoan tattooing might not be the stable, culturally homogeneous practice that is objectified and upheld as emblematic of Sāmoan culture.

The two family lines of sā Su'a and sā Tulou'ena are still widely acknowledged in Sāmoan society today as the custodians of tatau. However, while they are perceived by Sāmoan society as agents for the control and persistence of tatau, they are also among the most active agents for its transformation. Tattooing in Sāmoa has always been subject to local (Sāmoan) and translocal influences, but these processes have been at their most intense since the 1990s. The ease of communication between different groups of people today makes it easy to recognise how cultural symbols like tatau and associated ideas and information move on global cultural flows. Understanding the

circulation of tatau and the juxtaposition of its various contexts gives us a greater appreciation of the transnational and international systems of which it is a part.

The increasingly global practice of Sāmoan tā tatau means that tatau is open to a wider range of interpretations from many different groups of people – Sāmoan and others; and even those who are Sāmoan don't all think similarly. There are many ways in which tatau acquires significance in our societies and cultures, and many perspectives on its value and meaning. One useful approach to understanding the globalisation of tatau involves what some researchers call 'following the thing': anthropologists, for example, have used this strategy to study cultural phenomena across multiple sites;[2] other Pacific-based researchers have employed it to trace the movement of hip hop music, or the use of phosphate rock for fertiliser.[3] In the case of Sāmoan tatau, 'following the thing' involves following the circulation and appropriation of tatau through different contexts, examining how, why and where people use it and the many ways they give it meaning. It is a process of mapping the connections, associations and various relationships that tatau mediates in order to understand how they are articulated.

From at least the 1980s tufuga tā tatau have been taking tatau to the world in an unprecedented way – working in Sāmoa and beyond its borders, and also beyond the Pacific Islands. They have travelled to non-Sāmoan communities in the United States and Europe and demonstrated tā tatau at tattooing conventions and exhibitions. They have toured to Sāmoan communities in New Zealand, Australia and the United States. After Su'a Sulu'ape Paulo's death in 1999, his brother Su'a Sulu'ape Alaiva'a Petelo became the most active family member tattooing Sāmoans and non-Sāmoans overseas. His schedule in 2002 included visits to Hawai'i in July and August, where he completed nine pe'a in six weeks; he then returned to Hawai'i to complete three more pe'a. In a throwback to the practices of his ancient border-crossing ancestors, Alaiva'a and his team worked on Tongans Ata'ata Fineanganofo of San Francisco and later Hawai'i-based Tongan tattooist 'Aisea Toetu'u, reproducing on them a Tongan version of a pe'a based on a rare drawing made by Louis Auguste de Sainson during the voyage of Dumont d'Urville between 1826 and 1828.[4] They were then booked to fly to the United States for a week, to Sweden for a few days, then to Germany for a convention, then on to another in Malmö and back to Sāmoa – all in under five weeks.

These overseas engagements helped to create an awareness of Sāmoan tatau globally and provided new opportunities for the tufuga tā tatau to meet and share their work with other tattooing enthusiasts. In the new millennium there have been more frequent overseas tours, and further invitations to participate in tattooing conventions – resulting in a diversification of the places where tatau was being made, who was making it and who was wearing it. The international interest in tatau among Sāmoans and non-Sāmoans was the catalyst for major transformations in the work and lives of the tufuga. Financially, the tours had a big impact at home, with benefits for the tufuga, their families and, in some cases, their villages. Culturally, the tufuga were travelling and seeing the world; socially, they were enhancing their status as tattooists, as artists and as cosmopolitans.

2.
GE Marcus, 'Ethnography in/ of the World System. The Emergence of Multi-sited Ethnography', *Annual Review of Anthropology* vol. 24, no. 1 (1995): 95–117.

3.
See April Henderson, 'Gifted Glows: Netting the Imagery of Hip Hop Across the Samoan Diaspora', Master's thesis, University of Hawai'i, 1999; April Henderson, 'Dancing Between Islands: Hip Hop and Samoan Diaspora' in Dipannita Base and Sidney J Lemelle (eds), *The Vinyl Ain't Final: Hip Hop and the Globalization of Black Popular Culture* (London: Pluto Press, 2006), 180–199; KM Teaiwa, *Consuming Ocean Island: Stories of People and Phosphate from Banaba* (Bloomington, Indiana: Indiana University Press, 2014).

4.
See discussion on page 31.

TATAU

Two events that took place at the start of the twenty-first century highlight the connections between the tufuga tā tatau and tattooists internationally: the Second International Tatau Convention in Sāmoa, and the bestowal of Suluʻape titles in the village of Lefaga. They offer myriad insights into how the global context shapes and influences local tatau practices. As with other Pacific Island cultural contexts – arts festivals, music festivals, tourism festivals and beauty pageants[5] – they gave participants the opportunity to negotiate and play out local and translocal identities and roles.

In November 2001 the second Sāmoa-based international tattoo convention took place on the island of ʻUpolu. The convention brought together tattooists from around the world and built on the success of Le Tatau Tattoo International Convention, held in November 1999. From the organisation of the tattooing space to the interaction between tufuga and client, and the practice and hygiene related to the tattooing process itself, the tatau convention was a site where cultural boundaries and ideas converged and intersected. The happenings at the convention provided insight into the way local and translocal ideas and practices about tattooing came up against each other. The Second International Tatau Convention was convened to bring the arts of tatau to prominence, ensuring its recognition and maintaining its presence in the public domain. However, it was also destabilising, providing opportunities for tatau to develop in new directions.

The convention was organised by Malagamaʻaliʻi Lavea Vui Levi Fosi and Mālōfie a Sāmoa, the national society dedicated to tatau. Local and non-local Sāmoans attended, along with a sizeable contingent of tattooing artists and enthusiasts from New Zealand, Australia, the Netherlands, Denmark, Germany, France, Croatia, the Canary Islands, Hawaiʻi and the US mainland. Generally visitors from overseas were well informed about Sāmoan tatau. They had read historical texts and magazine articles, and had seen tatau in photography and film or at other tattooing conventions. Some had met and developed very close friendships with the late Suʻa Suluʻape Paulo and his brother Suʻa Suluʻape Alaivaʻa Petelo in the course of their travels to the United States and Europe.

The main area in which the convention took place was Saleapaga, a beachfront village on the south coast of ʻUpolu, where villagers had set up faleoʻo (small open-sided huts) and other facilities to host the convention's activities and visitors. In the village malae (centre), a long fale structure was built specially to house the tattooing booths where visiting artists would work. Each booth was fitted with electricity, and lighting, and was open to the sea breeze. Local village families looked after convention participants and fed them during the course of their stay. Some participants chose to stay at hotels in Apia, almost 40 miles away, or with friends or relatives, and travel every day to Saleapaga by bus, taxi or car.

The non-Sāmoan contingent of tattooists included a number of people heavily tattooed with a combination of Western neotribal-style tattoos and indigenous Pacific designs. In the first few days, participants had the opportunity to display their tattoos

5.
See J Teilhet-Fisk, 'The Miss Heilala Beauty Pageant: Where Beauty Is More Than Skin Deep', in *Beauty Queens on the Global Stage: Gender, Contests, and Power* (London: Routledge, 1996), 185–202; N Besnier, 'Transgenderism, Locality, and the Miss Galaxy Beauty Pageant in Tonga', *American Ethnologist* vol. 29, no. 3 (2002): 534–66; N Besnier, *On the Edge of the Global: Modern Anxieties in a Pacific Island Nation* (Palo Alto, California: Stanford University Press, 2011).

during a public parade on the Apia waterfront. Led by the Sāmoan Police Brass Band, the parade slowly made its way along Beach Road to the grounds behind the Sāmoan Visitor Bureau. There the gathering was seated under small marquees to listen to an address by a member of Sāmoa's parliament and a formal welcome by leading tufuga Su'a Sulu'ape Alaiva'a Petelo. One particular moment stood out for me in this multicultural gathering. While the convention participants milled around drinking beer and wine, in an informal end to the formalities, I noticed that many of the Sāmoans in attendance were standing at the periphery of the event and staring at the tattooed Europeans. Some of these spectators joked and laughed at the foreigners, but others were respectful and looked quietly amazed at what they were witnessing. The tattooed Europeans seemed quite comfortable with this very public display of their tattoos – they were away from Europe, in a country with a very strong tradition and appreciation of tattooing; however, in the context of this event and in a complete turnaround, tatau – a familiar sight for Sāmoans – had become on European skin an almost foreign and exotic 'curiosity'.

Back at Saleapaga, despite a great deal of preparation, there were problems with the long fale structure that had been built specially for the overseas tattooists: the conditions inside were not up to the standard of hygiene they required for tattooing. The sandy floors combined with the sea breeze made clean and safe work difficult. After some reorganising, though, the visiting tattooists managed to construct some booths that were suitable to work in, and by the third day of the convention, tattooing was underway.

The arrangement of space at the Saleapaga convention reflected social groupings and relationships between the tattooists. The seniority of the foreign and Sāmoan tattooists present at Saleapaga was symbolised in the locations of their workspaces. The convenors had presumably organised the workspace to reflect the hierarchy and seniority of those present – this follows cultural practices in Sāmoan society, where the organisation of space is a prime marker of rank, and the use of space reinforces a social order and particular roles within that order.[6]

The senior visiting tattooists and tufuga tā tatau received special treatment, and Sāmoans were at the top of the hierarchy. Su'a Sulu'ape Alaiva'a Petelo worked in a fale adjacent to but spatially defined from the fale housing the booths. Alongside him, leading European tattooists from Denmark, Holland and France took their places. Situated in the same fale as Alaiva'a was a member of the sā Tulou'ena. Further along, in another spacious fale, Petelo's brother Su'a Sulu'ape Lāfaele was tattooing. Tufuga from the sā Su'a were assigned the most spacious locations, where protocols were strictly enforced for the people being tattooed as well as those observing. Other tattooists were allocated booths where there were fewer restrictions of movement and access in and out of the space was open.

The organisation of space also shaped the way interactions took place in the tattooing workspaces. In the spaces where the senior tattooists and Sāmoan tufuga worked there was a state of heightened formality: the activities taking place in this area were

<div style="float:right">TATAU</div>

6.
See Bradd Shore, Sala'ilua:
A Sāmoan Mystery (New York: Columbia University Press, 1982); Derek Freeman, Margaret Mead and Samoa: The Making and Unmaking of an Anthropological Myth (Cambridge, Massachusetts: Harvard University Press, 1983); Roger Neich, Material Culture of Western Samoa (National Museum of New Zealand, Bulletin 23, 1985); Alessandro Duranti, 'Language and Bodies in Social Space: Samoan Ceremonial Greetings', American Anthropologist vol. 94 no. 3 (1992): 657–91.

almost separate from the other activities of the convention, making them appear more important. Tattooing in the other, more accessible booths at Saleapaga was done on a table, with American and European music blaring from cassette players, and the walls decorated with images and banners featuring the designs by the various artists working there. In the fale where the senior European tattooists and tufuga were working the atmosphere was quiet and uncrowded. People who were close to the tattooing in this area were reminded to wear an 'ie lavalava and not stand above or crowd around the tufuga at work; observers were asked to sit and watch the proceedings from a distance. The enforcement of protocols relating to access, attire and observation of the tatau were necessary to maintain the formality of activities in the space.

To an outsider the protocols surrounding tatau may seem unnecessary and obstructive. With their insistence on these types of protocols, the tufuga reinforce their role and status as well as the specialness of their craft. The requirement to behave in a particular way also highlights the social status and the position of those present – it determines why they are in the space and what they should be doing. It determines how close they get to the tattooing, and it stops them from standing over the tattooing operation, crowding the tattooed person and generally being intrusive.

The majority of people receiving Sāmoan tattoo from Sāmoan tattooists at Saleapaga were European and American. This may have been partly because they were more likely to pay in cash as opposed to Sāmoan customary forms of payment such as food and 'ie tōga – but it was also because they were visitors and would have access to Sāmoan tufuga for only a short time. One Dutch man had been tattooed several times by Alaiva'a in various locations in Europe, gradually adding more and more to his tatau; he was in Sāmoa hoping to finally complete it and he eventually did. In 2009 he listed for me the dates and places he had tried to intercept Alaiva'a – they included Florence (2000), Berlin (2000), Auckland and Wellington (2001), Sāmoa (2001), and Auckland and Sāmoa (2003).

A Sāmoan from New Zealand arrived at the convention, hoping to be tattooed with a full pe'a in order to fulfil the wish of his elderly father who had always wanted a pe'a but never had the opportunity to receive one. He was a massive man who already had a taulima on his bulging, muscled arm. It was a pilgrimage for him to come to Sāmoa and undergo this process – one that he took very seriously. In contrast to longterm, almost spiritual quests like his, local Sāmoans that I observed sought European or American-style tattoos as a souvenir of an event probably unique in their village history. I saw an eagle with spread wings being tattooed on a matai by a female European tattooist, and on other Sāmoans I saw octopus, sea creatures, snakes and personal names being tattooed. Apart from the fascinating transactions around the images of tatau and tattoo, there were other ways to see the influence of the translocal on tatau and tattooing practice at the convention.

Although it could easily be seen as unimportant, the use of tattooing ink offers an insight into the intersection of global and local practices. Tufuga at the Saleapaga convention used black commercial ink supplied in a plastic bottle. This contrasts with

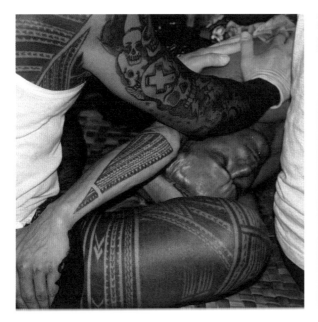

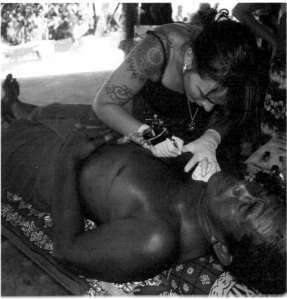

the ink used by tufuga at the Seventh Festival of Pacific Arts in Apia in 1996, which was produced locally in the 'traditional' fashion by burning candlenut and collecting the soot in a specially constructed shelter. The use of these different materials symbolises the contrasting concerns of tufuga at the 1996 Festival of Pacific Arts and at the 2001 Tatau Convention. At the 1996 festival the organisers were anxious to represent tatau as a symbol of cultural identity and authenticity, through use of local 'traditional' materials and the strict enforcement of 'traditional' cultural protocols. In Saleapaga, the priority was less on 'traditional' materials and practices and more on tattooing in a way that was 'Sāmoan' and acceptable to international visitors.

The priorities were also evident in other aspects of the 2001 Tatau Convention – including hygiene. The Sāmoan organisers and tufuga were anxious to meet the standards of hygiene that would be deemed acceptable to the international visitors, many of whom were experienced tattooists and seasoned conventioneers. For example, Su'a Sulu'ape Alaiva'a Petelo worked with an ultrasound steriliser, and the cushions on which clients rested their limbs were covered with black plastic bags to prevent blood and ink from contaminating the cloth. The toso (skin stretchers) wore surgical gloves. In 2001 there was a greater awareness than in 1996 and a determined concern to follow safe hygiene procedures, despite the challenging environmental conditions of wind, sand and sun. It appears that cultural 'authenticity' was of less importance than acting as a responsible health-and-safety-conscious member of the international tattoo community.

In many respects the convention was a great success, but Sāmoa and the Western tattoo community didn't exactly gel. Some convention delegates left soon after they arrived when they discovered accommodation and other comforts they were expecting were not in place. In a series of blogposts, Bob Baxter, the editor in chief of *Skin and*

Fig. 118
Sāmoan and Western tattooing practices come together at the Second International Tatau Convention at Saleapaga, Sāmoa, 2001.

Fig. 119
A European tattooer tattoos a local with an eagle design at Saleapaga, Sāmoa, 2001.

7.
Bob Baxter, 'Tattoo Chronicle #7
– Return to Samoa', *Bob Baxter's
Tattoo Chronicles*,
http://www.vanishingtattoo.
com/tattoo_chronicles/tattoo_
chronicles_bob_baxter_07.html;
Bob Baxter, 'Tattoo Chronicle #8
– Aboard the Bus', *Bob Baxter's
Tattoo Chronicles*, http://www.
vanishingtattoo.com/tattoo_
chronicles/tattoo_chronicles_
bob_baxter_08.htm. See also Bob
Baxter and Bernard Clark, *Tattoo
Road Trip: Two Weeks in Samoa*
(Atglen, Pennsylvania: Schiffer
Publishing, 2002).

8.
This account was first published
in Sean Mallon, 'Samoan Tattoo
as Global Practice', in *Tattoo:
Bodies, Art and Exchange in
the Pacific and Europe*, edited
by Nicholas Thomas, Anna Cole
and Bronwen Douglas (London:
Reaktion Books, 2005), 145–69.

Ink magazine, wrote about some of the frustrations of the event – from the comfort of his room in Aggie Grey's Hotel.[7] He contrasted this convention with the very successful first tatau convention in 1999. On one hand he was full of praise for the people and culture, and wrote glowingly of the landscape, the tequilas and 'pretty dancing girls', but on the other hand he complained:

> the convention site was miles away … a site with only one source of running water (a half-inch, galvanized pipe), sand for a floor and sleeping facilities with leaking palm frond roofs and only bread and butter sandwiches to eat. There was even an incident when a local villager put a knife to a tattoo artist's throat and demanded a free tattoo. Not good.

While the first tatau convention in 1999 had been held indoors and close to the major hotels and Apia city centre, this convention was more ambitious in scope and aimed to provide a more grassroots cultural tourism experience. The programme of activities promised much and delivered some memorable cultural excursions and experiences. From my own observations and from reports such as Baxter's, it is clear that some visitors were unprepared for the reality of life in parts of Sāmoa outside the tourist resorts. Families with young children were worried about access to medical treatment for injuries and ailments, and some were not prepared to spend a week or more staying in an open beach bungalow. Some of the visiting tattooists were unhappy that when they finished tattooing a local all they got as payment was a shell or seed necklace. Others, on the other hand, weren't bothered by this at all. In a situation where the global met the local, where international tattooists came to the homeland of their tattooing heroes, there were communication breakdowns, cultural misunderstandings and culture shock.

◄ • ►

If there is one event that disrupts the stereotype of tatau as unchanging – and Sāmoa as its single locus of production – it is a saofaʻi (title bestowal) that took place during the Second International Tatau Convention, held at this time to take advantage of the prospective title-holder's attendance at the convention. I was invited to attend the saofaʻi by one of the participants.[8] He would receive the Suluʻape tattooing title from the Suluʻape family in the village of Lefaga, one of several non-Sāmoan tattooists to receive the title that day. On the morning of the saofaʻi we drove to a family property in Lefaga where we awaited the arrival of the village matai. The title recipients were ushered to a small fale nearby and dressed by people from the ʻāiga in long pieces of ʻie pālagi (printed cloth) and then rubbed down with oil. Stripped to the waist, with long flower garlands draped around their necks, the recipients of the Suluʻape title were Pili Moʻo, a Frenchman; Michel Thieme (Captain Caveman) from the Netherlands; Uili Tasi, a Sāmoan; Freewind from the United States; Keone Nunes, a Hawaiian; and Inia Taylor, a New Zealand Māori. Other Sāmoans present were there to receive the Pasina family title. What the new title-holders all had in common was their profession

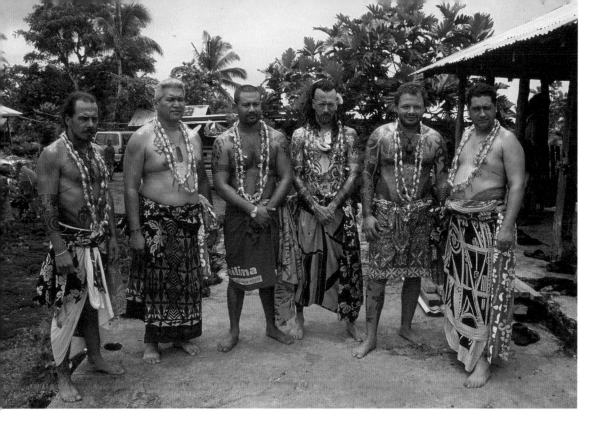

Fig. 120
Participants before the
Suluʻape title bestowal at
Lefaga, Sāmoa, in 2001.
From left to right: Pili
Moʻo (Tenerife); Keone
Nunes (Hawaiʻi); Uili
Tasi (Sāmoa); Freewind
(USA), Michel Thieme
(Netherlands); Inia Taylor
(Aotearoa New Zealand).

as tattooists and a shared connection to Suʻa Suluʻape Paulo and Suʻa Suluʻape Alaivaʻa Petelo. Most had met the brothers during their international travels and had received instruction from them in the use of Sāmoan tattooing tools.

Once the prospective title recipients were dressed, they moved into the faletele, the big house, where the matai of the village were waiting for them. The prospects were seated in the centre of the fale and formalities commenced that would incorporate them into the Suluʻape family. The symbolic handing over of the titles came at a price. The recipients were obligated to make substantial cash gifts to the title owners and the family who, in return, presented them with a toʻotoʻo (ceremonial staff) and fue (ceremonial flywhisk) – the status symbols of the tulāfale (orator chief). After speeches, the bestowal took place in front of an audience that included locals as well as friends and family of the new matai.

The bestowal was an initiative conceived by Suʻa Suluʻape Paulo several years before his death in 1999. Despite some opposition from within the family and village, Suʻa Suluʻape Alaivaʻa Petelo decided to see the initiative through to completion. With the exception of one participant, all had been students of Paulo; the remaining one (Freewind) was Petelo's student. Historical accounts of the apprentice/guild arrangement indicate that the specialist arts and trades of Sāmoa are long established; therefore a social structure is already in place in Sāmoan society that enables new apprentices or agents to be incorporated into the Suluʻape family of the ʻāiga sā Suʻa. According to Suluʻape Alaivaʻa Petelo, the bestowal of the Suluʻape title gave the recipients the right to tattoo others using the Sāmoan tattooing tools, but in their own specific cultural styles. It was not a licence to tattoo tatau. It appears, however, that this intention was not communicated effectively, and this has resulted in various responses from the new Suluʻape title holders.

Regardless of the original intentions, there are several reasons why this particular bestowal of Sulu'ape titles to foreigners might have been considered beneficial not only to the newly installed tufuga and the Sulu'ape family but also to the 'āiga sā Su'a as a whole. First, the bestowal of the titles creates agents or apprentices for the sā Su'a in a range of communities overseas; this ensures access to different markets and clients for tatau. Second, an international distribution of members of the sā Su'a keeps tatau prominent in the conventions and tattoo shows in the areas in which they are located. This develops and helps to service an existing client base, one that is interested not only in the markings but also in having images created with the distinctive Sāmoan tools.

Third, while the scatter of tufuga around the globe makes the tatau more prominent, it also provides the sā Su'a (intentionally or unintentionally) with a sense of control over who appropriates, uses and renders Sāmoan designs overseas; prospective clients are probably more likely to approach an authorised tattoo artist to produce Sāmoan designs than not, especially if an 'authentic' motif and the experience of tattooing under the au is sought after. Fourth, these tatau agents have the potential to reduce the demands on the Sāmoa-based tufuga. The newly installed California-based tufuga Sulu'ape Freewind said that when Su'a Sulu'ape Alaiva'a Petelo visited there for the Long Beach Tattoo Convention in the 1990s he was swamped by the number of people who wanted tattooing work from him. At the time, having a member of the sā Su'a in California may have helped to meet this demand. Freewind said that Alaiva'a wanted him to have a Sulu'ape title so that he might eventually have permission to produce Sāmoan tatau in a region where there is a substantial Sāmoan community:

> he wants me to learn 'traditional Samoan technique and pattern', so that I can tattoo the hundred and thirty thousand Samoans that live in California alone … there is going to be so many people that won't be able to wait, or be able to travel to Samoa or be able to wait for him to come … and even if they did, he is only one man that can't do them all … he wants me to help take on the responsibility of learning the pe'a and giving the pe'a to the Samoan population that is there.[9]

9.
Sulu'ape Freewind, interview with Sean Mallon, Saleapaga, Sāmoa, 2001.

In Europe this type of arrangement did not arise – or at least the responsibility and privileges of the title were considered differently. The newly installed tufuga Sulu'ape Michel decided not to actively seek opportunities to work in the Sāmoan style. He had completed one pe'a on a European that was started by Su'a Sulu'ape Paulo, but he did not plan to pursue Sāmoan tatau work further. I interviewed him six months after he received the title. At that point he was of the view that the family title was not necessarily a licence to practise tatau abroad or to claim some kind of authority over Sāmoan tatau. He said:

> To me it seemed it was an honorary thing. Each one of us had done something for Samoan tatau or traditional tattoo … there are persons [title holders in the group] who hardly have anything Samoan on them who carry the title … If I go to Samoa I will never introduce myself as Sulu'ape Michel. Because I might be shaking hands with Malietoa so and so. By introducing myself as Sulu'ape

I bring relations to such a high level of protocol that I would make a fool of myself because I don't know this level. So I think it is something that people can only say of me to other people, and then I can be the clown and say that it is an honorary thing, it's not the same as you and your title. So I think that there is really a misunderstanding of what happened [at the bestowal].[10]

The longterm implications of the introduction of these non-Sāmoans into the Suluʻape family and the sā Suʻa tattooing fraternity have been difficult to monitor. When I first wrote about this event in 2005 I was concerned to show how tufuga of the ʻāiga sā Suʻa were seeking to share tatau with the wider world. I argued that they were active agents in its dissemination and dispersal, and that the saofaʻi suggested they possessed confidence in the people they were entrusting with their matai title and knowledge. I suggested that some of the tufuga were worried that the skills and knowledge of tatau may be lost if they are not shared. I also posed a number of questions.

For example, to what extent will Sāmoan communities in the United States accept these non-Sāmoan members of the sā Suʻa, some of whom are claiming they are permitted to serve? How will they be viewed by the other families in the sā Suʻa? And how will the tufuga be accepted and recognised among the Western tattoo community? Will they be seen as experts and authorities in Sāmoan tatau? Will they meet clients' expectations and perceptions of what a tufuga tā tatau is and can be? In 2018 we can find answers to only some of these questions; I was told that questions relating to the relationships between the Suluʻape title holders were family business.

In 2016–17 Michel Thieme was a tribal art dealer in Amsterdam, and Inia Taylor worked out of Moko Ink studio in northwest Auckland, where he tattooed across cultural forms and has trained several tattooists. Suluʻape Pili Moʻo was based in Hawaiʻi, with a steady clientele for his Polynesian-inspired work with machine and Sāmoan tattooing tools. Suluʻape Freewind was based in California and was a patron sponsor for the *Tatau: Marks of Polynesia* exhibition at the Japanese American National Museum in 2016. I was unable to trace Suluʻape Uili Tasi. Suluʻape Keone Nunes from Hawaiʻi has made the most public statement about where he stands culturally in relation to his Suluʻape tattooing title. In 2013 on his personal Facebook site he posted the following:

> In 2001 at Faleseʻela Uta, Upolu, Samoa I was presented with a great honor. In full ceremony and in front of the chiefs of the village I was one of six individuals at that time that received the chiefly title of 'Suluʻape'. Long before the ceremonies were to begin I was asked by Suʻa Suluʻape Alaivaʻa to consider receiving this title. Initially I was hesitant as I know the responsibilities and protocols that go along with receiving a title. As a non-Samoan I felt that I did not have the cultural background to live up to those responsibilities, and as a Polynesian and one who knows protocol I knew enough to know that. In considering it I spoke with several people including titled Chiefs. Everyone I

10.
Suluʻape Michel Thieme, interview with Sean Mallon, Amsterdam, 2002.

TATAU

contacted encouraged me to accept the title to honor my teacher Su'a Sulu'ape Paulo and to leave a legacy to any future student that I would 'uniki (graduate). After long self reflection and thought I accepted the honor afforded me. I felt it was very personal and something that I held close to me. I also felt that, due to the closeness in time of the passing of Paulo, I did not want anyone, including members of his family, to feel that I would misrepresent or take advantage by using the honored name and title of Sulu'ape, so although I always acknowledged the honor, I never really used it. It has been nearly 14 years since Su'a Sulu'ape Paulo was taken from us, but in many ways he still plays an active role in my life. He still teaches me with every piece that I do, and the tools he made and left for us in Hawai'i still teach the new tools that are made by Kanaka hands. I recently told Su'a Sulu'ape Alaiva'a [Petelo] and Su'a Sulu'ape Peter [his son] the reasons that I have not used the name, not because I did not honor it but because I have always had the utmost respect for the name and family. Su'a Alaiva'a responded that he understood that, but the name was given to me to honor myself and to honor the legacy of his brother, to continue that legacy I should use my titled name. I have thought about it for a while now and if not for Paulo, along with all of my other teachers, I would not be able to do the work that I do now. I am a Kanaka ka uhi and that will never change. Mau Piailug bestowed the 'Pwo' title to 5 Kanaka navigators in front of his island for all to see as a way to carry on his work and honor all of Hawai'i before his passing. I am proud to have been the first Kanaka given the name 'Sulu'ape'. Although my focus and my work will stay the same, as any change in that would not honor my other teachers, I will be using the Chiefly name of Sulu'ape and ask support from all who have been part of my journeys.

11.
This criticism was expressed publicly at the Tatau/Tattoo: Embodied Art and Cultural Exchange Conference held at Victoria University of Wellington, New Zealand in 2003. The event was also the subject of questions to and a response from Su'a Sulu'ape Alaiva'a Petelo at the Sacred Marks Samoan Styles Symposium at Unitec, Auckland, New Zealand in 2008.

There are several – and in some aspects conflicting – perspectives of what the saofa'i event was about. It was not universally accepted by the family, or by other families in the tattooing clan, and was criticised by matai in Sāmoa and New Zealand." What is not widely known is that these titles were offered to people who had strong relationships with the 'āiga sā Su'a. They had looked after the tufuga on their travels through Europe and the United States, and they had tattooed alongside them. In Paulo's case, people such as Michel Thieme (among others) had nursed him back to health when he was seriously ill in a hospital in Amsterdam. They had provided service or tautua to the family. Behind the bestowal was also a desire from some members of the family to share Sāmoan tattooing technology, ensuring its survival and perhaps developing some sense of fellowship among practitioners. The conflicting views around the title bestowal and the various directions the title holders have pursued in their work highlight the paradox. Just when circumstances are set up to take hold of tatau, fix its meaning and stabilise or control its dissemination and relevance, it somehow slips away and moves in a new direction.

Although the cross-cultural aspect of this title bestowal in 2001 represents an unprecedented event in the history of Sāmoan tattooing, Sulu'ape Alaiva'a was nevertheless carrying on with managing the trade that his father Sulu'ape Paulo I

started in the previous generation. If one compares it with what has been the usual custom in transmission among the 'āiga tufuga, the late Sulu'ape Paulo I initiated a remarkable dispersal of the craft among his extended family, rapidly increasing the number of tufuga tā tatau within the archipelago during the period from the 1960s to the 1980s.

As regards the bestowal at Lefaga, the main innovation was to give titles to papālagi and non-Sāmoan citizens who were working outside Sāmoan communities. In 2003 Sulu'ape Alaiva'a doubtless went to the next level in the liberalisation of this profession when he bestowed his family title on Angela Bolton, an American female apprentice of his. We have not investigated the circumstances of this decision, but the YouTube footage of the ceremony has provoked highly polarised comments and positioning about this singular event, despite the precedent of the non-Sāmoan bestowals in Lefaga. Further enrolments into the Sulu'ape family caused less trouble, as the tattoo artists involved were all of Polynesian descent; this seems to have been received with a more watchful eye than the previous cross-cultural title bestowing.

As Sāmoan communities have relocated in cities around the Pacific in Australia, New Zealand and United States, new branches of tufuga tā tatau have emerged. Whereas in Sāmoa the 'āiga of reference those that until recently were providing apprenticeship, titles and identification for young tufuga – remained the sā Tulou'ena and the sā Su'a, several Sāmoan tattooers outside of Sāmoa have progressively abandoned their tattooing machines in favour of the au – hand-tapping tools. The high demand for pe'a and malu within the diaspora can certainly explain this movement from being a tusi ata tā masini (machine tattooist) to a tufuga tā pe'a. They have learnt the craft of Sāmoan tattooing in unusual ways, sometimes self-taught, or via short-term apprenticeships and through different social strategies in the multi-cultural contexts of suburban Australia and New Zealand and throughout the Sāmoan diaspora.

There are several tufuga whose learning departs from the conventional longterm master–apprentice relationship: tattooists such as Kasala Sanele, Tuifa'asisina Peni, Li'aifaiva Imo Levi, Fuiavailili Lawrence Ah Ching and Brent McCown have all found alternative ways of embracing the practice of tatau and negotiating the politics of status transmission. In addition to these developments, the 'āiga sā Su'a has bestowed its title on other Sāmoan tattooists who established relationships with the family. They include Sulu'ape Steve Looney, based in Hawai'i, who works with masini (machines), and Los Angeles-based Sulu'ape Si'i Liufau, who works with the au and masini. The presence of these Sāmoan tattooists (among others) in the Sāmoan diaspora reduces the need for Sāmoans to rely on non-Sāmoan tattooists, whether they are title holders or not.

◄ • ►

Fig. 121
The poem 'Wild dogs
Under My Skirt' by Tusiata
Avia (2004), illustrated
by Vaughan Tangiau
Flanagan (2017).

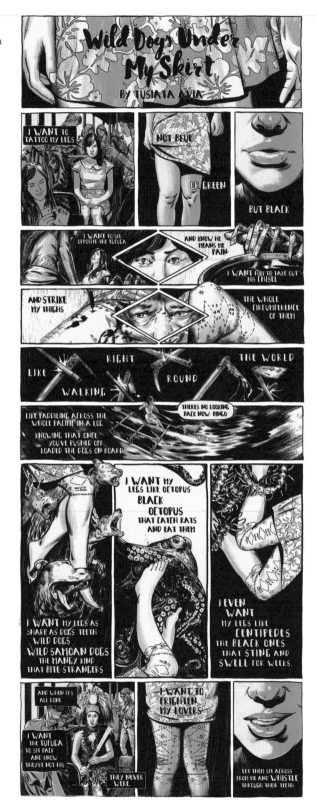

Non-Sāmoans receiving the tatau is not a new phenomenon, and nor is it a practice of recent decades. Sāmoans tattooed Tongans as long ago as the 1700s and a host of other nationalities ever since then, both within and beyond Sāmoa. The difference is that it happens more frequently today and in more geographically diverse locations. Non-Sāmoans are not peripheral to Sāmoan tattooing but rather help create the greater whole; they in part constitute the practice. Today Sāmoan-style tattooing globally cuts across national, cultural and ethnic boundaries: it is made in the United Kingdom, mainland US and Hawai'i, across Europe and in New Zealand and Australia. The tattooing of Sāmoans and non-Sāmoans at these locations highlights the transnational and global processes that shape Sāmoan tattooing and the meanings people make through it.

The non-Sāmoan appropriation of Sāmoan tatau is most prevalent among tattooing artists and people who are extensively tattooed, rather than the occasional collector who might wear only one or two pieces. These individuals are often longterm members of tattooing communities that appreciate body art; they have more than a passing interest, and engage with Sāmoan tatau either through being tattooed, witnessing Sāmoan tattooing at conventions, or through accounts and images in the tattooing literature. In the United States, the appropriation and use of indigenous tattooing designs from the Pacific emerged after the American tattoo renaissance of the 1960s and 1970s. The popularity of these images led to the development of a tattooing style called tribalism – pioneered by Ed Hardy's explicit strategy for upgrading Western tattooing by incorporating non-Western imagery, and by tattooists such as the then Los Angeles-based Leo Zulueta, a Hawaiian of Filipino descent.[12]

Tribalism manifested itself mainly in a black graphic tattooing style that experimented with positive/negative space, heavy black linework and shading. Tribal-style images often involved the appropriation and reworking of tatau motifs from cultures in the Pacific Islands and the Pacific rim. The appeal of the imagery is in its visual style but also its origin within other cultures that are deemed more primitive or connected to a less industrialised way of life, or engaged in 'non western and premodern ways of living'.[13] Exponents of tribalism are drawn to the 'primitive' (in this case embodied by the tattooing arts) in order to find an alternative view of the world, a more appealing social ordering. Zulueta has said that the tatau styles of other cultures were merely a 'springboard for his own creativity' and his work could be considered as a sign of 'admiration for a culture that no longer exists'.[14] But what happens when that culture does still exist?

Whereas tribalism appropriated Sāmoan motifs, it did not appropriate the Sāmoan tatau process using customary tools. Two non-Sāmoans who wear the Sāmoan pe'a – an American and a European – both told me that they see tatau as a point of difference within the genre of tribalism. Sāmoan tatau rendered using Sāmoan tools is assumed to retain its original meaning – an element of authenticity that they consider is missing in Western tattooing styles. Of course Western tattooing and the tattooing styles of tribalism do have meaning and are authentic in their own right, but tatau has the additional element of the ritual and process mediated by the au, the Sāmoan

12.
Margo DeMello, *Bodies of Inscription: A Cultural History of the Modern Tattoo Community* (Durham, North Carolina: Duke University Press, 2000), 86; Ed Hardy, *Tattootime No. 1 The New Tribalism* (1982), 8.

13.
Daniel Rosenblatt, 'The Antisocial Skin: Structure, Resistance, and "Modern Primitive" Adornment in the United States', *Cultural Anthropology* vol. 12, no. 3 (1997): 287–334, at 311. For a critique of the myths of primitivism, see M Lodder, 'The Myths of Modern Primitivism', *European Journal of American Culture* vol. 30, no. 2 (2011): 99–111.

14.
DeMello, *Bodies of Inscription*, 87.

tattooing tool. For tattooed non-Sāmoans living in the West, tatau – and especially tatau rendered with the au – is seen as the closest they can get to an 'authentic' and 'primitive' tattooing experience. If the tattooing community is already marginal from mainstream society because its constituents wear tattoos, the wearing of Sāmoan tatau is a further degree of difference and a mark of authenticity within the tattooing community's own politics of value.

Some members of the Sāmoan cultural elite see the tattooing of non-Sāmoans by Sāmoan tufuga as a threat to their cultural values. They are concerned that tatau and its associated imagery and customs will be cheapened, misused or lost if they are taken outside the usual Sāmoan cultural contexts. This concern was expressed on Sāmoan talkback radio station Radio Sāmoa in Auckland in late 1999 and in February 2002: the discussion took the form of a panel of matai who discussed various aspects of Sāmoan culture, followed by a public call-in session. Many times throughout the research for this book Sāmoans questioned the tattooing of non-Sāmoans with the pe'a and malu and the bestowing of tattooing family titles.

It is possible that these critics view the use and appropriation of tatau as a threat to the Sāmoan social order. In practice, however, the wearing of the pe'a by non-Sāmoans does not challenge the Sāmoan social order because Europeans are not likely to be seen with the pe'a in situations where it is socially relevant. For example, at the tatau competition that Paulo organised in Auckland, the Sāmoan audience cheered the non-Sāmoan participants tattooed with pe'a, even though they were not taken seriously as competitors because of their inability to meet the other performance criteria of the show. Concerns over who wears the pe'a are likely to be local debates among a Sāmoan elite about what is authentic or legitimate Sāmoan culture and who has authority over Sāmoan customs. The question of exactly who is authorised to embody cultural heritage and to introduce new or innovative elements is a matter of endless debate in the community. As with similar struggles for authority over 'traditional' culture in other societies,[15] knowledge relating to Sāmoan tatau could merely be another factor in the struggles for status and power among Sāmoan matai in New Zealand.

Sāmoan matai regularly debate other cultural practices and ideas because there is no universally recognised authority. In Sāmoan communities there is a constant struggle for the status that cultural products such as tatau mediate. A memorable example was a debate over who could wear the 'ulafala – a necklace made of the red 'keys' of pandanus, most often worn by tulāfale (talking chiefs) as temporary ceremonial markers of status in Sāmoan society. Like many aspects of Sāmoan culture, the customs concerning the use of 'ulafala seem to be changing and up for debate. In 1999 New Zealand prime minister Jenny Shipley attended the funeral of former Sāmoan prime minister Tofilau Eti wearing an 'ulafala given to her by a Sāmoan colleague. She was criticised by Sāmoan commentators in New Zealand for wearing it on such an occasion; one stated in an interview that the 'ulafala was worn at celebratory occasions and was inappropriate for more sombre events.[16]

15.
For an example of discussions relating to Tuareg nobles and artisans in Niger, see Elizabeth Davis, 'Metamorphosis in the Culture Market of Niger', *American Anthropologist* vol. 101, no. 3 (1999): 490.

16.
Dominion, 29 March 1999.

This prompted a letter to the editor of the *Dominion* newspaper from another New Zealand-based matai, who argued that Sāmoan culture had evolved in all directions and there were no guidelines for the 'ulafala's use.[17] The argument soon dropped out of the newspaper headlines, but it highlighted the important issue of the contentious and changing nature of Sāmoan custom. Community and academic debate over how to define fa'asāmoa centre on a popular investment in the ways of the past, as if they somehow represent an idealised way of living that needs to be restored to secure one's cultural proficiency or authenticity. However, as this history and a closer look at past lifeways reveal, a static and unchanging view of culture is untenable.

By sharing tatau beyond the Sāmoan community, Su'a Sulu'ape Paulo II took the position that the tatau was something the wearer could not exchange or sell; it was a treasured adornment that would be with them for life. With this in mind he had little hesitation in taking tatau to the world and sharing it with other admirers and enthusiasts of tattooing. It seems that Paulo assumed that to receive the pe'a a recipient must have some respect and appreciation for its history, values and aesthetic.[18] This is not an unreasonable assumption to make. It is clear that the pe'a is a formidable financial and psychological commitment for most people. Sāmoan-style tatau in its fullest form is not a style that can be easily removed by laser treatment.

—— • ——

It is through the media first and foremost that tatau makes its way across the globe – its distinctive images attract interest and draw people in. Tatau has moved off the skin in a variety of ways to become a public and often very visible expression of cultural values, and a politics of knowledge, information and ignorance often characterises these processes of circulation and cultural exchange.[19] By following the circulation of the images of tatau we can consider the social contexts where tatau appears, and how it is made relevant in these contexts. And by understanding how tatau circulates we can see what social and cultural processes shape and define its value.

In Sāmoa the main forms of Sāmoan tatau – the pe'a and malu – are significant in public and mainly ceremonial contexts. They are seen at gatherings and are displayed in ceremonial functions at local, national and international levels, where the use of tatau determines its meaning. In these situations tatau has high value as a social and political resource that can bring prestige and acquire responsibility for those who wear it and those who make it. It also exists in informal contexts off the body in a range of media from printed images on adornments, T-shirts and other clothing to letterheads on stationery and painted decoration on buses in Sāmoa.

Outside of Sāmoan social contexts, information about tatau has been most widely disseminated through literature, film and photographic representations. Two important historical sources on Sāmoan tattooing are still popular references today, in the

17.
Dominion, 7 April 1999.

18.
Su'a Sulu'ape Paulo II, interview with Sean Mallon, Auckland, 1999.

19.
Arjun Appadurai (ed.), *The Social Life of Things: Commodities in Cultural Perspective* (Cambridge, UK: Cambridge University Press, 1986), 43.

TATAU

20.
See for example ME Cox,
'Indigenous Informants or
Samoan Savants? German
Translations of Samoan Texts in
Die Samoa-Inseln', *Pacific Studies*
vol. 32. no. 1 (2009), 23–47.

21.
De Mello, *Bodies of Inscription*,
101.

22.
These reporters include German
'Travelling Mike' as well as
Hawaiian tattooist Keone Nunes.

23.
Sia Figiel, *They Who Do Not
Grieve* (Auckland: Vintage,
1999); Albert Wendt, 'Afterword:
Tatauing the Post-colonial Body',
in *Inside Out: Literature, Cultural
Politics and Identity in the New
Pacific*, edited by V Hereniko and
R Wilson (Lanham, Maryland:
Rowman and Littlefield, 1999);
Albert Wendt, 'The Cross of Soot',
*Flying Fox in a Freedom Tree
and Other Stories* (Auckland:
Penguin, 1988), 7–20. See also
Juniper Ellis, '"Tatau" and "Malu":
Vital Signs in Contemporary
Samoan Literature', *PMLA*, vol.
121, no. 3, 2006, 687–701; Tusiata
Avia, *Wild Dogs Under My Skirt*
(Victoria University Press, 2004);
Selina Tusitala Marsh, 'To Tatau
or Not to Tatau – That Is the
Afakasi Diasporic Question', in
Home: New Writing, edited by
Thom Conroy (Auckland: Massey
University Press, 2017), 18–32.

24.
Other films from the late 1990s
and early twenty-first century
include documentaries such
as *Tatau: What One Must Do*,
directed by Micah van der
Ryn (University of California
Extension Center for Media and
Independent Learning, 1997);
Tatau Samoa, directed by Gisa
Schleelein (Lichtblick Film, 1999);
and *Savage Symbols*, produced
and directed by Makerita Urale
(2002).

twenty-first century: Augustin Krämer's two-volume *The Sāmoa Islands* (1994 and 1995 editions) and Carl Marquardt's *The Tattooing of Both Sexes in Sāmoa* (1984). The two books were originally published in the late nineteenth and early twentieth centuries; they were written by Germans and are based on or include first-hand accounts from tufuga tā tatau (Krämer) and tattooed Sāmoans (Marquardt). Among contemporary Sāmoans, the volumes by Krämer are often coveted, copied and quoted, but also critiqued as part of a distrust of sources originating outside the Sāmoan community, and perhaps as a backlash against the ethnographic projects of Sāmoa's former colonisers. However, scholars of Krämer's work have argued for the indigenous authorship of key parts of his text.[20]

Apart from well-established media such as travel magazines and newspapers, tattooing magazines that have featured stories on Sāmoan tatau include the US-based *Tattootime, International Tattoo Art* and *Skin and Ink,* and in Europe *Tattoo Life*. In 2000 the main market for tattooing magazines was the Western tattooing scene, and while individual magazines did not have a wide circulation, their combined total readership was quite considerable.[21] On occasion *Tattootime* and *Skin and Ink* included contributions from travelling journalists or indigenous tattooing practitioners reporting on current events in the Pacific region.[22] One example is Hawai'ian tattooer and Sulu'ape title holder Keone Nunes, who reported on the first two international tatau conventions in Sāmoa for *Skin and Ink.*

As the popularity of tatau has grown it has been utilised as a medium for delivering all kinds of messages and telling a range of stories. Celebrated Sāmoan novelists and poets Albert Wendt and Sia Figiel have memorably used the imagery of tatau to speak to wider issues of cultural change in Sāmoan society. Selina Tusitala Marsh and Tusiata Avia have referenced tatau in their biographical writing and poetry.[23] Tatau has been the subject of plays such as *Tatau: Rites of Passage* (1996), the short film *Tatau* (2012) and feature film *The Tattooist* (2007).[24] Tatau has become emblematic of the Sāmoan nation and culture in popular media, too. It has featured on postage stamps and, in 2002, a series of phone cards – items that serve a practical communication purpose but also travel internationally and are collected and traded. Sāmoan tourist brochures and calendars often feature tattooed Sāmoan men and women. In coversation with the author, American tattooist Sulu'ape Freewind describes his first glimpse of the tatau on a travel brochure:

> It was an epiphany; I mean it led directly to the path for me to get my own pe'a and to my own title and to my own path of 'traditional'. The first time I saw a Sāmoan pe'a, was on a travel brochure, literally. I saw this obscure image that was peeking out from under something and a guy in the background, it wasn't even the featured picture, there was something in there … what is that … what? Look at that tattoo, look at that pattern! … it was just a little bit of the inner thigh that was showing.

Other kinds of public promotion include the New Zealand Land Transport Safety Authority using the popular taulima (armband tattoo) as part of a national safety

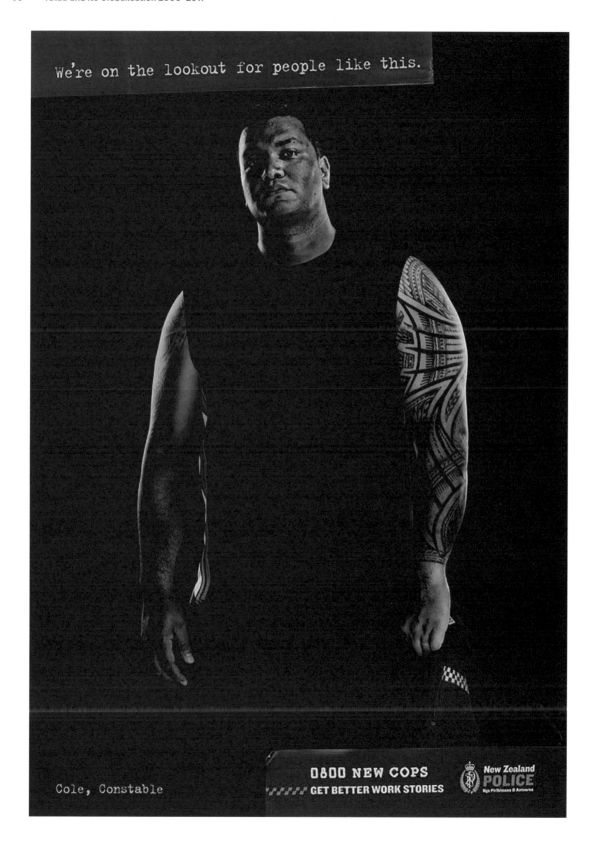

Fig. 123
Promotion for the
2011 Rugby World
Cup, Wellington
airport, New Zealand.

awareness campaign in 2000 to remind people to wear a seatbelt: they produced a taulima non-permanent transfer featuring Sāmoan world heavyweight boxer David Tua saying 'Let's get it on' as the medium to deliver the message. Tatau also featured in a recruitment campaign for new police officers, with the tataued figure of 'Cole, Constable' and the caption 'We're on the lookout for people like this.' International promotions included the 2007 Virgin Sāmoa-commissioned pe'a-inspired design from the tufuga Tuifa'asisina Peni: the finished design was used in an advertising campaign and printed on the engine cowling of the Virgin Sāmoa aircraft. In 2011 credit card company Mastercard and the Rugby World Cup organisers used a photograph of a Sāmoan tatau in a promotion for the competition, highlighting the Sāmoan national rugby team's historic win over Wales at the 1991 Rugby World Cup.

Many young people are learning about the images of tatau through television and popular culture, highly accessible sources where they can engage with its imagery.[25] Tatau has appeared on action figures associated with the WWE (World Wrestling Entertainment) such as Sāmoan wrestler and High Chief Peter Maivia, the grandfather of wrestler and actor Dwayne 'The Rock' Johnson. It has inspired the design of characters in the Disney film *Moana* (2016) and the motifs available in Tattoo Editing functions in Xbox and PlayStation console games such as *Far Cry* and *Rugby League Live*, in which players can design and edit their own tribal-style tattoos.

25.
Māori scholar Puawai Cairns made this point with reference to tā moko (Māori tattooing) in her presentation 'Appearances of Tā Moko in Contemporary Pop Culture' at the 2003 conference Tatau/Tattoo: Embodied Art and Cultural Exchange 1760–2000, held at Victoria University of Wellington, New Zealand.

◄ • ►

Tufuga have been proactive in using technology and electronic media to disseminate information about their work since the late 1990s. The internet has now become the

most effective tool for documenting, promoting and disseminating information about tattooing.[26] It has also become a key medium for debating its meanings. In the early 2000s, Australia-based Suluʻape Uili Tasi used the internet to educate and generate discussion about Sāmoan tatau, and he administered two websites to support the work of Sāmoa-based Suʻa Suluʻape Alaivaʻa Petelo. He was a regular correspondent on the *Sāmoa Sensation* website where, in the message board section, visitors to the site posted questions relating to Sāmoan history and culture. Tatau was a topic that frequently came up for discussion. Suluʻape Uili Tasi used the site to answer questions, explain the meanings of tatau and direct people to specific events and the location of tufuga tā tatau.[27]

Whereas the commercialisation of Sāmoan tattooing in New Zealand in the 1990s and 2000s made it a novelty to see a tufuga with a business card or a few sheets of flash advertising their work, social media applications have taken the artists' portfolios and flash sheets online in an unprecedented way. Through the growing popularity of social media platforms such as Facebook and Instagram, Sāmoan tattooists have become increasingly interactive with clients and fans of their work. Several tattooists of the ʻāiga sā Suʻa have Facebook pages and Instagram accounts that either they manage themselves or are managed by others. But the studio-based tattooers using the masini tā tatau are the most visible online. For example, Michael Fatutoa (Sāmoan Mike) of Sacred Tatau in Tampa, Florida, has over 137,000 followers on Instagram. He regularly posts images of his latest work and of tattoo-related merchandise and events.

Not all followers on social media are friends, however: it is also a platform for criticism. There is often negative commentary about how and where people reveal their tattoos as well as the work of tufuga. In May 2012 there was a string of heated criticism of the work of Suʻa Suluʻape Paulo III when images were posted on Facebook of tattoos he had rendered on a Sāmoan woman: he had tattooed her back extensively with the motifs usually used for the malu that appears on the legs. People were understandably critical of this particular tattoo, given that there is heightened awareness of the malu and it has arguably become more important to Sāmoans since the 1990s, particularly in the Sāmoan diaspora. However, the appearance of these motifs on a woman's back is similar to the use of the motifs of the peʻa on the arms of young men and women in the forms of taulima and sleeves – yet there is almost no fuss on social media about this appropriation of male tatau motifs.

The use of the internet is an example of how tufuga are able to distribute information about Sāmoan tatau to the world but also how they (and others) attempt to fix and control its dissemination. Online social media platforms like Facebook allow people from a range of ethnicities and backgrounds to have a say in the making – and remaking – of Sāmoan tattooing. In social media, the meaning of tatau is even less the preserve of the tufuga tā tatau, the cultural elite or the Mālōfie association than it ever has been. Like other forms of visual media Facebook makes the images of Sāmoan tattooing available to wide audiences; they are copied, repurposed and incorporated into new products.

26.
DeMello, *Bodies of Inscription*, 37.

27.
In the early 2000s, of the other internet sites that featured Sāmoan tattooing histories, perhaps the most notable was the Tattoo History Source Book, a site run at the time by Steve Gilbert: http://tattoos.com/jane/steve/index.htm.

TATAU

But it is not just the images that are accessible and reworked. The cultural knowledge and various beliefs, superstitions and values associated with tatau are also discussed, critiqued and sometimes created. There have been attempts to control and communicate knowledge of Sāmoan tattooing through Facebook pages such as 'Stop Idiots from Getting a Tatau or Malu' and on pages with a broader editorial interest such as 'Sāmoa mo Sāmoa'. Tatau regularly features as a focus of lively debate on these sites, so much so that some commentators accuse the site administrators of trying to stir argument and drive visits to and comments on their page.

28.
This section of the chapter is derived from a longer essay: Sean Mallon, 'Samoan Tattooing and the Rise of the Machine' in *Tatau: Marks of Polynesia*, edited by Takahiro Kitamura (Los Angeles: Japanese American National Museum, 2016).

Another key site for the creation, dissemination and circulation of the images of tatau and their meanings is professional tattooing studios.[28] Since the 1990s, the most prolific producers of Sāmoan tatau have been tattooists working with masini, also referred to as masini tā pe'a or masini tā tatau. Initially many of them worked from home, then gradually transitioned into professional premises and established profitable businesses. They were able to do this because customer demand was high and they were more accessible than tufuga tā tatau. At the time, the taulima and the tauvae were the most popular tattooing forms, then sleeves became fashionable, before back pieces and other body placements found favour. A new generation of Sāmoan people discovered they could be tattooed without the cultural obligations, time and expense of getting a full pe'a or malu. Those aspiring to be tattooists found they didn't have to seek an apprenticeship with a recognised tufuga tā tatau – they could experiment and teach themselves or approach an established tattooing studio for training.

Tattooing studios and masini tā tatau may not appear to be important in the history of Sāmoan tatau. The tattooing machine is associated with mainstream, commercialised tattooing practice, where it is assumed that ceremony and customs are unimportant; where there is seemingly no culture; where tattoos are made purely for decoration. On closer scrutiny, though, tattooing with masini tā tatau can be a serious undertaking, a set of processes with cultural significance for the tattooists and their clients. For a start, professional tattoo studios are workplaces that already have their own customs and culture. They are not just hubs of creativity – they also have their own protocols and practices shaped by their professional responsibilities. They are complex sites of cultural production with their own set of politics and demands. Tattooing studios have genealogies and histories of tattooists and clients who have passed through the business, and they utilise a model of training apprentices that is very similar to the apprentice/master system of indigenous Sāmoan tatau.

Fig. 124
Poster advertising
Su'a Peter Sulu'ape as
guest artist at Taupou
Tatau Wellington,
New Zealand, 2017.

There is fellowship between tattooists, but there is also competition and politics. The studio setting itself is also important and creates expectations related to professionalism, hygiene and quality of customer service. It is a visible, marketable space for the formal interaction between clients and tattooists. Even the Sulu'ape family opened a tattooing studio in Apia. Potential customers no longer had to struggle to contact the tufuga, and tourists no longer had to make their way out to a village location to be tattooed. The studio had regular business hours, and even car parking. By 2017, the Sulu'ape operation had moved to a fale near the visitor information centre, and two studios, including Urban Village Tattoos, were located in the central business district.

The accessibility of tattooing machines and tattooing studios democratised Sāmoan tatau, taking its production and meaning beyond the 'āiga sā Su'a and 'āiga sā Tulou'ena and the control of the social and cultural elites. The masini tā tatau put the production of tatau into the hands of ordinary people. This meant that aspiring tattooists without genealogical ties or apprentice relations within culturally sanctioned tattooing families could create tatau-inspired work. It allowed for gender restrictions to be renegotiated, creating space for women such as New Zealand-based Tyla Vaeau Ta'ufo'ou to tattoo and follow in the footsteps of Ugapo Makerita Heather, who tattooed with the au in Sāmoa for a short time in the late 1980s.[29] It enabled non-Sāmoan tattooists such as American Tricia Allen and New Zealanders Roger Ingerton and Tim Hunt (Pacific Tattoo), who already worked with tattooing machines and Polynesian motifs, to train others to do so. Allen trained two American Sāmoans to use the masini while Hunt apprenticed Sāmoan tattooist Fred Vaoliko, who went on to establish Savage Origins Polynesian Tattoo and Design.

The democratisation of tattooing may sound progressive, but having more tattooists producing tatau with masini has pros and cons. One tufuga lamented the rise of the masini, saying '… that by using modern technology for tattoos, the sacredness of the Sāmoan traditional tattoos is slowly but surely fading away.'[30] Alongside professionally trained studio tattooists there were amateurs, the untrained (scratchers and backyard tattooists), who introduced an inevitable variation in artistic and technical quality, and commitment to hygiene practices. As tattooists working outside the main family lines, tufuga tā masini introduced further reformulations of cultural knowledge around motifs and Sāmoan customs.

Although studio-based Sāmoan tattooists don't work in exactly the same way as tufuga tā tatau, it doesn't mean their tattooing is less important culturally or devoid of ritual-type elements. Sometimes clients instigate the ritual and customs in the studio, heightening the cultural significance of a tattooing session in ways the tattooer may not realise or anticipate. Getting tattooed can be a solitary undertaking, but it can also be a significant social and cultural event involving others. It can be connected to a coming-of-age moment, the birth of a child, the beginning of a new relationship or a commitment to an existing one. A client may invite family and friends along to witness the tattooing and support them in the studio, where they have the potential

29.
Noel L McGrevy, 'O Le Tatatau, Traditional Samoan Tattooing', unpublished manuscript (Auckland: Culture Consultants Ltd, 1989), 135–37.

30.
Su'a Vaofusi Pogisa Su'a, quoted in 'Is the Tatau Losing Its Sacredness?' Samoa Observer, http://Samoaobserver.ws/other/culture/1906-is-the-tatau-losing-its-sacredness-?tmpl=com.

to overcrowd it and get in the way of other clients, discouraging walk-in customers for the other tattooists. They may take photographs with their cellphones and present special gifts to the tattooer, such as 'ie tōga or perhaps a bottle of whisky. Some clients might even add a tip to the bill. The cultural aspects of the process may include other activities that the tattooists will not see, demonstrating how being tattooed by masini tā tatau is not just an everyday event. For some clients this may involve undertaking their own research about appropriate patterns and designs, or consulting with parents or elders for approval to be tattooed.

Through these processes a refreshment and transfer of cultural knowledge occurs that keeps the images and knowledge associated with tatau circulating. Unlike the tattooing of a pe'a or malu, where the design is determined by the tufuga, there is often a relationship of co-creation of the machine-rendered tatau in a tattoo studio setting. For example, the client might request a tatau that represents particular stories or genealogies; this influences the design of the tatau, which may take the form of a set of abstract motifs, or involve the rendering of a pictorial scene, a family name or a portrait. Needless to say, clients and tattooists will possess varying levels of knowledge, cultural fluency and access to the visual vocabulary of Sāmoan culture: this is a risk if a client is interested in a particular level of cultural authenticity or

Fig. 125
The Sulu'ape family's first tattoo shop in Mata'utu, Apia, Sāmoa, 2007.

TATAU

accuracy about the tatau they are receiving. There is inevitably a process of creativity and cultural loss. But even among the clients of the tufuga tā tatau, the transmission of cultural knowledge relating to tattooing is not guaranteed either. Some wearers of the peʻa cannot name the specific motifs, the larger structures of the tatau, or even the tufuga who did the work. I asked one tattooed man, 'What was the name of your tufuga?' He replied, 'I don't know, I'll have to ask my dad.'

Fortunately there are some strong connections between tufuga tā tatau and Sāmoan studio-based tufuga tā masini. A few of the leading studio-based tattooists are holders of Suluʻape matai titles and have worked with the family on a regular basis. In New Zealand, Tuigamala Andy Tauafiafi of Taupou Tattoo has hosted the tufuga of the Suluʻape family on their regular visits to Wellington. His team manages the advertising and advance bookings; they organise the space within the studio and look after the tattooists over the course of their stay. In September and October 2017, Suʻa Suluʻape Peter worked at Taupou Tattoo for almost three weeks, tattooing peʻa and malu but also contemporary-style tattoos. Once in the space he managed his own transactions and queries from the public, and essentially operated as a guest artist.

Other studios have done the same for other members of the ʻāiga sā Suʻa in Hawaiʻi and the United States. A measure of the level of collaboration and the strengthening ties among the tufuga tā tatau and tufuga tā masini was the ground-breaking exhibition *Tatau: Marks of Polynesia* held at the Japanese American National Museum in Los Angeles in 2016. Curated by tattooist and Japanese tattooing scholar Takahiro Kitamura, the exhibition and catalogue were milestones in the representation and imaging of tatau, showing how the art of the au inspired the art of the masini tā tatau and a new contemporary style of tattooing with tatau as its cornerstone.

Sāmoans working in professional studios are calling this new style of tattooing 'Contemporary Polynesian'. It is based largely on Sāmoan iconography but incorporates many other cultural motifs and compositional structures. As Sāmoan tattooists have gained experience in the tattooing industry and participated in overseas conventions, they have been inspired by other traditions and styles. These range from the iconic lettering styles of Chicano tattooing from the United States to Māori, Marquesan and Hawaiian tattooing styles in the Pacific. In the twenty-first century, the globalisation of tattooing imagery and knowledge has seen Sāmoan tatau move beyond armbands and sleeves to include chest plates, large back pieces and body suits characteristic of Japanese tattooing. In Europe the same process is also underway, with Polynesian-influenced designs covering entire bodies and being made by Sāmoans and non-Sāmoan tattooists who come from a range of ethnic and cultural backgrounds.

Sāmoan/African American Dwayne (The Rock) Johnson, a Hollywood actor, is probably the most visible person tattooed in a Contemporary Polynesian style. His extensive shoulder and chest piece features Marquesan- and Sāmoan-inspired images, and he is one of many Sāmoans for whom tattooing and Polynesian-inspired iconography is a marker or affirmation of ethnic and cultural identity, and stories of

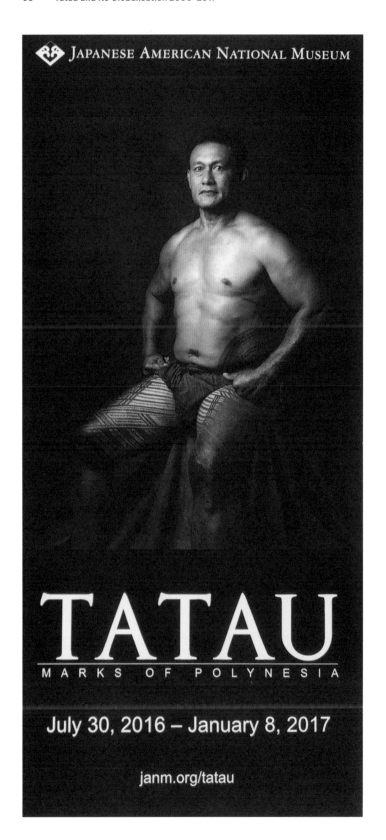

Fig. 126
Promotional flyer for
the exhibition *Tatau:
Marks of Polynesia* at
the Japanese American
National Museum, Los
Angeles, 2016–2017.

31.
GQ magazine published detailed
explanations of The Rock's
tattoos that gave Sāmoan names
to motifs that were distinctly
Marquesan..

32.
See Sidney Colvin (ed.), *Vailima
Letters; Being Correspondence
Addressed by Robert Louis
Stevenson to Sidney Colvin,
November, 1890–October 1894,
Vol. II* (New York: Scribner, 1896),
245 and LP Churchill, *Sámoa
Uma* (New York: Sampson Low,
1902), 87.

family and life's journey. However, the interest in a Contemporary Polynesian style is stronger in some locations than others. In New Zealand, where there are many Pacific Island peoples living together in close proximity, clients are often more fluent in the visual vocabulary of their own culture(s). There is less demand for a pan-Polynesian style, and people are more interested in distinctive cultural motifs from their specific island groups. Internationally – and particularly in Europe where there are fewer Pacific peoples – Sāmoan tattooists like New Zealand-based Ma Ching find they have more artistic freedom and can create tatau combining multiple cultural styles.[31]

All these developments have attracted their share of criticism from cultural purists. One focus of attention is the use of motifs from the pe'a and malu to create other forms of tatau considered less authentic, such as the taulima and tauvae. The use of pe'a motifs on the arms and torso is, for some observers, a misappropriation of the designs. They question why patterns that usually appear on the legs are now appearing on other parts of the body. This point of view overlooks how the pe'a itself has undergone transformation over time – the most obvious changes being the breaking up of large areas of black with more ornamentation, and the introduction of new motifs – and it doesn't account for the existence of other small forms of tatau in Sāmoa such as the taulima as far back as the mid 1800s.[32] It doesn't acknowledge, either, the role of the customer in shaping change and innovation and the widespread appropriation of tatau motifs by Sāmoans on printed garments like lavalava and T-shirts, in art, on stationery, on cars and on other material items across the Sāmoan diaspora.

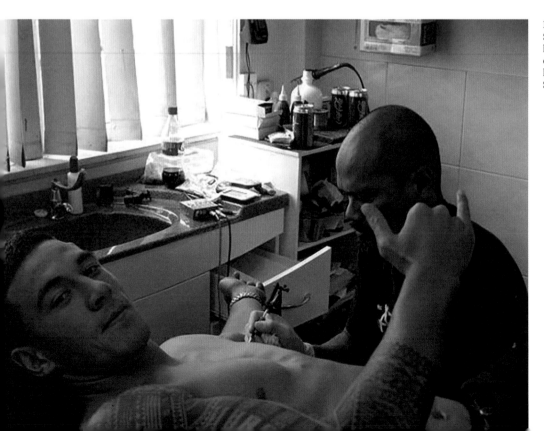

Fig. 127
Steve Ma Ching adding to his much-copied tattoos on high-profile rugby league and union player Sonny Bill Williams.

The anxiety about the use and appropriation of the peʻa and malu is because ideas about their social and cultural relevance are widely shared; there are people and groups in the Sāmoan community in which they circulate who are vested in trying to fix its meaning and relevance. Other forms of tatau such as the taulima are widely understood to be not connected to important ceremonial contexts. The taulima does not carry the same social commitment or cultural responsibilities as the peʻa and malu. It is not so deeply embedded in the Sāmoan sociocultural order and therefore not exposed to the same scrutiny by cultural arbiters such as matai and other community leaders.

While tufuga tā masini are being accused of cultural misappropriation of tatau, they are facing their own problems as they deal with the appropriation of their work and breaches of copyright. US-based Michael Fatutoa has struggled to get acknowledgement of his tatau work on Sāmoan WWE wrestler Roman Reigns, which has been reproduced without his permission as a stencil and sold through an online auction site. Steve Ma Ching has discussed how a sleeve he tattooed on rugby sports star Sonny Bill Williams has been copied repeatedly by tattooists, line for line. His frustration at people trying to claim his work was expressed in a story on his Facebook page in 2013 where he talks about how 'this guy – so-called tattooist' came into his shop years ago after being released from prison for meth and tried to tell him that, even though he was a hard-out meth user when he got busted, he could still do a good Sāmoan tattoo and that one of his pieces was Sonny Bill Williams' sleeve. Steve says he laughed and, after a few expletives he told him 'No, you didn't do it' and showed him photographs to prove it; the guy apologised to Steve and thanked him for putting him straight.[33]

33.
Steve Ma Ching, Facebook post, 19 July 2013.

◄ • ►

Academics talk about how the body is a key site for the inscription of identities and the marking of life's journeys. Tataued bodies carry the images of tatau, making them visible and public on the skin.[34] Despite the global traffic in ideas, images and information that connect us in so many ways, and seem to smooth over cultural differences, globalisation theorists tell us that people actively seek distinctiveness. We cling to boundaries, identities and ethnic groups because they offer resistance to integrating into a perceived cultural mainstream or into groups or movements with which we are uncomfortable. People with Sāmoan tatau are looking for a point of difference in the tatau they wear. That difference may lie in the aesthetics of the tatau, its placement or sometimes its interpretation. The images of tatau help people to set boundaries of an ethnic, geographical, political and social nature, where they strive to anchor difference and claim it. Even within Sāmoan tattooing in Sāmoa, the meanings of tatau are not fixed.

34.
Enid Schildkrout, 'Inscribing the body', *Annual Review of Anthropology* 33 (2004): 319–344; *Tatau: What One Must Do*, directed by Micah van der Ryn (University of California Extension Center for Media and Independent Learning, 1997); *Tatau Samoa*, directed by Cisa Schleelein (Lichtblick Film, 1999); and *Savage Symbols*, produced and directed by Makerita Urale (2002).

One impressive example is worn by Sāmoa-based matai Tauiliʻili Watti Mika, who is extensively tattooed with what Western tattooists would call a body suit. His tatau covers him from head to foot, across the feet, chest, back, legs, arms and calves. The

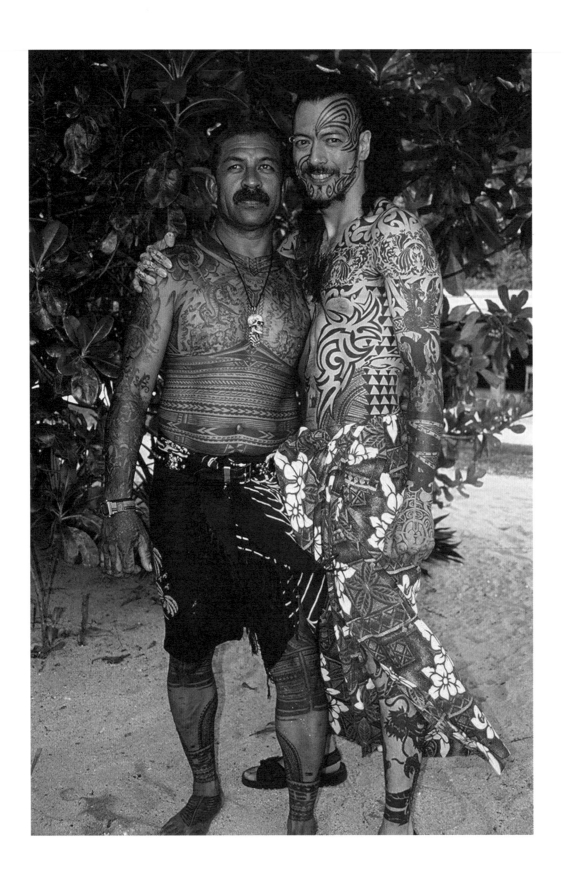

majority of the designs are tatau motifs but there are several of non-Sāmoan origin and rendered by tattooing machine. Tauili'ili wanted to create a special pe'a, and his friend Su'a Sulu'ape Alaiva'a Petelo obliged. The extent of the design singles out Tauili'ili as very unusual in Sāmoa, and he was criticised for being tattooed in this way and rupturing the structure of the seemingly unchanging pe'a. So he turned to oral traditions relating to Lafai Taulupo'o and Leutogitupa'itea to locate his pe'a historically and culturally within a fa'asāmoa customary framework. He connected his distinctive pe'a with the equally distinctive white pe'a (flying fox) mentioned in some versions of these stories. According to Tauili'ili, when he published a statement in the local newspaper explaining the meaning of his pe'a and challenging anyone to dispute him, no one came forward.[35]

Like Tauili'ili, other people devise their own sets of meanings for tatau. The markings help them resist aspects of the wider society and maintain a sense of self-identity or self-determination; but they also associate or socialise them within a group. Some individuals describe how the tattooing experience changes them as people, heals them and inspires them to live different lives.[36] One of these is Mattijis, a tattooist and musician from the Netherlands, who refers to the healing that receiving the pe'a offered.

> Yes, it has changed me inside, I didn't do it for the outside world, it gives me strength and when it's finished, I am a man. That's my meaning for it. It gives me inner strength and when I've got my pe'a, no one can harm me anymore. I can explain this to nobody … but it means a lot to me.

Tatau can also serve a process of healing that brings people together across time and distance, bridging generations. In her documentaries *Measina Sāmoa: Stories of the Malu* (2003) and *Tatau: A Journey* (2004), director Lisa Taouma highlights how being tattooed with the malu could be a process of social and cultural recovery. Her interviews with women highlight how receiving the malu helped them to strengthen relations with other women, or connect with grandmothers or elders who had been tattooed with the malu in their youth. One woman was tattooed on behalf of a relation who failed to complete her malu; another was tattooed for a relative who never had the opportunity to get one.

Tatau can symbolise immediate kinship ties or connections. It is common to see brothers, sisters and cousins and friends being tattooed in groups to support each other and strengthen family bonds. Within the Masoe family in New Zealand the tatau is a statement of their commitment to Sāmoan culture but also of their blood ties to each other: the entire family is tattooed – the men with pe'a and three generations of women with malu, and they also wear taulima. The shared experience of being tattooed binds them together as a family, and it commits them as a family to an active role in their Sāmoan social and cultural life. In 2017, the Wendt family used the occasion of a reunion in Sāmoa to have a group of women in the family tattooed with the malu. Mele Wendt said, 'It was the most moving and powerfully significant cultural experience we've ever been through. Li'aifaiva Lavea Levi is not only a brilliant artist and tufuga but he honours and adheres to the Fa'aSāmoa rituals of tatau, which we appreciated and loved. We wear our malu with so much pride.'[37]

Fig. 128
Tauili'ili Watti Mika and Sulu'ape Freewind and their tattooed bodysuits, Saleapaga, Sāmoa, 2001.

35.
Tauili'ili Watti Mika, interview with Sean Mallon, Saleapaga, Sāmoa, November 2002.

36.
Makerita Urale's documentary *Savage Symbols* takes a similar approach that examines the very individual meanings that tattooed Sāmoan men give to tatau.

37.
Mele Wendt, email correspondence with Sean Mallon, 7 December 2017.

TATAU

In his 2008 analysis of a survey of tattooed Sāmoan people, anthropologist Unasa Va'a emphasises how the tatau in the twenty-first century is no longer a rite of passage and obligatory, but rather 'more symbolic, representing certain cultural qualities Sāmoans are proud to be associated with [and] provide them with a cultural identity in the eyes of fellow Sāmoans and "outsiders".'[38] Another study, in Auckland, supports this finding and emphasises the importance of a settled relationship and the ability to economically support family and community as more important markers of the transition from boy into an adult man than being tattooed. The authors of this study argue: 'Young men may be tattooed by Sāmoan tattoo specialists in Auckland or return to Sāmoa for this purpose. However, this is more a matter of identity claim than life-stage marker. To a man, all the younger men cited as their primary role being the provider for their family as did their older counterparts.'[39]

Tatau is often used by Sāmoans outside Sāmoa as a symbol of connection between themselves and their ancestral homeland. It is a mark of identity for Sāmoans around the world but also for other people who are not Sāmoan. However, the identities that people claim from the creation and wearing of Sāmoan tatau are not necessarily ethnic Sāmoan identities. For example, in the Western tattooing milieu Sāmoan tatau provides a point of difference for those people already heavily tattooed and long familiar with neotribal styles; in certain circles Sāmoan tatau is considered more authentic because it is rendered with hand tools, and the meanings of its images are believed to be ancient. For some, this perception of Sāmoan tatau transcends the pseudo-authenticity of more recent neotribal styles. It highlights a view that Sāmoan tatau is somehow closer to an original unaltered form, more natural and seemingly unchanged by the industrialised world. The au and the tattooing process are a way of experiencing culture – and in effect, the past – directly, thereby 'validating' the tatau.

Darius, who is from the Netherlands, relates the meaning of the pe'a to the process of being tattooed and enduring the long and painful sessions under the au. For him, the physical and mental qualities required to see the process through represent a state of self-control that he should aspire to in everyday life.

> Patience and strength. It is kind of abstract, but the strength and patience in being able to deal with situations no matter how rough they come … to make things come clear for you in a relaxed way … without arrogance or aggression.[40]

Sāmoan woman Vanessa Masoe reflects on the process of being tattooed, where being brave and enduring the pain of the tattooing process is more important than the final tataued image and its aesthetic qualities.

> At first, I regretted getting the malu, because I stood out from those around me in New Zealand. But during Sāmoan functions, I am really proud. It makes my family really proud … culturally it is a sign of being brave and being strong, a statement that says you've gone though the pain.[41]

38.
Unasa LF Va'a, 'Tatau: From Initiation to Cultural Symbol Supreme', Proceedings of Measina a Samoa Conference 2 & 3 (2008): 91–119; Bernadette Samau, 'Perceptions on the Commercialization of the Malu: A Case of Samoa', Global Journal of Arts, Humanities and Social Sciences vol. 4, no. 6 (June 2016): 69–80.

39.
J Park and C Morris, 'Reproducing Sāmoans in Auckland "In Different Times": Can Habitus Help?', The Journal of the Polynesian Society vol. 113, no. 3 (2004): 227–61, at 244–45.

40.
Darius, interview with Sean Mallon, Apia, Samoa, 2001.

41.
Vanessa Masoe, quoted in Sean Mallon with U Fecteau, 'Tatau-ed: Polynesian Tatau in Aotearoa', in Pacific Art Niu Sila: The Pacific Dimensions of Contemporary New Zealand Arts, edited by Sean Mallon and Fuli Pereira (Wellington: Te Papa Press, 2002).

Experiences are central to understanding the contemporary meanings of tatau. Much like souvenirs, tatau can serve a double function for the tattooed person – 'to authenticate a past or otherwise remote experience and, at the same time, to discredit the present'.[42] The exotic souvenir – in this context the tatau – can be seen as a sign of 'the survival of the possessor outside his or her own context of familiarity. Its otherness speaks to the possessor's capacity for otherness.'[43] Tatau served this double function for Mattijis: he was attracted to the visual aesthetic of the pe'a, and its perceived uniqueness made him stand out in the Western tattooing world. Acquiring the pe'a allowed him to feel distinct from everyone else.

> First, I love the pe'a, it looks great on you. I think it is the ultimate tattoo. It's the design you cannot find nowhere else in the world, it's only Sāmoa, so you've got something completely different than the rest of Europe.[44]

Similarly, American tattooist Lyle Tuttle highlighted how his first Sāmoan tatau, acquired in the 1970s, was an authenticating mark – more 'authentic' than his extensive tattoos from his own cultural background (see page 126) :

> When I went to Sāmoa, they tattooed me across the small of my back: I added this 'authentic' work to my previous work to 'baptise' it. I wanted some of the 'real stuff' put on.[45]

The tatau can be a distinguishing mark that associates some wearers with a worldliness; it highlights their access to exotic travels and the exploration of the 'unknown and untamed'.[46] It is a symbol of Sāmoan social and cultural origin that is appropriated to enhance the 'status politics' of others beyond its point of origin.[47] In these first decades of the twenty-first century, the images and experience of Sāmoan tattooing can socialise the body and take the recipient to new and different levels of participation in social life. However, as the images of tatau circulate in new transnational and global contexts, the body socialises the tatau, introducing it into widening spheres of visibility, where people who are both Sāmoan and non-Sāmoan make it relevant to their own circumstances.

42.
Susan Stewart, *On Longing: Narratives of the Miniature, the Gigantic, the Souvenir, the Collection* (Durham, North Carolina: Duke University Press, 1993), 139.

43.
Ibid., 148.

44.
Mattijis, interview with Sean Mallon, Apia, Sāmoa, 2001.

45.
Interview with Lyle Tuttle, in V Vale, Ed Hardy and Lyle Tuttle, *Modern Primitives: An Investigation of Contemporary Adornment and Ritual* (San Francisco: Re/Search Publications, 1989), 116.

46.
Nelson HH Graburn, 'Introduction: The Arts of the Fourth World', in *Ethnic and Tourist Arts: Cultural Expressions from the Fourth World*, edited by Nelson HH Graburn (Berkeley: University of California Press, 1976), 2–3, 18.

47.
Arjun Appadurai (ed.), *The Social Life of Things*, 47.

TATAU

Following pages:

Fig. 129
A selection of tattooists' business cards.

Fig. 130
A selection of tatau-related T-shirts.

TATAU

SU'A FUIAVAILILI LAWRENCE AH CHING

SAMOAN TRADITIONAL TATAU

SEGAULA TATAU

SAMOA, NEW ZEALAND, UK, EUROPE

WWW.SAMOANTATAU.COM
LESEGAULATATAU@GMAIL.COM
f LESEGAULATATAU / LAWRENCETHIRTEENINK

Western
Tattoo

Vaga Faalavaau

Western
Tattoo

Cliff Cole

western
tattoo

Steve Ma Ching

@Samoan_Mike

Si'i Liufau

WWW.ATOWNTATTOOS.COM
facebook.com/a-town-tattoo

A TOWN TATTOO

12776 Brookhurst St.
Garden Grove, CA 92840
Tel: 714-534-8784
siitattoo@yahoo.com

JONNY HILLSON

TAUPOU TATAU

TATTOO ARTIST
LIO FA'AMASINO
CUSTOM LETTERING & FREESTYLE POLYNESIAN
310-901-0862
liofaamasino.com

TYLATATTOO.tumblr.com
Tyla Vaeau Ta'ufo'ou
Auckland, New Zealand

e: tylatattoo@gmail.com p: 021 1505 602

SULUAPE STEVE LOONEY

Pacific Soul Tattoo

Savage Origins
POLYNESIAN TATTOO & DESIGN

HOUSE OF WK TATTOO

45 HOOLAI ST, KAILUA HI, 96734 262-4455
WWW.HOUSEOFINKTATTOO.NET

SPACIFIK INK

Pacific and Custom Tattoo

Dwain Aiono
E: info@spacifikink.co.nz
www.spacifikink.co.nz
P: 06 878 2872 / 021 217 7810

D Tatt
unique designs

DEREK SAVEA TATTOOIST
027 339 4734

Soul Signature
TATTOO AND ART GALLERY

SULU'APE TOETUU ~ AISEA
1667 KAPIOLANI BLVD 808.330.5612
HONOLULU, HAWAI'I
www.soulsignaturetattoo.com

Tatau and health

Sean Mallon

1.
Margot McLean and Amanda D'Souza. 'Life-threatening Cellulitis After Traditional Samoan Tattooing', *Australian and New Zealand Journal of Public Health* vol. 35 no .1 (2011): 27–29.

2.
'Sterilising the Art of Samoan Tattooing', *New Zealand Herald*, 21 March 2003, http://www. nzherald.co.nz/nz/news/article. cfm?c_id=1&objectid=3251292.

3.
Ministry of Health, *Customary Tattooing Guidelines for Operators. Ta'iala mo Tufuga Tā Tatau a Samoa* (Wellington: Government of New Zealand, 2010), http://www.health.govt.nz/ system/files/documents/ publications/customary- tattooing-guidelines-for- operators-apr2010v2_0.pdf.

4.
'Tattooists Share Concern', *Samoa Observer*, 1 September 2016, http://www.Samoaobserver. ws/en/01_09_2016/local/10692/ Tattooists-share-concern.html.

In the early 2000s, public health officials in New Zealand documented several cases of people suffering life-threatening infections related to Sāmoan tattooing. In one case, a 23-year-old man was diagnosed with severe, extensive cellulitis (infection of the inner layers of the skin), septic shock and acute renal failure. He required plastic surgery, and six weeks after his discharge from hospital he needed ongoing treatment.

In a second case, a 25-year-old man arrived at hospital with septic shock and multi-organ failure. He had severe cellulitis and necrotising fasciitis (a flesh-eating infection) of his tattoo and suffered infection to 25 percent of his total body surface area. He required a prolonged course of antibiotics and five surgeries to deal with the infection. After six weeks he was discharged, but required further wound management, physiotherapy, occupational therapy and counselling.[1]

Incidents like these, although rare, greatly affect everyone involved. They are life-changing and tragedies for the victims and the tufuga. In 2002, after the death of a 29-year-old man in Auckland from acute heart failure due to septicaemic shock, it was reported that the tufuga who had tattooed hundreds of people without incident had buried his tools in the garden and 'resigned forever'.[2]

Since the 1990s at least, tufuga tā tatau have been proactive in improving the health and safety of their work. This has ensured their participation in international tattooing conventions, where organisers closely monitor health standards. Today tufuga use disposable latex gloves and professional sterilising equipment. They have developed metal components for indigenous Sāmoan tools, making them easier to clean and greatly reducing the risks associated with previous technology and practices.

Public health officials emphasise the importance of pre-tattooing health checks, sterilising tattooing equipment and work spaces and meticulous aftercare. In 2010, the Ministry of Health in New Zealand, working with the Lagi Malofie Society and medical experts, published *Customary Tattooing Guidelines for Operators*. This document reminds people that any breaking of the skin's surface brings a risk of infection: 'Unhygienic practices can introduce common bacteria (bugs) such as staphylococcus into the body, which may lead to skin infection, wound breakdown or infection of the blood.' Other possible infections include hepatitis B and C, which can cause inflammation of the liver, cancer and HIV/AIDS.[3] In 2016, tufuga tā tatau met with Ministry of Health officials in Sāmoa to discuss how to prevent the spread of blood-borne diseases. They discussed protecting tufuga and their clients through measures such as blood testing, using only one set of needles per client, and inspecting tattooing premises to ensure that high standards of hygiene are maintained.[4]

Fig. 131
Newspaper billboard,
Dominion Post,
New Zealand, 2006.

On malu:
And the certainness and
definitiveness of the au

Tupe Lualua

Tupe Lualua is a practitioner of dance and theatre who has toured internationally. She is the artistic director of award-winning dance theatre company Le Moana and teaches siva Sāmoa in New Zealand. Tupe shares how the malu became part of and a vehicle for her life journey.

TATAU – 7 September 2010

'Aga kā sou malu e sili aku i le si'usi'u o le laumei gā ua kā i kua o lou ua!' This was the common response from my family in Sāmoa after seeing my fresh, abstract (at least I thought), finely detailed, contemporary artwork from the internationally renowned Sulu'ape tattoo studio in Apia, 2010. It had been sixteen years since I had last been in Sāmoa. Until that point, I had found my career as an artist, travelling the world through Pacific dance. Now an adult, I am reminded of the climate, landscape, environment, indigenous culture and Hamo 'swag' that I had fallen in love with when I had first visited at the age of thirteen. It had been a year since I was appointed as the Sāmoan dance tutor and Sāmoan community advisor at Whitireia Polytechnic in New Zealand. Still settling into the role, and sometimes overwhelmed with the immense world of Sāmoa that continuously reminded me of how much I didn't know, the thought of getting a malu had never crossed my mind. First, my father was not a matai ali'i and I therefore not a tāupou. Second, there must be some level of knowledge that is required before a tufuga even considers marking you – which is why they say 'Tā muamua le gutu'. And last, the visual aesthetic of it never appealed to me … and I really liked wearing shorts.

So when my family in Sāmoa said to me, 'Had you got a malu it would have been better, instead of a turtle's behind on the back of your neck!', for the first time the thought of possibly wearing a malu entered my mind. I asked my father several times about it and he said, 'Leai e lē manaia'. So, although I knew I wasn't going to get one right away, the seed of curiosity had been planted. Fast forward to 2013, when I was travelling as a solo performer through Taiwan, Japan and New Caledonia; I grew to understand the importance of my role as an ambassador for Sāmoa. I knew that I would devote my life to siva Sāmoa and learning about Sāmoan culture.

My reply to my cousins in 2010 was 'Ae e le'o a'u se tāupou, ma e lē lelei fo'i lo'u fa'asāmoa', to which they so boldly yet lovingly replied, 'But you're a dancer! You should be wearing it whenever you dance and you better commit to learning your fa'asāmoa! Those things come with life experience and will help you grow.'

TATAU – 10 Aukuso 2015

I arrived back in New Zealand at 1.25am on Tuesday 11 August. It was cold, it was dark, and I was wishing that I was still in Sāmoa. My thoughts and my heart remain in our makeshift, Fuī DIY extended fale in Sāvaia – built with love and accepted with gratitude. We had all travelled there from New Zealand to celebrate the life of our matriarch, to lay her in her final resting place, her home that she truly loved. For me, it had been a hectic ride, heading straight to Sāmoa after a performance season of *1918* to farewell our beloved Nana, whose vivid memories had inspired that theatre production.

After landing in Auckland, I made my way to the ladies' room to slip on my skins that I had prepacked in my carry-on. I was freezing. The blue dress that I had flown over in was the safest (and trendiest) option, the smooth texture and light swaying breeze with each movement helped to cool down my latest adornment, my malu. I had only just received it the Saturday before. Still tender, still swollen and still carrying that burning heat, I welcomed the Auckland chill and slippery coolness of my skins. But getting them on was a new journey in itself. First, I needed to go to the bathroom, so the first mission was to get my underwear off without touching the freshly tapped etchings in my skin, from the top of my thighs to below my knees. Second, to reverse that action in an upwards motion and then repeat with the skins, to fully cover my legs. The smooth material of the skins was fine but the thick elastic, rough-edged waistband and overlocked stitching, not so much; it brushed against the freshly chiselled patterns, scratching at the open wounds. As I went through this process I hear the voices of my 'āiga during the tāga pe'a; 'Mālō le sausau Su'a! Mālō lava le tā Tupe! Mālō le 'a'ao solo!' as I lay alongside the graves of my Nana, Grandfather, Uncle Sopi, Uncle Gogo and Cousin Eliapo in front of our family home.

My sister and I are the first female descendants from my grandmother to wear a malu and our father her only son to receive a pe'a. We received our malu in honour of our Nana, who had lived for 100 years, 10 months and 31 days and was the backbone of our 'āiga sā Fuī. Like the certainty and definitiveness of the au, the course of my life journey had now been carved out for me.

On sogā'imiti:
The tattooed male body

The Reverend Tavita Maliko (Congregational Christian Church Sāmoa)[1]

1.
Extract reproduced with permission from T Maliko, 'O le Sogā'imiti: An Embodiment of God in the Samoan Male Body', Doctoral dissertation, University of Auckland, 2012, www. researchspace.auckland.ac.nz.

2.
F Aiono-Le Tagaloa, *O le Fa'asinomaga: Le Tagata Ma Lona Fa'asinomaga* (Alafua, Samoa: Le Lamepa Press, 1997); G Pratt, *Pratt's Grammar and Dictionary of the Samoan Language* (4th edn) (Apia: Malua Press, 1911).

3.
Michel Foucault, 'Nietzsche, Genealogy, History' (trans. DF Bouchard and S Simon) in *Language, Counter-memory, Practice: Selected Essays and Interviews by Michel Foucault*, edited by DF Bouchard (Ithaca: Cornell University Press, 1977), 139–64.

4.
Pratt, *Grammar*, 279.

5.
Papaāli'i Dr Semisi Ma'ia'i, *Tusi 'Upu Sāmoa* (Auckland: Little Island Press, 2017).

6.
F Aiono-Le Tagaloa, *O La Ta Gagana* (Apia: Le Lamepa Press, 1996).

7.
RW Allardice, *A Simplified Dictionary of Modern Sāmoa* (Auckland, New Zealand: Polynesian Press, 1985); GB Milner, *Samoan Dictionary* (London; Wellington, New Zealand: Oxford University Press, 1966)

Sogā'imiti means children who are tattooed before they are of the suitable age of sixteen,[2] but the term has evolved into a new meaning and it now signifies any male who has a tatau.

This means there was no specific Sāmoan word for a person with a tatau, and this may be attributed to the fact that every male was supposed to acquire a tatau in pre-Christian times when he reached the appropriate age, so it was a normal rite of passage and every male was expected to go through it. The word pula'ū means a rotten taro, and it now denotes a male without a tatau; it is a humorous ridicule that implies someone with unused potential who simply rots like a useless taro instead of being harvested and used properly. Today, sogā'imiti entails such meanings as pride, masculinity, bravery and manhood.

Like many Sāmoan words that have changed meaning over time or have undergone genealogical accidents, deviations, errors or false appraisals,[3] the word sogā'imiti originally had an unfavourable and condescending meaning – it meant children tattooed before they are of suitable age,[4] or 'children tattooed before their majority',[5] but Ma'ia'i adds that the word is synonymous with seugā'imiti, which he defines as a derogatory term for minority or youth. He also has an entry for the word sogā'i which he defines as premature or unnecessary; miti means thin so the term sogā'imiti points to the derogatory labelling of a tama'i sogā'imiti tautala'ititi (young thin cheeky lad) who has taken up the tatau before his appropriate age, which is a rite of passage into adulthood for men.

Sāmoan scholar Le Tagaloa explains that part of this Sāmoan traditional ritual of tatauing for men in pre-Christian times was their learning about sexual relations with women.[6] Elderly research participants hinted that actual sexual intercourse took place between the tatau recipients and women as part of the tatauing rite, and this is one reason that younger prospects are frowned on and labelled as sogā'imiti, as they are too young to have community-sanctioned sexual relations with women – hence the term sogā'imiti. Sāmoan dictionary scholars

Allardice and Milner define sogā'imiti as 'a youth recently tattooed; this is generally the current accepted meaning in contemporary Sāmoa which now refers to anyone who wears the tatau'.[7] […]

A sogā'imiti is symbolic of the ultimate Sāmoan male: he is brave, fearless, has wisdom and knowledge, the provider and protector of his family, church, village and country. His tatau is a literal inscription of his socioreligious identity, beliefs and duties; the motifs of which are a visual depiction of his embodied life; this constitutes […] his environment, family and God […] cultural pride, beauty, bravery, ability and potentiality. In contemporary Sāmoa, not all males have a tatau, but all males are expected to live the same embodied life and have the same […] qualities as those of sogā'imiti described above, to enable them to serve their families and communities.

To tatau or not to tatau – that is the afakasi diasporic question

Selina Tusitala Marsh

At 8am we arrive in Maluafou. Marj, my dear colleague Silafau Sina Va'ai, who comes to tapua'i (nurture the relational spaces), and Dave are with me. I am greeted by Rula, Li'aifaiva's mother and Marj's good friend (hence the connection and recommendation).

Rula's hands are customarily tatooed. She encourages me to get the same as we walk to a faleo'o (small fale) in the backyard, complete with the usual fala (mats) on the floor and the unusual but welcome fans installed in the ceiling.

We put on our lavalavas before being greeted by the tufuga, Li'aifaiva, a young man in his early thirties. He thanks me for choosing him and for this honour. I thank him for being my tufuga. We have obviously been googling each other.

I show him the symbols I have an affinity with, including the gogo (the migrating tern), symbol of navigational prowess, direction and freedom. Li'aifaiva speaks about an aesthetic of balance: dark and heavy lines offset light and thin lines. The delicate lines of the gogo are used to support more substantial motifs. After learning more about me, my role in the family and my community, he suggests that the fa'atala fa'alava (octopus suction cups) serve as the border for the taulima. Once an octopus grasps their prey or desire, it never lets go. The octopus symbolises provision, tenacity, strength and determination. The vae tuli would then be placed inside the border in three different forms.

On the underside of my wrist are ten bird tracks walking to the right, and nine tracks walking to the left. As both sets reach the outside of my wrist, there appears a single gogosina (white tern) followed by two 'kissing' fish (me and Dave), designed from the original outward-facing vae tuli which are then mirrored to create something like an ichthys. Next comes the central heavy symbol of the ulutao – spearheads. This design is instantly recognisable as Sāmoan.

I'd read that it represents war, death, peace and life, and is also a tool for catching food. The tufuga, however, explains that he loves it because the layered spearheads also represent family, their mutual dependency and their collective strength.

The spearheads are oriented towards me – giving me strength. The next layer of symbol consisted of the straightened wavy lines of the ilo. On the underside of my wrist, the ilo is broken by an internal border in which fly three gogo – my sons. They are placed in that intimate space, closest to my heart. After them another band of fa'atala fa'alava appear.

I lie on the plastic-wrapped cushions and extend my left arm, which is held in position by two helpers. Not only do they stretch the skin every two centimetres at the tufuga's signal (a sped-up tapping of the plastic-wrapped wooden handles taped to single-use disposable stainless-steel tooth-combs), but they also press so hard in order to ensure a still and smooth canvas that the bruise takes weeks to disappear. Everyone wears gloves and even the inkpot kava bowl has a plastic sheath over it. Next to it sits a bottle of ink from New Zealand: 'blacker than black'.

I don't move. I can't look away. 'Look away, Selina, think of something else!' calls Sina, fanning me in the heat. But I can't. I am mesmerised by this ancient tapping, fully present in this ancient pain. It is oddly cathartic, even when the needle repeatedly strikes the paper-thin skin over the bone and on the soft underside of the wrist. I think of other kinds of pain I've gone through to be here: the ignorant and arrogant attacks on my Sāmoan identity; the earnest doubts about my cultural validity; and my final moving from pain to peace about who and whose I am.

After 75 minutes of hammer and chisel tap tap tapping 47 tentacles, 19 bird tracks, 18 spearheads, three birds, two fish and one long worm into my skin, I am done. I am welcomed into the mālōfie 'āiga – the tattooed people of Sāmoa – with an 'ava ceremony. I am served first. I tip a libation to God and, raising the half coconut shell to my lips, thank my new family, saying 'Manuia!'

My Apia-based friend Filipo, who received his mālōfie three years ago, said the next step for me is the malu. I disagree and remind him of the Sāmoan proverb: E ta muamua le gutu ae le ta le vae. Tattoo the mouth before tattooing the legs.

It makes sense to me. I would feel uncomfortable wearing such a declarative traditional statement of my Sāmoan-ness without being able to explain it or myself in Sāmoan. Filipo says that's a bull reason. He makes me feel as if I'm contradicting my own argument against cultural purity and authenticity. His tufuga, of the esteemed Sulu'ape line, said that as an artists' guild, tufuga don't have the right to turn away anyone who wants a pe'a or a malu. While tufuga are sometimes criticised for this lack of discrimination (and accused of having mercantile motives), the tatau is believed by many to be a gateway through which to learn more about one's culture – after the fact, not before it. I'm left with the words of Filipo's tufuga: sometimes a tatau marks the end of a journey; sometimes it marks the beginning.

Extract originally published in *Home: New Writing*, edited by Thom Conroy (Auckland: Massey University Press, 2017), 18–32.

TATAU

'Do you know The Rock?': Tatau and popular culture

Rachel Yates

1.
Zack O'Malley Greenburg, 'The World's Highest-paid Celebrities 2017', *Forbes*, 12 June 2017, https://www.forbes.com/sites/zackomalleygreenburg/2017/06/12/full-list-the-worlds-highest-paid-celebrities-2017/#55838bb49eca.

2.
Raymond F Betts and Lyz Bly, *A History of Popular Culture* (New York: Routledge, 2004).

3.
Michael Atkinson, 'Fifty Million Viewers Can't Be Wrong: Professional Wrestling, Sports-entertainment, and Mimesis', *Sociology of Sport Journal vol.* 19, no. 1 (2002): 47–66.

4.
Leati Anoa'i, 'Roman Reigns Explains the Significance Behind His Tribal Tattoo', interview by Corey Graves, *Superstar Ink*, http://www.wwe.com/videos/roman-reigns-explains-the-significance-behind-his-tribal-tattoo-superstar-ink.

5.
This discussion has been limited to male wrestlers, as while there are Sāmoan female wrestlers in the professional wrestling circuit, none feature tatau as a core part of their wrestling persona.

6.
Moana, directed by Ron Clements and John Musker, Disney, 2016.

7.
See Madeline Chapman, 'Hear Us Out: That "Brown Face" Maui Costume Is Maybe Okay', *The Spinoff*, 20 September 2016, https://thespinoff.co.nz/tv/20-09-2016/disneys-lose-lose-battle-with-making-a-maui-costume/.

'Where are you from?' or 'What are you?' are questions we can all relate to when abroad. I'd struggle to answer them and work through all the typical references for Sāmoa that were generally taken for granted as common knowledge in New Zealand; for me, the blank looks that would follow after I sounded out 'Sa-mo-a' several ways became a norm.

This was until an interaction with a Korean student in my class gave me the most efficient way to identify as a Sāmoan while living and working overseas.

It simply came down to the question, 'Do you know The Rock?' – and, just like that, whomever I was speaking with had an instant reference point for Sāmoa and Sāmoans. Dwayne 'The Rock' Johnson, who is of Sāmoan and African-American descent, is one of the biggest superstars of our generation and currently one of the highest paid actors in Hollywood.[1] He has maintained a huge following from his time as a professional wrestler with World Wrestling Entertainment (WWE). Through The Rock, I now form an instant connection with people because of our shared knowledge of him. We would imitate his signature moves: the eyebrow, elbow and his classic phrase 'If you smelllll lalala what The Rock … is cooking?' More often than not, we would move on to a discussion about The Rock's Sāmoan- and Polynesian-inspired tattoo.

The term 'popular culture' refers to mainstream media and the cultural products that are commercially produced for and consumed by large audiences.[2] The professional wrestling scene is part of this milieu – a multimillion-dollar industry broadcast all over the world, accompanied by mass-produced licensed merchandise.[3] The athletic drama that unfolds on a weekly basis transcends languages, cultures and socioeconomic backgrounds, and consistently draws over fifty million viewers of all ages. The popularity of Sāmoan tatau among Sāmoan professional wrestlers makes tatau visible to this global audience, and it serves as a distinct visual representation of Sāmoan people. For many non-Sāmoans, it's a core – and even solitary – reference for Sāmoan culture.

In this far-reaching WWE arena we see Sāmoan men display their identities through tatau, and the intertwining of personal cultural heritage and professional wrestling personas. Recent superstars of WWE include the late Umaga (1973–2009), who was heavily tataued, the successful tag team duo of The Usos, and World Heavyweight Champion Roman Reigns, who describes his tatau as being on trend, of cultural importance and symbolic because the site of his tatau (on his arm) is representative of his profession allowing him to provide for his family.[4] Fans of WWE engage with these images and ideas and form their own understanding of what Sāmoans are. The students in my class understood that Sāmoans had culturally significant tattoos, were predominantly 'brown' in appearance – and they believed we were all 'strong' and 'very big' people. These superstars therefore contribute to common perceptions of the Sāmoan male,[5] and are examples of the complex ways in which culture can be commoditised, marketed and consumed.

The influence and commodification of tatau is not limited to WWE; it is present across many sites of popular culture. We see tatau in popular music videos, video games, movies and in the realm of professional sports. In 2016, multinational mass media company Disney released *Moana*, a blockbuster movie that features tatau.[6] The film attracted criticism from academics, politicians and Pacific people across the region. The merchandise released to promote the film included a full-body suit of Maui with brown skin covered in tattoos that was quickly pulled from Disney after public outcry and accusations of 'brownface'.[7] Interestingly, the demigod character Maui, voiced by The Rock, is said to have been inspired by his grandfather and Hall of Fame wrestler Peter Maivia – a high chief who was noted for his sogā'imiti (flying fox pe'a) throughout his career.[8]

As evident with professional Sāmoan wrestlers, the globalisation of tatau is entangled within commerce and identity. The reach of mainstream media and the wealth of tatau imagery dominates people's knowledge and perspectives of Sāmoans. In hindsight, while I was meeting people abroad as a non-tattooed, female Sāmoan of mixed heritage, by using The Rock as a quick reference point, I most likely unwittingly reinforced preconceived ideas of Sāmoans. The presence of tatau within popular culture is layered and complex yet powerful in the way in which it can inform people's understandings of Sāmoan culture.

8.
Kelly McCarthy, 'Dwayne "The Rock" Johnson Shed "Manly Tears" During "Moana"', *ABC News*, 21 November 2016, http://abcnews.go.com/Entertainment/dwayne-rock-johnson-shed-manly-tears-moana/story?id=43680580.

Fig. 132
Hall of Fame wrestler Peter Maivia fights World Wide Wrestling Federation Champ Bob Backlund at Madison Square Garden in 1979. Maivia is the grandfather of Dwayne ('The Rock') Johnson.

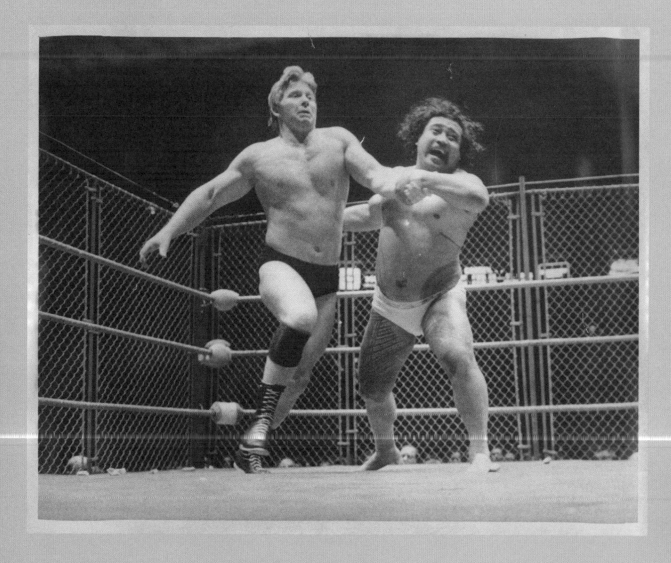

287

Fashion and tatau appropriation: Flattering or offensive?

Sonya Withers

1.
Susanne Kuchler and Graeme
Were, *Pacific Pattern* (London:
Thames and Hudson, 2005).

2.
Sean Mallon, *Samoan Art and
Artists, O Measina a Samoa*
(Honolulu: University of Hawai'i
Press, 2002), 111.

3.
https://www.freshness-
mag.com/2013/07/31/
nike-tattoo-tech-for-women/.

4.
https://www.change.org/p/nike-
cease-the-production-of-the-ni-
ke-pro-tattoo-tech-tights.

5.
Sean Mallon and Pandora
Fulimalo Pereira, *Pacific Art Niu
Sila: The Pacific Dimensions of
Contemporary New Zealand
Arts* (Wellington: Te Papa Press,
2002), 71.

Before Europeans began voyaging into the Pacific, Sāmoans were already pushing the boundaries of fashion beyond what is seen on the international catwalk today by appropriating their own skin in creating a 'fashion' of identity. Similar to body adornment and wrapping ourselves in cloth, these 'fashions' are centred on the social design of the body.[1]

The first Europeans to see Sāmoan tatau were so intrigued by these body markings that they misread them as externally worn artworks. In the early 1700s when Europeans first visited the Sāmoan Islands, a crew member on board one of the three Dutch ships commanded by Jacob Roggeveen described Sāmoan tatau from afar: 'they do not paint themselves … but on the lower part of the body they wear artfully woven silk tights or knee breeches'; it wasn't until closer inspection that they realised these 'silk tights' were in fact the wearer's own skin. As European contact increased in the 1800s, sailors adopted tatau fashion on their own skin – including US sailor Mickey Knight and, later, runaway convicts and sailors who had abandoned ship and remained in Sāmoa.[2]

Recently there has been a similar emergence of tatau in the fashion industry. In 2013, Nike released a new range of women's wear that featured their advancement in technical sportswear: Dri-FIT. Dri-FIT was designed as a high-performance microfibre polyester fabric that allows sweat to be removed from the body by evaporating through the fabric surface. Nike attempted to decorate this range with tatau motifs, described by one fashion magazine as 'tattoo art from the South West Pacific – highlighted by the island nations of Fiji, Sāmoa and New Zealand'.[3]

Unfortunately it did not occur to Nike that tatau is already a form of body, spiritual and social enhancement advanced by the indigenous peoples of the Pacific or that the particular tatau appropriated for their women's wear are actually reserved for men – particularly those who serve the matai. From a Sāmoan design perspective, if Nike had engaged in talanoa consultations with prominent tatau experts maybe they could have identified the cross-cultural and technological body enhancements that both tatau and Dri-FIT represent. The potential for a cohesive collection that would be visually correct and equally recognise the values in Pacific people's knowledge systems through an ethical creative process would benefit both sides immensely – especially within the design world. After much backlash on social media and petitions,[4] Nike eventually removed the range.

Sāmoan designers were experimenting with tatau and the body through fashion long before Nike tried it. Louis Fesolai and his wife were among the first Sāmoan designers to produce fashion similar to the 'silk tights' described by early Europeans. Noted for their use of tatau icons on puletasi and aloha wear, the couple presented at the first Fashion Pasifika show in 1998: their entry transcended the culturally significant form of pe'a through a different medium other than skin in the style of a painted Lycra body suit.[5] Prominent Sāmoan couture designer Lindah Lepou's Pacific heritage informs her beaded body-suit 'Le Tatau'. Like our Polynesian ancestors, Lindah's creative vision utilised the entire body as a canvas to reveal the intricacy and respect of tatau. Her careful beaded work and persistent process of handcraft invites us to lean in and navigate the patterned body.

Today designers of local island wear are taking advantage of the emerging print production market. One could suggest that Nike's attempts provoked a mass production of tatau printed fashions through Sāmoan designers to reclaim, commercialise and experiment with tatau through new digital resources – this time beyond the canvas of skin. Family businesses such as United States-based Tatau brand and Australian-based Jandal Broz produce basketball shirts, hoodies, T-shirts and babywear that fuse tatau aesthetic through garment-specific

printing. Each piece is extremely bold and colourful in its representation of Pacific heritage and the range is popular among the Pacific diaspora. It is naturally embraced by our own people, but there are some who also point to the risks of internal appropriation (within the culture) and its threat to the respect that surrounds tatau.

However, the perspective of this afakasi (part-Sāmoan, part-European) Sāmoan textile designer is that if we don't embrace the new resources emerging in the garment industry we risk losing the value of our identity to non-Pacific designers. Like our ancestors before us, it is in our gafa (genealogy) to advance the fashioning of our identity through new resources in order to continue the journey of tatau. It will be interesting to see how tatau will advance through fashion in the next decade.

Fig. 133
A baby's onesie outfit
by Tatau Brand.

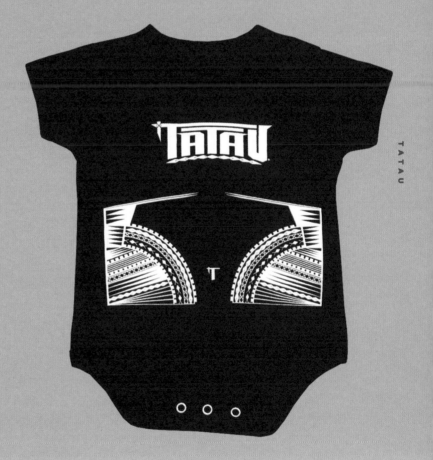

TATAU

Tatau: The cultural continuum

Sean Mallon
Auckland, 17 August 2017

Tyla Vaeau Ta'ufo'ou is a tufuga tā masini based in Auckland, New Zealand. She is one of a few Sāmoan women, if not the only one, actively working with tatau motifs. She talks about her journey and learning her trade.

SM: What is your family connection to Sāmoa?

TT: I have Sāmoan heritage through my father's side. My grandfather migrated to New Zealand from Sāmoa in the 1950s. His mother was from Sale'a'aumua, Aleipata and his father was from Safune, Savai'i.

SM: How long have you been tattooing?

TT: I have been tattooing since 2009. Growing up, tattoos were a visible part of my everyday life as my dad is heavily tattooed. I've been drawing for as long as I can remember and tattooing felt like a natural progression, a development from my art practice and research. While I was at college I became really interested in the pe'a, malu and taulima, their history and significance, and I began designing tattoos for family and friends. After college I went on to complete a BFA at Elam School of Fine Arts and a BA in art history. Tatau remained a constant theme throughout my studies. I designed a piece for my uncle in Wellington which he took to the late Roger Ingerton to tattoo. I was able to sit in on these sessions, photograph the process and chat with Roger about tattooing. In 2008 my husband had another of my designs tattooed by Roger; during this session he allowed me to do some of the shading. Roger was really encouraging and I'm really grateful for the time I had with him. My dad was also supportive and helped me get the equipment I needed to start and was my first guinea pig! I'm largely self-taught, which is not an easy road to take, but I've received a lot of support, encouragement and guidance from my family and a number of tattoo artists I've met along the way.

In 2011 I met Su'a Sulu'ape Alaiva'a Petelo while he tattooed my friend Falaniko Tominiko and his brother. Su'a knew I was a tattoo artist and I would sit in on the sessions often. Although we had spoken it took me two weeks to build up my courage to ask him if he would consider teaching me the 'au. I was overwhelmed and honoured when he agreed. Later I watched him tā a malu and it was during this session that he gifted me one of his 'au. It was an empowering moment and set me on a path towards learning our sacred tatau method.

The journey to learn the 'au is ongoing. In 2017 I went to Samoa and received my malu from his son Su'a Sulu'ape Paul Junior which was an important step for me as a practitioner, apprentice and tamaita'i Samoa. I'm working towards the day I'm able to serve our people, particularly our women, with this treasured art form.

SM: How would you describe your style? What inspires your work?

TT: I would describe my style as contemporary, however it is very much inspired by the malu and pe'a. I reconfigure ancient patterns into contemporary designs using modern techniques to tell the wearer's story. I also reference designs from siapo mamanu (freehand painted barkcloth) and occasionally include naturalistic renderings of flowers, 'ava bowls and other symbols of significance to the recipient. I'm inspired by our heritage artforms and the innovation and creativity found throughout the Pacific and the diaspora. More recently I have been inspired by the old Western-style 'sailor tattoo' and the archetypal hula girl. I've been redrawing the 'hula girl' as more culturally specific Pasifika women wearing adornments from their island groups. I've

done some of these women as tattoos and I've been thinking about how this style can be used to tell our own stories.

SM: What have been some of the challenges?

TT: It can be challenging to see our designs misappropriated or reproduced by non-Sāmoans without any understanding of the historical and cultural context they come from. This is an ongoing issue not only for Sāmoan tatau but also for indigenous tattoo practices globally. Thanks to Google our markings are only a click away, and quite often they are mislabelled or mashed together with other designs from across the Pacific. Because of this, education is an important part of my practice. I strive to be a culturally responsible artist and to treat our designs with respect. People just assume that my husband is the tattooist when we're at conventions. However, tufuga tā tatau and other male tatau artists I've met have been open and accepting, which is really heartening.

SM: What have been some of the rewards?

TT: It's incredibly rewarding to be able to connect or reconnect people with their cultural heritage. I enjoy collaborating with people, hearing their backgrounds – which so often are shared experiences – and translating them into patterns worn in the skin. To be able to play a part in the cultural continuum of Sāmoan tatau is an honour and a privilege I don't take for granted.

Fig. 134
Tyla Vaeau Ta'ufo'ou in
2017. Photographed by
Pati Solomona Tyrell.

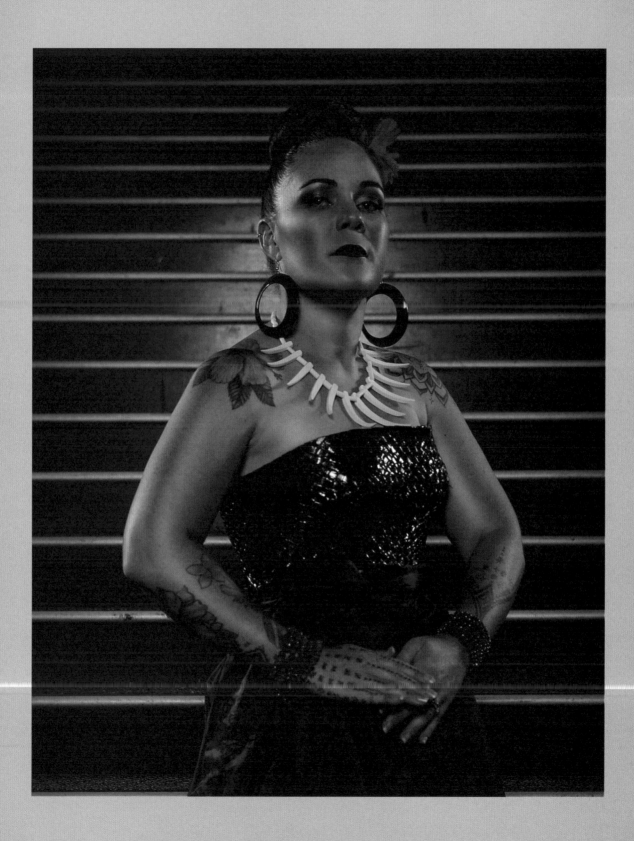

Tattooed bodies in contemporary art

Nina Tonga

1.
http://www.angelatiatia.com/work.

Since the 1980s the presence of tatau in contemporary art in New Zealand has taken many forms; it has been brushed across canvases, etched into stone and wood, and captured on film and video. Within the visual vernacular of contemporary Sāmoan artists the rich symbolism of tatau was often overlaid with the artists' personal meanings and metaphors.

For many Sāmoan artists who wear tatau, their engagement is mediated by their own tattooed bodies. Greg Semu's seminal self-portraits taken a year after receiving his pe'a in 1994 are emblematic of the ways in which artists are presenting their own tattooed bodies as the subject and object of their works. This artistic gesture reveals an inherent duality where the representation of tatau is autobiographical, serving as a cultural signifier and as a symbol of cultural identity.

Navigating this contested terrain is Australian-based Sāmoan artist Angela Tiatia, who utilises her body as a political tool to confront and challenge the representation and commodification of the body and place. In her ongoing work *Inventory of Gestures*, Tiatia has created a series of moving-image works that explores the tensions that operate between mass global culture and minority groups.[1] Each of her works employs a simple performative gesture that confronts, and in some cases renders visible, conflicting norms placed on female bodies.

In her moving-image work *Walking the Wall* (2014), Tiatia dons a pair of black heels before lying on the ground with her feet propped up against a wall. With her gaze fixed at the camera she begins to scale the height of the wall through small steps similar to those adopted in siva Sāmoa (Sāmoan dance). The most controversial feature of this work was her choice to wear a black bodysuit that deliberately exposes her malu (female tattoo). Tiatia's work prompted online debate among Sāmoan communities for whom there is a well-established understanding that the malu should not be displayed in public outside of ceremonial contexts.

While her performance was read by many as an act of cultural defiance, it is also useful to read it as a form of feminist critique addressed at the type of femininity and beauty that mass consumerism promotes. Her choice of dress, free-flowing hair, a body suit, black high-heels and the presence of her malu are powerful symbols that collectively evoke a number of associations around the presentation of women's bodies as exotic and alluring, inviting a voyeuristic gaze. Disrupting these pervasive connotations is Tiatia's gaze, confronting the viewers by looking directly at the camera. Her powerful stare and the physicality of her actions suggest that her work is also a form of endurance, her steps constantly navigating the unwieldy tensions between her body as a fetishised object and her identity as a Sāmoan woman.

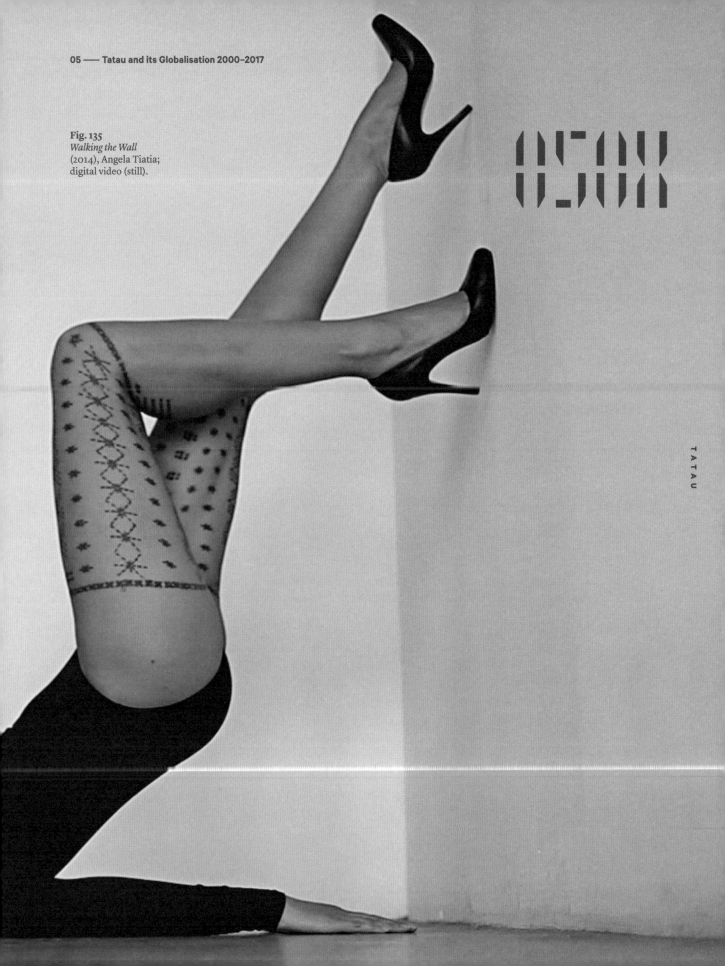

Fig. 135
Walking the Wall
(2014), Angela Tiatia;
digital video (still).

TATAU

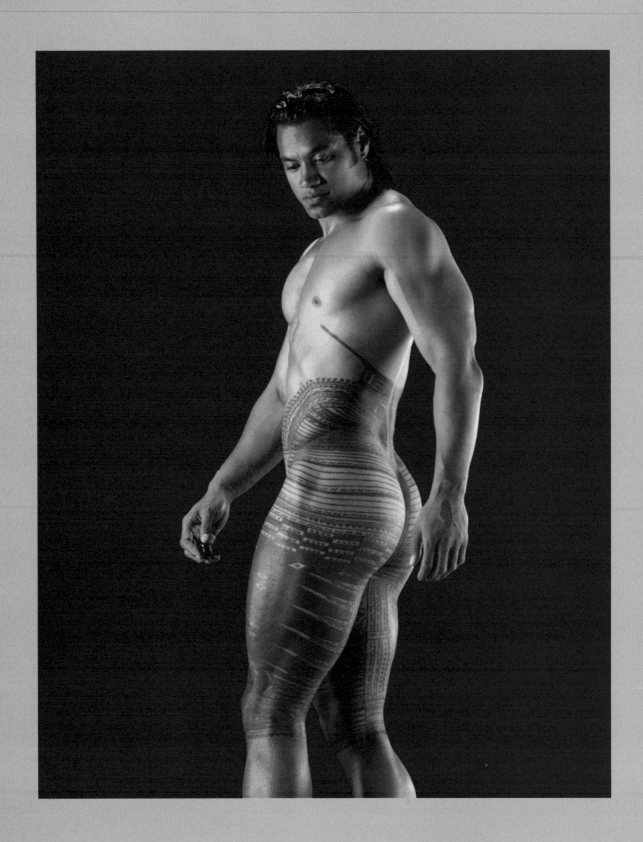

TÀTAU

Genealogical bodies and luminous beings: Those who are not tattooed and those who are

Leali'ifano Albert L Refiti

I have always been puzzled by some aspects of Sāmoan culture where the ali'i pa'ia (paramount chief) and his tamāali'i (children) were exempted from being tattooed. Otto von Kotzebue in 1824 described seeing an ali'i pa'ia, who has been identified as Leiataua Tamafaigā, with a finely plaited mat hanging from his shoulders and wearing a girdle, but who was not tattooed;[1] and Reverend John Williams observed that Mālietoa Vaiinupō, the paramount ruler of Sāmoa in 1830, was not tattooed[2] – unlike most Sāmoan men.

This is consistent with the idea that high-ranked ali'i were not tattooed[3] because they embodied a certain kind of 'luminosity' or pa'ia (sanctity) that drew people to their presence.[4] The ali'i pa'ia and his descendants, the tamāali'i, exuded a presence that a tattoo would obscure. This impersonal aura required the protection of something other than a tattoo, which is why in Sāmoa, the tamāali'i were confined to the interior of the faletele during daylight hours.[5]

The Sāmoan tatau conveyed a particular kind of subject: the patterning and markings of a pe'a or malu allow the person's soul to be thrown on to the surface of the body in a demonstration of their commitment to serving the community. The tattooed person therefore must always perform his or her tautua or duties: the pattern they wear is a kind of genealogical guarantee that they are malu (protected) by wearing the tatau.

Luminous bodies cannot help but exude the charisma of divine ancestors and, in return, they are trapped by their pa'ia status making them tapu. This means that they are kept from coming in contact with the normal population, who must avert their gaze when in the presence of an ali'i pa'ia. The tatau, on the other hand, marks and wrings the body of its essential nature and forces it to bleed the genealogical self to the surface so that it can be identified and seen.

The concept of sanctification of bodies through being tattooed is still reinforced by some tamāali'i families today; for example, Tui Atua Tupua Tamasese's family prevented him from getting a tatau some years ago. When I was a teenager, my grandmother forbade me and my brother from getting a tatau because of her observance of our tamāali'i status – a tapu that we still observe today. This has not stopped my younger sister Leute-ole-tifa-o-A'ana, who is the tāupou for the Aiono Fa'apologaina's family in Fasito'outa, from getting her malu. It is a practice that has become not so much an expression of one's duties to the community but rather the performance of one's fa'asāmoa identity in the diaspora.

1.
O von Kotzebue, *A New Voyage Round the World, In The Years 1823, 24, 25, and 26, Volume 1* (London: Henry Colburn & Richard Bentley, 1830).

2.
R Moyle (ed.), *The Samoan Journals of John Williams, 1830 and 1832* (Canberra: ANU Press, 1984).

3.
A Gell, *Wrapping in Images: Tattooing in Polynesia* (Oxford: Clarendon Press, 1993).

4.
Serge Tcherkézoff, 'First Contacts in Polynesia – the Samoan Case (1722–1848): Western Misunderstandings About Sexuality and Divinity', 2008, (Canberra ANU Press, 2008).

5.
AL Refiti, 'Whiteness, Smoothing and the Origin of Samoan Architecture', *Interstices: Journal of Architecture and Related Arts* 10 (2009): 9–19.

Fig. 136
Former Manu Samoa rugby player, Lome Fa'atau.

TATAU

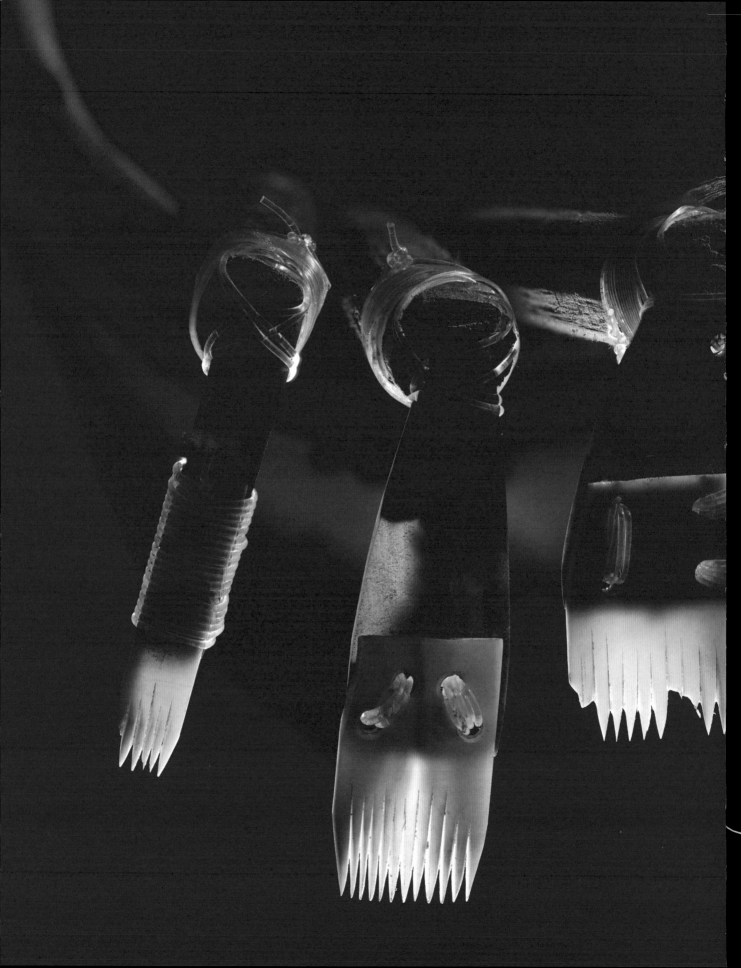

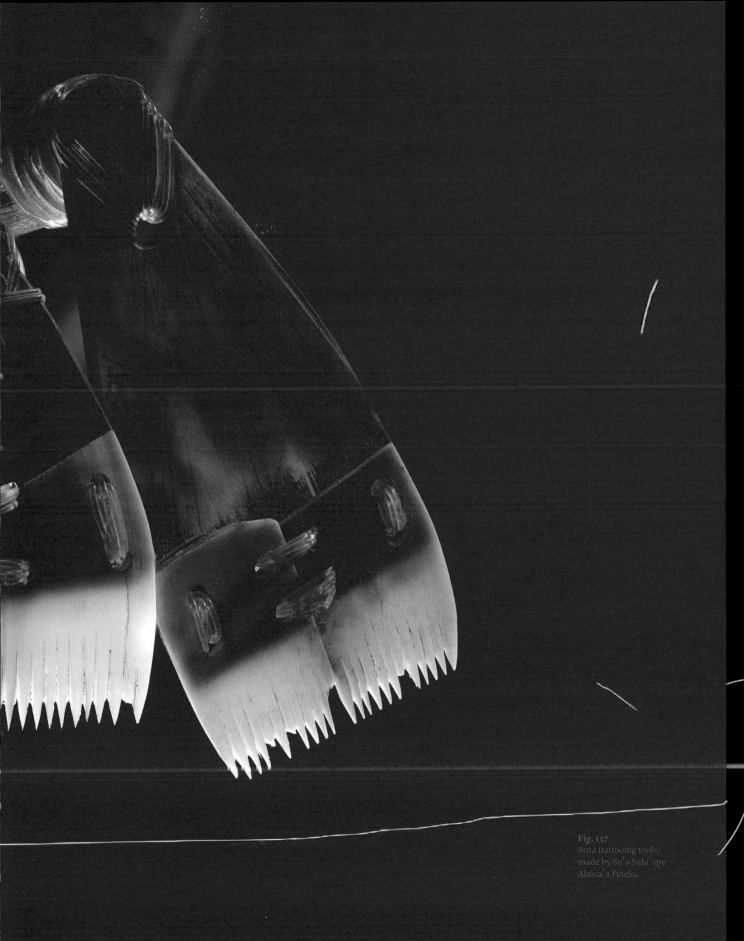

Fig. 137
Autà (tattooing tools)
made by Su'a Sulu'ape
Alaiva'a Petelo.

POSTSCRIPT

One of the stereotypes associated with tatau is that knowledge of the practice and the meanings of its designs are handed down intact and unchanged from generation to generation. But the history of tatau has in fact been one of both continuity and disruption, with social, cultural and technological change coming from within Sāmoan society as much as from the outside world.

This book's closing chapter, on the processes of globalisation, demonstrates how Sāmoan tatau was 'de-territorialised' and reinterpreted in many locations, and how Sāmoans have been active agents in these developments. Considering Sāmoan tatau as a global phenomenon is not to suggest that it is everywhere in the world. Rather, it is disembedded from one particular place, but it is also local in the sense that it is perceived and interpreted locally. Tatau means different things to a non-Sāmoan than to a Sāmoan, and has a range of meanings again even among Sāmoans.

The arguments about the effects of the globalisation of culture usually fall into two camps: it is a process that will either make all people the same or all people different. The situation is actually somewhere in between. The globalisation of tatau can be best understood as a simultaneous process of homogenisation and heterogenisation. There is a tension in the way people and cultures become more similar, but also in how they strive to maintain their differences. People attempt to hold on to distinctiveness in some ways and to find commonality and sameness in others. Ironically, the blurring of boundaries between places and localities somehow makes the ideas of culturally and ethnically distinct places more important and relevant.[1] The main point is that the globalisation of cultural phenomena like tatau does not mean that the world is becoming culturally uniform or homogeneous. Rather it suggests, '... "cultures" and "peoples" however persistent they may be, cease to be plausibly identifiable as spots on the map'.[2]

This argument doesn't reassure people who are aware of Sāmoa's history of colonisation and cultural loss, or feel they are still experiencing unwelcome aspects of these processes. But for Sāmoans concerned about losing tatau to non-Sāmoans, the task of taking tatau back from the world is impossible. The reality is that tatau is out there circulating on global cultural flows; it is irretrievable. Nonetheless, it is remarkable that tatau has persisted as an important cultural practice and has transformed to continue to meet the changing needs of Sāmoan people. In the face of globalisation a useful focus could be on ensuring the continuity of ceremonies and cultural practices where tatau has most meaning for Sāmoan people, while acknowledging that these contexts will change, too, just like the lines, motifs and meanings of tatau. This is why this book is far from the last word on Sāmoan tatau. There are other histories to be written and other stories to be told – of individual tattooists, tattooing families and tattooed people, of tattooing studios, tattoo conventions and groups such as the Mālōfie association.

The drawing of the Statue of Liberty on the walls of a tattooing shed in Apia in 2002 may have represented many things: an image of a famous statue, the 'Americanisation' of cultural forms so often associated with globalisation, or perhaps ideas about liberty and the ideals of American life. However, walking out of a tattooing shop in downtown Apia with a red rose on your shoulder can also represent many things: a favourite flower, a new love interest, or the freedom to make choices about what is relevant to you, to be locally grounded in Sāmoa and globally connected at the same time.

1.
Akhil Gupta and James Ferguson, 'Beyond "culture": Space, Identity, and the Politics of Difference', *Cultural Anthropology* vol. 7. no. 1 (1992): 6–23, pages 10–11.

2.
Gupta and Ferguson, 'Beyond "culture"', 10.

TATAU

Sāmoa and the Pacific

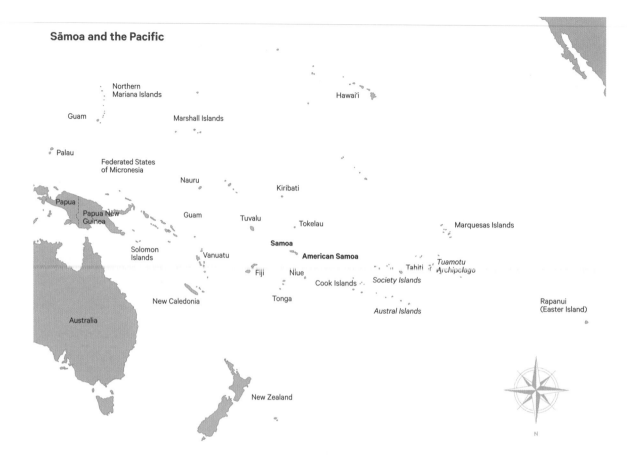

Northern Mariana Islands
Guam
Palau
Federated States of Micronesia
Nauru
Papua
Papua New Guinea
Solomon Islands
Vanuatu
Fiji
Australia
New Caledonia
New Zealand
Guam
Tuvalu
Tokelau
Samoa
American Samoa
Niue
Cook Islands
Tonga
Kiribati
Hawai'i
Marquesas Islands
Tahiti
Tuamotu Archipelago
Society Islands
Austral Islands
Rapanui (Easter Island)
N

Sāmoa's eleven political districts

Samoa

American Samoa

Savai'i

Manu'a Islands
Olosega
Ofu
Ta'ū
Tutuila
'Upolu

*Map not drawn to scale.

Key settlements (•) and landmarks (▲)

Savai'i

'Upolu

Tutuila

Aunu'u

1 Vaisigano	**11** Va'a-o-Fonoti	**21** Salelologa	**31** Mālua	**41** Mt Tafua Upolu	**51** Pago Pago
2 Gaga'ifomauga	**12** Vaotupua	**22** Tafua	**32** Āpia	**42** Mt Siga'ele	**52** Aūa
3 Gaga'emauga	**13** Papa	**23** Sili	**33** Laeli'i	**43** Mt Fiamoe	**53** Pagai
4 Fa'asaleleaga	**14** Āsau	**24** Tāga	**34** Fusi	**44** Fito	**54** Aunu'u
5 Palauli	**15** Ā'opo	**25** Faletoa	**35** Falevao	**45** Āfao	**55** Leulofo'oleva
6 Satupa'itea	**16** Sasina	**26** Samata	**36** Sāmusu	**46** Leone	**56** Olotele Mountain
7 Aiga-i-le-Tai	**17** Safotu	**27** Falelima	**37** Lotofaga	**47** A'oloaufou	**57** Taumata Peak
8 A'ana	**18** Patamea	**28** Maugaloa	**38** Poutasi	**48** Faleniu	**58** Mt Le'ele
9 Tuamasaga	**19** Pu'apu'a	**29** Silisili	**39** Fusi	**49** Nu'uuli	**59** Matafao Peak
10 Atua	**20** Sāfotulāfai	**30** To'iave'a	**40** Matāutu	**50** Faga'alu	

ACKNOWLEDGEMENTS

SÉBASTIEN GALLIOT

Since 2001, my research about Sāmoan tattooing has been supported by a doctoral grant from the École des Hautes Études en Sciences Sociales. Additional and post-doctoral fieldwork funding was provided by the Centre for Research and Documentation on Oceania, the Observatoire Nivea-CNRS, the Musée du Quai Branly-Jacques Chirac and the LABEX 'Creations, Arts et Patrimoines'.

I would like to thank my dear mother for her unwavering support. My warmest thanks also to Chantal Dang Van Sung for her caring presence and patience in the hard and good times of life, travel and fieldwork.

My warm thanks and recognition go to the many people in Sāmoa, New Zealand and Europe who allowed me into their homes, showed me their skills, taught me how to speak Sāmoan and how to behave, and eventually made this book possible: Serge Tcherkézoff; Pierre Lemonnier; Loli Misitikeri ma lona ʻāiga; Vengie and Sueina Lokeni; Suluʻape Alaivaʻa ma lona ʻāiga; Suʻa Laʻai; Tuifaʻasisina Peni; Pio Faʻaofonuʻu; Vaipou Vito; Lesa Moli Tusiʻofo; Lau Asofou Soʻo; Greg Semu; Malagamaʻaliʻi Fosi Levi; Liʻaifaiva Imo Levi; Fiu Iosefa ma lona ʻāiga; Lawrence Ah Ching; Brent McCown; Faʻalavelave Vitale, Colin Dale; Lars Krutak; Matthias Reuss; Massimo Diomedi; Fuatino and Mike Fradd; Areta and Veronique Aukuso, Kori and Louison; Julien Clément; Steven Ball; Briar March; and Richard Moyle. My apologies to those I may have forgotten.

SEAN MALLON

My writing on Sāmoan tatau had its beginnings in a research project, 'Tatau/Tattoo: Embodied Art and Cultural Exchange', led by Nicholas Thomas. It was supported by grants from the Arts and Humanities Research Board (now Council) (2001–05) and the Getty Grant Program, now the Getty Foundation (2002–04). Since the conclusion of this project, the Museum of New Zealand Te Papa Tongarewa has supported this research. Niko Besnier supervised my Masters thesis on this topic.

My thanks to the following people for the many and varied contributions they made to this work: Mark Adams, John Agcaoili; Su'a Tavui Pasina Iosefo Ah Ken; Safua Akeli; Lisa and Elisara Ala; Courtney-Savali L. Andrews; Father Anthony Brown; Ron Brownson; Peter Brunt; Tony Brunt; Eteuati Ete; Uili Fecteau, Jeroen Franken; Sulu'ape Freewind; Brigitta Grevel; Roger Ingerton; Takahiro Kitamura; Terry Koloamatangi Klavenes; Lars Krutak; Cole Lemalu; Malagama'ali'i TF Levi; Matt Lodder; Sulu'ape Si'i Liufau; Sulu'ape Steve Looney; Vanessa Masoe; Steve Ma Ching; Mike Fatutoa; Alexa Masina; Noel McGrevy; Dan Taulapapa McMullin; Tauili'ili Watti Mika; Sulu'ape Pili Mo'o; Pat and Kat Morrow; Claire Murdoch; Sulu'ape Keone Nunes; Rene and Carina Persoons; Benoit Robitaille; Henk and Louise Schiffmacher; Philipp Schorch; Greg Semu; Inipeni Simanu; Reverend Sio; David Sulu'ape; Su'a Sulu'ape Paulo II; Su'a Sulu'ape Paulo III; Su'a Sulu'ape Peter; Su'a Sulu'ape Alaiva'a Petelo; Joseph Seupule; Sulu'ape Uili Tasi; Tuigamala Fugamaivasa Saveatama Andy Tauafiafi; Sapphire Aitcheson; Sulu'ape Inia Taylor; Sulu'ape Michel Thieme; Nicholas Thomas; Michel Tuffery; Fuimaono Norman Tuiasau; Mele Wendt; Zanto and Jackie Zandbergen.

Thanks also to Sanele and Telesia Afoa, Stephen and Cathy Penn-Ruscoe and Lily Mallon for hosting me in Sāmoa, London and Amsterdam respectively; my grandfather Afoa Ioane Mauga (1914–2005); my late wife Teresia Teaiwa (1968–2017), and my sons Manoa and Vaitoa.

Thank you also to the New Zealand History and Pacific Cultures teams at Te Papa; Martin Lewis, Christine Kiddey and Mary Smart from Te Papa Library; and Nicola Legat, Claire Gibb and Estelle Best from Te Papa Press.

GLOSSARY

'afa sennit cord

agaiotupu sovereign's attendant, master craftsman

'āiga extended family

aigofie wrestling / club fighting contest

'aiuli to play the clown and draw attention to a more important performer

aitu ghost or spirit

alagā'upu proverb

ali wooden or bamboo headrest

ali'i chief

ano le tua drawing the first line of a tattoo

ao a paramount title

apisā special house for tufuga and / or for tātatau

'asofa'aifo abdominal tattoo designs

'atoau basket containing tattooing tools

au, autā tattooing tool

au mono tattooing tool (narrow)

au sogi 'asofa'aifo tattooing tool (for curved lines)

au sogi 'asosasa'o tattooing tool (for straight lines)

au tapulu tattooing tool (for large dark areas)

aualuma village association of unmarried women

'aumāga village association of young or untitled men

'autāpua'i group which supports tattooing through silent prayer

'autufuga the tattooing work group

auvili pump crankshaft drill used to make holes

'ava beverage made from kava root

fa'aaloalo respectful address / courtesy

fa'aila small window-like tattooing designs that frame motifs and skin imperfections

fa'alupega ceremonial address for titles of a village or district in order of precedence

fa'amāsei'au ritual public deflowering (depriving a woman of her virginity)

fa'amo in the form of a letter M

fa'anu in the form of a letter N

fa'apapālagi the European way

fa'asā taboo, proscriptive rules

fa'asāmoa the Sāmoan way

fa'atupe in cash

fa'au'ua anoint with oil

fagu coconut shell drinking vessel

fala mat woven from pandanus leaf

fale house

faleo'o small fale / house

faletele large and usually round-shaped house

fesoasoani partnership during tattooing ritual

fofō medicinal massage

fono conference / meeting or council

Fono a Faipule council of district representatives to the colonial administration

fue.................................ceremonial flywhisk

fufulu pe'a...................washing the tatau/pe'a

fusitā...........................presentation of 'ie tōga

gafa.............................lineage

'ie lavalavacloth worn around waist

'ie tōga........................hand woven ceremonial fine mat made from pandanus leaf

'igōa ipu......................named cup for ceremonial 'ava drinking

ilāmutu........................descendant of the female founding ancestors

itūmālōvictorious clan

itūvāivai......................defeated clan

lamatattooing pigment made from candlenut soot

lama kalesenitattooing pigment made from kerosene soot

lama sāmoa.................tattooing pigment made from candlenut soot

lama'avea....................changes in the properties of pigment

lātū o le faiva...............formal term for a master craftsman or expert

lavalava.......................cloth worn around the waist

lotu Tōga.....................the Tongan form of Christian worship (Wesleyanism, later known as Methodism)

lulu'uga.......................ceremonial breaking of a gourd containing coconut water or the contents of an egg over the head of a newly tattooed person

malae..........................the central ceremonial area of a village

malaetā.......................ceremonial ground for tattooing

malaga........................a travelling party or group

mālōfie........................formal term for a completed pe'a or malu

maluwomen's tattoo

mamanu......................freehand-rendered patterns or motifs

mānaia........................son of a chief or leader of the 'aumāga

masini tā tatauelectric tattooing machine

mataititled head of a family

mātaisau.....................craftsman; carpenter

matapule.....................(Tongan term) ceremonial attendants similar to Sāmoan tulafale

matua o faiva...............senior craftsman/expert

meana'i tāua...............spouse of the tattooist

moheofo......................(Tongan term) the ranking wife of the Tui Tonga

momoli........................a special presentation of food made to an expert craftsman/tattooist

nifo pua'aboar's tusk

nofotānea woman residing in her husband's household

'oloa............................goods, trade goods; wealth

papālagi / pālagi........European

pāpāhigh-ranking chiefly titles

papala.........................wound

pa'ū le mālōfie
tu'itu'i mālōfieformal language terms for the process of tattooing

pe'amale tatau

pe'amutu....................incomplete tattoo

pe'apisikoa.................Peace Corps tattoo in the form of a wrist or armband

pōulanight dance

puletasi......................a woman's two-piece garment consisting of a lavalava and blouse

punialo..........................triangular tattoo
design applied to lower
abdomen and pubis

pute...............................navel

sā...................................indicates extended
kinship of a group
or family

sama.............................mixture of ground
turmeric and coconut
oil

samāga pe'a..................anointing ceremony
for the tattooed person

saofa'i...........................title bestowal

sausau..........................striker, mallet

siapo.............................barkcloth

siapo mamanu...............freehand decorated
barkcloth

sigano...........................male flower of the
pandanus plant

siva...............................dance

sogā'imiti......................tattooed man

solo...............................wiping cloths, person
who wipes the
tattooing wound

sua................................special presentation
of food to chiefs

suafa matai...................chiefly title

suafa tā pe'a.................tattooing titles

suli................................successor

su'isu'i..........................to be sewn or stitched

Tafa'ifa.........................sovereign, king

tāga..............................tattooing operation

ta'inamu.......................mosquito net

talalaupaongo...............thorned edge of the
pandanus leaf

talie...............................tropical almond tree
(*Terminalia catappa*)

tapa..............................barkcloth

tāpafua.........................to be without a 'ava
title

tāpua'iga......................act of worship, church
service

taualuga.......................special final dance
performed by a taupou

taufalemau....................master of ceremonies
(during the tattooing)

taufolo..........................a special dish made
from breadfruit paste

and coconut

taule'ale'a / taulele'a.....untitled man / untitled
men

taulima.........................armband or wristband
tattoo

taumafa 'ava................kava ceremony

tauvae..........................anklet tattoo

tāupou..........................daughter of village
high chief

tautua...........................service to matai

toso...............................skin stretcher
(assistant to tattooer)

to'oto'o..........................ceremonial staff used
by tulāfale

tufuga fau fale..............master carpenter

tufuga tā tatau.............master tattooist

Tui Tonga.....................(Tongan term)
paramount chief or
king

tulāfale.........................orator chief

tulāfono.........................distinctive oral
traditions and
customs, prescriptive
rules, laws

tunuma.........................cylindrical wooden
container

u'a................................the paper mulberry
tree, or unfinished
barkcloth

ulutao...........................spearhead motif

umu..............................earth oven

umusāga.......................final ceremony after
tattooing is complete

u'u................................oil prepared from
coconut kernals

va'a..............................canoe or boat

vae'ali..........................tattooing motif
representing legstands
of a bamboo headrest

vāega............................zones, areas of the
tattoo

vaetulī..........................tattooing motif
representing the feet
of tulī (seabirds)

vaisalo..........................a special coconut dish

vatu'e...........................a sea-urchin whose
spines are used to
sharpen the tattooing
tool's needles

306

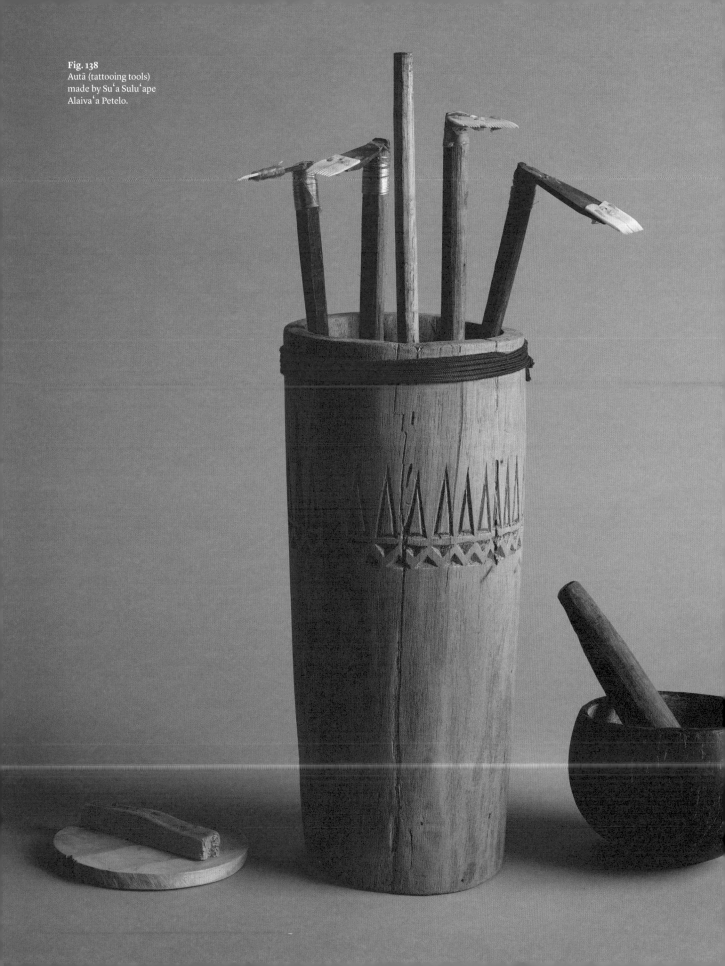

Fig. 138
Autā (tattooing tools)
made by Suʻa Suluʻape
Alaivaʻa Petelo.

BIBLIOGRAPHY

UNPUBLISHED SOURCES

Abbreviations

APM ON – Archivio dei Padri Maristi (Archives of the Marist Fathers, Rome)

CWM/LMS – Council for World Mission / London Missionary Society

SOAS – School of Oriental and African Studies, London

Archival

Cairns, Puawai, 'Appearances of Tā Moko in Contemporary Pop Culture', conference presentation Tatau/Tattoo: Embodied Art and Cultural Exchange 1760–2000, held at Victoria University of Wellington, New Zealand, 2003.

Gavet, Fr., journal, 25 December 1859, APM ON (Samoa).

Groves, Jack W, 'Notes on the Samoan Tattoo (Pe'a) with Original Diagrams and Illustrations by the Author', unpublished manuscript held at the Ethnography Department, British Museum, n.d.

Harbutt, 'Upolu, 9 December 1854, CWM, South Seas, Incoming correspondence, Box 25, Folder 8/Jacket D.

King, Joseph, letter to Reverend A Lidman, CWM, South Seas, Incoming correspondence, Box 30, Folder 4/Jacket C, SOAS.

Marist Archive No. APM 1351/1915.

Mugnery and Verne, Frs., letters, September–October 1846, page 208, APM ON (Samoa)

Mugnery, Fr., letter to Jean Claude Colin, 24 February 1850, APM ON (Samoa).

Padel, Fr., journal, vol. 1, page 108, APM ON (Samoa).

Padel, Fr., journal, vol. 2, 7 November 1850, APM ON (Samoa).

Padel, Fr., letter to Jean Claude Colin, 26 February 1850, APM ON (Samoa).

Padel, Fr., letter to Jean Claude Colin, 24 February 1850, page 208, AMP ON (Samoa).

Padel, Fr., letter to Poupinel, 6 September and 18 October 1853, APM ON (Samoa).

Padel, Fr., letter to Poupinel, 31 August 1848, APM ON (Rome).

Padel, Fr., letter to Poupinel, 31 August 1848, APM ON (Samoa).

Powell, T, Visit to Ta'u, Manu'a, c. 1860, CWM/ LMS, South Seas Journals, Box 10, SOAS.

Pratt, George, 24 January, Matautu, Savai'i, CWM, South Seas, Incoming correspondence, Box 19d, Folder 5.

Roudaire, Gilbert, letter to Jean Claude Colin, December 1845, APM ON (Samoa); Letter from Father Roudaire to Abbot Meydat, January 1847, APM ON (Samoa).

Sunderland, Tutuila, 25 December 1851, CWM/LMS, South Seas, Incoming correspondence, Box 24, Folder 5/Jacket D, SOAS.

Vidal, Julien to Fr. Fraysse, 10 August 1874, APM ON (Samoa).

Violette, Rev. Fr., letter to Jean Claude Colin, 26 April 1848, page 208, APM ON (Samoa).

Virchow, 'Samoanern', 389. After an unpublished translation by I Glebov of the original text in German, given to the author by Serge Tcherkézoff.

Wendt, Mele, email correspondence with Sean Mallon, 7 December 2017.

Williams, John, letter of 17 October 1835, CWM/LMS/Home, Incoming correspondence, Box 6, folder no. 5, Jacket A, SOAS.

Williams, J, Narrative of a Voyage Performed in the Missionary Schooner 'Olive Branch', Saturday 20 October 1832, CWM, South Seas Journals, Box 7, SOAS.

Theses

Forsyth, Claudia, 'Samoan Art of Healing: A Description and Classification of the Current Practice of the Taulāsea and Fofō. PhD thesis. (San Diego: United States International University, 1983).

Henderson, April, 'Gifted Glows: Netting the Imagery of Hip Hop across the Samoan Diaspora', Master's thesis, (University of Hawai'i, 1999).

Kuwahara, Makiko, 'Making Multiple Skins: Tattooing and Identity Formation in French Polynesia', PhD thesis, Australian National University, 2003.

Maliko, Tavita, 'O le Soga'imiti: An Embodiment of God in the Samoan Male Body', Doctoral dissertation, University of Auckland, 2012, http://www.researchspace.auckland.ac.nz.

McGrevy, Noel L, 'O le Ta Tatau: An Examination of Certain Aspects of Samoan Tattooing to the Present', MA thesis, Pacific Island Studies, University of Hawai'i, 1973.

McGrevy, Noel L, 'O le Ta Tatau, Traditional Samoan Tattooing', unpublished manuscript (Auckland: Culture Consultants Ltd, 1989).

MacQuoid, Lisa P, 'The Women's Mau: Female Peace Warriors in Western Samoa', Plan B Paper candidate for Master of Arts Pacific Islands Studies (University of Hawai'i at Manoa) 15 April 1995, http://scholarspace.manoa.hawaii.edu/bitstream/10125/21186/1/MacQuoid_1995.

Schoeffel, P, 'Daughters of Sina: A Study of Gender, Power and Status in Samoa', PhD thesis, Australian National University, 1979).

Wendt, Albert, '"Guardians and Wards": A Study of the Origins, Causes, and the First Two Years of the Mau in Western Samoa', master's thesis (Victoria University of Wellington, 1965) http://nzetc.victoria.ac.nz/tm/scholarly/tei-WenGua-c4.html.

Film and Television

Moana, directed by Ron Clements & John Musker, Disney, 2016.

'Tatau: A Journey, Part 1', TheCoconet TV, 31 October 2013, https://youtu.be/DSipc5t_4Gg.

'Roman Reigns Explains the Significance Behind His Tribal Tattoo', interview by Corey Graves, *Superstar Ink*, http://www.wwe.com/videos/roman-reigns-explains-the-significance-behind-his-tribal-tattoo-superstar-ink.

Signatures of the Soul: Tattooing Today, New Zealand On Screen, http://www.nzonscreen.com/title/signatures-of-the-soul-tattooing-to-day-1984.

Tatau Samoa, directed by Gisa Schleelein (Lichtblick Film, 1999).

Tatau: A Journey, directed by Lisa Taouma, 2004.

Savage Symbols, produced and directed by Makerita Urale (2002).

Tatau: What One Must Do, directed by Micah van der Ryn (University of California Extension Center for Media and Independent Learning, 1997).

Published Sources

A-04 Trade Between New Zealand and Fiji, Tonga, Western Samoa, and Cook Islands, Report of the Commission to Inquire into the Conditions of)., Untitled, 1 January 1920, http://paperspast.natlib.govt.nz/parliamentary/AJHR1920-I.2.1.2.5.

A-04 Trade Between New Zealand and Fiji, Tonga, Western Samoa, and Cook Islands (Report of the Commission to Inquire into the Conditions of), Untitled, 1 January 1920, http://paperspast. natlib.govt.nz/parliamentary/AJHR1920-I.2.1.2.5.

Abercromby, J, 'Samoan Tales', *Folklore*, no. 2 (1891): 455–67.

Administration of Western Samoa, *Handbook of Western Samoa* (Wellington: Government Printer, 1925), 52.

Afutoto, Seupule Tuala Tuita 'asauali'i Onofiatele Leaoaniu Afutoto, *'O 'Auega 'o le Aganu'u Sāmoa Sa'Afi'Afiga 'o Tū Ma Agaifanua: Po Tala a Sāmoa*, Methodist Church in Sāmoa, (Samoa, 2012).

Aiono-Le Tagaloa, F, *O le Fa'asinomaga: Le Tagata Ma Lona Fa'asinomaga* (Alafua, Samoa: Le Lamepa Press, 1997).

Aldrich, R, *The French Presence in the South Pacific, 1842–1940* (Honolulu: University of Hawai'i Press, 1990).

Allen, Tricia, 'Tatau: The Tahitian Revival', http://tattoos.com/tatau-the-tahitian-revival/.

Akeli, Safua, 'Reconfiguring Cricket Culture in Colonial Sāmoa', in *The Lives of Colonial Objects*, edited by A Cooper, L Paterson & A Wanhalla (Dunedin: Otago University Press, 2015), 281–85.

Ambrose, W, 'Oceanic Tattooing and the Implied Lapita Ceramic Connection', *Journal of Pacific Archaeology* vol. 3, no. 1 (2012): 1–21.

Appadurai, Arjun, (ed.), *The Social Life of Things: Commodities in Cultural Perspective* (Cambridge, UK: Cambridge University Press, 1986), 43.

Appadurai, Arjun, *Modernity at Large: Cultural Dimensions of Globalization, Vol. 1* (Minneapolis: University of Minnesota Press, 1996).

Andrew, Thomas, 'Samoa and the South Sea Islands', *Auckland Star* XXIII, issue 276, 19 November 1892, 12, http://paperspast.natlib.govt.nz/newspapers/AS18921119.2.96

Auckland Star XXIII, issue 276, 19 November 1892, 12.

Atkinson, Michael, 'Fifty Million Viewers Can't Be Wrong: Professional Wrestling, Sports-entertainment, and Mimesis', *Sociology of Sport Journal* vol. 19, no. 1 (2002): 47–66.

Avia, Tusiata, *Wild Dogs Under My Skirt* (Victoria University Press, 2004).

Balme, C, 'New Compatriots: Samoans on Display in Wilhelminian Germany', *Journal of Pacific History* vol. 42, no. 3 (2007): 331–44.

Baxter, Bob, 'Le Tatau: Tattoo Millennium Convention', *Skin and Ink: The Tattoo Magazine* (2000): 36–46.

Baxter, Bob, 'Tattoo Chronicle #7 – Return to Samoa', *Bob Baxter's Tattoo Chronicles*, http:// www.vanishingtattoo.com/tattoo_chronicles/tattoo_chronicles_bob_baxter_07.htm; Bob Baxter, 'Tattoo Chronicle #8 – Aboard the Bus', *Bob Baxter's Tattoo Chronicles*, http://www. vanishingtattoo.com/tattoo_chronicles/tattoo_chronicles_bob_baxter_08.htm.

Baxter, Bob, and Bernard Clark. *Tattoo Road Trip: Two Weeks in Samoa* (Atglen, Pennsylvania: Schiffer Publishing, 2002).

Behrens, CF, *Histoire de l'Expédition de Trois Vaisseaux, Envoyés par la Compagnie des Indes Occidentales . . .* (The Hague: Aux Dépens de la Compagnie, 1739), 206 (French translation, under the name of the author's initials only, of the original in German: *Reise durch die Südländer und um die Welt* [Frankfurt & Leipzig, 1737]).

Besnier, N, 'Transgenderism, Locality, and the Miss Galaxy Beauty Pageant in Tonga', *American Ethnologist* vol. 29, no. 3 (2002): 534–66.

Besnier, N, *On the Edge of the Global: Modern Anxieties in a Pacific Island Nation* (Palo Alto, California: Stanford University Press, 2011).

Besnier, N, & K Alexeyeff (eds), *Gender on the Edge: Transgender, Gay and Other Pacific Islanders* (Honolulu: University of Hawai'i Press, 2014).

Betts, Raymond F, & Lyz Bly, *A History of Popular Culture* (New York: Routledge, 2004).

Brank, Chuck, *Lyle Tuttle Forefather of Modern Tattooing*, http://www.prickmag.net/ lyletuttleinterview.html.

Brunt, Peter, 'The Temptation of Brother Anthony: Decolonization and the Tattooing of Tony Fomison', in *Tattoo: Bodies, Art and Exchange in the Pacific and the West*, edited by Nicholas Thomas, Anna Cole & Bronwen Douglas (London: Reaktion Books, 2005), 123–127.

Brunt, Tony, 'To Walk Under Palm Trees: The Germans in Samoa: Snapshots from Albums', http://germansinSamoa.net/page-11/.

Buschmann, RF, *Anthropology's Global History: The Ethnographic Frontier in German New Guinea* (Honolulu: University of Hawai'i Press, 2009), 33–35.

Buse, JE, 'Two Samoan Speeches', *Bulletin of the School of Oriental and African Studies* vol. 24, no. 1 (1961): 104–15.

Carter, Anton, 'Taking Centre Stage: Pacific Theatre in New Zealand', in *Pacific Art Niu Sila: The Pacific Dimensions of Contemporary New Zealand Arts*, edited by Sean Mallon & Fuli Pereira (Wellington: Te Papa Press, 2002).

'Cease the Production of the Nike Pro Tattoo Tech Tights', https://www.change.org/p/nike-cease-the-production-of-the-nike-pro-tattoo-tech-tights.

Chapman, Madeline, 'Hear Us Out: That "Brown Face" Maui Costume Is Maybe Okay', The Spinoff, 20 September 2016, https://thespinoff.co.nz/tv/20-09-2016/disneys-lose-lose-battle-with-making-a-maui-costume/.

Churchill, LP, *Samoa Uma* (New York: Sampson Low, 1902).

Churchward, W, *My Consulate in Samoa: A Record of Four Years' Sojourn in the Navigator Islands, with Personal Experiences of King Malietoa Laupepa, His Country, and His Men* (London: Bentley & Son, 1887).

'Vindication for Tufuga', *City Life* (11–17 September 2008): 4.

Colvin, Sidney (ed.), *Vailima Letters; Being Correspondence Addressed by Robert Louis Stevenson to Sidney Colvin, November, 1890–October 1894, Vol. II* (New York: Scribner, 1896), 165, 166, 171.

Court of Appeal of New Zealand, The Queen v Epifania Suluape NZCA 6 (21 February 2002) In the Court of Appeal of New Zealand, CA249/01, http://www.nzlii.org/cgi-bin/sinodisp/nz/cases/NZCA/2002/6.html?query=tuvalu*.

Cox, David, 'The Name for Britain Comes from Our Ancient Love of Tattoos', BBC, 2016, http://www.bbc.com/future/story/20161110-the-name-for-britain-comes-from-our-ancient-love-of-tattoos.

Cox, ME, 'Indigenous Informants or Samoan Savants? German Translations of Samoan Texts in Die Samoa-Inseln', *Pacific Studies* 32.1 (2009): 23–47.

D'Alleva, A, 'Christian Skins: Tatau and the Evangelisation of the Society Islands and Samoa', in *Tattoo: Bodies, Art and Exchanges in the Pacific and the West*, edited by Nichola Thomas, Anna Cole & Bronwen Douglas (Durham, North Carolina: Duke University Press, 2005), 90–108.

Davis, Elizabeth, 'Metamorphosis in the Culture Market of Niger', *American Anthropologist* vol. 101, no. 3 (1999): 485–501.

de Bougainville, L, *A Voyage Round the World: Performed by Order of His Most Christian Majesty, in the Years 1766, 1767, 1768, and 1769*, trans. Johann Reinhold Forster (London, 1772).

de Lurcy, Lafond G, 'Quelques Semaines dans les Archipels de Samoa et Viti', *Bulletin de la Société de Géographie* vol. 3, no. 3, pt 1 (1845), 17–18.

DeMello, Margo, *Bodies of Inscription: A Cultural History of the Modern Tattoo Community* (Durham, North Carolina: Duke University Press, 2000).

Dominion, 29 March 1999.

Dominion, 7 April 1999.

Dunmore, J, (ed. & trans.), *The Journal of Jean-François de Galaup de la Pérouse, 1785–1788 (2 vols)* (London: Hakluyt Society, 1994).

Duranti, Alessandro, 'Language and Bodies in Social Space: Samoan Ceremonial Greetings', *Anthropologist* 94 (1992): 657–91.

Duriez-Toutain, C, *Présence et Perception: Maristes à Tonga, 1840–1900* (Bordeaux: CRET, Collection Îles et Archipels no. 22, 1995).

Dyson, Martin, *Samoa and the Samoans*, 1882, http://nla.gov.au/nla.obj-101243022.

Ellis, Juniper, '"Tatau" and "Malu": Vital Signs in Contemporary Samoan Literature' (*PMLA*, vol. 121, no. 3, 2006) 687–701.

Erskine, JE, *Journal of a Cruise Among the Islands of the Western Pacific, Including the Feejees and Others Inhabited by the Polynesian Negro Races, in HMS* Havannah (London: John Murray, 1853) [facsimile by Southern Reprints, Papakura, NZ 1987].

'The Mysterious Rescuer', *Evening Post* CXXV, issue 84, 9 April 1938, http://paperspast.natlib.govt.nz/newspapers/EP19380409.2.147.13.

Field, Michael, *Mau: Samoa's Struggle for Freedom* (Auckland: Polynesian Press, 1991).

Figiel, Sia, *They Who Do Not Grieve* (Auckland: Vintage, 1999).

Foucault, Michel, 'Nietzsche, Genealogy, History' (trans. DF Bouchard & S Simon), in *Language, Counter-memory, Practice: Selected Essays and Interviews by Michel Foucault*, edited by DF Bouchard, (Ithaca: Cornell University Press, 1977), 139-64.

Franco, R, 'Samoans, World War II, and Military Work', in *Remembering the Pacific War*, Occasional Paper series 36, edited by Geoffrey M White (Honolulu: Center for Pacific Islands Studies, University of Hawai'i, 1991), 173-179.

'Sir Q's Tattoos', in *Frank 151 Chapter 35: Samoa* (2012), 69-70.

Fraser, J, 'Some Folk-songs and Myths from Samoa', *Journal of the Polynesian Society*, no. V (1896): 170-78.

Freeman, JD, 'The Joe Gimlet or Siovili Cult: An Episode in the Religious History of Early Samoa,' in *Anthropology in the South Seas*, edited by JD Freeman & WR Geddes (New Plymouth: Thomas Avery, 1959), 185-200.

Freeman, Derek, *Margaret Mead and Samoa: The Making and Unmaking of an Anthropological Myth* (Cambridge, Massachusetts: Harvard University Press, 1983).

Friedlander, B, 'Notizen über Samoa', *Zeitschrift für Ethnologie*, no. 31 (1899): 1-55.

Galliot, Sébastien, 'Ritual Efficacy in the Making', *Journal of Material Culture* vol. 20, no. 2 (2015): 101-25.

Gell, Alfred, *Wrapping in Images: Tattooing in Polynesia* (Oxford: Clarendon Press, 1993), 106-08.

Gilson, RP, *Samoa 1830-1900: The Politics of a Multi-cultural Community* (Melbourne: Oxford University Press, 1970), 72-73.

Girard, C, *Lettres des Missionnaires Maristes en Océanie, 1836-1854* (Paris: Karthala, 2008).

Graburn, Nelson HH, 'Introduction: The Arts of the Fourth World', in *Ethnic and Tourist Arts: Cultural Expressions from the Fourth World*, edited by Nelson HH Graburn (Berkeley: University of California Press, 1976), 2-3, 18.

Grand, S, *Tahu'a, Tohunga, Kahuna: Le Monde Polynesien des Soins Traditionnels* (Tahiti: Au Vent des Îles, 2007).

Green, RC, 'Early Lapita Art from Polynesia and Island Melanesia: Continuities in Ceramic, Barkcloth and Tattoo Decorations', in *Exploring the Visual Art of Oceania*, edited by S Mead, (Honolulu: University of Hawai'i Press, 1979).

Grimwade, Jennifer, 'Revival of an Ancient Art: Tattoo Tricks Catch on Again among Samoans', *Pacific Islands Monthly* 63, no.9 (1993): 42-43.

Gupta, Akhil, and James Ferguson, "Beyond "Culture": Space, Identity, and the Politics of Difference", *Cultural Anthropology* 7.1 (1992): 6-23.

Hale, H, *United States Exploring Expedition During the Years 1838, 1839, 1840, 1841, 1842 under the Command of Charles Wilkes, Vol. VI, Ethnography and Philology* (Philadephia: Sherman, 1846).

Handy, ES, Craighill & Willowdean Chatterson Handy, *Samoan Housebuilding, Cooking, and Tattooing* (Honolulu: Bernice P. Bishop Museum Bulletin 15, 1924).

Hardy, Ed, *Tattootime No.1 The New Tribalism* (1982).

Hardy, Ed, & Joel Selvin, *Wear Your Dreams: My Life in Tattoos* (New York: St Martins Press, 2013).

Hanson, A, 'Political Change in Tahiti and Samoa: An Exercise in Experimental Anthropology', *Ethnology* vol. 12, no. 1 (1973): 1-13.

Hiery, HJ, *The Neglected War : The German South Pacific and the Influence of World War I* (Honolulu: University of Hawai'i Press, c. 1995).

Hiroa, Te Rangi (Peter Buck), *Samoan Material Culture* (Honolulu: Bernice P. Bishop Museum. Bulletin 75, 1930).

Hood, TH, *Notes of a Cruise in HMS* Fawn *in the Western Pacific in the Year 1862* (Edmonston and Douglas, 1863).

Houzé, E, 'Les Samoans de Leone', *Bulletin de la Société d'Anthropologie de Bruxelles* 7 (1889): 243.

Ivory, Carol S, 'Art, Tourism, and Cultural Revival in the Marquesas Islands', in *Unpacking Culture: Art and Commodity in Colonial and Postcolonial Worlds*, edited by Ruth B Phillips & Christopher B Steiner (Oakland: University of California Press, 1999), 317-33.

Kim, John, 'Nike – Tattoo Tech For Women', https://www.freshness-mag.com/2013/07/31/nike-tattoo-tech-for-women/.

Jolly, Margaret, 'White Shadows in the Darkness: Representations of Polynesian Women in Early Cinema', *Pacific Studies* vol. 20, no. 4 (1997): 125-50.

Kaeppler, A, 'Exchange Patterns in Goods and Spouses: Fiji, Tonga and Samoa', *Mankind* vol. 11, no. 3 (1978): 246-52.

Kaeppler, A, 'Kie Hingoa: Mats of Power, Rank, Prestige and History', *Journal of the Polynesian Society*, vol. 108, no. 2, (1999), 168-232.

Keesing, FM, 'The Taupou System of Samoa: A Study of Institutional Change', *Oceania* vol. 8, no. 1 (1937): 14.

Kirch, Patrick Vinton, *The Lapita Peoples: Ancestors of the Oceanic World* (Oxford: Blackwell, 1997).

Kirch, Patrick Vinton, *On the Road of the Winds: An Archaeological History of the Pacific Islands Before European Contact* (Berkeley: University of California Press, 2000).

Kneubuhl, VN, 'Traditional Performance in Samoan Culture: Two Forms', *Asian Theatre Journal* vol. 4, no. 2 (Autumn 1987); 166-176.

Koyama, N, 'Japanese Tattooists and the British Royal Family During the Meiji Period', in *Britain and Japan: Biographical Portraits, Vol. VI* (Leiden, The Netherlands: Brill, 2007), 95-104.

Koch, G, *The Material Culture of Tuvalu* (Suva: University of the South Pacific, 1984).

Krämer, Augustin, *The Samoa Islands, Vol. I* (Honolulu: University of Hawai'i Press, 1994).

Krämer, Augustin, *The Samoa Islands, Vol. II* (Honolulu: University of Hawai'i Press, 1995).

Kuchler, Susanne and Graeme Were, *Pacific Pattern* (London: Thames and Hudson, 2005).

Kuwahara, Makiko, *Tattoo: An Anthropology* (New York: Berg Publishers, 2005).

Lange, Raeburn, *Island Ministers: Indigenous Leadership in Nineteenth Century Pacific Islands Christianity* (Christchurch: Macmillan Brown Centre for Pacific Studies, University of Canterbury, 2006), 85-86.

Latai, L, 'Changing Covenants in Samoa? From Brothers and Sisters to Husbands and Wives?', *Oceania* vol. 85, no.1 (2015): 92-104.

Lave, J, & E Wenger, *Situated Learning. Legitimate Peripheral Participation* (Cambridge: Cambridge University Press, 1991).

Author unknown, 'Les Nouvelles Lois Samoanes', *Les Missions Catholiques* 6 (1874): 350-52.

Lévi-Strauss, C, 'Nobles Sauvages' in *Culture, Science et Développement: Contribution à une Histoire de l'Homme. Mélanges en l'Honneur de Charles Morazé* (Toulouse: Privat, 1979), 48 (trans. Sébastien Gaillot).

Lindstrom, Lamont, & Geoffrey White, *Island Encounters: Black and White Memories of the Pacific War* (Washington & London: Smithsonian Institution Press, 1990).

Lilomaiava-Doktor, SI, 'Beyond "Migration": Samoan Population Movement (Malaga) and the Geography of Social Space (Vā)', *The Contemporary Pacific* vol. 21, no. 1 (2009): 1-32.

Liua'ana, Ben Featuna'i, 'Dragons in Little Paradise: Chinese (Mis-) Fortunes in Samoa, 1900-1950', *The Journal of Pacific History* vol. 32, no. 1 (1997): 29-48.

Liufau, Sulu'ape Si'i, 'Tatau Motifs' in *Tatau: Marks of Polynesia*, edited by Takahiro Kitamura (Los Angeles: Japanese American National Museum, 2016), 193-199.

Lodder, M, 'The Myths of Modern Primitivism', *European Journal of American Culture* vol. 30, no. 2 (2011): 99-111.

Lucas, 2d Lt. Jim G, 'Loyalty of Native Split by Tattoos', *Marine Corps Chevron* vol. 3, no. 28 (15 July 1944): 8, http://historicperiodicals.princeton.edu/historic/cgi-bin/historic?a=d&d=Marine-CorpsChevron19440715-01.2.56&srpos=1&e=-------en-20--1--txt-txIN-tattoos------.

Ma Ching, Steve, Facebook post, 19 July 2013.

Mageo, JM, 'Continuity and Shape Shifting: Samoan Spirits in Culture History', in *Spirits in Culture, History and Mind*, edited by JM Mageo & A Howard (New York: Routledge, 1996), 29–54.

Māhina-Tuai, Kolokesa, 'A Land of Milk and Honey? Education and Employment Migration Schemes in the Postwar Era', in *Tangata o le Moana: New Zealand and the People of the Pacific*, edited by Sean Mallon, Kolokesa Mahina Tuai and Damon Salesa (Wellington: Te Papa Press, 2012), 161–78.

Maʻiaʻi, Papaāliʻi Dr Semisi, *Tusi ʻUpu Sāmoa* (Auckland: Little Island Press, 2017).

Mallon, Sean, *Samoan Art and Artists: Measina a Samoa* (Honolulu: University of Hawaiʻi Press, 2002).

Mallon, Sean, with Uili Fecteau, 'Tatau-ed: Polynesian Tatau in Aotearoa', in *Pacific Art Niu Sila: The Pacific Dimensions of Contemporary New Zealand Arts*, edited by Sean Mallon & Fuli Pereira (Wellington: Te Papa Press, 2002).

Mallon, Sean, 'Samoan Tattoo as Global Practice', in *Tattoo: Bodies, Art and Exchange in the Pacific and Europe*, edited by Nicholas Thomas, Anna Cole & Bronwen Douglas (London: Reaktion Books, 2005), 145–69.

Mallon, Sean, Peter Brunt & Nicholas Thomas (eds), *Tatau: Samoan Tattoo, New Zealand Art, Global Culture*, edited by Sean Mallon, Peter Brunt & Nicholas Thomas (Wellington: Te Papa Press, 2010).

Mallon, Sean, 'Samoan Tattooing, Cosmopolitans, Global Culture', in *Tatau: Samoan Tattoo, New Zealand Art, Global Culture* (Wellington: Te Papa Press, 2010), 15–32.

Mallon, Sean, '"A Living Art": An Interview with Suʻa Suluʻape Paulo II', in *Tatau: Samoan Tattoo, New Zealand Art, Global Culture* (Wellington: Te Papa Press, 2010), 51–61.

Mallon, Sean, 'War and Visual Culture 1939–1945', in *Art in Oceania: A New History*, edited by Peter Brunt and Nicholas Thomas (London: Thames & Hudson, 2012), 326–347.

Mallon, Sean, 'Tourist Art and its Markets 1945–1989', in *Art in Oceania: A New History* (London: Thames & Hudson, 2012), 384–409.

Mallon, Sean, 'Samoan Tattooing and the Rise of the Machine' in *Tatau: Marks of Polynesia*, edited by Takahiro Kitamura (Los Angeles: Japanese American National Museum, 2016).

Mallon, Sean, & Pandora Fulimalo Pereira, *Pacific Art Niu Sila: The Pacific Dimensions of Contemporary New Zealand Arts* (Wellington: Te Papa Press, 2002).

Marcus, GE, 'Ethnography in / of the World System: The Emergence of Multi-sited Ethnography', *Annual Review of Anthropology* 24, no. 1 (1995): 95–117.

Maroto Camino, Mercedes, 'Ceremonial Encounters: Spanish Perceptions of the South Pacific', in *European Perceptions of Terra Australis*, edited by Anne M Scott, Alfred Hiatt, Claire McIlroy & Christopher Wortham (New York: Routledge, 2011), 156.

Marquardt, C, *The Tattooing of Both Sexes in Samoa* (Auckland: R McMillan, 1984). Translation of *Die Tätowirung Beider Geschlechter in Samoa* (Berlin: D Reimer, 1899).

McCarthy, David, & HC Westermann, *HC Westermann at War: Art and Manhood in Cold War America* (Newark: University of Delaware Press, 2004).

McCarthy, Kelly, 'Dwayne "The Rock" Johnson Shed "Manly Tears" During "Moana"', *ABC News*, 21 November 2016, http://abcnews.go.com/Entertainment/dwayne-rock-johnson-shed-manly-tears-moana/story?id=43680580.

McCarty Jr, Milburn, 'Even In Samoa They're Interested In "Teines"', *Marine Corps Chevron* vol. 2, no. 38 (25 September 1943): 4, http://historicperiodicals.princeton.edu/historic/cgi-bin/historic?a=d&d=MarineCorpsChevron19430925-01.2.31&e=-------en-20--1--txt-txIN------#

McLean, Margot, and Amanda D'Souza, 'Life-threatening Cellulitis After Traditional Samoan Tattooing', *Australian and New Zealand Journal of Public Health* vol. 35 no. 1 (2011): 27–29.

McMullin, D, 'Faʻafafine Notes: On Tagaloa, Jesus and Nafanua', in *Queer Indigenous Studies: Critical Interventions in Theory, Politics, Literature*, edited by QL Driskill, C Finley, BJ Gilley & SL Morgensen (Tucson: University of Arizona Press, 2011), 81–94.

Meleisea, Malama, *O Tama Uli: Melanesians in Western Samoa* (Suva: University of the South Pacific, 1980).

Meleisea, Malama, 'The Last Days of the Melanesian Labour Trade in Western Samoa', *The Journal of Pacific History* vol. 11 no. 2 (1976): 126–32.

Meleisea, Malama, *The Making of Modern Samoa* (Suva: University of the South Pacific, 1987).

Meleisea, Malama, *Lagaga: A Short History of Western Samoa* (Apia: University of the South Pacific, 1987).

Mills, A, 'Bodies Permeable and Divine: Tapu, Mana and the Embodiment of Hegemony in Pre-Christian Tonga', in *New Mana: Transformations of a Classic Concept in Pacific Languages and Cultures*, edited by M Tomlinson & TPK Tengan (Canberra: ANU Press, 2016), 77–105.

Milner, GB, *Samoan Dictionary* (Auckland: Pasifika Press, 1966), 8, 137, 98.

Milner, G, 'Siamese Twins and Samoan Tattoos', *Man* vol. 8, no. 1 (1973): 108.

Ministry for Culture and Heritage, 'Influenza in Samoa', https://nzhistory.govt.nz/culture/1918-influenza-pandemic/Samoa.

Ministry for Culture and Heritage, 'Samoan Influenza Obituaries', https://nzhistory.govt.nz/media/photo/Samoan-influenza-obituaries.

Ministry of Health, *Customary Tattooing Guidelines for Operators: Tuʻiala mo Tufuga Tā Tatau a Sāmoa* (Wellington: Government of New Zealand, 2010). http://www.health.govt.nz/system/files/documents/publications/customary-tattooing-guide-lines-for-operators-apr2010v2_0.pdf.

Monfat, RPA, *Les Premiers Missionnaires des Samoa* [Lyon: E. Vitte, 1922], 71).

Moore, Clive, *Making Mala: Malaita in Solomon Islands, 1870s–1930s* (Canberra: ANU Press, 2017).

Moulin, Jane Freeman, 'What's Mine Is Yours? Cultural Borrowing in a Pacific Context', *The Contemporary Pacific* 8, no.1 (1996): 128–153.

Moyle, Richard M, *The Samoan Journals of John Williams, 1830 and 1832* (Canberra: ANU Press, 1984).

Moyle, Richard M, *Traditional Samoan Music* (Auckland University Press. Auckland, 1988).

Murray, AW, *Forty Years' Mission Work in Polynesia and New Guinea: From 1835 to 1875* (J Nisbet & Co, 1876).

Myers, Vinnie, 'The Tatau's Endless Journey', *International Tattoo Art* (May 2000): 14–17.

'Flash Harry of Savaiʻi', *New Zealand Herald* XXXIX, issue 12152 (24 December 1902): Supplement.

'Wife Jailed for Manslaughter of Tattooist', *New Zealand Herald*, 20 July 2001, http://www.nzherald.co.nz/tony-stickley/news/article.cfm?a_id=143&objectid=201213.

'Faʻafafine Told: Tattoo and Die', *New Zealand Herald*, 6 December 2007.

'Sterilising the Art of Samoan Tattooing', *New Zealand Herald*, 21 March 2003, http://www.nzherald.co.nz/nz/news/article.cfm?cid=1&objectid=3251292.

The New Zealand Official Yearbook 1976, https://www3.stats.govt.nz/New_Zealand_Official_Yearbooks/1976/NZOYB_1976.html#idchapter_1_9158.

Neich, Roger, *Material Culture of Western Samoa* (National Museum of New Zealand, Bulletin 23, 1985).

Nordstrom, Alison Devine, 'Popular Photography of Samoa: Production, Dissemination and Use', in *Picturing Paradise: Colonial Photography of Samoa 1875 to 1925*, edited by Blanton Casey (Southeast Museum of Photography, Daytona Beach Community College, 1995).

Ochs, E, *Culture and Language Development: Language Acquisition and Language Socialization in a Samoan Village* (New York: Cambridge University Press, 1988), 78.

O'Malley Greenburg, Zack, 'The World's Highest-paid Celebrities 2017', *Forbes*, 12 June 2017, https://www.forbes.com/sites/zackomalleygreenburg/2017/06/12/full-list-the-worlds-highest-paid-celebrities-2017/#55838bb49eca.

O'Meara, Tim, *Samoan Planters: Tradition and Economic Development in Polynesia* (Fort Worth, Texas: Rinehart and Winston, 1990).

'A Cruise in the Southern Seas', *Otago Daily Times*, issue 18411, 24 November 1921, http://paperspast.natlib.govt.nz/newspapers/ ODT19211124.2.82.

'Terrible Experience of Samoans', *Otago Daily Times*, issue 10943, 26 October 1897, http://paperspast.natlib.govt.nz/newspapers/ODT18971026.2.67.

Park, J and C Morris, 'Reproducing Samoans in Auckland "In Different Times": Can Habitus Help?', *The Journal of the Polynesian Society* vol. 113, no. 3 (2004): 227–61.

Peteru, Chris, 'The Pacific's Grand Cultural Celebration', *Pacific Islands Monthly* vol. 66, no. 9 (1996): 47.

Poignant, Roslyn, *Professional Savages: Captive Lives and Western Spectacle* (Yale University Press, 2004), 198–201.

Popo, H, 'Samoa Tattoo Convention', *Tattoo Life: The First Global Tattoo Magazine*, no. 5 (1999).

Powell, Rodney, 'Tattooing and Traditional Tongan Tattoo', 2012, https://matadornetwork.com/nights/tattooing-traditional-ton- gan-tattoo/.

Pratt, G, *Pratt's Grammar and Dictionary of the Samoan Language* (4th edn) (Apia: Malua Press, 1911).

Quanchi, Max, 'The Imaging of Samoa in Illustrated Magazines and Serial Encyclopaedias in the Early 20th-Century', *The Journal of Pacific History* vol. 41, no. 2 (2006): 207–17.

Refiti, AL, 'Whiteness, Smoothing and the Origin of Samoan Architecture', *Interstices: Journal of Architecture and Related Arts* 10 (2009): 9–19.

Reid, AC, 'The Fruit of the Rewa Oral Traditions and the Growth of the Pre-Christian Lakeba State', *Journal of Pacific History* 12, pt 1 (1977): 17.

Rill, James C, *A Narrative History of the 1st Battalion, 11th Marines During the Early History and Deployment of the 1st Marine Division, 1940-43* (New York: Merriam Press, 2003).

Roggeveen, J, *Daagverhaal der Ontdekkings-reis van Mr Jacob Roggeveen in de Jaren 1721 en 1722* (Middelburg: Abrahams,1838), 189.

Rosenblatt, Daniel, 'The Antisocial Skin: Structure, Resistance, and "Modern Primitive" Adornment in the United States', *Cultural Anthropology* vol. 12, no. 3 (1997): 287–334.

Salesa, Damon, '"Travel-happy" Samoa: Colonialism, Samoan Migration and a "Brown Pacific"', *New Zealand Journal of History* vol. 37, no. 2 (2003): 171–88.

Salesa, Damon, 'New Zealand's Pacific', in *The New Oxford History of New Zealand*, edited by Giselle Byrnes (Oxford: Oxford University Press, 2009), 149–172.

Salesa, Damon, 'A Pacific Destiny: New Zealand's Overseas Empire, 1840-1945', in *Tangata o le Moana: New Zealand and the People of the Pacific*, edited by Sean Mallon, Kolokesa Mahina Tuai and Damon Salesa (Wellington: Te Papa Press, 2012), 97–121.

Samau, Bernadette, 'Perceptions on the Commercialization of the Malu: A Case of Samoa', *Global Journal of Arts, Humanities and Social Sciences* vol. 4, no. 6 (June 2016): 69–80.

'Tattooists Share Concern', *Samoa Observer*, 1 September 2016, http://www.Samoaobserver.ws/en/01_09_2016/local/10692/Tattooists-share-concern.htm.

'Three Weeks in Samoa', *Samoa Weekly Herald* 1, issue 20 (8 April 1893), http://paperspast.natlib.govt.nz/newspapers/SWH18930408.2.12.

'South Sea Island Show at Chicago', *Samoa Weekly Herald* 2, issue 57 (30 December 1893): 3.

'Samoan Affairs', *Samoa Weekly Herald* 2, Issue 75 (5 May 1894), http://paperspast.natlib.govt.nz/newspapers/SWH18940505.2.22.

Advertisements, *Samoa Times and South Sea Advertiser* 9, Issue 4 (24 October 1896), http://paperspast.natlib.govt.nz/newspapers/STSSA18961024.2.15.3.

'Death of Mr Peter Rasmussen', *Samoanische Zeitung* 17, issue 42 (20 October 1917).

'How the Epidemic Began', *Samoanische Zeitung* vol. 18, no. 47 (December 1918).

Tatau Greetings from SEEREEVES in Texas http://seereeves.blogspot.co.nz/2009/01/tatau.html, 5 January 2009.

Schiffmacher, Henk, 'In Memoriam: Paulo Suluape "The chief is dead, long live the chief!"', July 2002, http://www.tattoomuseum.com/top/memorial.html.

Schmidt, JM, 'Being "Like a Woman": Fa'afafine and Samoan Masculinity', *Asia Pacific Journal of Anthropology* vol. 17, nos 3-4 (2016): 287–304.

Schoeffel, P, 'The Samoan Concept of Feagaiga and Its Transformations', in *Tonga and Samoa: Images of Gender and Polity*, edited by J Huntsman (Christchurch: Macmillan Brown Centre for Pacific Studies, 1995), 85–106.

Semu, Greg, 'O le Tatau Samoa: The Tattooing of the Samoan People', *Metro* 177 (March 1996).

Sharp, A, (ed.), *The Journal of Jacob Roggeveen* (Oxford: Clarendon Press, 1970).

Shore, Bradd, *Salaʻilua: A Samoan Mystery* (New York: Columbia University Press, 1982).

Sorrenson, MPK, 'Buck, Peter Henry', Dictionary of New Zealand Biography Te Ara – the Encyclopedia of New Zealand, http://www.TeAra.govt.nz/en/biographies/3b54/buck-peter-henry.

Stair, JB, *Old Samoa; or Flotsam and Jetsam from the Pacific Ocean* (London: Religious Tract Society, 1897).

Steinmetz, Georg, *The Devil's Handwriting: Precoloniality and the German Colonial State in Qingdao, Samoa, and Southwest Africa* (Chicago: University of Chicago Press, 2008).

Stewart, Keith, 'A Rare View of the Pacific Way', *Sunday Star-Times*, 24 March 1996, F2.

Stewart, Susan, *On Longing: Narratives of the Miniature, the Gigantic, the Souvenir, the Collection* (Durham, North Carolina: Duke University Press, 1993).

Stünzner, Inga, 'The Man with the Double Tattoo', *Talamua, the Samoan Monthly Magazine* (Feb 1998), 36.

Suʻa, Suʻa Vaofusi Pogisa, in *Samoa News* (6 November 2012): 4.

Suʻa, Suʻa Vaofusi Pogisa, quoted in 'Is the Tatau Losing Its Sacredness?' *Samoa Observer*, http://Samoaobserver.ws/other/culture/1906-is-the-tatau-losing-its-sacredness-?tmpl=com.

Suluʻape, Paulo II, 'Meaning of the Peʻa' in *Fomison: What Shall We Tell Them?*, edited by Ian Wedde (Wellington: Wellington City Gallery, 1994), 77–81.

Suʻapaia, Kipeni, *Samoa, the Polynesian Paradise: An Introduction to Ancient and Modern Samoa and the Polynesian Triangle* (New York: Exposition Press, 1962).

Pritchard, WT, *Polynesian Reminiscences, or Life in the South Pacific* (London: Chapman & Hall, 1866).

Summerhayes, GR, 'The Face of Lapita Archaeology', *Oceania* 33 (1988): 100.

Teaiwa, KM, *Consuming Ocean Island: Stories of People and Phosphate from Banaba* (Bloomington, Indiana: Indiana University Press, 2014).

Tcherkézoff, Serge, 'Culture, Nation, Society: Secondary Change and Fundamental Transformations in Western Samoa – Towards a Model for the Study of Cultural Dynamics', in *The Changing South Pacific, Identities and Transformations*, edited by S Tcherkézoff & F Marsaudon (Canberra: ANU E Press, 2008), 245–302.

Tcherkézoff, Serge, *'First Contacts' in Polynesia: The Samoan Case (1722–1848)* (Canberra: ANU Press, 2008).

Tcherkézoff, Serge, 'FaʻaSamoa, une Identité Polynésienne (Économie, Politique, Sexualité) in *L'Anthropologie comme Dialogue Culturel* (Paris: L'Harmattan, 2003) 390.

Tcherkézoff, Serge, *FaʻaSamoa: Une Identité Polynésienne* (Paris: L'Harmattan, 2005).

Tcherkézoff, Serge, 'The Illusion of Dualism in Samoa: "Brothers and Sisters" Are Not "Men and Women"', in *Gendered Anthropology*, edited by T del Valle (London: Routledge, 2016), 54–87.

Tcherkézoff, Serge, 'Sister or Wife, You've Got to Choose: A Solution to the Puzzle of Village Exogamy in Samoa', in *Living Kinship in the Pacific*, edited by C Toren & S Pauwels (New York: Berghahn, 2015), 166–85.

Teilhet-Fisk, J, 'The Miss Heilala Beauty Pageant: Where Beauty Is More Than Skin Deep' in *Beauty Queens on the Global Stage: Gender, Contests, and Power* (London: Routledge, 1996), 185–202.

Thode-Arora, Hilke, (ed.), *From Samoa with Love? Samoan Travellers in Germany 1895–1911: Retracing the Footsteps* (Museum Fünf Kontinente, 2014).

Thomas, Nicholas, 'The Beautiful and the Damned', in *Pirating the Pacific: Images of Travel, Trade and Tourism*, edited by Ann Stephens (Haymarket: Powerhouse Publishing, 1993).

Thomas, Nicholas, 'Marked Men', *Art Asia Pacific* 13: 66–73 (1997).

Thompson, Liz, 'Eye-land Style: Resurrecting Samoan Culture', *Pacific Islands Monthly* vol. 66, no.7 (July 1996): 53–54.

Tiatia, Angela, http://www.angelatiatia.com/work.

Tuimaleali'ifano, MA, *Samoans in Fiji: Migration, Identity and Communication* (Suva: University of the South Pacific, 1990).

Tunumafono, Apelu, 'Reviving an Old Art for $35,000', *Pacific Islands Monthly* (January 1982), 23-24.

Turner, George, *Samoa: A Hundred Years Ago and Long Before* (London, 1884).

Turner, George, *Nineteen Years in Polynesia* (London: John Snow, 1861).

Tusitala Marsh, Selina, 'To Tatau or Not To Tatau: That Is the Afakasi Diasporic Question' in *Home: New Writing*, edited by Thom Conroy (Auckland: Massey University Press, 2017), 18-32.

Tuwai, Lili, 'Celebrating the Pacific: Sydney's Pacific Wave Festival Dispels Stereotypes and Common Myths About Island Cultures', *Pacific Islands Monthly* vol. 67, no. 1 (1997): 52.

Va'a, UF, 'Five Days with a Master Craftsman', *Fashion Theory* vol. 10, no. 3 (2006): 297-313.

Va'a, Leulu Felise, *Saili Matagi: Samoan Migrants in Australia* (Suva: Institute of Pacific Studies, University of the South Pacific & National University of Samoa, 2001).

Va'a, Unasa LF, 'Tatau: From Initiation to Cultural Symbol Supreme', *Proceedings of Measina a Samoa Conference 2 & 3* (2008): 91-119.

Vale, V, and Andrea Juno, 'Lyle Tuttle' in *Modern Primitives: An Investigation of Contemporary Adornment and Ritual* (San Francisco CA, Re/Search Publications 1989), 114-117.

Vallec, 'Huit Jours aux Îles Samoa', *L'Homme: Journal Illustré des Sciences Anthropologiques*, vol. 1, (1884) 491.

The Veiqia Project – an artist-led research project inspired by the practice of Fijian female tattooing, https://theveiqiaproject.com/about/.

von Bulow, W, 'Beiträge zur Ethnographie des Samoa-Inseln', *International Archiv für Ethnographie*, no. 12 (1899): 129-31.

von Kotzebue, O, *A New Voyage Round the World, In The Years 1823, 24, 25, and 26, Volume 1* (London: Henry Colburn & Richard Bentley, 1830).

von Kubary, FS, 'Aus den Samoanischen Familienleben', *Globus* 47 (1885): 70-88.

von Luschan, Felix, *Beitrag zur Kenntnis der Tätowierung in Samoa* (Verhandlungen des Berliner Gesellschaft für Anthropologie, Ethnologie und Urgeschichte, 1896).

Wonu-Veys, Fanny, *Unwrapping Tongan Barkcloth: Encounters, Creativity and Female Agency* (London: Bloomsbury, 2017).

Virchow, R 'Samoanern', *Verhandlungen der Berliner Gesellschaft für Anthropologie, Ethnologie und Urgeschichte* (1890), 387-92.

Wakefield, EJ, *Adventure in New Zealand from 1839 to 1844 with Some Account of the Beginning of the British Colonisation of the Islands* (Wellington: Whitcombe & Tombs, 1908).

Wedde, Ian, (ed.), *Fomison: What Shall We Tell Them?* (Wellington: Wellington City Gallery, 1994).

Wendt, Albert, 'The Cross of Soot' in *Flying Fox in a Freedom Tree and Other Stories*, 1974. (Auckland: Penguin, 1988), 7-20.

Wendt, Albert, 'Afterword: Tatauing the Post-colonial Body', in *Inside Out: Literature, Cultural Politics and Identity in the New Pacific*, edited by V Hereniko and R Wilson (Lanham, Maryland: Rowman and Littlefield, 1999), 409. Originally published in *Span* 42-43 (April-October 1996): 15-29.

Western Samoa (Report of Royal Commission Concerning the Administration of), Appendix to the Journals of the House of Representatives, 1928 Session I, A-04b.

Western Sāmoa (Report of Royal Commission Concerning the Administration of), Appendix to the Journals of the House of Representatives, 1928 Session I, A-04b, page 183.

'Walking Birth Certificates', *Western Star*, Issue 2190 (26 March 1898), http://paperspast.natlib.govt.nz/newspapers/WSTAR18980326.2.34.

White, Geoffrey & Lamont Lindstrom, (eds), *The Pacific Theater: Island Representations of World War II* (Honolulu: University of Hawai'i Press, 1989).

Wilkes, C, *Narrative of the United States Exploring Expedition during the Years 1838, 1839, 1840, 1841, 1842, vol. II* (Philadelphia: Lee & Blanchard, 1845).

Williams, John, *A Narrative of Missionary Enterprises in the South Sea Islands* (London: John Snow, 1837).

IMAGE CREDITS

ABOUT THE
CONTRIBUTORS

TUSIATA AVIA was born in Christchurch in 1966, of Sāmoan descent. She is an acclaimed poet, performer and children's book writer. Her previous poetry collections are *Wild Dogs Under My Skirt* (2004; also staged as a one-woman theatre show around the world from 2002–2008) and *Bloodclot* (2009). Tusiata held the Fulbright Pacific Writer's Fellowship at the University of Hawaiʻi in 2005 and was the Ursula Bethell Writer in Residence at the University of Canterbury in 2010. She was also the 2013 recipient of the Janet Frame Literary Trust Award. She teaches creative writing and performing arts at Manukau Institute of Technology, Auckland.

RON BROWNSON is Senior Curator New Zealand and Pacific Art at Auckland Art Gallery Toi o Tāmaki. He is an expert on New Zealand and Pacific art, with a particular interest in photography. He has initiated many exhibition and publication projects ranging from *John Kinder photographs* (2004), and *L. Budd et al, Flight plan* (2018) to *Ralph Hotere godwit kuaka* (2014). He edited *ART TOI — New Zealand art in the collection of Auckland Art Gallery.* He is a trustee of the Tautai Contemporary Pacific Arts Trust.

ADRIENNE L KAEPPLER is Curator of Oceanic Ethnology at the Smithsonian Institution, Washington. Her research and publications focus on the interrelationships of social structure and the arts, especially poetry, music, dance and the visual arts, and she has carried out extended fieldwork in Tonga, Hawaiʻi and other parts of Polynesia.

TAKAHIRO 'RYUDAIBORI' KITAMURA was born in Japan and raised in California. He has been a tattoo artist since 1998. He practised tattooing under the artist name 'Horitaka' until 2014, when he took the name 'Ryudaibori'. Since 2002, he has been the owner and operator of State of Grace Tattoo in San Jose, California, and since 2004, the co-founder and co-host of the Bay Area Convention of the Tattoo Arts. His many books include *Bushido: Legacies of the Japanese Tattoo* (2000), *Tattoos of the Floating World: Ukiyo-e Motifs in the Japanese Tattoo* (2003), *Tattooing from Japan to the West: Horitaka Interviews Contemporary Artists* (2004), *We Are Tattoo* (2008), and *I Love Tattoos* (2012). He curated the exhibitions *Perseverance: Japanese Tattoo Tradition in a Modern World* (2014) and *Tatau: Marks of Polynesia* (2016) for the Japanese American National Museum in Los Angeles.

TUPE LUALUA GDipArts, BAppa, BA Hons, Sāvaia, Lefaga, Leusoaliʻi, Luatuanuʻu, Porirua, is a dance and theatre practitioner. She has toured internationally both as a student and graduate of Whitireia Polytechnic, New Zealand, where she teaches siva Sāmoa. She is also a graduate of Victoria University of Wellington, where she has taught Pacific Studies as a teaching fellow. She is the artistic director of award-winning dance theatre company Le Moana, which tours internationally representing Aotearoa and Sāmoa through dance workshops and live performances.

REVEREND TAVITA MALIKO is an ordained minister of the Congregational Christian Church Sāmoa. He is a lecturer in Theology at Malua Theological College in Sāmoa. His doctoral thesis (2012), 'O le Sogaʻimiti: An Embodiment of God in the Sāmoan Male Body', examines how the Sāmoan male body embodies God, and how this 'embodiment' is visually depicted in the male tatau (tattoo) motifs. The thesis is an interesting weaving together of culture and theology to express an understanding of God from the perspective of the Sāmoan male body. Tavita is from the villages of Asau, Vaisala, Saleaula and Samauga.

SELINA TUSITALA MARSH is a Pasifika poet-scholar and is the current New Zealand Poet Laureate. As the 2016 Commonwealth Poet she wrote and performed a poem for Queen Elizabeth II at Westminster Abbey. Her third collection of poetry, *Tightrope*, was published in 2018 by Auckland University Press. Selina is an associate professor in the English Department at the University of Auckland, teaches Pacific literature, convenes its largest course in creative writing, and supervises poets in its Master of Creative Writing programme. She has informed her teenage sons that sure, they can get tattoos . . . as long as they are done in Sāmoa by their 'family' tufuga, Li'aifaiva.

LE'AUSĀLILŌ LUPEMATASILA FATA 'AU'AFA SADAT MUAIAVA is a lecturer in the Sāmoan Studies programme, Va'aomanū Pasifika Unit, at Victoria University of Wellington, and is currently completing his PhD in Pacific Studies. His doctoral thesis is a corpus-based examination of Sāmoan language change from 1906–2014. His Master's thesis researched the parsonage experiences of Sāmoan faife'au (pastor) kids (FKs). Sadat is from the villages of Sāfa'ato'a (father) and Faleāse'elā (mother). He holds the Le 'Ausālilō and Lupematasila titles from his mother's family in Faleāse'elā and Falelātai, respectively, including the orator titles Fata (Afega) and 'Au'afa (Lotofaga, Aleipata) from his wife's family.

LEALI'IFANO ALBERT L REFITI is a senior lecturer at the AUT University and co-leader of the Pacific Spaces Research Cluster. Albert has an architectural degree, and also completed a PhD on the relationship between Pacific cosmogony and the emergence of space and architecture in Pacific thought. He has written recently on Pacific concepts that underlie technical tendencies in the creative arts and architecture.

BENOÎT ROBITAILLE and his family operate a small produce farm in the hills of Southern Québec, Canada. In his free time he continues to work on a world-wide investigation of pre-electric traditional tattooing instruments, a project he initiated two decades ago as a student of cultural history under the tutelage of Professor Paul Tolstoy at the University of Montréal.

NICHOLAS THOMAS visited the Pacific first in 1984 to research culture and history in the Marquesas Islands. He has since travelled and written extensively on cross-cultural encounters, empire, and art in the Pacific. His books include *Entangled Objects* (1991), which influentially contributed to a revival of material culture studies; *Islanders: The Pacific in the Age of Empire* (2010), which was awarded the Wolfson History Prize, and a collaborative work, *Art in Oceania: A New History* (2012), which was awarded the Authors' Society's Art Book Prize. Since 2006, he has been Director of the Museum of Archaeology and Anthropology and a Fellow of Trinity College, Cambridge.

NINA TONGA is an art historian and Curator Pacific Art at the Museum of New Zealand Te Papa Tongarewa. She is from the villages of Vaini and Kolofo'ou in Tonga and was born and raised in New Zealand. She holds a Master of Arts specialising in contemporary Pacific art and is a doctoral candidate in art history at the University of Auckland. Her current research focuses on contemporary Pacific art in New Zealand and the Pacific, with a particular interest in internet art from 2000 to the present.

MARIA CAROLINA VESCE holds a PhD in Anthropology and Historical-Linguistic Sciences from the University of Messina. She is an independent researcher and teaches Cultural Anthropology at the Linguistic Academy of Fine Art in Genoa. She conducted fieldwork in Naples and Sāmoa and has contributed articles and essays to edited books and journals. She is interested in the anthropology of the body, of genders and persons, with a focus on non-heteronormative gender experiences.

MAUALAIVAO ALBERT WENDT ONZ, CNZM is of the 'āiga Sa-Maualaivao of Malie, 'āiga Sa-Su'a of Lefaga, āiga Sa-Patu of Vaiala and āiga Sa-Asi of Moata'a, Sāmoa. An esteemed novelist, poet, short-story writer, playwright and painter, he is also emeritus professor of English at the University of Auckland, specialising in New Zealand and Pacific literatures and creative writing. Albert has been an influential figure in the developments that have shaped New Zealand and Pacific literature since the 1970s, and was made Companion of the New Zealand Order of Merit in 2001 for his services to literature. In 2013 he was made a Member of the Order of New Zealand, New Zealand's highest honour.

SONYA WITHERS is of Sāmoan and Scottish descent and her village is Sama'i, Falelatai. She is formally trained with a BDes in Textile Design, a PGDip in Visual and Material Culture and a Master's degree in Design. Her tertiary studies provided her with an opportunity to explore her 'afakasi identity through the frameworks of design. Sonya was a recipient of the 2017 Creative New Zealand Pasifika Internship, which she completed at the Museum of New Zealand Te Papa Tongarewa. She is currently a Pacific Collections technician on Auckland Museum's Pacific Collections Access Project.

RACHEL YATES is of Samoan and New Zealand/European descent and hails from the village of Vaisala, Savai'i. She was a Curator of Pacific Cultures at the Museum of New Zealand Te Papa Tongarewa and is currently teaching fellow and PhD candidate in Pacific Studies at Victoria University of Wellington. Her current research analyses the experiences of Pacific women as skilled migrants in the twenty-first century and draws on her experience of living and working abroad. Rachel lives in Wellington with her husband and three children and is an active participant at Pacific conferences and events in the region.

INDEX

Bold page numbers indicate illustrations.

Āʻana (district) 59
Adams, Mark 16, 81, 82, 129: photographs **83-95**
adze blades 24
ʻafa (sennit cord) 25, 157
affirmations 203
afterlife 217
Agate, Alfred Thomas: drawings **34, 75**
Agcaoili, John 225, 226: photographs **227-39**
Ah Ching, Fuiavailili Lawrence 255
Ah Ken, Tavui Pasina Iosefo (Sefo) 84-5, 94-5, 127
AIDS 157
ʻāiga sā Fui 283
ʻāiga sā Mālietoa (Mālietoa's clan) 50
ʻāiga sā Meleisea (Meleisa clan) 125
ʻāiga sā Suʻa (Suʻa clan) 24, 112, 113, 122, 125, 153, 179, 180, 182, 185-7, 207, 244, 251-2, 254, 268: foundation 185-7; growth 186-7; practitioners 186-7; rules 207
ʻāiga sā Tulouʻena (Tulouʻena clan) 24, 179, 180, 182-5, 207, 244: foundation 183; practitioners 183; rules 207; terms of address 185
aitu (mythical beings) 180, 200; see Taemā and Tilafaigā
alagāʻupu (proverbs) 216-17
Alameda, SS 78
aliʻi paʻia (paramount chief) 295
Allen, Tricia 266
alphabet 114: see also writing

Amsterdam Tattoo Museum 134-5, 153
Analega (cave) 183
André, Laulu Tulouʻena 183
Andrew, Thomas 99, 106, 109
annexation by Germany 61, 99
ano le tua (first lines) 195
anthropology 82, 245; see also ethnography
anthropometric studies 69-71
anti-colonial movements 102-3, 105, 106
Apia 152, 243-4, 247: tattoo shops 243-4
Apia Way Nite Club 148
apisā (tattooing house) 198-200
Appadurai, Arjun 127
apprenticeship 187-8, 192-3, 214-15, 251, 264: master-apprentice relationship 193
appropriation of tatau 72, 100, 105, 142, 146, 157, 257-9, 263, 267, 269-71, 275, 288-90
armbands see taulima
art, tatau in 15, 129, 270: tatau as artform 15; and tattooed bodies 205, 292-3
artefact, tattooed body as 205
ʻaso (motif) 195, 196
ʻaso e lua (motif) 196
ʻaso e tasi (motif) 195
ʻasofaʻaifo (abdominal designs/motifs) 196, 224
ʻasofaʻalava (motif) 195
ʻasofaʻavaetuli (motif) 196
ʻasotaliʻitu (motif) 196
assistants see toso
Astrolabe (ship) 30
Atafu/Atofau 71, 78
atigivae (motif) 196

Atme, John and Marwan 136
ʻatoau (basket of tools) 35, 180
A-Town Tattoo 233
au/autā (tattooing tools) **6-7**, 14, 15, 23, 25, **27**, 38, 39-40, 62, 70, 72, 111, **112**, **124**, 143-4, 153, **156**, 187, **188-9, 190**, 214-15, **217**, 282, **296-7, 305**: assembly **188**; boar/pig's tusk comb 25, 156, 157, 188, 189, 215; comb 14, 25, 38, 40, 45, 111, 156, 157, 187, 188, 189, 215; hand-tapping 25, 154, 157, 187, 192, 214-15, 285; human bone 157; plates 14, 25, 111, 157, 189; sausau (mallet/striker) 25, 187, 188, 215; steel **156**, 157, 188, 190, 215, 285; synthetic materials 144, 157; toolkit 25, 182, 209; vatuʻe (file) 187; see also lama (ink); machine tattooing
ʻaumāga (dances) 46-7, 194
au mono (caulking needle) 187
au nifo puaʻa (boar's tusk comb) 25, **156**, 157, **188**, 189, 215
au nila (steel needle) **156**, 157, 188, 190, 215, 285
au sogi aso sasaʻo (straight rafter needle) 187
au sogi asofaʻaifo (curved rafter needle) 187
au tapulu (tool) 187, 188
au vili (pump drill) 187, **189**
Auckland 82, 131, 136, 137, 159, 162, 176, 183, 274
Auckland Art Gallery Toi o Tāmaki 162
Auckland Tattoo Convention 159
Auckland Tattoo Studio 131
Australia 144-5, 187, 204

Austronesian languages 25
autā see au/autā
ʻautāpuaʻi (participants supporters) 202, 205, 209
autāpuaʻi (group supporting with silent prayer) 74, 202, 205, 209
ʻautufuga (tufuga and assistants) 191-3, 205
Auvaʻa (chief) 23, 179, 185
ʻava (kava) 115, 150, 152, 185-6, 198, 210, 285: ʻigōa ipu (ʻcup name') 185-6
ʻavaʻega (construction of tatau) 218
Avia, Tusiata 256, 308

Bach, Elsie 125
baptism 207
Barff, Charles 37
Barnum, PT 78
Bastian, Adolf 70
Baxter, Bob 249-50
beautification 75
Behrens, CF 36
Bell, Captain 80
Berking, Rudolph 100
Betham, Fune **94-5**, 127
Betham, Gus **94-5**
Betham, Lui **94-5**
Betham, Pasina **94-5**
Betham, Willie 127
bloodletting ritual 200
Blue Horizons 133
Bluo 143
boar's tusk comb see au nifo puaʻa; au/autā (tattooing tools)
Bolton, Angela 255
Bougainville, Louis-Antoine de 36-7
Bouman, Cornelis 36
British explorers 37

Brown, Anthony 148
Buck, Peter (Te Rangi Hīroa)
111–15, 196
burns 38
Buse, JE 199

calligraphy, Chinese 141
candlenut 109, 157, 189, 190: soot
25, 38, 40, 109, 143, 144, 157,
189, 190, 204, 249
Caroline Islands 103
cars, tatau on 270
Carter, Anton 145
Cartwright, Bruce 111
Catholicism 47–8, 50, 52, 63: see
also Marist order
ceremonial contexts 122, 179, 259
change, cultural 157, 244–5, 270–1
chart of deeds, tatau as 216
Chicago World Fair 106, 109
chiefs see matai
China, southern 25
Chinese influence in Sāmoa 103
Chinese motifs 141
Christianity 26, 35, 45–6, 47–57,
59, 67, 69, 194: integration
with Sāmoan way 67, 69;
introduction to Sāmoa 48, 67;
prohibitions on tatau 45–6, 51,
109; and sexuality 50–1; and
tatau 26, 47–57, 194
Churchward, William 45, 67
circumcision 70
clans 180: see 'āiga
clothing 64, 288, 289:
requirements 198–9, 202; tatau
as 64
Clothing of Tongans in Nomuka 30
clubs, incised 31
coat of arms 138
colonial (German) period 69–71
comb, tattooing 14, 25, 38, 40, 45,
111, 187, 188: boar/pig's tusk 25,
156, 157, 188, 189, 215; stainless
steel 285
commercial tattooing 72, 125, 131,
138, 146–8, 263–4, 288; see also
studios
Commerson, Philibert 37, 39
competitions, tatau 148
compulsory tatau 152
Congregational Christian Church
of Sāmoa, tattooed pastors
of 211
constitution (1873) 59, 61
construction of tatau 218–21
Contemporary Polynesian style
268, 270
contemporary tattooing 243–95

continuity 117, 157, 244
convention, tatau (Sāmoa) 152
Cook Islands 24, 47
Cox, David 72
creation myths and tatau 26: see
also Taemā; Tilafaigā
crest, Sāmoan 138
cults, Sāmoan 51, 67, 69
cultural contexts 14–15, 152–3, 155,
157, 246
cultural flows 127, 135–6, 245
cultural loss 139, 157
Cunningham, Robert 70, 78–9
Cusack-Smith, Thomas Berry 72
Customary Tattooing Guidelines for
Operators 282

dance troupe, Leone 78–9:
newspaper ad for 79
dances 46–7, 56, 75, 150, 152, 153, 283
Davis, John 106
deaths from infection 204, 282
democratisation of tatau 264
designers, Sāmoan apparel 288–9
Deutsche Handels- und
Plantagengesellschaft 99
diaspora, Sāmoan 99, 127, 137, 141,
187, 255
Die Tätowirung Beider Geschlechter
in Samoa (The Tattooing of
Both Sexes in Samoa) 16, 162
dissemination of tatau
information 259–71
drawings of tatau 31, 32, 34, 44,
68, 102, 113, 117, 118, 119, 136
Dumont d'Urville, Jules 30, 31,
245
Dutch explorers 36
dyes/ink see lama

eagle motif 117, 119, 120–1, 249
ear piercing 103
Edwards, Edward 37
Efi, Tupua Tamasese 189
Ekeni, Asi 132
emigration 126–7; see also diaspora
Erskine, John E 41
ethnography 69–71, 75, 106;
documentation of tatau 110–15,
195–6
Eti, Tofilau 168
Europeans: colonisation 69–71;
contact/observations 15, 30,
33–79; settlers 37–8
Everett, Kandi 133
exemptions from tatau 295
fa'aaloalo (respectful address) 46
fa'aatualoa (motif) 196
fa'afafine tattoos 212–13

fa'aila (design elements/motifs)
112–14, 196
Fa'alavelave, Su'a, 122
Fa'amafi 24
fa'amāsei'au (ceremonial
deflowering) 50, 194;
prohibition 194
Fa'amau, Pio 143
Fa'amausili, Fa'aofonu'u Pio 183
Fa'amausili, Moemoe 183
Fa'amausili, Tulou'ena Peni 13,
183, 185
fa'amo (motif) 114
fa'amuli'ali'ao (motif) 196
fa'anu (motif) 114
fa'apa'ia le galuega (consecration
of the work) 198
Fa'apologaina family 295
fa'asā (proscriptions) 190, 202–3
fa'asāmoa (Sāmoan way) 67,
150–1, 259, 273
fa'atala fa'alava (octopus suction
cup motif) 285
fa'atala laupaogo (motif) 196
fa'avala (motif) 196
Facebook 263–4
Faioso 112–13
Fakauakimanuka II 29
fale Sāmoa (Sāmoan house) 194:
motif 138
Faleālili 125
Faleālupo 23, 54, 153, 183
faletele (roundhouse)
inauguration ceremony 208
family, titled head of see matai
fashion 288–9
Fashion Pasifika (1998) 288
Fasito'otai 224
Fatutoa Michael (Sāmoan Mike)
237, 263, 271
Fau Ola, Revd Oka 211
feagaiga relationship 213
female tatau see malu
female tattooists 249, 266, 290–1
Fesche, Charles Félix 36–7
feso'ota'iga (meeting with
tufuga) 197
fesoasoani (partnership) 200
Festival of Pacific Arts/Pacific
Arts Festival: Seventh, Apia
(2006) 142, 143, 144–5, 249;
Ninth, Palau (2004) 240
festivals, cultural 142–52, 240, 249
Feu'u, Fatu 88–9, 129
Figiel, Sia 260
Fiji 22–3, 24: female tattooed figure
12; mythical beings Tufou and
Filelei 74
Filelei 22

film/video 16, 82, 99, 106–11, 133,
259–60, 262, 273, 286, 292
Fineanganofo, Ata'ata 31, 245
Fitafita Colour Guard, American
Sāmoa 119
Fitiao, Wilson 192–3
Fitiuta (Sāmoa) 22, 23
flag motifs 119
Flaherty, Frances 108–9
Flaherty, Robert 82, 108–9
Flanagan, Vaughan Tangiau 256
'Flash Harry', 80
flying fox 154, 216, 218, 273
fofō (massage) 27, 187, 191, 204,
224
Foi 78, 79
Fomison, Tony 86–7, 129, 147
Fonda, Peter 133
Fono a Faipule (the Pule) 59, 105
Fono o Ta'imua 59
Fosi, Malagama'ali'i Lavea Vui
152
Fosi Levi, Malagama'ali'i Lavea
Vui 246
Franconia, SS 116
Franklin, Old Tom 80
Freewind, Sulu'ape 250, 251, 252,
260, 272
French explorers 36–7
Frost City Tatau 234
Frost, Fred 234
fue (flywhisk motif) 138
fufulu pe'a ('washing the
tattooing': sex) 50–1
fusi (motif) 196
fusitā (mat presentation) 114, 199

Gagaifolevao (village) 186
Galliot, Sébastien 211, 214–15
games, console 262
Gavet, Father Léon 62–3
Gell, Alfred 75, 194
George I, King 30, 55
George V, King 72
Germany: annexation 99;
explorers 37; influence 100–103
gift-giving 46, 53, 146, 191, 195–6,
198, 208–10, 267: see also
payment/recompense
Gilbert Islands (Kiribati) 103
Gilsemans, Isaac 30
globalisation 16, 243–95
Godeffroy, Johan Cesar 70
gogo (tern motif) 114, 196, 285
gogosina (white tern motif) 285
Graffe, Raymond 132
Groves, Jack W 117–19
Gurr, EW 105
Hale, Horatio 38–9

Hammonia, SS 78
Handbook of Western Samoa 114
hands, tattooed 110, 115, **118**
hand-tapping 25, 154, 157, 187, 192, 214–15, 255, 285
Handy, ESC and WC 110
Harbutt, William 56
Hardy, Don Ed 133, 257
Hauke, Frau 79
Hawai'i 25, 124–5, 245, 268: armband 124–5
Hazard (ship) 80
healing: physical 162, 190, 199, 204–5, 207; sociocultural 273–5
health and safety **282**: newspaper billboard 282; *see also* hygiene
Heather, Ugapo Makerita 266
Henninger, Julius: tatau drawings **102**
hereditary profession 45
heterogeneity of tatau 111, 114–15, 138, 191, 218, 244–5, 298–9
hierarchy *see* status
HIV/AIDS 157, 282
Hood, Thomas H 45
Horiyoshi III 133
House of Ink 138
Houzé, Dr Émile 70
Hunkin, Galumalemana Alfred 148
Hunt, Tim 266
Huukena, Teiki 13
hygiene 143–4, 157, 188, 246, 249, 282

iconography 72, 75, 218–23
identification 72
identity, personal 14–15, 152–3, 155, 157, 205, 216, 246, 271–5, 286, 288–9, 292–3, 295
'ie lāvalava 202
'ie tōga (fine mats) 24, **28**, 46, 47, 67, 114, 146, 195–6, 197, 209; regulation of 101, 102, 105
incomplete tatau 112
independence, national 122–3
Indian ink 189
individuality 72, 152, 154, 213
infection from tatau 204, 282
influenza pandemic 104–5
Ingerton, Roger 129–30, 266
inheritance 216
initiation rite *see* rite of passage
ink *see* lama
innovation in tatau 112, 114, 117, 119, 142
Instagram 263
intermediary 197–8
international influences 142–3, 152–3, 157, 187, 192, 245–55, 260, 270–1

International Tattoo Art 260
internet 262–3
Inventory of Gestures 292
Ioane, Fa'amoana 145
Ioane, Tufuga 183
Iosua, To'afa 138
Ita'ifafo, Pasino 127

Jandal Broz 288–9
Japanese American National Museum (Los Angeles) 226, 253, 268
Japanese tattooing 72, 226
Jerry (sailor) 80
Johnson, Dwayne (The Rock) 262, 268, 286, 287
Johnson, Rocky **287**
Jolly, Margaret 109

Kaeppler, Adrienne L 308
kava *see* 'ava
Keesing, Felix 46
Kelly, Sailor Geoff 131
kernels 306
kerosene soot 143, 157, 189, 190; *see also* lama
kie hingoa (fine mats) 24, 28, 29
Kightley, Oscar 145
kilikiti 101
King, Joseph 52–3
Kinselas nightclub 144
kinship connections 273–4
Kitamura, Takahiro 226, 268
Knight, Mickey 80, 288
Kotzebue, Otto von 295
Krämer, Dr Augustin 36, 52, 67, 71, 75, 109, 179, 195, 196, 207, 260
kupesi (pattern design boards) 31

L'Asino e la Zebra (convention, Rome) 133, 158
La Boudeuse (ship) 36–7
La Pérouse, Jean François de Galaup de 37
La'ai, Su'a 13, 207
Lafaele, Su'a Sulu'ape 136, 192–3, 224, 247
Lafai Taulupo'o 273
Lagi Malofie Society 282
Lalotalie (worship site) 23, 53
lama (candlenut tree): nuts **190**
lama (ink/pigment) 25, 26, 62, 143, **145**, 157, 187, 189–90, 201, 248–9: changes in 190; commercially produced 189, **190**; lama kaleseni (kerosene soot) 143, 157, 189, 190, lama Sāmoa (candlenut soot) 25, 38, 40, 109, 143, 144, **145**, 157, 189, **190**, 204, 249;

production rules 190
lama'avea 190, 204
Lands and Titles Commission 101
Lapita people 15, 20–2: Lapita ware 15, 20, 21–2; sites 21
Latu (painting) 30
Lau (Fiji) 24
Laupepa, Malietoa 59, **60**, 61
lavalava, tatau on 270
Lave, Jean 193
Lavea/Seve (chief) 23
Le Maire, Jacques 30
Le Moana 283
Le Tatau Tattoo International Convention (1999) 246
Le Tatau-Tattoo Millennium Convention 152–3
Lealatele 55
Leali'ifano, Leute-ole-tifa-o-A'ana 295
Lealofi 78
Lealofi III, Tupua Tamasese 105
Leasusu 78, 79
Lee, Bruce 139
Lefaga (village) 125, 186, 246, 250
Lefaoseu, Paul and Peter 141
Lemalu, Cole **261**
Lemi, Mulitalo 111
Leone (village) 70: dance troupe 78–9
Lepou, Lindah 288
Letungaifo 78, 79
Leutogitupa'itea 273
Levi, Li'aifaiva Imo 213, 214–15, 255
Levi, Li'aifaiva Lavea 273
Lévi-Strauss, Claude 180
Li'aifaiva clan 214, 285
Li'o, Lesa 132
Lister, Joseph: tatau drawing **44**
literature on tatau 16, 259–60
Liufau, Su'a Si'i 219
Liufau, Sulu'ape Si'i 233, 255
London Missionary Society (LMS) 37, 41, 47, 48–59: and marriages 50
Long Beach Tattoo Convention 252
Looney, Sulu'ape Steve 138, 231, 255
lotu Tōga 48
Low, Edwin H 78
Lualua, Tupe 283, 308
Lubeck, SS 79
lulu'uga (sprinkling/taboo removal) 41, **206**, 207
Lurcy, Gabriel Lafond de 37, 75
Luschan, Felix von 70, 71, 75, 124: tatau drawing **32**, **68**

Ma Ching, Steve 131, 137, 138, 143, 239, **270**, 271

Ma'afutukui'aulahi (chief) 24
Macdonald, Charlotte 72
machine tattooing (masini tā pe'a/ masini tā tatau) 16, 137–9, 147, 152, 187–8, 255; *see also* au/autā (tattooing tools)
Mafua (chief) 23
magazines 260
Maile [Mataele], Halaevalu 29
Maivia, High Chief Peter 262, 286, **287**
malae (ceremonial ground) 98, 195
malaetā (ceremonial ground associated with tatau) 23, 24, 53–5, 181, 182: role in tatau 53–4
malaga (ceremonial visits) 46–7, 105: restrictions on 105
Malaspina, Alessandro 30
male figure, carved **66**
male tattoo (pe'a, tatau) 14, 35, 38–9, 154, 218–21: on female 148; *see* tatau
Malielegaoi, Ronald 198
Malielegaoi, Tuilaepa Aiono Sailele 198
Mālietoa Vaiinupō 50
Maliko, Revd Tavita 309
mallet *see* sausau
Mālōfie (association) 152
mālōfie (completed tattoo) 205
Mālōfie a Sāmoa 246
Malone, Mike 125, 157
mālosi, meaning of 47
malu (female body tatau) 14, 22, 23, 37–8, 69, 74–5, 112, 114, 154, 263, 283, 292: construction 218, 222–3; meaning of 154–5; photographs of **144**, **184**, **213**, **228–31**, **240**
Malua 54, 211
mamalu (dignity) 205
mamanu (pattern motifs) 218
Mamea, Faiga **90–1**
Mamoe, Lauaki Namulau'ulu 102, 103
mānaia (ceremonial leader of 'aumāga) 46
Manogi 78, 79
Manono (Island) 24, 29, 59, 136, 192
Manu'a (island group) 22, 23, 29, 41, 51, 99, 114–15: law code 52; tatau 114–15
Māori 25, 30, 268: and Sāmoans 147, 148
Mapuifagalele 23
Marist order 47, 50, 52, 54, 61, 63–4, 179: competition with Congregationalists 56

Marquardt, Carl 16, 71, 75, 106, 124, 162, 260: drawing **76**
Marquesas Islands 132, 268: tattoos 132
marriage 24, 26, 50–1, 67, 74, 194; tatau as prerequisite for 67
Marsh, Selina Tusitala 260, 309
Marshall Islands 103
masini *see* machine tattooing
Masoe family 273
Masoe, Vanessa 274
massage *see* fofō 204
Mata'afa, Dennis 230
matai (chief/titled head of family) 46, 52, 57, 59, 69, 101, 104–5, 114, 185, 186, 195, 197, 258, 295: and missionaries 52, 56–7, 67, 69; regulations restricting 105; and tatau 46, 52, 195; title system 101; and tufuga titles 185, 186
mātaisau 24
matapule 24
mats, fine *see* 'ie tōga
Mau (movement) 105–6, 123
Mau o Pule (movement) 102–3, 106, 123
maua le soa (ritual partner) 200
Mauga, Afoa Ioane 10
Māvaega i le Tai 35
McCarty Jr, Milburn 117
McCown, Brent 255
McGrevy, Noel 127, 183
Mead, Margaret 180
meana'i tāua (tattooist's spouse) 200–202, 224
meanings of tatau 271, 273–5
Measina Samoa: Stories of the malu (documentary film, 2003) 273
media and tatau 259–62
media, electronic 262–4
Melanesians in Sāmoa 103–4
Meleisea, Malama 56, 57, 101, 104
Merensky, Jutte 96, 122–3
Methodists 48, 54–5, 59
Metro magazine 144
Mika, Tauili'ili Watti 271, **272**, 273
military service 72
Milner, George 200
Ministry of Health (NZ) 282
misappropriation concerns 146–8
Misitikeri, Alaiva'a 13
Misitikeri, Su'a Loli 13, 155, **184**, **188–9**
missionaries, Christian 35, 45–6, 47–57, 59, 64, 194
Mo'o, Sulu'ape Pili 136, 250, **251**, 253
Moana (film, 2016) 17, 262, 286

Moana (novel) **108**
Moana of the South Seas (documentary film, 1926) 82, 108–9, **110**, 111
Modern Primitives 12
Moe (chief) 55
Moko Ink 148, 253
Mōlī, Mālietoa 59, 61
Monfat, Father 62
Morrow, Pat 238
Mortillet, Gabriel de 69
motifs 41, 112, 114, 138, 187, 218–19, 220, 222, 267–8, 271, 273–5, 285: appropriated 257–8; Chinese 141; contemporary 267–8; order of 195–6
mourning practices 38
Moyle, Richard 74–5, 204
Mt Albert Tattoo Studio 131
Mua 78, 79
muāgagana (proverbs) 216–17
Muaiava, Sadat 309
Muaifaiva 23
muli (conch motif) 138
Mulinu'u, Paina 119
Murray, AW 80
Musée de Tahiti et des Iles 132
music 74–5, 111
Mussau 103
My Consulate in Samoa (book, 1887) 45
mythological elements 39–41, 186: *see also* Taemā and Tilafaigā

Nakano, Mayumi 133
Nanook of the North (film, 1922) 109
National Geographic 133
national symbols 122
nationalism 103, 122, 155
natural environment 216, 218
needles *see* au/autā (tattooing tools)
Nelson, Taisi OF 105
Netherlands 92–3
New Caledonia 47, 54
NEW Gallery (Auckland) 144
New Zealand 104–5, 136, 187, 204, 258, 263, 268: colonisation by 104–5, commercialisation of tatau 263; Sāmoans in 127–8, 258
New Zealand Sāmoa Mālōfie Association Inc. 152
ngatu (decorated barkcloth) 30
nifooti (cane knife motif) 138
Niuas (Tonga) 30

non-Sāmoans tattooed 80, 100, 125, 126, 142, 146–7, 257–9
nonu leaves 203
Nordstrom, Alison 106
nose piercing 103
Nunes, Sulu'ape Keone 250, **251**, 253–4, 260

O le Tatau Sāmoa (exhibition) 144
O'Connor, Merv 131
O'Meara, Tim 122
Ofu Island 29
'oloa 46
Olosega Island 29
operation, tatau *see* process of tatau
oral traditions 22–4, 35, 52
oratory 74, 179, 197, 209–10
origins of tatau 15, 19–31: Austronesian 25; autā (tools) 22, 23, 25; and clans 23, 24; and Fiji 22; and Lapita pottery 20–2; and linguistics 22; oral traditions 22–4; and Pacific islands trade 24; and rights to status/trades 24; and tapa 21; techniques 25; and Tongan fine mats 28–9 and Tongan royalty 29; and Tongan tatatau 21, 24, 30–1; tufuga tā tatau 24, 25
ornamentation 14, 36, 37, 111, 112, 114, 187, 203, 218–19
Osbahr, Wilhelm 100

pa'ū le mālōfie/tu'itu'i mālōfie (tatau process) 14: *see also* process, tatau
Pacific exploration/settlement 21–2
Pacific Festival of the Arts 142–3
Pacific Soul Tattoo 138, 231
Pacific Tattoo 266
Pacific Underground 145
Pacific Wave Festival (Sydney) 145
Padel, Father 55, 59, 61–3
Pago Pago 80, 99
Palea, Maleko 183
pāpā (titles) 57
papala (wounds) 205
Papua New Guinea 21
pastors, tattooed 211
Paulo I, Sulu'ape 112, 114, 143, 186, 254–5
Paulo II, Su'a Sulu'ape 86–7, **88–9**, **92–3**, 122, 127, 129–30, 134–6, 139, 141–2, 144, 145, 146–51, 153, 158, 160, 162, 187, 216, 219, 245, 246, 251–2, 254, 259: criticism of 146–8; death 153; drawing 136; interview 160; studio 147

Paulo III, Su'a Sulu'ape **228–9**
payments/recompense (for tatau) 45, 46, 102, 114, 115, 146, 191–2, 195, 196, 208–10, 248, 267: gift-giving 46, 53, 146, 191, 195–6, 198, 208–10, 267; non-payment 115; redistribution 208–9
pe'a (male tattoo) *see* tatau
pe'a (flying fox) 216, 218, 273
pe'amutu (incomplete tatau) 112, 205
pe'apisikoa (Peace Corps tattoos) 124, 125
Peace Corps 123, 124, 125–6, 142: tattoos 123, 124, 137, 142
Peni, Tuifa'asisina 176, 183, 184, 255, 262
Penisula, Lyle 129
Perseverance: Japanese Tattoo Tradition in a Modern World (exhibition) 226
Persoons, Rene and Carina **92–3**
pese tatau 74
Petelo, Fa'alavelave 122, 160
Petelo, Su'a Sulu'ape 90–1
Petelo, Su'a Sulu'ape Alaiva'a 13, 27, 31, 133–4, 135, 136, 138, 142, 143, 152, 153, 158, **159**, 183, **184**, 193, 207, 214, 216, **227**, 245–9, 251–2, 254, 263, 273: interview 158–9; overseas engagements 245
Petelo, Su'a Sulu'ape Peter/Pita 142, 214, 216, 236, 254, **269**
Petithuguenin, Jean **108**, 109
phone cards 260
photographs of tatau (male) **83–95, 96, 99, 120–1, 213, 219–23, 232–9**
photography 106–10
pigment *see* lama
plate 14, 25, 111, 157, 189: Perspex 157; turtleshell 14, 111, 157, 189; *see also* au/autā (tattooing tools)
Police, New Zealand safety campaign 260–2: poster **261**
political instability 59, 61, **99**
polygamy 47, 48, 50, 51, 69
Polynesian Reminiscences 41–2
Polynesian Tattoo Factory 232
popular culture 262, 286–7
pōula (dances) 46–7, 69, **75**; prohibition 194
Poutasi 125
Powell, Revd Thomas 23, 51–2
Powerhouse Museum (Sydney) 144
practitioners *see* tufuga
Pratt, George 23, 56
prescriptions, tatau (tulāfono) 202–3
printed garments, tatau on 270, 278–81

Pritchard, Mary 192
Pritchard, William Thomas 41–2, 67, 195
process of tatau (operation/ session) **49**, 62, 69, 70, 187–90, 195–6, 198–9, 257, 285: construction of tatau 218–21; photographs of **49**, **96**, **100**, **107**, **110**, **116**, **122–3**, **126**, **130**, **159**, **163–75**, **176**, **190**, **204**, **249**, **270**; seating positions 198–9, 202, 205; skin stretching 191, 192, 214; *see also* au/autā (tattooing tools)
prohibitions: food and drink 202; by missionaries 45–6, 51, 109; tattoo 26, 30, 41–2, 45–6, 48, 51–2, 55, 59, 61, 63, 64, 109, 115, 194
proscriptions, tatau (faʻasā) 202–3
puberty rite 75
pubic area tatau *see* punialo
Puhetini, Ioteve Tuhipuha 132
pūhoro (Māori thigh tattoo) 30
pula (motif) 195
pulatama (motif) 195, 216
pulatele (motif) 216
Pule, John 154
punialo (pubic area tattoo) 14, 11–12, 75, **76**, 111–12, 117, 119, **120–1**
pute (motif) 196

Qʼs Tattoos 138
Queen Sālote 29

Rasmussen, Peter 80
Ravenet, Juan 30
Refiti, Lealiʻifano Albert L 309
Reigns, Roman 271, 286
religious practices, pre-Christian 67, 69
remittances 137
responsibilities, sociocultural 111, 139, 197, 207, 213, 216, 253, 259, 271
revival of tatau 122–3, 126–7, 153, 157
RiccyBoy, Suluʻape **232**
Right Hand, of Laumua Amalogota **118**
rite of passage 45, 46–7, 64, 67, 109, 111, 112, 194, 195, 274
ritual 16, 26–7, 39–41, 42, 46–7, 62, 69, 74, 176–239: rules of ritual 202–5
Robitaille, Benoît 308
Roggeveen, Jacob 36, 179, 288
Rosieur, Vern 148
Rugby World Cup (2011) 262: billboard **262**

Rurutu (Austral Islands) 132
sā o le galuega (rules of the ritual) 202–5
Sacred Centre Tattoo 237
Sacred Tatau 263
saemutu (motif) 196
Safata 23, 24
Safotu 23
Safotulafai 102
Safune 109
Saga (district) 186
Sailorʼs Lotu 51
Sainson, Louis Auguste de 30, 31, 245: Tongan tatau drawing **31**
Saipan 119
Sakila, Tui 103
Sale, Akiu ʻQʼ 138
Saleʻilua 23
Saleapaga (village) 246–9
Saleilua Faleālili (village) 193
Salelāvalu 23, 24, 52
Salelologa 191
Salesa, Damon 105
Salevalu 55
Salmon, Bill 133
Salmon, Tavana 132, 157
sama (ground turmeric and coconut oil) 27, 201, 207–8, 224
samāga (anointing ceremony) 27, 194, 199, 201, **206**, 207–9
Sāmoa College 143: students **144**
Sāmoa National Dance Troupe **153**
Sāmoa Sensation website 263
Samoan Housebuilding, Cooking, and Tattooing (book, 1924) 110–11
Samoan Material Culture (book, 1930) 111
Samoan-Chinese 139, 141
sanctification by tatau 295
Sanele, Kasala 193, 255
Santa Cruz group (Solomon Is) 21
saofaʻi (title bestowal) 250–5
saotamaʻitaʻi (female leader of villageʼs unmarried women) 47
sausau (mallet/striker) 25, 187, 188, 215
Savage Origins Polynesian Tattoo and Design 266
Savaiʻi 45, 52, 55, 56, 59, 61, 80, 99, 102, 109, 152, 179, 183, 185, 209
Schiffmacher, Henk (Hanky Panky) 133–6
Schouten, Willem 30
Schultz, Dr Erich 100
scientific interest in Sāmoa 69–71
seating positions 198–9, 202, 205
Second International Tatau Convention (Sāmoa, 2001) 246–8, **249**, 250

Second World War 115–19
Selesele, Siaosi 199, 200
self-mutilation 38
selu (motif) 196
Semu, Greg 129, 141–2, 144, 161–75: self-portraits 161–2, **163–75**, 292
service (to community) 216–17
sexuality 26, 50–1, 59, 75, 148, 194, 205, 212–13, 284: faʻafafine tattoos 212–13; gender roles 148; *see also* marriage, polygamy
Shipley, Jenny 258
siapo (barkcloth) 46, **58**, 72, 105, 192: motifs 129
siapo mamanu (freehand painted barkcloth) 73, 290
Signatures of the Soul (documentary film, 1983) 133
Silauliʻi 78
Sina 23
singing 46, 74–5, 111
Sio, Taumuafono Leatigaga 132
Siovili 51
Siumu (village) 132
Skin and Ink 260
skin stretchers *see* toso
skin stretching 191, 192, 214
skin, preserved tattooed 78
smoking 202
Smyth, AG 105
Soʻo, Lau Asofou 211
soa partnership 200
social advancement 152–3
social Darwinism 69, 70
social ideals 216
social implications of tatau 67–71
social uses of tatau 74–5
Society Islands 25
sociocultural recovery 273–5
sogāʻimiti (tattooed man) 139, 284, 286: meaning 284
Solf, Wilhelm Heinrich 100–101
Solomon Islands 24, 103
songs 74–5
Soʻo, Lau Asofou 211
sounds, tatau 187–8
South Pacific Tattoo Show 148–50: poster **149**
Southeast Asia, island 25
souvenir, tatau as 275
sperm-whale teeth 24
Stair, Revd John B 35, 179, 180, 195, 207
stamps, postage **130**, 260
stationery, tatau on 270
status/hierarchy and tatau 45–6, 71, 101, 111, 114, 179, 196, 210, 270, 295

Stehlin Jr, Edmund 112
Steinberger, Colonel AB 61
Steinmetz, Georg 100–101, 104
Stevenson, Robert Louis 72
Stewart, Keith 144
studios, tattoo 242, 264–6, **267**, 268–71: business cards **276–7**
Suʻa (chief) 52, 53
Suʻa clan 23, 24, 179, 180; *see* ʻāiga
Suʻa, Laʻai 186
Suʻa, Misa 13
Suʻa, Tala **155**
Suʻapaʻia 122
suʻisuʻi (technique) 138
suafa tā peʻa (tattooing titles) 180–2
Suluʻape family 266, 267, 268: studios Apia 266, **267**, 283
Suluʻape titles 246, 250–5
Suluape Black (ink) 189
Sunderland, Revd John 51
supernatural beings 180, 186, 200; *see also* aitu, Taemā, Tilafaigā, tupua

tā moko (Māori tattooing) 147
taʻoto (patient) 205
Taʻū 41, 45, 51: law code 51
Taʻufoʻou, Tyla 266, 290, **291**
Taemā (and Tilafaigā) 22, 23, 35, 39, 53, 74, 148, 153, 179, 180, 182, 185, 193, 203, 210, 212
Tafaʻifa (sovereign) 57
tafagi (motif) 195
Tafili 185
Tafua (district) 199
Tagaloa 26
Tagiilima choir 126
Tahiti 36, 47, 67, 132: Sāmoan influence in 132
Taimalelagi 57, 59
Taimata, Tapu 186
Taiwan 25
talalaupaongo (pandanus leaf motif) 138
Talavou, King 59
Talavou, Mālietoa (chief) 55, 59
Talune (ship) 104
tamāaliʻi (children) 295
Tamafaigā, Leiataua 57, 295
Tamasese, Tui Atua Tupua 51, 295
tanoa fai ʻava (kava bowl motif) 138
Tanoi, Leo 144–5
Taofinuʻu, Mr **83**
Taouma, Lisa 273
tapa 21
Tapu (chief) 24, 179, 186
tāpuaʻi (encouragement/silent worship) 200, 202–3, **204**
tāpuaʻiga (sharing/worship) 224